MASTERPIECES
OF THE WORLD'S
GREAT MUSEUMS

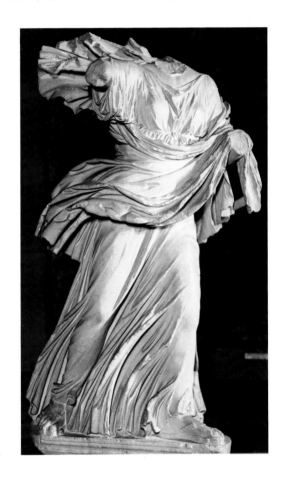

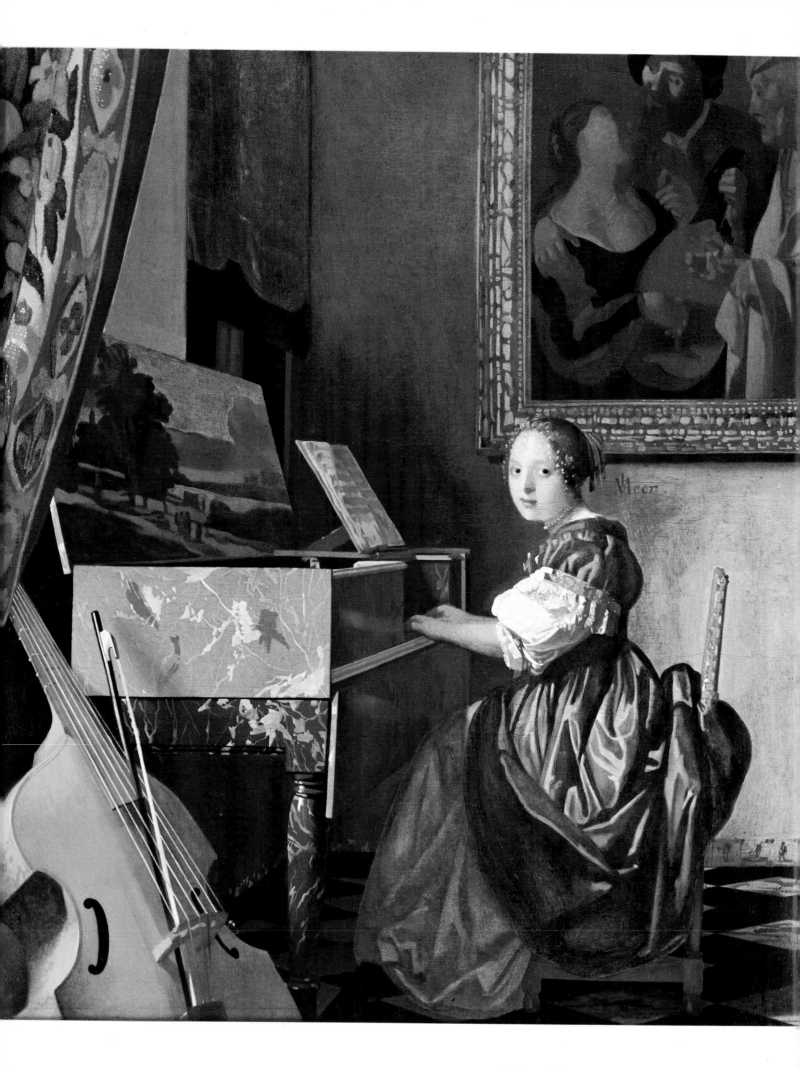

MASTERPIECES OF THE WORLD'S GREAT MUSEUMS

GALLERY BOOKS

Based on the NEWSWEEK series
edited by Carlo Ludovico Ragghianti

Text
ANTONINO CALECA
GIGETTA DALLI REGOLI
GIORGIO FAGGIN
GIAMPAOLO GANDOLFO
DECIO GIOSEFFI
GIAN LORENZO MELLINI
RAFFAELE MONTI
ANNA PALLUCCHINI
RODOLFO PALLUCCHINI
CARLO LUDOVICO RAGGHIANTI
LICIA COLLOBI RAGGHIANTI
ROBERTO SALVINI
PIER CARLO SANTINI

For the Hermitage
T. ARAPOVA, O. ANDROSOV, V. BEREZINA,
N. BIRJUKOVA, A. BANK,
S. VSEVOLOŽSKAJA, I. GRIGOR'EVA,
T. GREK, JU. ZEK, A. IVANOV,
A. KAKOVKIN, L. KAGANE,
JU. KAGAN, M. KOSAREVA, E. KOŽINA
A. KOSTENEVIČ, T. KUSTODIEV,
A. KANTOR-GUKOVSKAJA, JU. KUZNECOV,
M. KRŽIŽANOVSKAJA, I. LINNIK,
V. LUKONIN, B. MARŠAK, E. MOISEENKO,
I. NEMILOVA, N. NIKULIN,
I. NOVOSEL'SKAJA, O. NEVEROV,
L. NIKIFOROVA, G. PRINCEV, E. RENNE,
I. SAVERKINA, T. FOMIČEV

History of the museums
LUISA BECHERUCCI
WOLF-DIETER DUBE
MICHAEL LEVEY
RENÉ HUYGHE
A. HYATT MAYOR
FREDERICK SEBASTIAN LEIGH-BROWNE
EMMA MICHELETTI
DEOCLÉCIO REDIG DE CAMPOS
FRANCISCO JAVIER SÁNCHEZ CANTÓN
VITALIJ SUSLOV
JOHN WALKER

Originally published in Italian by
Arnoldo Mondadori Editore S.p.A., Milan
Copyright © 1988 Arnoldo Mondadori Editore S.p.A., Milan
Photographs copyright © Kodansha Ltd, Tokyo
Copyright © 1988 Kodansha Ltd, Tokyo — Arnoldo Mondadori Editore S.p.A., Milan
For the Hermitage
Text and illustrations have been kindly supplied by Aurora publishers, Leningrad, through Mladinska-Knjiga, Ljubljana
This edition copyright © 1988 The Hamlyn Publishing Group,
a division of The Octopus Publishing Group
Michelin House
81 Fulham Road, London SW3 6RB
English translation based on the NEWSWEEK edition copyright © 1969
First published in Great Britain in 1988 by
The Octopus Publishing Group

This edition published in 1988 by Gallery Books
An imprint of W.H. Smith Publishers Inc.
112 Madison Avenue
New York City 10016

ISBN 0-8317-5700-0

CONTENTS

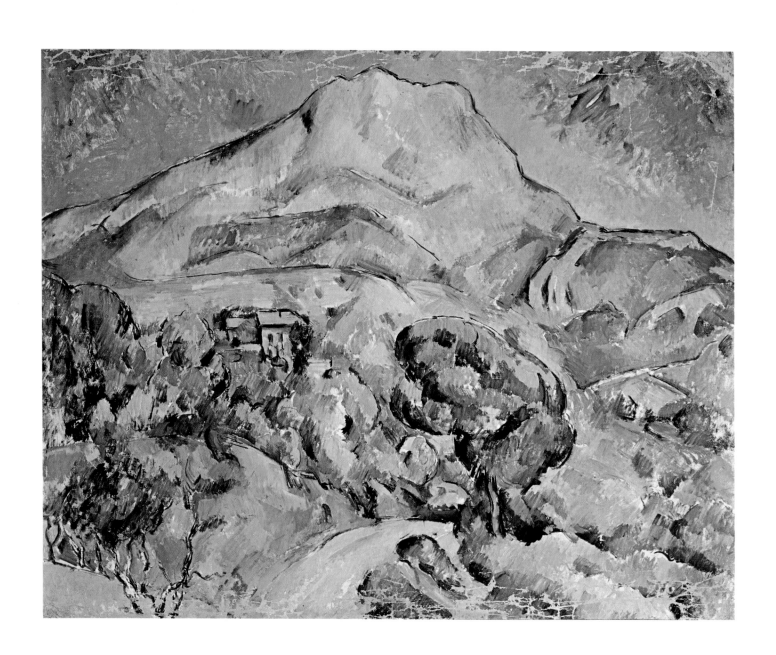

FOREWORD

This lavishly illustrated volume takes us on a tour of some of the world's most celebrated museums and their collections: the Alte Pinakothek, Munich; the British Museum and the National Gallery, London; the Hermitage, Leningrad; the Louvre, Paris; the Metropolitan Museum of Art, New York; the National Gallery, Washington; the Prado, Madrid; the Uffizi, Florence; and the Vatican Museums, Rome.

This book offers an introduction to these museums to those as yet unfamiliar with them, and a critical reassessment of them to those already acquainted with their collections. Individual works are appraised, and colour plates help the reader to appreciate their finer details. Background material is included on how the collections evolved and grew; there is also a plan of each museum outlining which rooms are devoted to which contents, together with a concluding catalog of the works discussed.

The museum is one of the most admirable institutions of a civilized society, the repository under one roof of the finest examples of creative endeavor. Through the works of art displayed we may glimpse artistic styles, costume and social conventions as they developed and changed through history, and enjoy the opportunity to review our cultural heritage in an enriching visual experience.

ALTE PINAKOTHEK

MUNICH

THE BUILDING

The Alte Pinakothek's present building is a large and imposing edifice in the Neo-Classical style. Designed by the architect Leo von Klenze, who was also responsible for the Propylaea and the Glyptothek in Munich, it was built between 1826 and 1836. Ludwig I, who ordered the reorganization of the Pinakothek, promoted the project. Von Klenze's constructions and others commissioned by the king give the Munich townscape of the period a completeness in keeping with Ludwig's philhellenic tastes.

PLAN OF THE MUSEUM

FIRST FLOOR

KEY
1 Early Dutch artists
2 Early German artists
3 Italian painting
4 Flemish painting
5 German painting — 17th century
6 Dutch painting
7 Italian painting
8 French painting
9 Spanish painting
10 Early German painting
11 Pictures from the 16th — 17th century

GROUND FLOOR

Where there is no number this denotes service areas or exhibition and conference rooms.

ALBRECHT DÜRER. *Self-Portrait in a Fur Coat.*

Dürer must have painted this *Self-Portrait* in the early months of 1500, some time before his birthday, which was on May 21. This would explain why the inscription in the background gives his age as 28 rather than 29. The solemn style and the broad, quiet forms show, however, that the painting must have been taken up again and largely retouched by the master himself in the early 1520s, after his visit to the Low Countries. For it is at that time that his portraiture acquired a new grandeur and power, accompanied by a greater density of color. The inscription, intended to consecrate this image of himself — which is based on the iconographic type of the Redeemer in benediction — must also belong to this second moment. Even if the first version of the painting, given the frontality of the scheme, aimed at the same general effect, it is certain that the definitive solemn and religious aspect is the work of the later repainting. In Dürer's later work, in fact, meditation on the spiritual essence of things — and in this case reflection on art as a gift of God and thus on the sacred character of the artist's function — prevails over the vitality and the intuition of reality that had been at the basis of Dürer's youthful work.

ALBRECHT DÜRER
Nuremberg 1471 — Nuremberg 1528
Self-Portrait in a Fur Coat
Lime panel; 26¼ × 19¼ in (67 × 49 cm).
Signed and dated on the left: "A.D. 1500." On the right an inscription in Latin states that the artist painted himself at the age of 28. Monogram, date and inscription appear to have been repainted, but X-ray examination shows that they are authentic. Dating: 1500 and *c.* 1521–25.

ALBRECHT DÜRER.

Portrait of Oswald Krell, Merchant of Lindau. *p.14*

Along with his *Self-Portrait* in Madrid, this is undoubtedly the finest of the numerous portraits executed by Dürer between 1497 and 1500, following his return from his first sojourn in Venice. The figure stands out from the background with the greatest plastic effect and is turned slightly to the right, while the lively eyes look to the left. The form is built up, as if in layers of different materials, by the successive planes of color, the dense and luminous hues recalling Antonello, Gentile Bellini and the Murano artists. These colors range from the red of the curtain and the bronzed flesh color to the dark-hued costume, which is barely interrupted by the white tunic, and the light, luminous brown of the fur. Along with the coloring should be noted the highly linear rendering of the features of the face and the firm contours of the figure. The powerful physical presence conveyed by the robust plastic and chromatic construction thus coincides with the sharp spiritual energy expressed by the linear fabric. The glimpse of landscape to the left is also highly linear and is stratified in a succession of colors that correspond to those of the figure. Instead of representing a contemplative and escapist motive, as in the Flemish and Venetian traditions, this portrait supports and emphasizes the strong-willed tension, the almost aggressive spirit of the subject.

ALBRECHT DÜRER. *The Four Apostles.* *p. 15*

The title of the painting has been universally accepted even though the fourth of the group of saints — John, Peter, Paul and Mark — was not an Apostle. In the artist's original intention the two groups would have flanked a panel of the Madonna, to make up a *Sacred Conversation.* He set to work

12

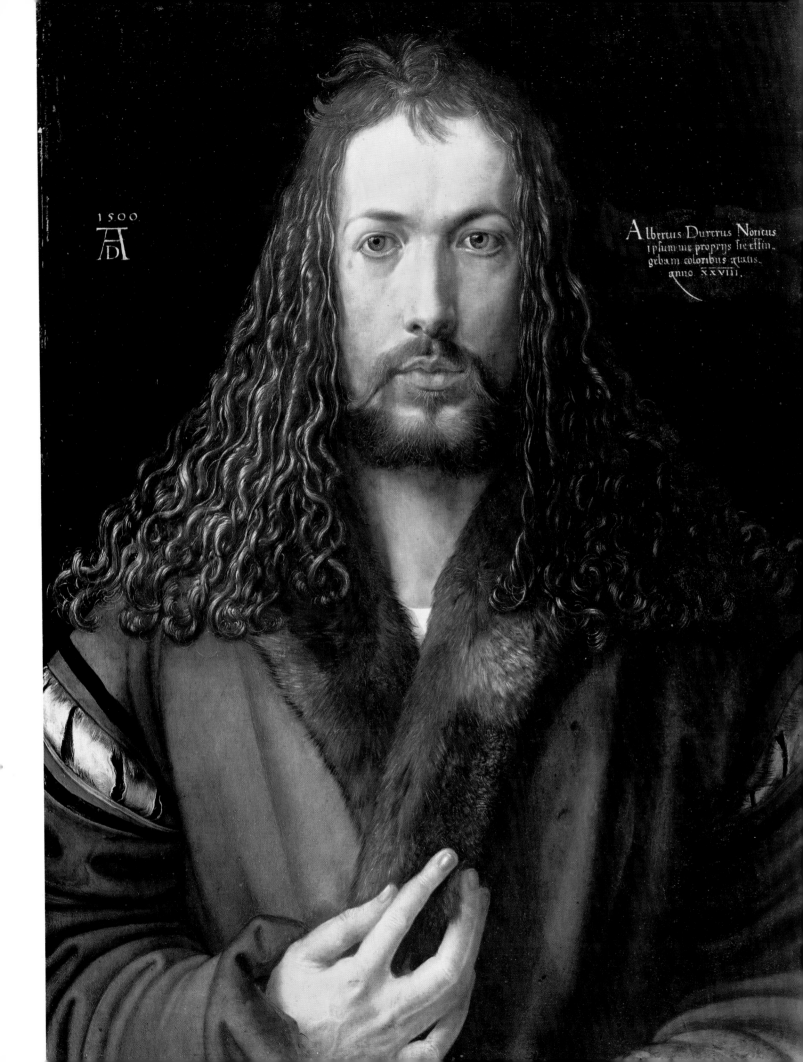

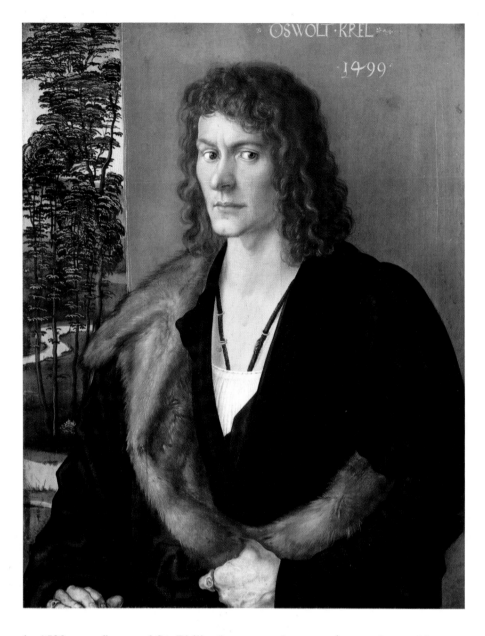

in 1523 on a figure of St. Philip that was subsequently transformed into a St. Paul. After the town council declared itself in favor of the Reformation in 1525, it became impossible to show a painting of the Madonna in Nuremberg and Dürer gave up the idea of painting the central panel. Instead, he presented the two wings to the council, after having added long inscriptions of quotations from the Epistles of Peter, John and Paul and from the Gospel of St. Mark.

The texts cited, in German, warned against false prophets, against hypocritical rebels who pose as servants of God but in reality love pleasure and sin and are the very ones who sack houses and rape women, and against Scribes and Pharisees who pontificate in the schools and sponge off widows. From the contents of these quotations it is easy to deduce that Dürer intended to incite the city officials against the sects of "left-wing reformers" no less than against the Papists. Dürer substantially adopted the position of Luther and the influential men of the city, with whom he had ties of

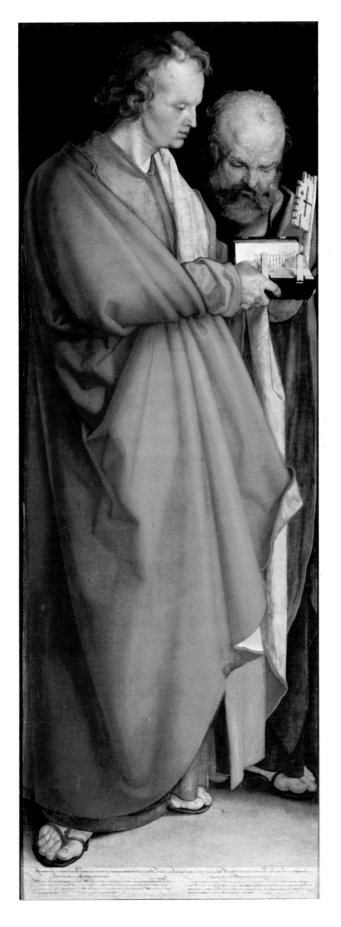
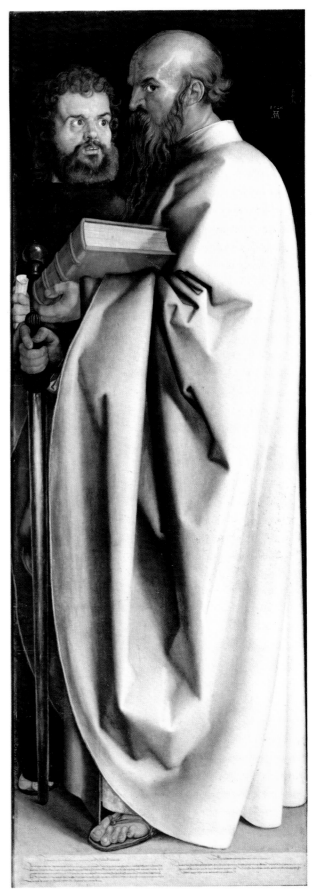

friendship and work, and was against the "communistic" interpretations of the Reformation that had led during those years to bloody tumults in the towns and to the Peasants' War in the countryside. This attitude should not be attributed only to an instinct for preserving his own social position. In view of the rigorous morality expressed in Dürer's work, it can be imagined that he viewed the mixture of religious with economic and social motives as a dangerous corruption of the Faith equal to — though in the opposite direction from — that caused by the trafficking of the Papist clergy.

Despite the travail of its creation, *The Four Apostles* is perhaps the greatest masterpiece of all Dürer's work, as well as the synthesis of all his experience as an artitst. In the disposition of the figures, there is an echo here of Venetian painting, while the clarity of the plastic form recalls Italy in the broader sense. Equally evident are the taste for luminous surfaces, which is of Flemish origin, and the fierce energy of the brushwork, which is nourished by the experience of a century of German art. But the proud, forceful sentiment that inspires the work leads to such a firm synthesis of opposites and to such imperious monumentality that no real comparisons can be found. The character of strenuous defenders of the purity of Faith, which the artist attributed to the four superb Apostles, is expressed in terms of pure pictorial language. The ideal of the dignity and strength of man as a participant in divinity and in nature is exalted here in an ideal of struggle against, or rather unshakable resistance to, evil.

LUCAS CRANACH THE ELDER. *Crucifixion.*

One of the earliest known works of the master, it shows not only the influence of Dürer's graphics but also, in the unusual emphasis on perspective, a knowledge of Michael Pacher and the more warmly colored early works of Pacher's pupil, Marx Reichlich. Cranach, who was born in Kronach in Upper Franconia, is known to have been in Vienna around 1502–3 and may have passed through the Tyrol. The spontaneous and monumental simplicity of this composition reveals a spiritual affinity with the young Dürer.

The traditional frontal disposition of Christ on the cross is given up, and the cross, seen foreshortened from the side, penetrates into the background and by itself establishes space for the landscape view. In the left-hand corner, the cross of one of the thieves is similarly foreshortened. In opposition to the third cross, seen in front view, it forcefully marks out a measurable, square section of space, which the screen of trees to the rear distinguishes from, but also connects with, the open space of the background landscape. But the landscape is not merely space, it is primarily a study of nature, sympathetically observed. Note the evident emotion expressed in the rendering of the faint rustle of wind in the tall willow and the majestic oak, or the pale blue luminosity of the snowy Alps on the horizon, behind the brownish hills and cliffs carpeted with green. This light then affects the figures, creating a mysterious radiance in the yellow, deep blue and red of the sorrowing spectators' garments, and in the bloody and livid flesh of the crucified. Thus a complete fraternity between figure and landscape is created. And the spiritual harmony of man and nature is expressed, in measuredly romantic terms, in this and other early works of Cranach.

LUCAS CRANACH THE ELDER
Kronach 1472 — Weimar 1553
Crucifixion (dated 1503)
Pine panel; 54¼ × 39 in (138 × 99 cm).

On pages 18–19:
ALBRECHT ALTDORFER
A detail of *The Battle of Alexander*
Lime panel; 62¼ × 47¼ in (158 × 120 cm).
Monogrammed and dated 1529.

16

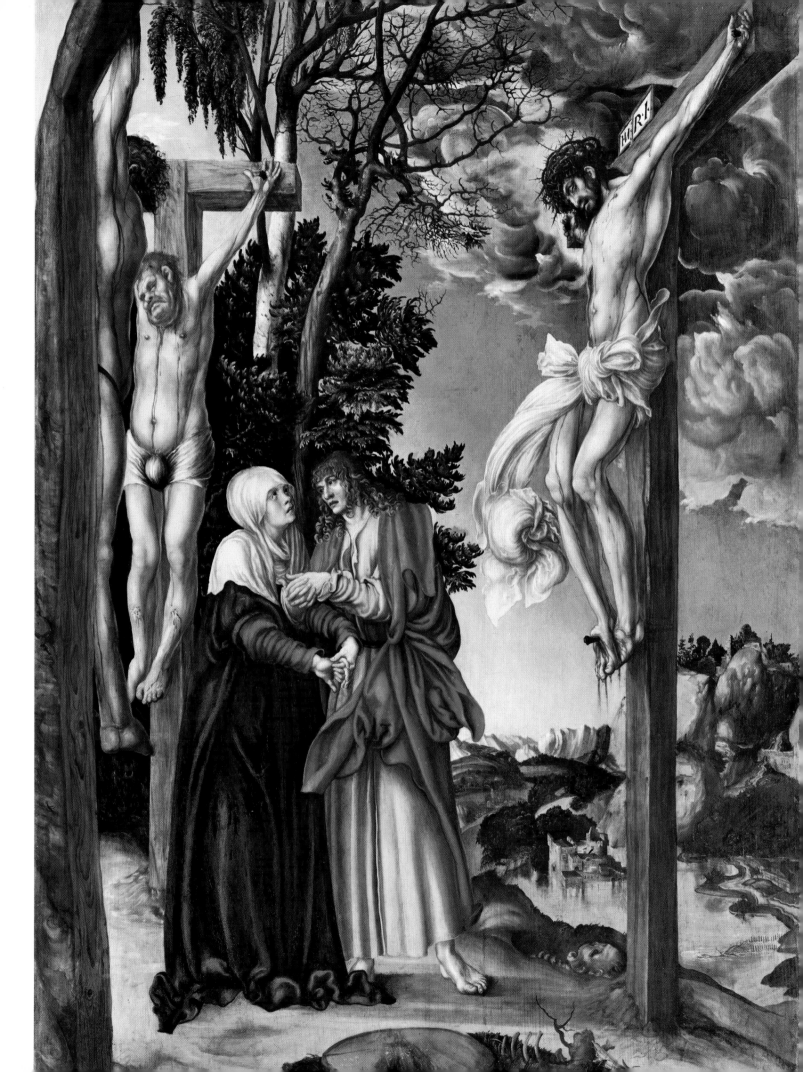

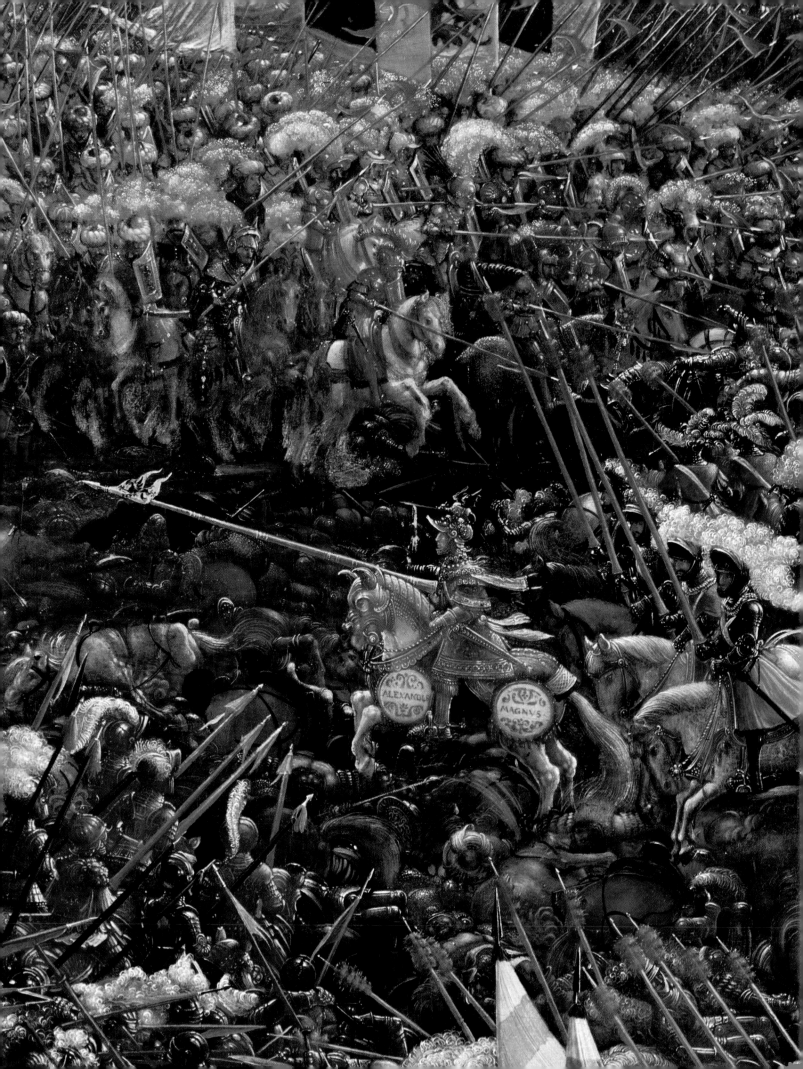

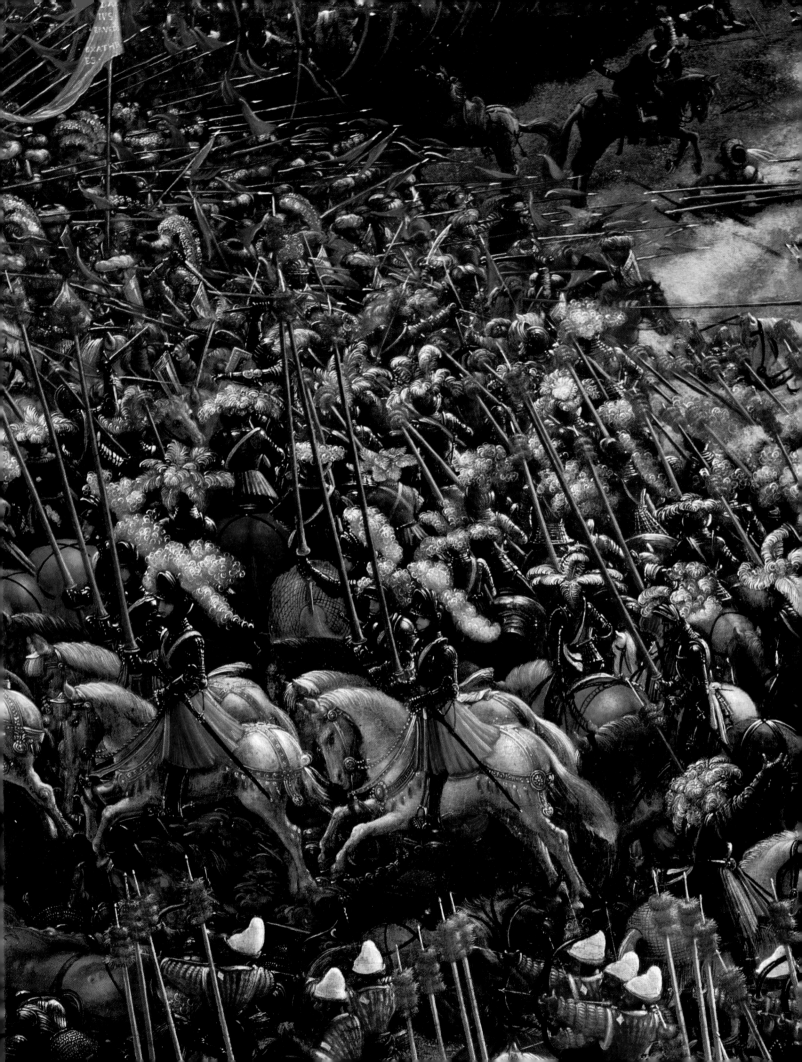

ALBRECHT ALTDORFER. *The Battle of Alexander.* *pp. 18–19*

Commonly called the *Alexanderschlacht* in German, it represents Alexander's battle against Darius on the river Issus and bears the bulletins, in Latin and German, of the losses inflicted on the enemy and those suffered.

This painting is admired for the virtuosity with which a vast number of figures has been included in a relatively small space. Indeed, the little figures of the combatants could actually be counted one by one throughout the distant view. The technical skill of the artist is undeniable, but no less noteworthy is his imagination. Fundamentally not so different from his other paintings, this work is enhanced by the multiplication of the figures and by the minute details of the landscape. Thus in the open, flashing light of the wonderful picture, the battle expands into a cosmic event in which the sun and the moon, the clouds and the air take part.

It is worth recalling that there is an unmistakable reference to this painting — perhaps through some copy or variant — in *The Suicide of Saul* (1562) by

PIETER BRUEGEL THE ELDER
Bruegel (?) 1530 (?) — Brussels 1569
The Land of Cockayne (1567)
Oil on panel; 20½ × 30¾ in (52 × 78 cm).
Dated and signed. In the inventories of Hradčany Castle in Prague from 1621 to 1648, then disappeared in the Swedish conquest. It reappeared at Vevey at the end of the 19th century, completely repainted, and was acquired by Dr. Henry Rossier for 5 francs. In 1901 he resold it after restoration, to the German collector, Kaufmann, for 10,000 francs. When his collection was auctioned off in 1917, the painting was acquired by the Alte Pinakothek.

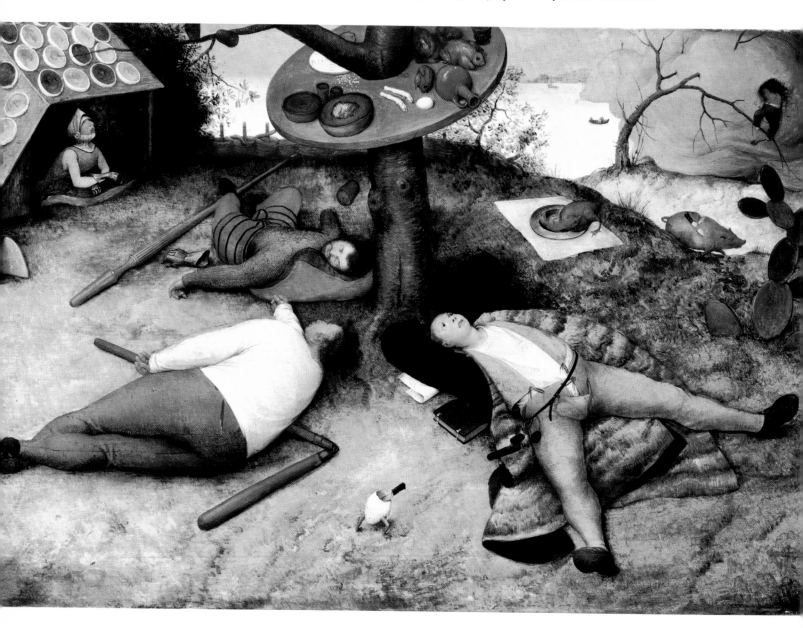

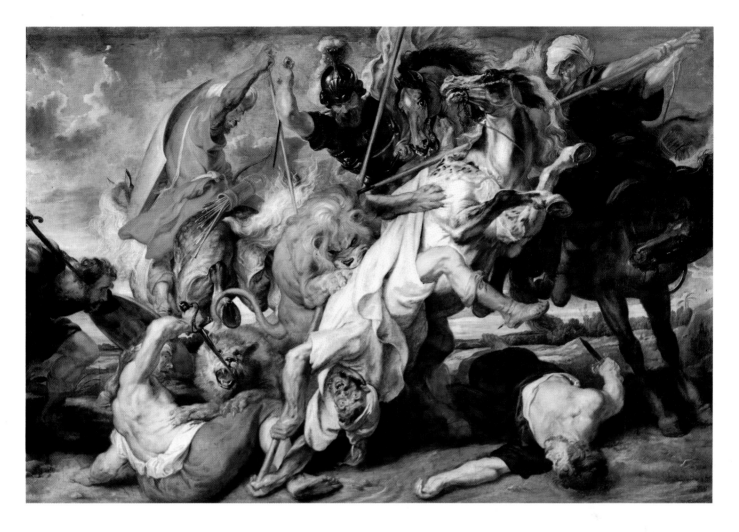

PETER PAUL RUBENS
Siegen 1577 — Antwerp 1640
Lion Hunt (1616)
Oil on panel;
8 ft 2 in × 12 ft 3¾ in (249 ×375.5 cm).
Painted for Duke Maximilian of Bavaria, it
belonged to the Royal Gallery of Munich. The
identification of this work, on the basis of a letter
the artist wrote to Sir Dudley Carleton, is
questioned by Burckhardt. His view is that the
Hunt painted for Maximilian was the one
formerly at Schleissheim Castle, which was sub-
sequently destroyed in a fired at Bordeaux in
1870.

the great Flemish painter, Pieter Bruegel. In that work the Israelites and the Philistines in battle are similarly shown as hosts of minute, many-colored figures, though the spirit of the whole is entirely different.

PIETER BRUEGEL THE ELDER. *The Land of Cockayne.*

The Land of Plenty, with all its delights, welcomes the representatives of the three estates — peasant, cleric, soldier — to the shade of the tree of plenty. Special treatment is reserved for the nobleman in armor resting under a shed covered with pies. In the background a fifth figure enters Cockayne in the approved way, that is by having dug a tunnel through the mountain of buckwheat. The tidbits promenade about and grow like trees. The roast chicken goes and puts itself on the plate, the hog moves around already partly sliced and the boiled egg strolls across the foreground. It is an irresistibly savory representation — one that, through complex symbols, is ready to follow the course of transformation into morality so typical of Bruegel. But this vividly fantastic narrative is also supported by a complex structure, the radiating construction centering on the foreshortened tree. Some scholars have seen this as typical of the "anti-classicism" of the master, but in fact it goes back to his study of Raphael's method, interpreted with free and irrepressible brilliance.

21

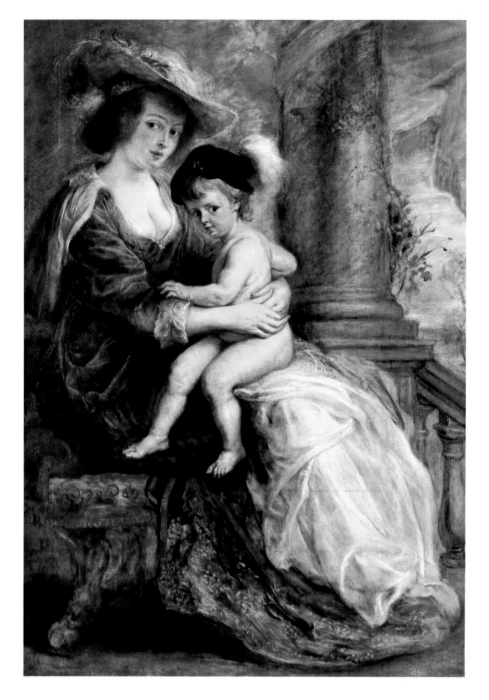

PETER PAUL RUBENS. *Lion Hunt.* p. 21
This celebrated painting is very much alive in modern history through its reinterpretation by Delacroix. The symmetrical correspondences seem to accentuate the leaping movements of the men and the beasts. Each detail is charged with a tension that is immediately transformed into an active sounding of the space. The narration is so powerfully synthesized as to appear elliptical where the opposite process brings out the opulence of lively, detailed representation. The figures form a dramatic knot, isolated in the midst of an otherwise deserted space, thus indicating that the memory of Leonardo's *Battle* is not a learned citation but a precise and aware cultural choice. According to some scholars, Van Dyck painted the figures of the

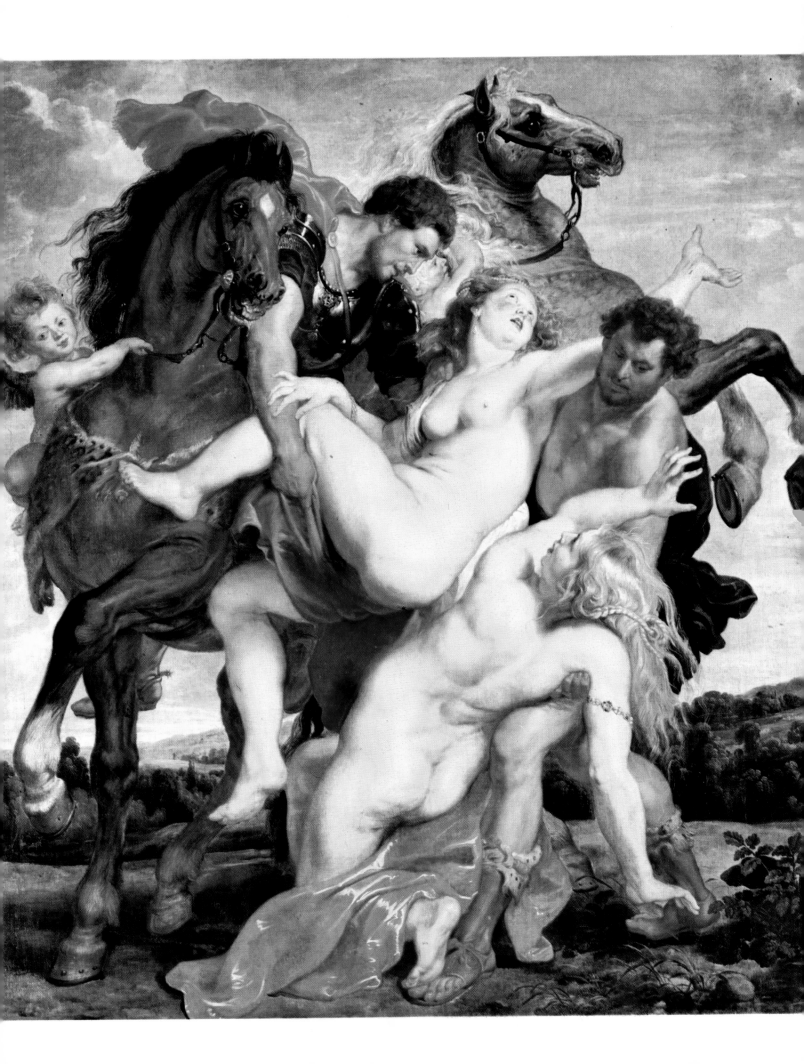

hunters, while Rubens merely retouched them. However, certain traits of these figures are typical of Rubens alone and do not belong to the repertory of his great pupil.

PETER PAUL RUBENS. *Helena Fourment with Her Son Francis.* *p. 22*
Rubens was greatly saddened by the death of Isabella Brandt, his first wife, in 1626. Four years after this tragic event, he remarried to 16-year-old Helena Fourment, whose beauty became almost the essence of Rubens' feminine ideal and his portraits of her that have come down to us number no less than 19. In these the painter also liked to portray the children of both marriages, as if this youthful concert of childhood and maternity were for him an eternal song of happiness. This portrait and the one in the Louvre are among the most sumptuous of the series. Originally the composition stopped at the knees of the female figure and half-way up the small balustrade column on the extreme right. It was subsequently enlarged by Rubens himself. Its pomp is somewhat amused and knowing, as is often seen in the "familial" works of the Flemish master. This is exemplified in the feathered hat on the nude child, which gives an unexpectedly colorful effect that enhances its tender irony. And it brings to mind the splendid "Rothschild Portrait," in which the painter and Helena are strolling with their first-born, and in which the joyous family activity is in contrast with the gorgeous opulence of their clothes. It is a contrast in which the happiest artist of his century, the idolized genius and great diplomat, states and immortalizes the deep truth of his affections.

PETER PAUL RUBENS. *Rape of the Daughters of Leucippus.* *p. 23*
This painting is of prime importance in understanding how Rubens overcame modular classical structure "from within." The great wheel made up of extended elements balanced against one another is in wonderfully calculated compositional equilibrium. Without disruption, the two female nudes stand out perfectly, each showing the side concealed in the other, so that they are entirely complementary. But this highly measured modulation is countered by an emotional vision, that of a cultivated yet brutal humanity. The opulent Venetian nudes become mystical in their overgrown sensuality, as they twist and clutch in the grip of the Dioscuri, between the terrible, plunging horses. Isolated from the vortex of the event, a squinting cupid, attached like a wasp to the flank of the horse, smiles knowingly. In the background the landscape extends serenely into the vast distance. In this contrast, which is emphasized by the low horizon line, the foreground is thrown into even greater emotional relief, almost against the light, and is relieved and balanced only by the variation of the color.

ANTHONY VAN DYCK. *Deposition.*
As shown by the date, 1634, this work was painted during a brief stay in Antwerp, when the artist returned to Flanders on family business. The religious theme is another confirmation that the picture could not have been done in England, where van Dyck had been established since 1632, and where such Roman Catholic subjects were not allowed to be represented.

ANTHONY VAN DYCK
Antwerp 1599 — London 1641
Deposition (1634)
Oil on panel; 43 × 58¾ in (109 × 149 cm).
Initialed "A.V.D.F." above on the right, and dated 1634. It belonged to the Düsseldorf Gallery.

24

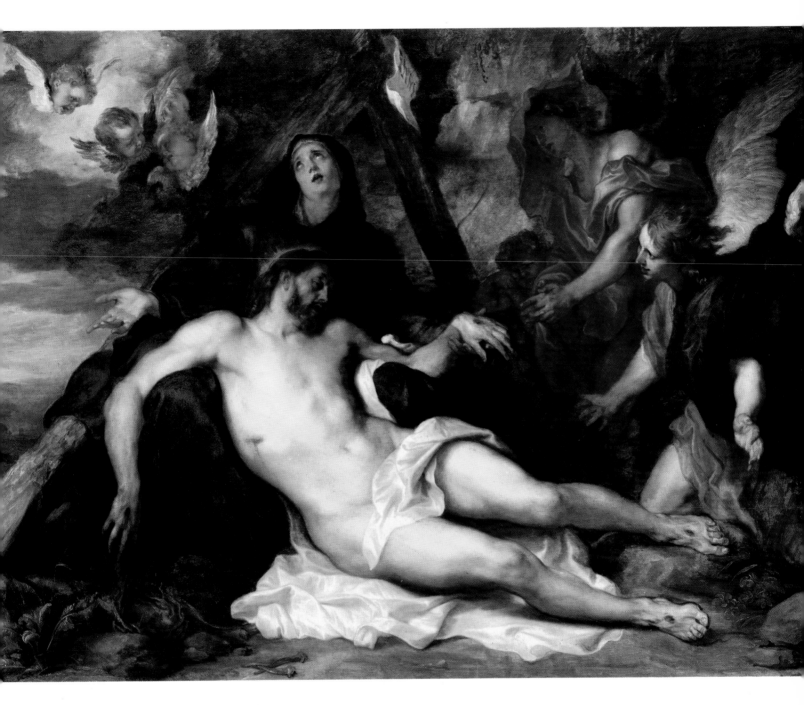

The composition is one of the most spectacular in van Dyck's entire reper-
tory. It makes up a tight pyramid that appears to collapse and spread under
the accentuated weight of the figures and the drapery, but is held together
internally by the miraculous equilibrium composed of varying directions
and deformations. The splendid passage between the head of Mary and that
of Christ connects with the exaggerated expanse of the nude body. This
baroque representation thus becomes a blazing description of sorrow. For
this reason it was necessary to include the tempestuous arrival on the scene
of the angels, and the grotesque and melting compassion of the cherubim,
in a convulsed landscape in which the deformed light is a measure of the
mood.

REMBRANDT VAN RIJN. *The Raising of the Cross.*

In the large concave space pervaded by heavy oppressive darkness, the diagonal motive of the cross with the already stiffening body rises abruptly. Like an unexpected spurt of flame, it flares up, with its pitiless light revealing every detail of its tragic burden. While the thick, subdued crowd of bystanders is lost in the dark shadow, the lateral light source barely brings out some of the more important episodes in the narrative. In a continuation of the main diagonal motive, the light slides along the soldier's armor, creating reflections reminiscent of van Dyck, and centers on the spectator in the blue cap. This stupendous and incongruous figure is a self-portrait that the artist has inserted into the composition. The fulcrum of the whole work, it is set off against the neutral, almost monochrome, background of the other figures, by the wonderful blue of the costume. This specific presence, representing real life, stands in contrast with the impersonal, distracted, chilled and mute actors in the rest of the sacred drama.

REMBRANDT VAN RIJN
Leyden 1606 — Amsterdam 1669
A detail of *The Raising of the Cross*
(1634)
Canvas rounded at the top;
39¾ × 28¼ in (96 × 72 cm).
One of a series of four paintings.
With the *Descent from the Cross*, it was commissioned in 1632 by the Prince Regent of Orange, through his secretary, Constantin Huyghens. Both works were completed in the following year. These, and the others subsequently commissioned in 1636 and 1646, make up a real "Passion cycle" whose function from the beginning, however, was not intended to be religious. It should be emphasized that neither the patron nor the artist ever thought of placing them in any church, despite the subjects and the round-topped format taken from 16th-century Italian altarpieces.

REMBRANDT VAN RIJN
Self-Portrait as a Young Man
Panel; 6 × 5 ft (15.6 × 12.6 cm).
Signed with the artist's monogram and dated
1629. From the Sachs-Coburg-Gotha family
foundation.

REMBRANDT VAN RIJN. *Self-Portrait as a Young Man.*

More than a hundred self-portraits of the artist exist, and those showing him in youth are particularly numerous. In fact, Rembrandt does not distinguish himself from his work and readily uses his own image throughout his long career — either to record moments, situations or events in his own life, or for more complex reasons. Among those reasons may be research in pictorial method concerning color effects, chiaroscuro and composition; studies in psychological expression; or notes on settings or on genres, such as the Oriental, the beggar, etc.

This image of Rembrandt at the age of 23 is unquestionably a combined experiment in form and psychology. A large part of the face is in shadow, as if to make one forget the eyes that are scrutinizing themselves and their own meaning. The summary indication of the bust, which is just enlivened by the contrast between the white collar and the dark garment, and the slightly opaque position, which gives an elegant profile, proclaim the artist's voluntary renunciation of facile effects in order to concentrate his attention on the real subject: the hair. The sprouting locks of hair seem to move by themselves, while lighter, vibrant strands (Rembrandt scratched them into the surface with the wooden end of the brush, it appears) in the dark mass leave only a large area of cheek in the light. Strong and sure, built up with broad, rapid, structural brushstrokes, the image stands out forcefully against the subtle nuances of the background. It has the genuineness of a live and eloquent presence, which further increases the frankly romantic fascination of this self-confident youthful portrayal.

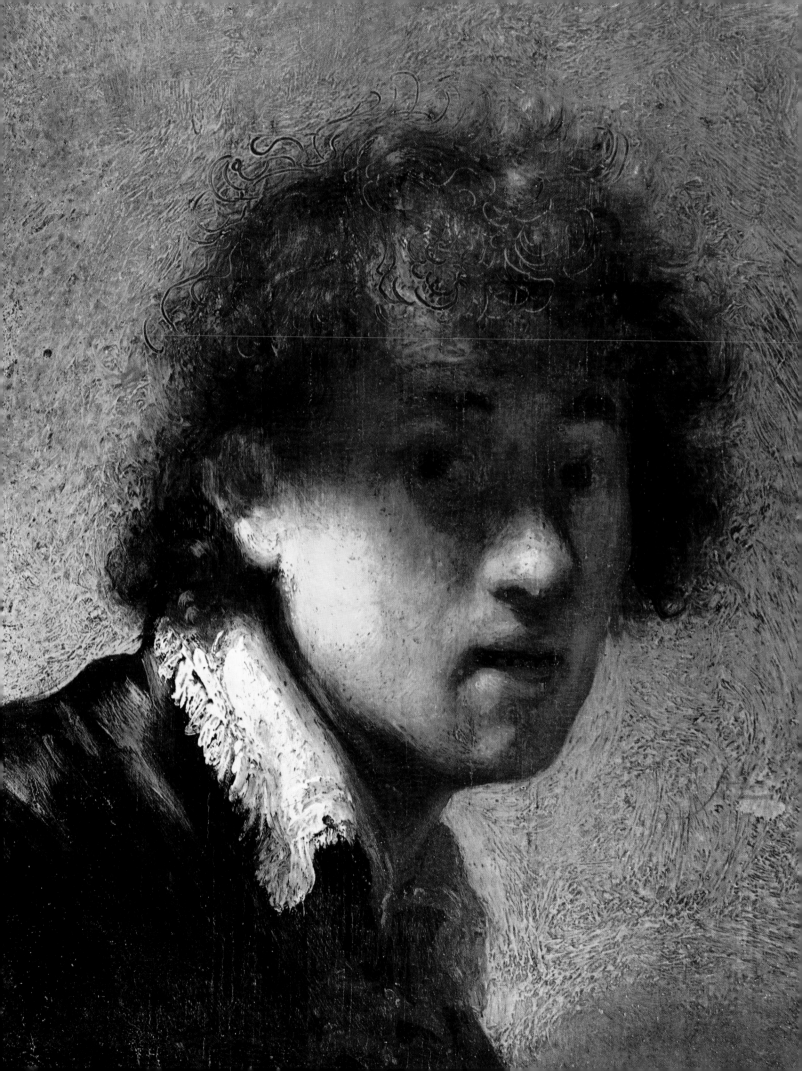

ADRIAEN BROUWER. *Interior with Four Peasants.*

The masterful perspective of this painting alone would be enough to suggest the name of Brouwer. The play of geometrical forms — to which all the elements of the background are largely reduced — matches the placing of the figures in an oblique rectangle, with the upright of the chair in the foreground serving as its forward corner. Although this carefully composed rhythmic equilibrium indicates that Brouwer himself did this painting, at least one critic has placed it among the many imitations that crowd the catalogue of the artist's work. This work was probably executed in Antwerp during the later years of the artist's life.

There are some incidental passages of less intense sincerity, especially in the figures, and there is an unusual horizontal broadening of the composition, accompanied by a relaxation in some secondary and not very stimulating episodes. All this perhaps suggests that the artist was less committed to this work, rather than that he was not the true author.

ADRIAEN BROUWER
Oudenaarde 1605 or 1606 — Antwerp 1638
Interior with Four Peasants
Panel; 17 × 22¾ in (43 × 58 cm).
From the Kurfürstliche Kunstkammer.

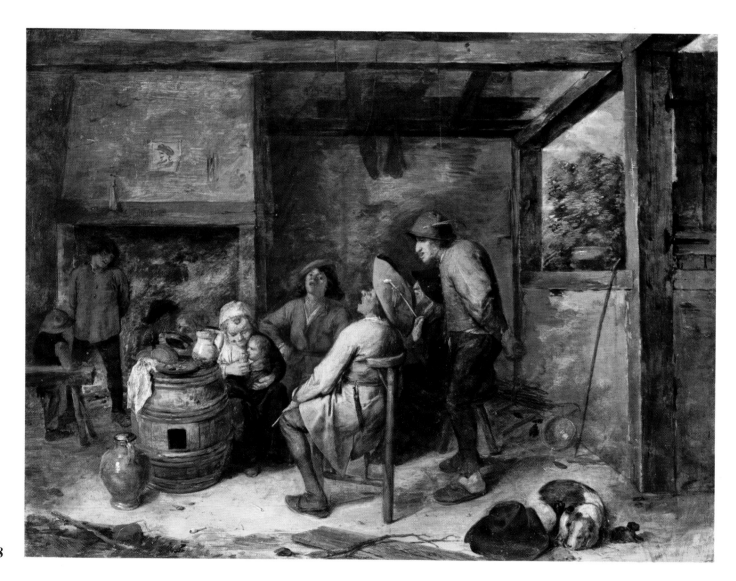

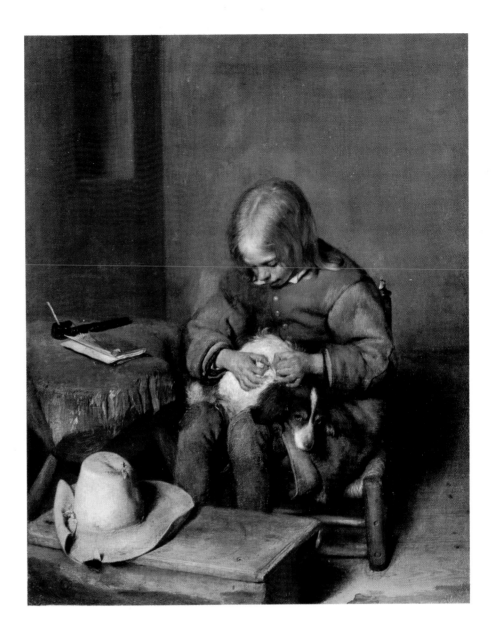

GERARD TER BORCH
Zwolle 1617 — Deventer 1681
Boy Picking Fleas from a Dog
Canvas transferred to panel;
12¾ × 11 in (32.2 × 28 cm).
Signed lower left.
From the Mannheim Gallery.

GERARD TER BORCH. *Boy Picking Fleas from a Dog.*
This is a simple, direct genre scene, in which nevertheless there are some cosmopolitan elements cited by scholars as typical of Ter Borch and resulting from his frequent travels abroad. In this case some recollection of Spanish painting, for instance of the contemporary Murillo, appears to emerge in the contrast of the softly modeled form with the bare background, and in the gentle melancholy that pervades the little figure of the boy and the sparse details of the setting.

The triangular composition favored by the artist, which he usually prefers to employ frontally and symmetrically, is here displaced diagonally towards the interior, as clearly shown by the wooden bench in front. From the corner of the bench up to the beginning of the part in the child's hair, the main axis solidly supports the composition, which slowly revolves around it, drawing the spectator's attention to the wonderful examples of still-life on the left.

29

GIOTTO. *Christ in Limbo* and *Crucifixion*.

These two little panels belong to an advanced phase in Giotto's career. Famous and widely celebrated after the completion of the fresco cycles in S. Francesco at Assisi and the Arena Chapel at Padua, Giotto at this time was directing a busy studio in Florence. Between 1318 and 1325 he also was working on the *St. John the Baptist* and the *St. John the Evangelist* scenes in the Peruzzi Chapel and the *St. Francis* scenes in the Bardi Chapel of S. Croce.

Relating these two works in the Alte Pinakothek (which also possesses the *Last Supper*) to other panels of the same size (*Adoration of the Magi*, New York, Metropolitan Museum; *Presentation in the Temple*, Boston, Gardner Museum; *Deposition*, Florence, Berenson collection; *Pentecost*, London, National Gallery) some art scholars have reconstructed the predella of one of the four polyptychs that Giotto painted for the chapels in S. Croce. Other, larger panels scattered among various museums are thought to belong to this work. Among the problems presented by this reconstruction there is the relatively small size of the chapels, which would mean either that the hypothetical polyptych was intended for another place, or that the panels come from more than one of the S. Croce works. The scholars do not agree on the question of Giotto's authorship; for some this is certain, while others ascribe the little paintings to studio assistants. In actuality the sureness of the compositional framework, which aims at a sober, compact effect, certainly comes from the master's own hand.

In the panel that represents *Christ in Limbo* — showing Christ drawing forth the righteous who were not baptized (Adam and Eve, Abraham, David, Solomon, etc.) — a large, faceted rock, in whose hollow the figures are crowded, occupies half the space. On the rock the damned are being tormented by demons, as Christ, accompanied by Dysmas, the Good Thief, whom he will take to Paradise, helps Adam up by the hand. In the *Crucifixion*, where perhaps more of the execution was shop work, the gold ground takes the event out of its historical context and enhances the compact quality of the figures. These are compositionally connected below, but separate and almost counterpoised in the upper part of the picture. Christ on the cross is in the center; kneeling at his feet are St. Francis and two donors; to the right is St. John the Evangelist with Nicodemus and Joseph of Arimathea; to the left is the Virgin, who has collapsed heavily into the arms of the Three Marys.

FRA ANGELICO. *Entombment.* *p. 32*

In his *Entombment* the artist expresses himself in even more sonorous and monumental terms than in other works. Opening behind the group of figures, in the flaked mass of the rock, is the dark mouth of the tomb, geometrically cut and decorated with reliefs below. The white shroud makes thin sculptural pleats on the body of Christ and unfolds on the grass, abruptly creating a suggestion of depth in the otherwise horizontal development of the composition.

The picture develops outwards from the large golden halos of the two central figures of Christ and Joseph in the direction of Christ's outstretched arms, to the figures of Mary on the left and St. John on the right.

GIOTTO
Crucifixion (*c.* 1320–25)
Tempera on panel; 17¾ × 17 in (45 × 43.5 cm).
Predella panel. Acquired by Maximilian I. The presence of St. Francis at the foot of the cross, with the donors, suggests that the work was probably executed for a Franciscan church, perhaps S. Croce in Florence.

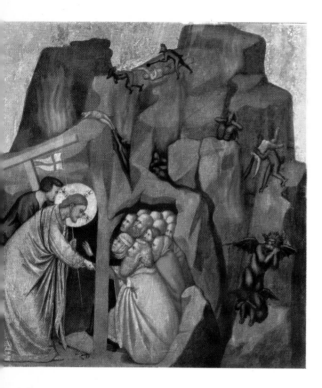

GIOTTO
(GIOTTO DI BONDONE)
Colle di Vespignano 1267 (?) — Florence 1337
Christ in Limbo (*c.* 1320–25)
Tempera on panel; 17¾ × 17¼ in (45 × 44 cm).
Predella panel. Acquired by Maximilian I of Hapsburg.

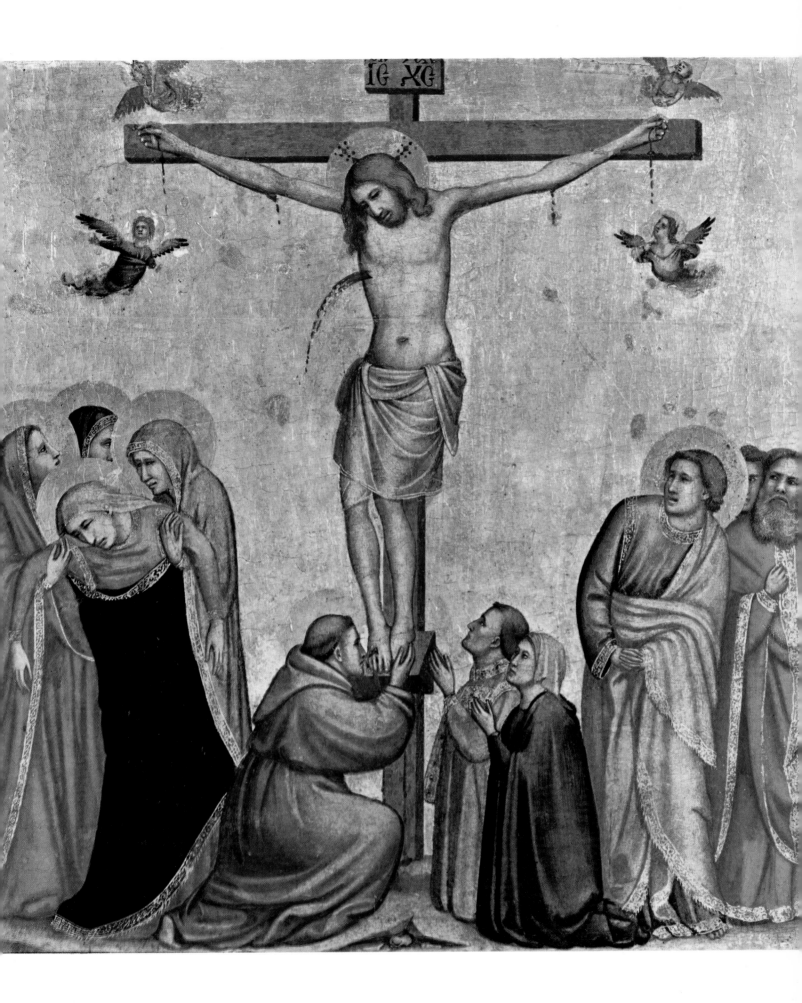

ANTONELLO DA MESSINA. *Virgin of the Annunciation.*

Writing in 1660, Boschini reported that a picture in the house of Ottavio Tassis of a "Madonna with a book in front" had no match for fineness among all such studies in the world; this panel has been identified with the painting he was describing. Like other single figures by Antonello — Madonnas, Christs, portraits — it has been studied and constructed essentially in volumetric terms. Compact in its uniform blue impasto, the mantle encloses the head and shoulders. The fold above the forehead, the line of the nose and the inner edges of the mantle converge by different paths towards the crossed hands, and from here — notice the slight bending at the wrist — moves on to the oblique fold of the missal. The setting is reduced to the minimum. A balustrade seen obliquely, covered with a strip of damask, holds the missal and another little volume tied with a strap; the latter, bright red on the yellow marble, helps establish the thickness of the space on which it rests. The face is turned to the left following the glance towards an image

ANTONELLO DA MESSINA
Messina *c.* 1430 — Messina 1479
Virgin of the Annunciation
Oil on panel; 17 × 12½ in (43 × 32 cm).
Perhaps half of a diptych with another panel,
now lost, representing the *Angel of the
Annunciation.* The surface of the painting has no
glazes and shows some damage. From a private
collection (1897).

FRA ANGELICO
Vicchio 1387 (?) — Rome 1455
Entombment (1440–42)
Tempera on panel; 14½ × 18 in (37 × 46 cm).
It came to the Alte Pinakothek in 1832 from the
collection of Ludwig I of Bavaria.

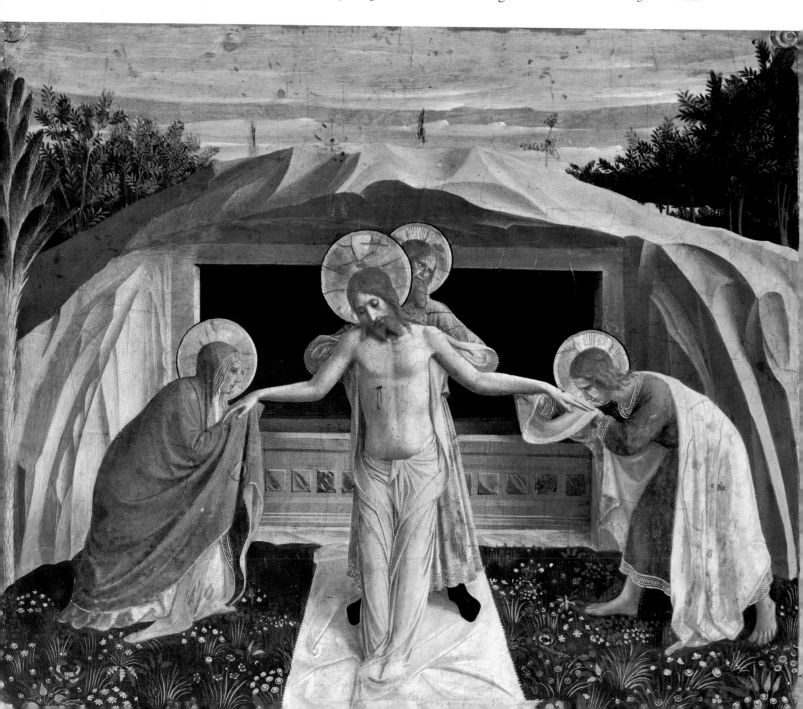

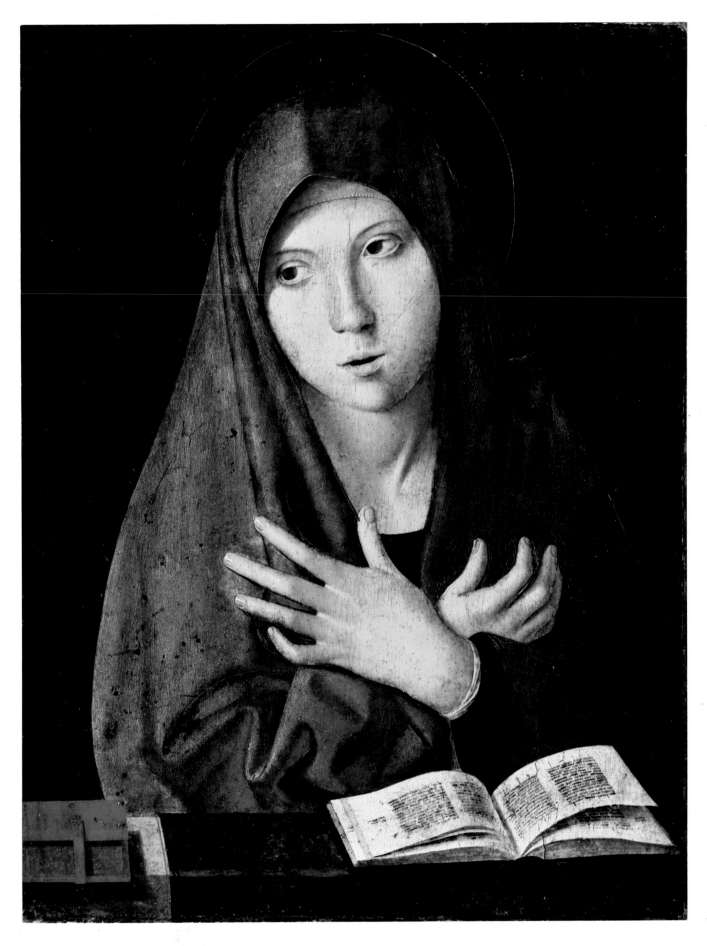

that is not visible to us and perhaps is only something imagined by the young girl. The hands are asymetrically arranged, and the long, extended fingers elude the cadence of the mantle.

LEONARDO DA VINCI. *Madonna and Child.*

The attribution of this painting has been long debated, but today it seems to be definitely accepted as a work of the young Leonardo — although the damages suffered by the painting would suggest caution. There no contemporary of Leonardo's to whom so free and mobile a composition might be assigned. It betrays a decided intolerance of any form of established order, especially for the "measure" peculiar to Florentine tradition, which had already been breached in some respects by Andrea del Verrocchio, Leonardo's master. Placed in the shadow of a large room, the seated Madonna offers a carnation to the child who seems to be rising from the wrinkled cushion. Without making use of perspective lines, the artist succeeds in separating the figures from the background wall, as well as the wall from the landscape. A raking light runs along the folds of the dress curling in every direction; it strikes the hair and the undulating veil raised on the head; and it touches the rising rotundities of the child. Distracting our attention from the real subject, the light lingers in the tangle of pleats opening out of the yellow lining of the mantle, which was intentionally so arranged on the model by the artist. Finally, it strikes the glass vase containing flowers, which has no material consistency and exists only through the flickering light reflections. Beyond the windows there is the well-known landscape typical of Leonardo, from which any sign of human presence has been removed. Its extent is indeterminate, and the mobility and remoteness of its dramatic, eroded forms are accentuated by the bluish haze that hangs over them.

LEONARDO DA VINCI
Vinci 1452 — Amboise 1519
Madonna and Child (c. 1478)
Oil on panel; 24½ × 18½ in (62 × 47 cm).
It entered the Alte Pinakothek in 1889, from the Haug collection in Günzburg. The surface is seamed with *craquelures* and numerous passages are partially repainted. The Louvre has a Flemish copy of this work.

RAPHAEL. *Tempi Madonna.* *p. 36*

This work belongs to the final moment of Raphael's activity in Florence. Compared to other paintings, such as the splendid but highly intellectual *Madonna del Granduca* or the complex *Ansidei Madonna* in the National Gallery, London, which are dated between 1504 and 1506, the *Tempi Madonna* is free of any conscious effort to show his worth with respect to his more illustrious contemporaries. In the limpid evening air, the Madonna turns to one side as she lightly presses the child to herself, while her mantle swells around her, creating a monumental effect. Only two tonalities — the pink sapped by the light and the blue that is tenuous in sky and landscape but dense in the mantle — enhance the compact texture of the rosy skin and the fine blond hair. Every conflict is calmed, and the idea of maternity shared both in human and in divine nature is set forth in unalterable purity.

TITIAN. *Portrait of a Man.* *p. 37*

There has been a great deal of controversy over the attribution of this work, described as the portrait of "a German of the House of Fugger wearing a fox fur, seen from the side as he turns." Both Giorgione and Palma il Vecchio

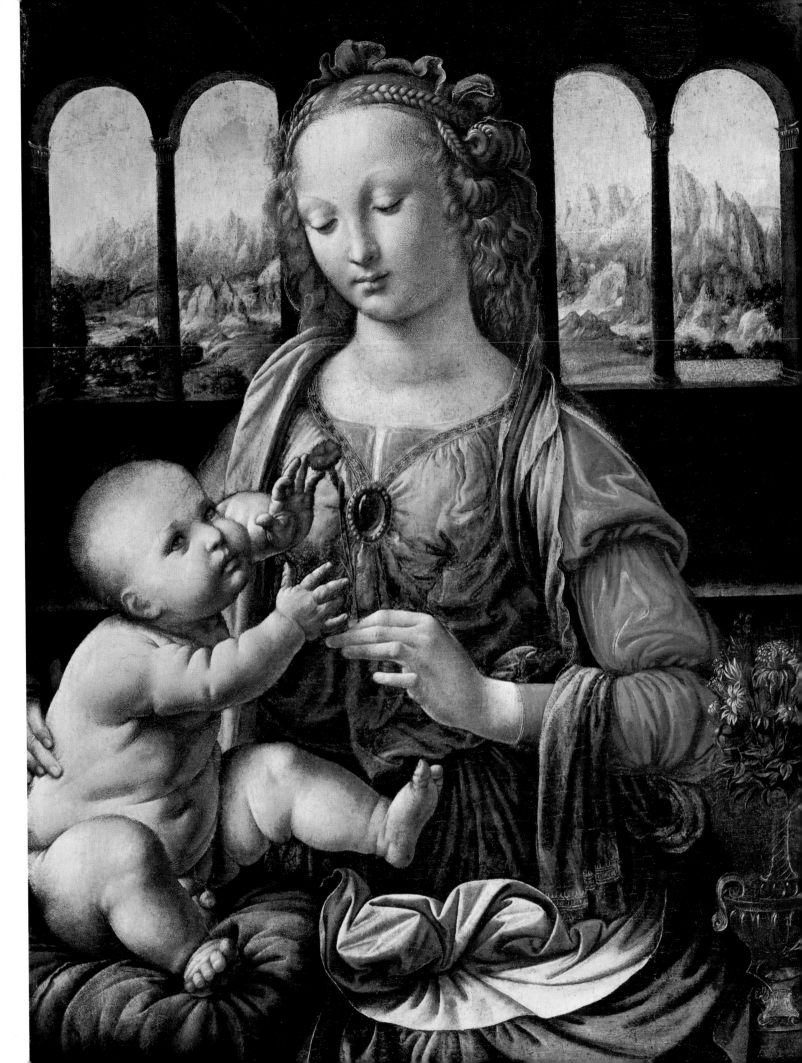

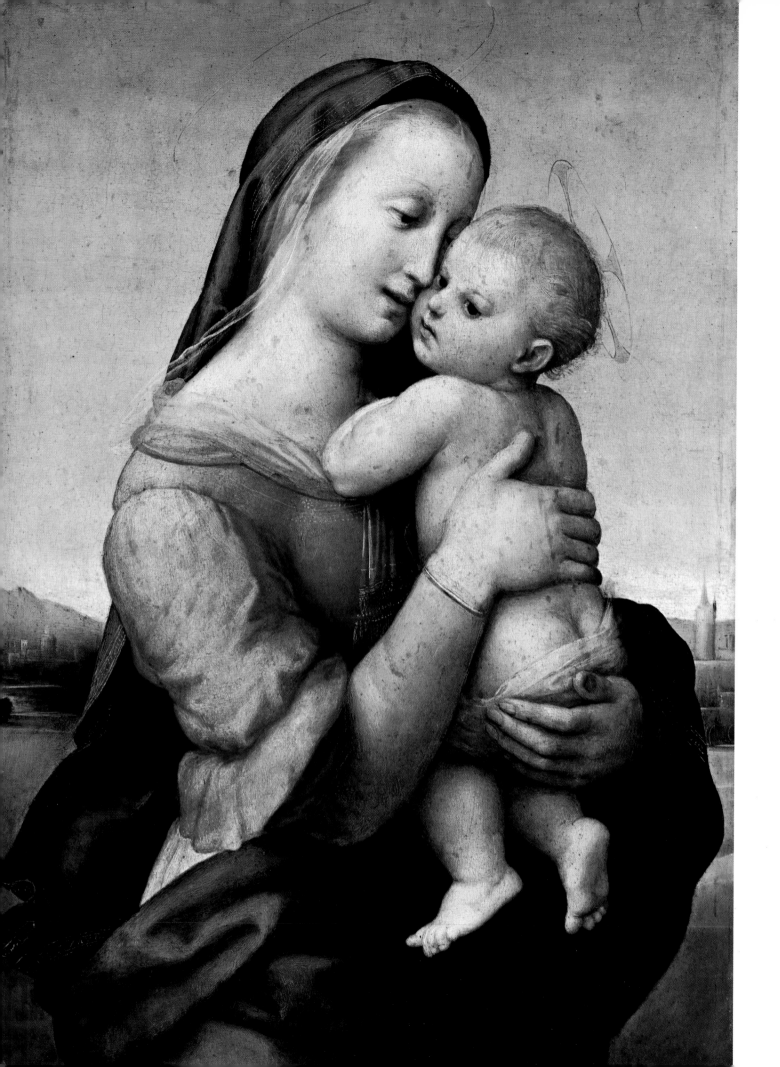

RAPHAEL
Urbino 1483 — Rome 1520
Tempi Madonna (*c.* 1507–8)
Oil on panel; 30¼ × 21¾ in (77 × 55 cm).
Executed for the Tempi family, in whose house
it was seen by Cinelli. Acquired in 1829 by
Ludwig I of Bavaria.

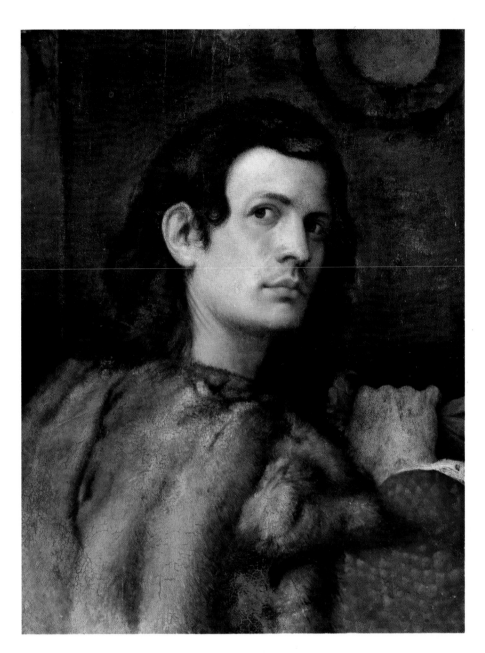

TITIAN
Pieve di Cadore 1488–90 — Venice 1576
Portrait of a Man (1512–13)
Panel; 27¼ × 20¾ in (69.5 × 52.8 cm).
From the Electoral Gallery of Munich, which
acquired it in 1748. Identified by some scholars
with the work cited by Vasari and Ridolfi as in
the Fugger household and from the hand of
Giorgione. Also attributed to Giorgione in a
print by W. Hollar, in 1650.

have been cited as the author, whereas modern critics think that the work is by Titian. The idea of a figure seen from the back is Giorgionesque — as in the *Portrait of Gerolamo Marcello* cited by Michiel — but here it is carried out in a very different manner. The subject turns towards us with an almost defiant look, pressing his lips together and clutching a glove in his right hand. The aggressive face is built up without any mysterious half-shadows, in broad lighted planes framed by the thick hair. A wonderful mastery and a feeling for materials allow the painter to render perfectly the soft, red fox-fur jacket from which the padded magenta sleeve emerges. All these elements lead us back to Titian. For the dating, probably one should not go too far from the frescoes in the Scuola del Santo (1510–11) at Padua. Even the hint of a story, suggested by the manner of presenting the figure, is connected with that moment of Titian's personal affirmation, in contrast with the subtle problems besetting Giorgione's contemporary creations.

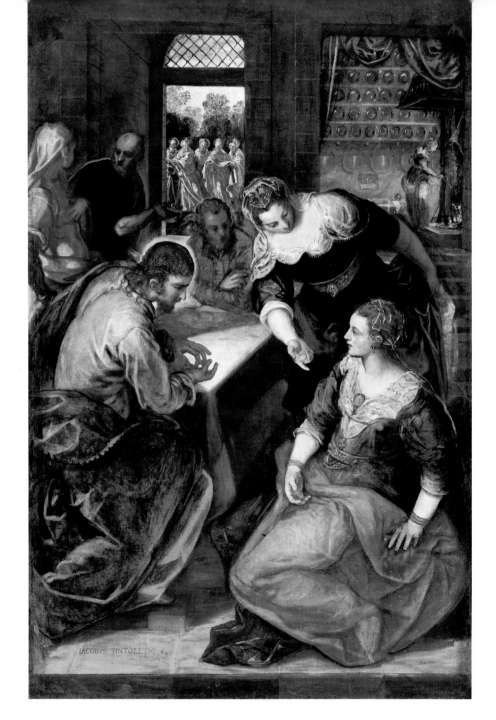

TINTORETTO
Venice 1518 — Venice 1594
Christ in the House of Martha and Mary
(1570–75)
Canvas; 77¾ × 51½ in (197.5 × 131 cm).
From the Dominican church in Augsburg. It
bears the inscription: "Jacobus Tintoretus F."

TINTORETTO. *Christ in the House of Martha and Mary.*

This work is a rather unusual Tintoretto, in the controlled development of the narrative aspects and in the almost refined finish of the descriptive detail. The psychological ties connecting the three principal figures have their compositional metaphor in the closed structure in which the group is inscribed. Rich but not gaudy, the color seems almost excessively controlled, as does the light that reveals every facet of reality, including Mary's trinkets, the copper pots hung in the corner of the kitchen and the figure of the maid by the hearth. On further study, however, it is precisely this intimacy that gives the painting its fascination. It is likely that such a work would have come before the period in which Tintoretto's imaginative violence was unleashed on the great enterprise of the upper hall of S. Rocco (1576–88). But disquieting details are not lacking: with his hands silhouetted against the light tablecloth, Christ seems less to be persuading the woman seated — not humbly — at his feet, than attracting her by hypnotic force.

GIOVANNI BATTISTA TIEPOLO
Venice 1696 — Madrid 1770
Adoration of the Magi (1753)
Canvas;
13 ft 11¼ in × 6 ft 10¾ in (425 × 210.5 cm).
The altarpiece was ordered for the Benedictine
church in Schwarzach, and was delivered in 1753.
In 1804 it entered the Hofgartengalerie in
Munich. Inscribed: "GIO. B. TIEPOLO F. A.
1753."

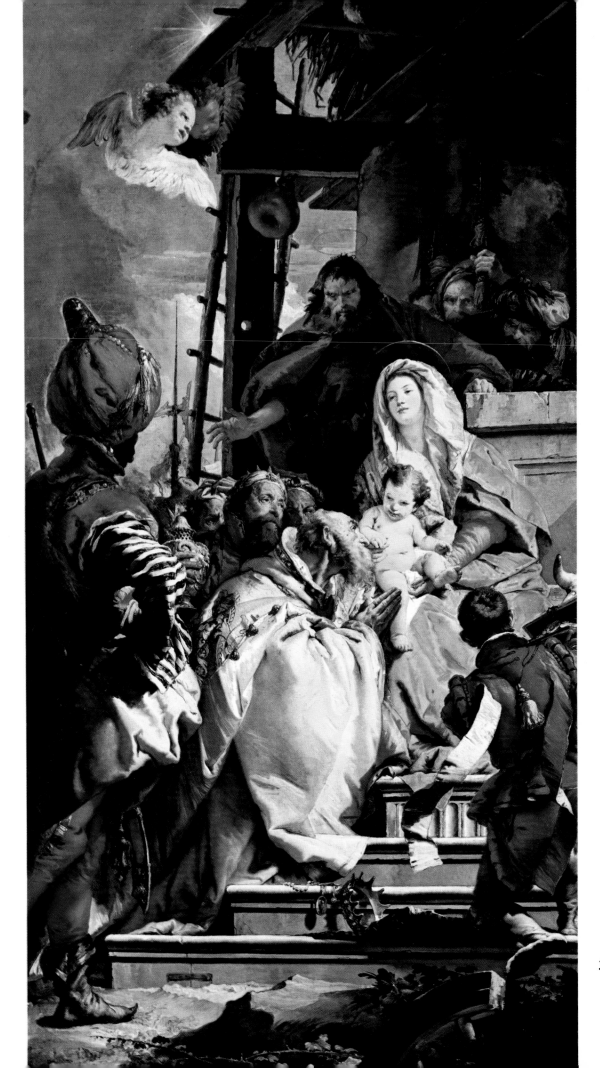

GIOVANNI BATTISTA TIEPOLO. *Adoration of the Magi.* *p. 39*

Giovanni Battista Tiepolo arrived at Würzburg on December 12, 1750, with his sons Domenico and Lorenzo, at the command of Prince Bishop Carl Philip von Greifenklau, who wished to have a hall in his Residence frescoed. The stay was longer than anticipated, as the patron was full of admiration for the first paintings in the Kaisersaal, and ordered the decoration of the immense ceiling over the stairs. But fresco work could not be carried out during the season of bad weather; and the Venetian master devoted himself, with his usual conscientiousness, to easel painting for churches and private clients. Perhaps the most important of these commissions was the great *Adoration of the Magi* in the Alte Pinakothek. Through Tiepolo's taste for spectacle, the *Adoration* becomes a theme exalting divinity over the earthly powers. The execution of the Würzburg frescoes had given Tiepolo's brush a sureness and a bold gaiety, and the extraordinarily luminous color here creates solid forms that are structured from within and expand into the space. Even though he may slide into the hyperbole with the gorgeous appearance of the Moorish king, the composition is perfectly controlled. For the first time in his repertory, he introduced the novelty of the northern peasant types, borrowed from Rubens and Jordaens, whose work Tiepolo had seen in German princely collections. The color is held to an exceptionally high-keyed range of light tones. In the sumptuous silk mantle of the kneeling king, the inclusion of a more or less warm tone of cream is a virtuoso feat. The coordinating element is always the strong light, which firmly models the structures, as may be seen in the regal face of the Madonna. It is allied to the quivering dark line used for underlining and to the luminous flicks on drapery, greenery and still-life.

EL GRECO (DOMENICO THEOTOKOPOULOS).
Disrobing of Christ.

The celebrated representation of the *Disrobing* was commissioned by the canons of the Cathedral of Toledo shortly after El Greco's arrival in the Spanish city, in July, 1577. He completed the work in 1579. Numerous copies exist, but this one, though smaller and less vivid than the original is certainly by the artist's hand and may be dated around 1583–84.

The grandiose mass of the red-clad Christ, the only element shown frontally in the whole crowded composition, stands motionless and distracted in the center. In the Toledo version this is the real center; here, in this second version, it is only the ideal center. The displacement of Christ to the side frees the entire work of a certain symmetrical constriction and permits the revolving motion that is its most peculiar feature. Crowded to a convulsive degree, the painting shows another typical characteristic of the blazing creations of the artist: total indifference to any realistic arrangement or gradation of the successive planes in the picture. The Three Marys, in the left foreground, stand on imaginary ground that is much lower than the bottom of the composition. The ground shown under the feet of Christ, the man in armor and the two executioners is almost vertical it is so unrealistically inclined. Above, all the hallucinatory creatures, with their almost caricatured heads, explode on the surface in a space so cramped and compressed that it is impossible to imagine that they are standing in any actual space.

EL GRECO
(DOMENICO THEOTOKOPOULOS)
Candia (Crete) 1541 — Toledo 1614
Disrobing of Christ (1583–84)
Canvas; 65 × 39 in (165 × 99 cm).
A later replica of the great canvas painted between 1577 and 1579 for the Cathedral of Toledo (still in place). Formerly in the Abreu collection in Seville, then on the market, at Duveen's in London and at Durand-Ruel's in Paris, where it was acquired in 1909. At least eight other replicas are known.

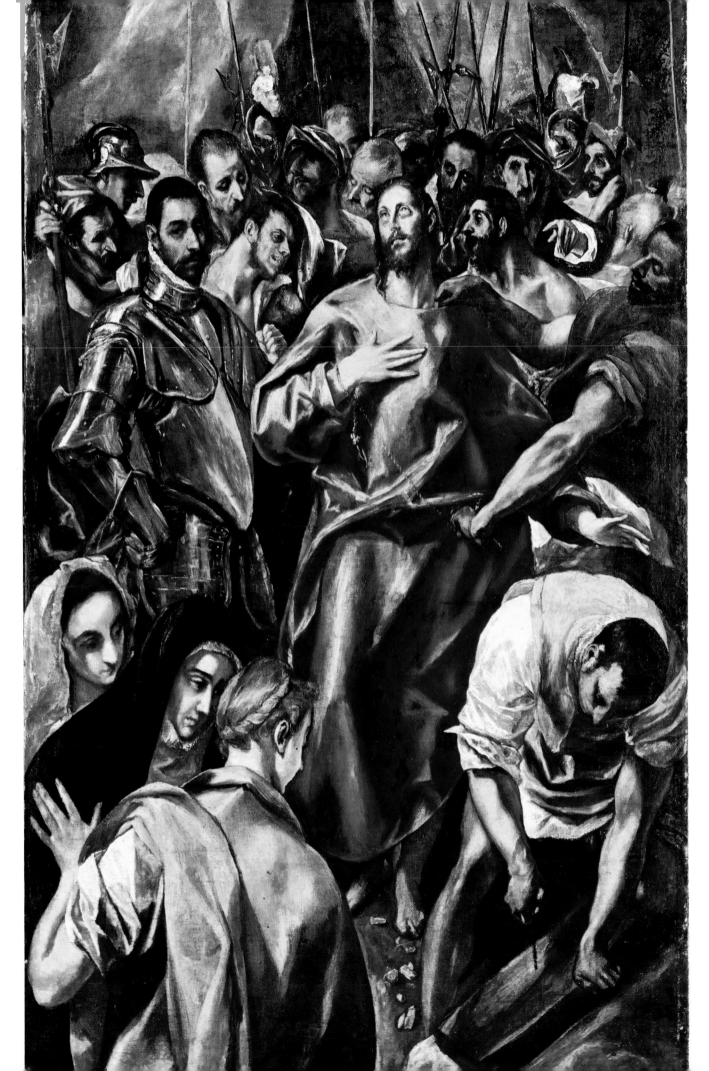

41

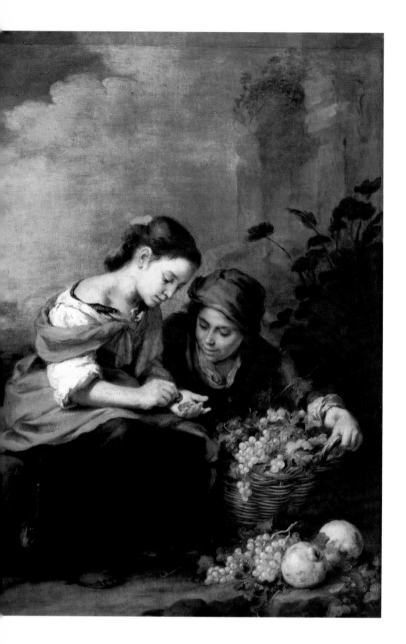

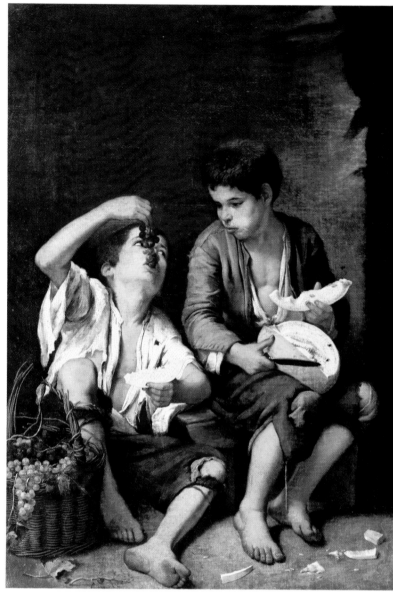

BARTOLOMÉ ESTEBAN MURILLO.
Girls Selling Fruit and *Boys Eating Fruit*.
These also are works of Murillo's maturity — executed presumably around 1670 — as is shown by the insistence on strong chiaroscuro; the assurance, the almost excessive bravura in the still-life passages; the soft, sweet faces; the iridescent materials and the nuances of the grounds. There is, in sum, an absolute mastery of a technique that has reached almost automatic perfection. Genre pictures like these sweetened images of working-class children, which the artist painted throughout his career, are often interpreted as the realistic, social and anti-conformist work of the painter, who was otherwise concerned with religious, sentimental and refined works. But an artfully torn shirt and a muddy bare foot are not enough to make protest manifestations out of these pleasingly anecdotal little scenes. They are merely pretexts for figures and compositions that have the same qualities as the artist's more official, religious production.

42

Left:
BARTOLOMÉ ESTEBAN MURILLO
Girls Selling Fruit (1670 ?)
Canvas; 56¼ × 42 in (143 × 106.5 cm) (original size; the two canvases have had strips about two centimeters wide added at the sides).
From Mannheim. It was inherited by Counselor Franz Jos von Dufresne with its pendant, *The Toilette*, which is also in the Alte Pinakothek.

Above:
BARTOLOMÉ ESTEBAN MURILLO
Boys Eating Fruit (1670 ?)
Canvas; 56¼ × 41¼ in (143 × 105 cm).
From the Mannheim Gallery in 1788.

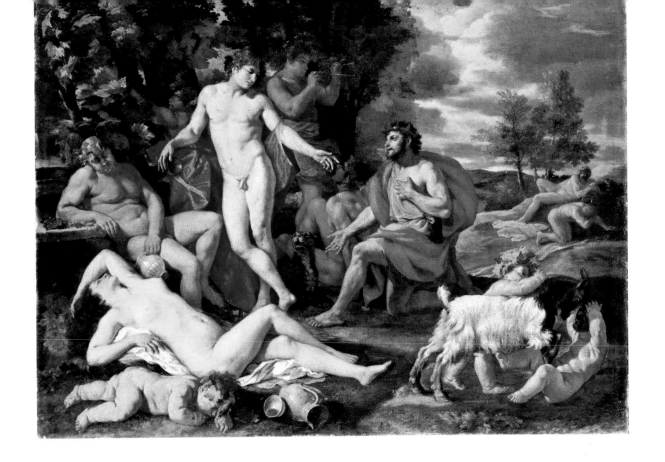

NICOLAS POUSSIN
Midas and Bacchus
Oil on canvas; 38½ × 53¼ in (98 × 135 cm).

CLAUDE LORRAINE
A Seaport
Oil on canvas; 28¾ × 38¼ in (73 × 97 cm).
Signed: "Claudio I.V.F. Roma 1674."

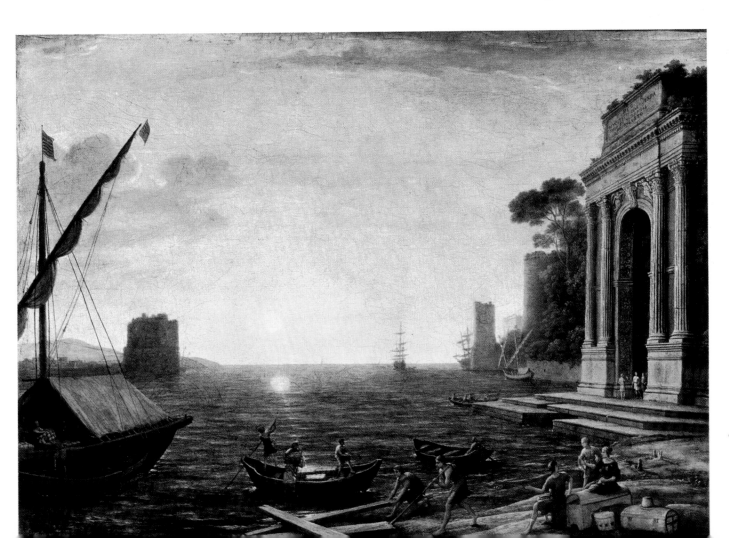

43

NICOLAS POUSSIN. *Midas and Bacchus.* *p. 43*
This canvas, together with *Apollo and Daphne*, of the same provenance, probably formed a pair, as they are identical in format, are related in theme and belong to the same moment in Poussin's career. The theme is subtly set forth, but goes beyond its mythological content: note the figure of Oblivion in the story of Daphne, which gives the scene a languishing pathos. In theme, the stories concern the Golden Age, one of the most strongly rooted literary ideals of the 17th century, and in effect that century's mode of looking at antiquity. The paintings were done during the decade after the artist's arrival in Rome (1625), a time when baroque classicism in the city was accompanied by a vein of neo-Venetian taste, which led to a revival of interest in 16th-century Venetian painting, especially Titian's work. In composition the two canvases reflect each other, mirror fashion and are constructed as dynamic rectangles, which gives the scenes a courtly solemnity, one of the characteristic features of Poussin's art.

CLAUDE LORRAINE. *A Seaport.* *p. 43*
A popular subject in Claude Lorraine's repertory is the marine view. This typical example shows the master's extraordinary skill in rendering the ephemeral sense of the fleeting hour by subtle nuances of light. The place is imaginary and the triumphal arch, inspired by the Arch of Titus in the Roman Forum, gives the note of ancient solemnity that is typical of the artist's pictures. They always show some trophies and reminders of classical antiquity, ranging from fragments of column drums and copings to entire ruins. But the vision always has its realistic side and is full of details studied from life and nature. Its only true subject, however, is the landscape in its broad sweep, accompanied by the intricate play of light from the low sun, which sends sparkling reflections across the water through the morning haze.

THE BRITISH MUSEUM

LONDON

THE BUILDING

Since the British Museum could not be adequately housed in any building already in existence — as was the case for so many other European museums which grew within older palaces and noble houses — a new building was designed especially for it and erected at the beginning of the 19th century. This building grew along with the collections it housed. In 1846 the gallery built for the Townley Collection was torn down: the oldest part of the present building is therefore the great Library, called the King's Library, built between 1823 and 1828 by Sir Robert Smirke for the enormous collection of books given by George IV to the Museum.

It was clear even then that the whole Museum needed a larger complex in which to expand. In 1827 construction began on two wings of the future four-sided building, again following Smirke's plans. In 1846 the old Montagu House was torn down to make room for the present building, under the direction of Smirke's brother. The building, finished in 1852, is in that Neo-Classical style which fitted so well with the archeological taste of the period, The Greek Revival;

PLAN OF THE MUSEUM

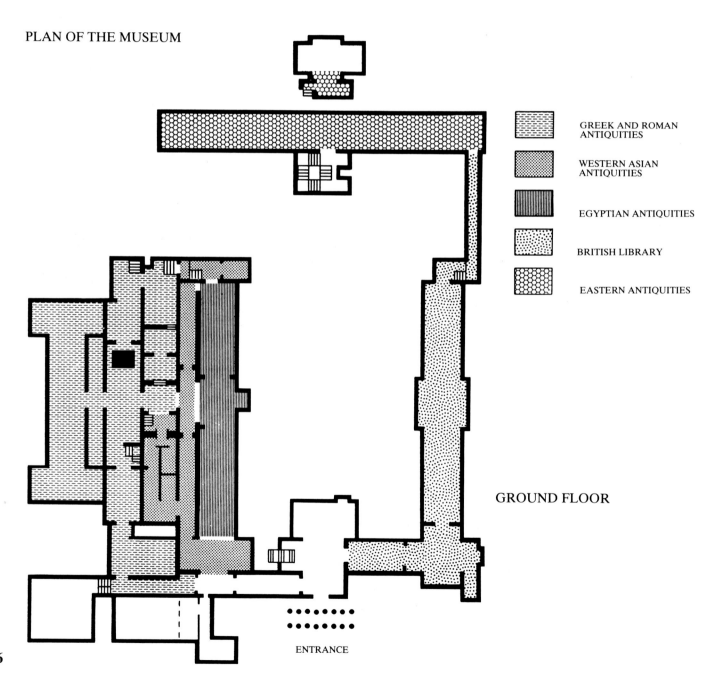

GREEK AND ROMAN
ANTIQUITIES

WESTERN ASIAN
ANTIQUITIES

EGYPTIAN ANTIQUITIES

BRITISH LIBRARY

EASTERN ANTIQUITIES

GROUND FLOOR

ENTRANCE

another great museum, the Altes Museum in Berlin, designed by Schinkel, was also conceived in that style. The colonnaded façade, its pediment filled with a statue group representing the "Progress of Civilization," by Westmacott, was evidently intended to suggest a "temple of art," with the optimistic belief in progress typical of the age.

The newly constructed sections were still not large enough, however. In 1857 the central courtyard had already been taken over as a new reading room and storerooms for the library. These were built according to the plans of Anthony Panizzi, the Italian patriot who became, during his exile in England, Librarian of the British Museum (1856–66). In 1888 it became necessary to house the Natural History collections separately, in South Kensington; at the same time a gallery was built especially for the marbles from the Mausoleum of Halicarnassus which had been sent to England by the Sultan Abdul Medjid; and a wing was constructed for the collection of manuscripts, prints and drawings.

In this century further construction was made possible especially by two donors. In 1914 the King Edward Building was completed with funds from a gift made in 1900 by Vincent Stuckey Lean as well as funds allocated by Parliament for this purpose. The new gallery to the north of the preceding building houses objects from The Departments of Oriental Antiquities, British and Medieval Antiquities, and Coins and Medals. The gallery to the west, built by 1938 to exhibit sculptures from the Parthenon, is due to the generosity of Lord Duveen.

ORIENTAL ANTIQUITIES

PRINTS AND DRAWINGS

EGYPTIAN ANTIQUITIES

WESTERN ASIAN ANTIQUITIES

GREEK AND ROMAN ANTIQUITIES

PREHISTORIC ART BRITISH AND ROMAN ANTIQUITIES

MEDIEVAL ART

COINS AND MEDALS

UPPER FLOOR

The unshaded areas are those used by the Museum administration or used for exhibitions and conferences.

47

BENIN ART. *Two Leopards.*

These works are owned by Queen Elizabeth II and are on loan to the British Museum. Each of the animals is made of five pieces of elephant tusk; it is thus a luxury item destined for the court. Like bronze sculptors, ivory carvers in the Kingdom of Benin formed a special caste, whose tradition lasted even after the end of the state. These two leopards, which can be dated to the 19th century, are composed in an imposing monumental style. Their bodies are decorated with a finely worked relief pattern of a beaded texture, surrounding the larger, copper plaques which give the surface a slower, more regular rhythm. The patterns converge towards the animals'

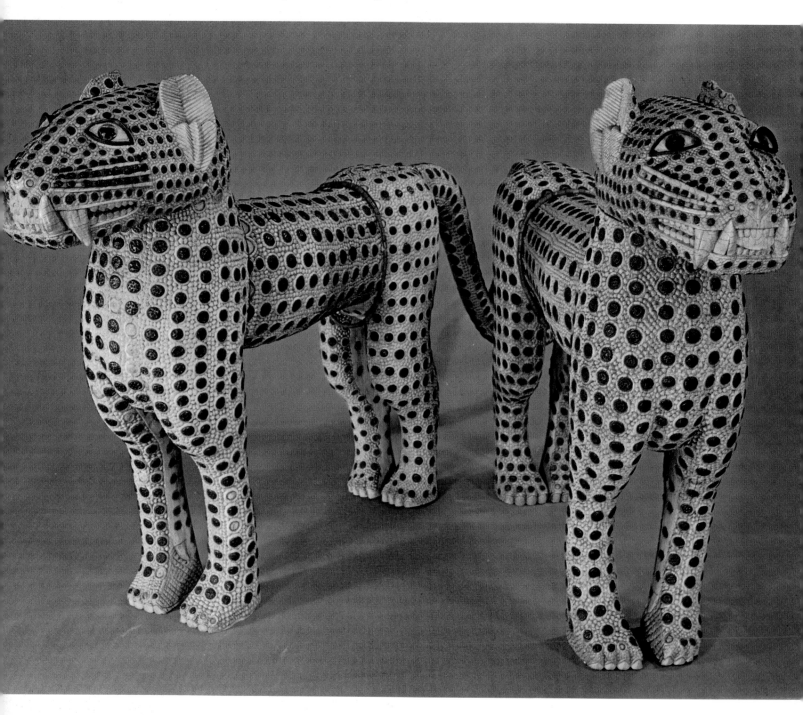

BENIN ART
Two Leopards
(Probably 19th century)
Ivory and copper; length 31½ in (50 cm).

IFE ART
Oni (King) of Ife
(12th–14th century)
Bronze, the crown was once red;
height 14½ in (36.8 cm) (life size).
Western Nigeria.

heads, with ears erect and jaws half-open. The artist has penetrated into the character of these wild animals; both their hidden energy and the splendor of their pelts have been transfigured. This and other remarkable works serve to prove the high level of civilization maintained in Nigeria by the people of Ife and Benin through the course of at least seven centuries.

IFE ART. *Oni (King) of Ife.* *p. 49*

It is only since the end of the 19th century that we know of an important artistic center of bronzes and terra cottas at Ife (in the Yoruba territory, Nigeria). According to tradition, the human figures and heads are portraits of kings. The chronology of this production has been much discussed, since it is characterized by a very high technical level and is completely different from any other African art. According to the most recent theories this sculpture is to be dated between the 12th and 14th centuries. One suggestion, recently reinforced by the finding of terra cottas dating from before the birth of Christ in North Nigeria, is that a source for Ife art may be found in ancient Egypt; the style of the figures, with their compact masses, fits in with this theory. Other archeologists believe that Ife art is an independent, native phenomenon, having no connection with European (as was supposed by some) or Oriental precedents. The example in the British Museum is one

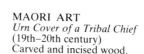

MAORI ART
Urn Cover of a Tribal Chief
(19th–20th century)
Carved and incised wood.

50

of the masterpieces of this group of sculptures. It is comparable only to Egyptian works such as the heads of the 4th dynasty, to late Roman heads of the 5th century or to Italian Renaissance busts by Laurana. The subtle curving pattern of the tattooing models the surface of the face, restraining the individual vitality, the lifelike quality of the statue, within a perfectly controlled sculptural mass.

MAORI ART. *Urn Cover of a Tribal Chief.*
This is a remarkable example of funerary Maori sculpture. The Maoris emigrated to New Zealand in about the 13th century and were discovered in 1799 by Captain Cook. Until 1871, when they made peace with the white settlers, they jealously preserved their own cultural and artistic identity, which still exists. The characteristics of form and decoration to be noted in this figure relate to those of all Maori productions: huts, canoes, coffins (made in the shape of a body), staffs and other instruments and objects. This piece continues an old tradition of clearly intelligible Realist form included in a composition of balanced, carefully distributed elements, animated by an all-over pattern of engraved surface decoration. Most evident is the spiral motif, together with other undulating and radiating motifs which were also used for tattoos. The execution, particularly of the head, shows an exquisitely sensitive sense of the material.

AZTEC OR MIXTEC ART
Two-Headed serpent
(15th century)
Turquoise and shells set on a wooden frame; width 17½ in (44.5 cm).

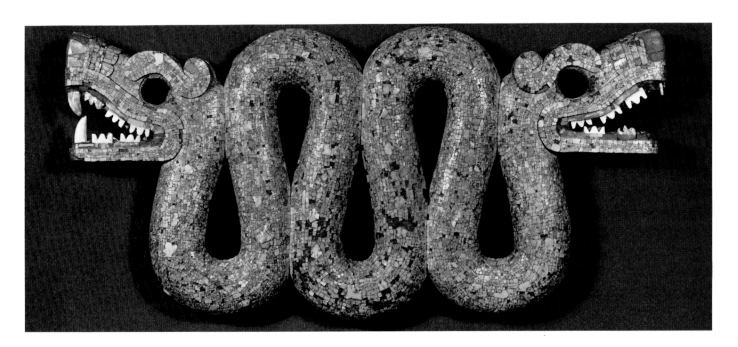

AZTEC OR MIXTEC ART. *Two-Headed Serpent.*
This mosaic work of precious stones, probably a breast-plate, comes from Monte Alban, where many examples of Mixtec handiwork — metalwork, gems, mosaics — have been found in the excavations. These works were exported by the commercial Pochetas into the country of the Mayas and elsewhere. This object is characterized by the controlled development of the serpentine line between the two vividly colored animal heads.

51

EGYPTIAN ART, NEW KINGDOM. *Banqueting Scene.*
Above the detail illustrated here, not shown in this reproduction, we see spectators, watching the spectacle. In spite of the sharp division of the black line separating the two zones, it seems certain that everything included in the upper area is intended to be *behind* what appears in the lower register. The dancers and the players, in other words, must be understood to be on a stage in the foreground, the audience in the back. In this composition all the Egyptian conventions seem to be respected. The same is true in respect to the representation of the various parts of the body, thus an eye appears frontally in a profile face, or we have a front view of a torso while the arms and legs are shown in profile. The only exceptions to this rule are the two central figures, the girl playing the double flute, and the other beating time with joined hands like her two companions at her left (or performing a static hand dance, as is still done today in Java or Bali). It is

EGYPTIAN ART, NEW KINGDOM
Banqueting Scene
(18th Dynasty: 1580–1314 B.C.)
Detail of a fragment from a wall painting.
Dimensions of the whole fragment:
27¼ × 11¾ in (68 × 29.4 cm).

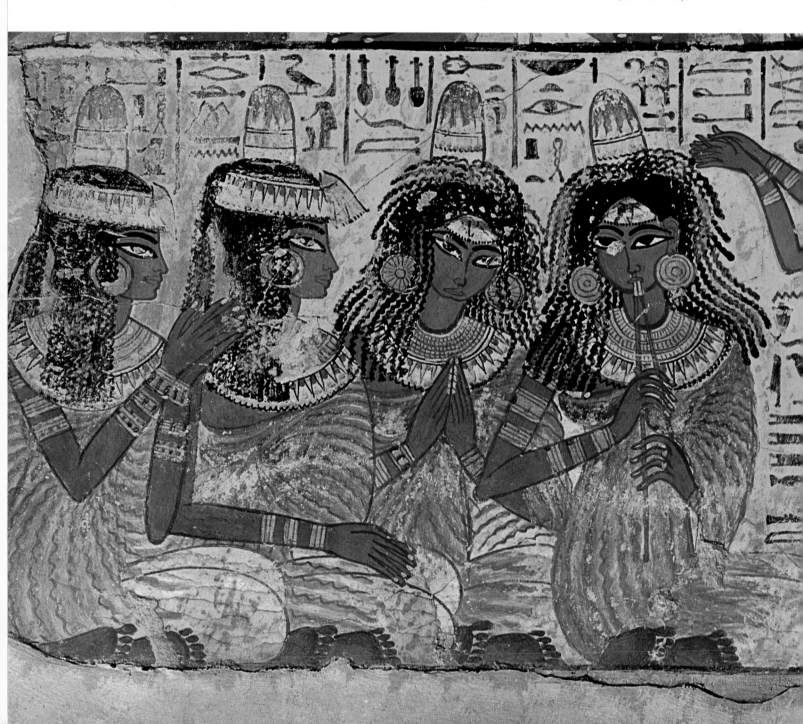

clear that the frontal view of a face was not inconceivable for an Egyptian artist: it was, however, usually avoided, because in an outline drawing a lateral view of the nose is almost necessary, as we see even in the present case. The inclusion of a nose in profile within a frontal face, although really neither less nor more credible than the usual frontal eye in a profile face, was nevertheless not a part of the accepted repertory, standardized ever since the time of the first dynasties. Having introduced it in this case implies on the part of the artist a remarkable courage. Innovations of this kind, however, were destined to remain isolated, or rather marginal attempts, since to persist in them would in the end mean trying totally to revise all accepted conventions. This in practice would be unthinkable as long as the indispensable ideographic writing imposed certain visual "models" endowed with an essential and privileged "truth."

PREHISTORIC IRANIAN ART. *Decorated Vase.*

In the first half of the fourth millennium B.C., parallel to the Sumerian culture there developed beyond the Zagros Mountains, in Western Iran, a special culture which is called Susa I. This culture precedes the Proto-Elamite phase and is characterized, above all, by the high level of its pottery. There are wheel-made bowls, cups and vases with thin walls, decorated in a dark brown color on a white-yellowish background. The Louvre has an even larger collection of pottery belonging to this period, also from Susa. This piece, however, is one of the most remarkable examples in the whole group because of the balance and harmony with which its geometric decorations are distributed. The shape is a truncated cone and with the exception of the band of stylized birds encircling the upper rim of the vase, only geometric forms appear: stripes, lines and vertical, horizontal or zigzag bands, lozenges and triangles. It is possible that such signs might have a symbolic meaning.

According to one opinion (Yoshikawa), the zigzag bands may represent the four rivers springing out from the mountains, signified by the black triangles alternating with the group of birds at the four cardinal points. This would be a prehistoric anticipation of the late myth of the four rivers of paradise.

In that case, the decreasing triangles disposed in the vertical sections could also be mountain chains, stylized according to the models of vertical overlapping forms. Even if we do not understand all the possible symbols, we can still admire the decorative vigor of this piece.

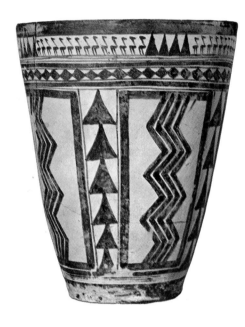

PREHISTORIC IRANIAN ART
Vase Decorated with Geometric Motifs and Stylized Birds
("Susa I" period: first half of 4th millennium B.C.)
Painted terra cotta; height 8 in (20 cm).
From Susa.

LATE SUMERIAN ART. *Portrait of Gudea (?).*

After the interruption of the Akkadian domination of Sargon ("Sharruukin") and his successors, which lasted less than two centuries, the Sumerian cities gradually regained their autonomy and a part of their previous political power. The first to regain power were the *ensi* (kings, rulers) of Lagash: this period derives its name from Gudea, the main personality of the time. The art of the period of Gudea follows the traditions of the Akkadian dynasty, which introduces a freer and more naturalistic concept of both the human figure and narrative relief. This art, however, is amost exclusively limited to subjects of worship and to votive statues, either seated or standing.

We have many statues of Gudea himself, shown at prayer. Identified by inscriptions, they are carved mostly out of diorite, a hard, black, shining stone. The fragment of a statue shown here has no inscription and it is not therefore possible to identify it with any real certainty — the physical resemblance is not significant, as other rulers, too, have similar features — but it is among the most remarkable of the group for the precision and modeling of its volumes.

It may be thought that the sculptors of this time, having to work with a very hard stone, which was, indeed, imported, would profit from Egyptian experience in this field. Though their ample, geometric shapes might have some resemblance with Pharaonic sculpture, there is nothing in these humble and human mortals who pray to their god to remind us of the proud detachment of the Pharaoh, the "living god."

LATE SUMERIAN ART
Portrait of Gudea (?)
Upper part of male statue.
(Period of Gudea: *c.* 2290–55 B.C.)
Diorite, with traces of gilt on the nails;
height 30¼ in (75.6 cm).
Probably from Telloh
(ancient Girsu, near Lagash).

56

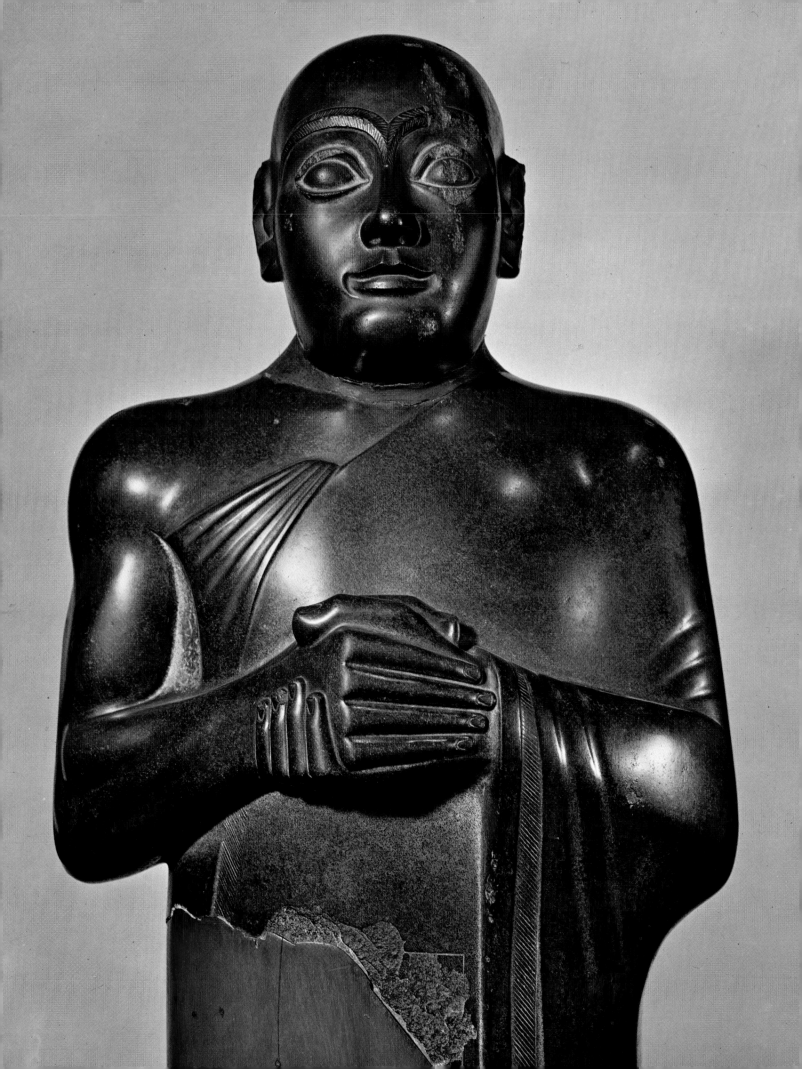

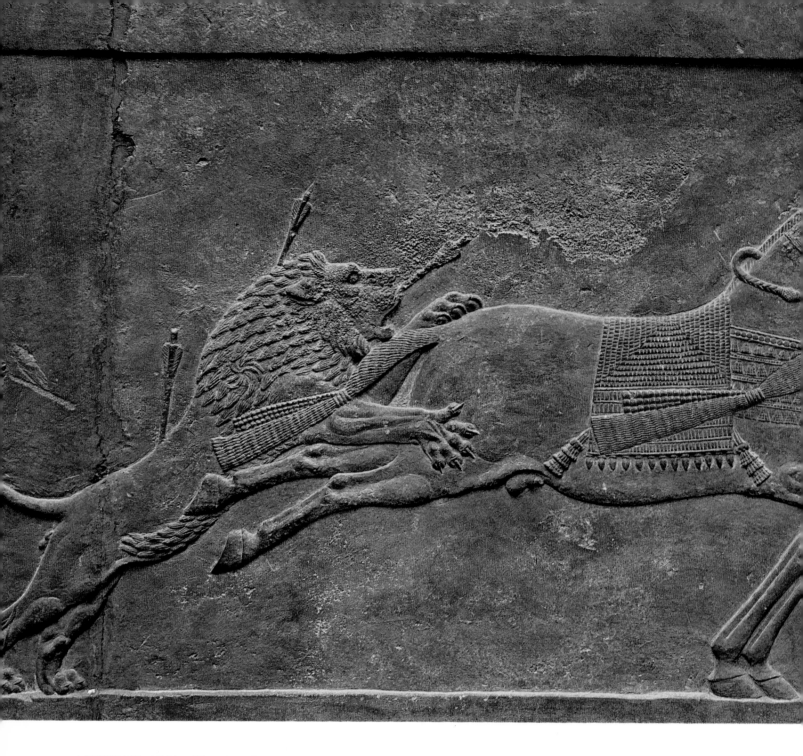

ASSYRIAN ART. *King Assurbanipal's Lion Hunt.*

The "Imperial" art of the Late Assyrian period, which inherited motifs from the preceding Mesopotamian cultures but was also open to other influences, returned to the narrative relief. Assyrian sculptors, when celebrating their kings' military achievements, sometimes became accurate chroniclers rather than creators, using formulae which they had borrowed from neighbors.

On the other hand they created imposing original figures of gods, demons and kings. In these, the juxtaposition of different perspectives — such as the use of a frontal eye in profiles — and the stylization of details of the anatomy and garments — such as sharply defined muscles or folds in relief — does not prevent the emergence of strong volumes and structures conceived naturalistically, almost like a prelude to archaic Greek art.

ASSYRIAN ART
King Assurbanipal's Lion Hunt
(*c.* 650 B.C.)
Alabaster relief, originally painted; height of plaque 66 in (165 cm).
From Nineveh.

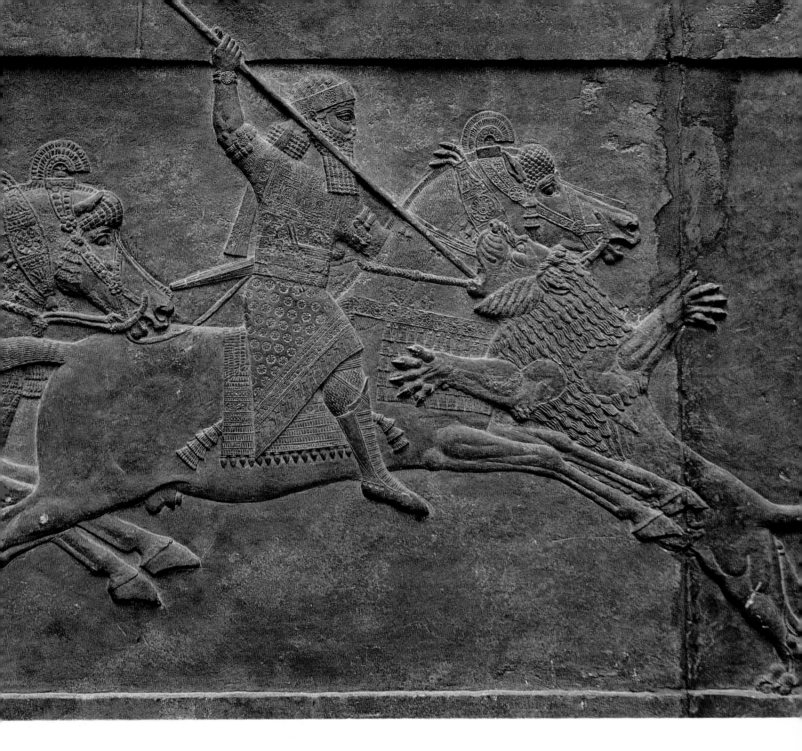

On pages 60–61:
ASSYRIAN ART
(*c.* 650 B.C.)
Detail from the *Royal Hunt of Assurbanipal*.
Alabaster relief, originally painted;
height of detail, 15¾ in (39 cm).
From Nineveh.

The highest achievements of Assyrian sculpture, however, are found in animal scenes, particularly in the large panels of *Assurbanipal's Hunt* (668–629 B.C.). These were sculptured in relief on alabaster as decoration of at least two rooms in the Northern Palace in Nineveh, built by this king around the middle of the century: most of the reliefs were discovered in 1854 and transferred to the British Museum.

The composition is set on a bare background; the spatial relationships succeed in attaining naturalistic effects; the animal figures, great vitality.

ASSYRIAN ART. *Dying Lioness.* *pp. 60–61*

This is deservedly one of the most admired sections of *Assurbanipal's Hunt*. It represents a mortally wounded lioness: though her spine is broken by the **59**

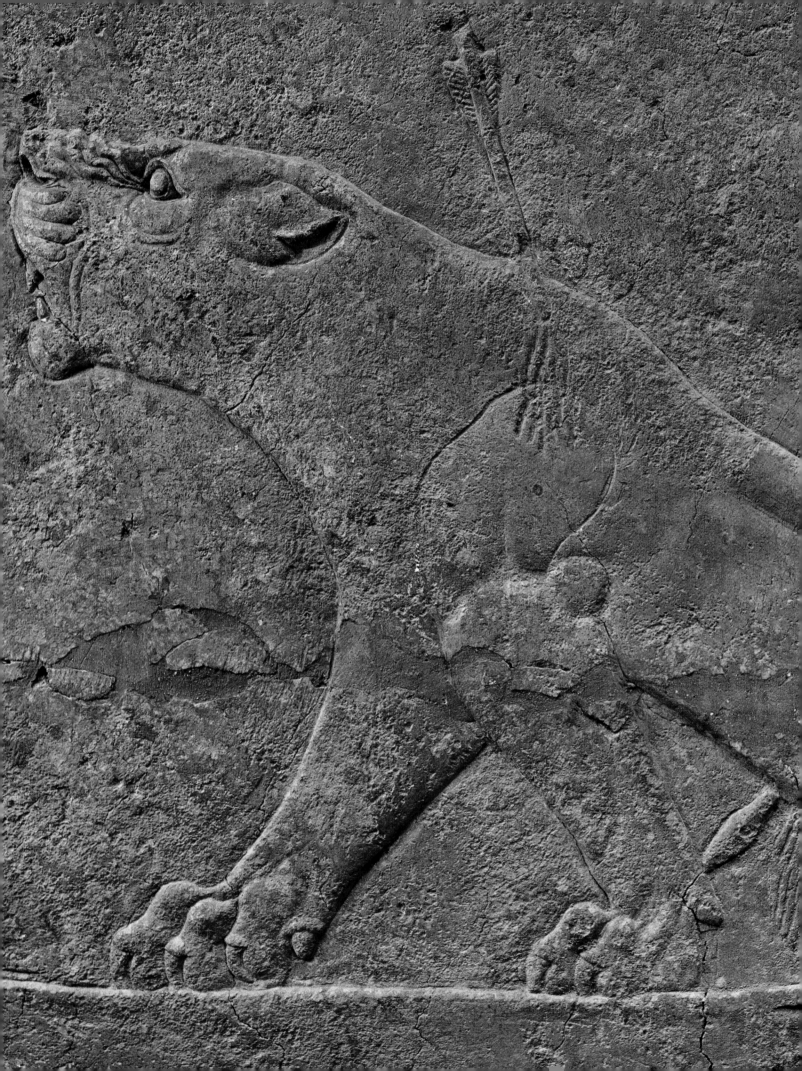

arrows and she drags her paralyzed back legs, yet she roars out, raising her head against her persecutors.

The ferocious and yet pathetic expression of the dying beast could not be obtained by mechanical, conventional formulae. As a matter of fact these achievements imply a very mature interest in reality and a skill in perspective; notice the perfection of the eye, nostril and mouth. To a modern observer it is difficult to believe that this same artist still could put frontal eyes on a human profile.

KASHAN ART
Plate
(13th century)
Ceramic with white enamel and green and black decoration on blue background.

PERSIAN ART
Bowl decorated with figures of horsemen
(12–13th century)
Polychrome enamel ware.

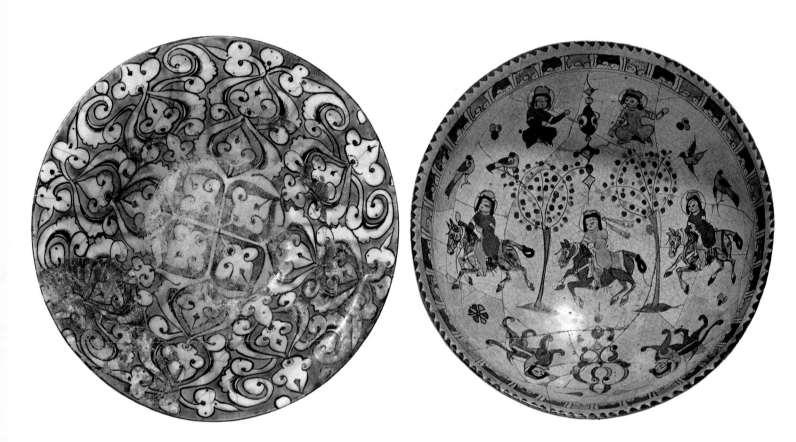

KASHAN ART. *Plate.*

This is a rare Iranian ceramic piece with white decoration on a cobalt blue background.

The ornamental motif develops from a center divided into four parts composed of ivy leaves set in a radial system; this is repeated in the second circle. The decoration ends at the border with alternately large and narrow branches and leaves symmetrically placed.

It is evident that the plate has been painted directly on the basis of a scheme which is standard in its order and composition.

This kind of plate, with these colors and this curving decoration in a geometrical design, is of historic importance: in all likelihood, the porcelain workshops of the Yüan and Ming Dynasties, beginning in the 14th century, were started following the impact of these Persian works.

BEHZAD
Caliph Haroun al Rashid and the Barber
Ms. Or. 6810, sheet 27/v.
Shiraz 1494.
Miniature on parchment;
5¹⁵⁄₁₆ × 5¹³⁄₁₆ in (15 × 14.8 cm).

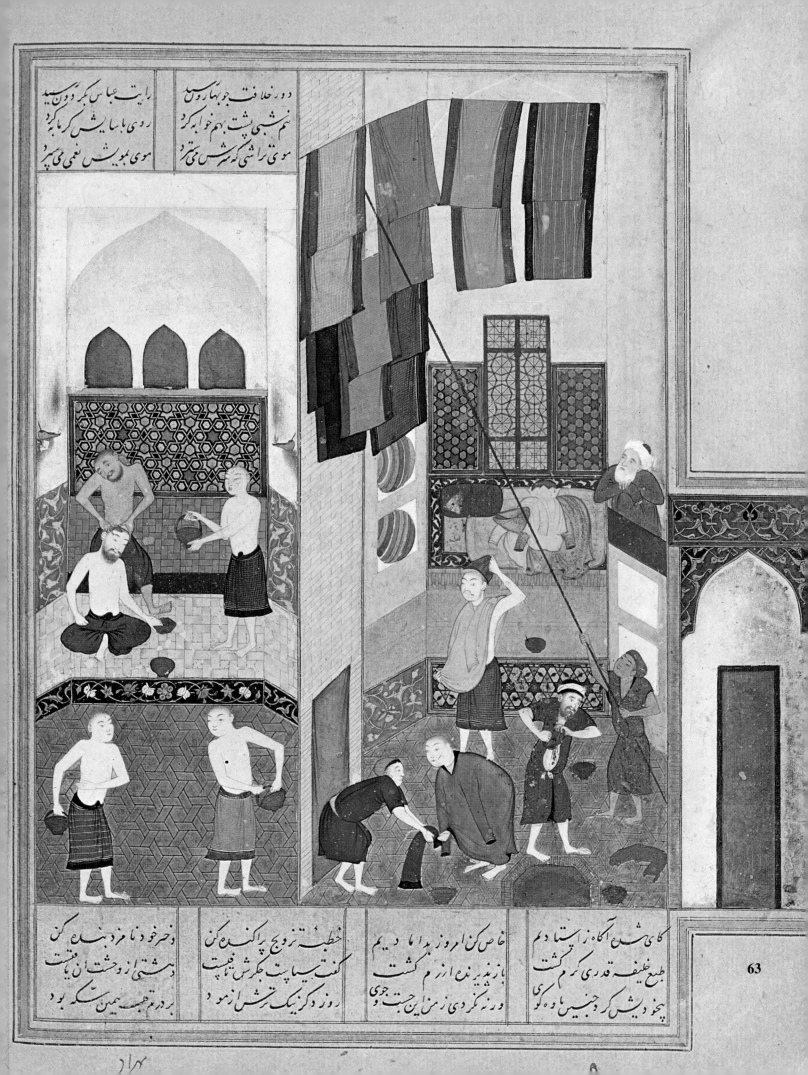

PERSIAN ART. *Bowl Decorated with Figures of Horsemen.* *p. 62*
A description of the technique used in the manufacturing of this ceramic, which is called "minai," indicates the refinement of its execution. The artist first drew the sketches of the figures with cobalt on a white enamel background. After having been fired once, the figures were painted with various colors; a second firing was necessary to fix the colors.

The figures of knights, birds, sphinxes and trees with crowns of leaves around the branches are drawn in a simple style, as in miniature painting. Sudden movements and the impressionistic character of the scenes are emphasized. The production of this, the richest period of Islamic ceramic art, spread widely in China and Japan.

BEHZAD.
The Caliph Haroun Al Rashid and the Barber, from the Nizami Anthology. *p. 63*
The scene belongs to Nizami's *Anthology* (Or. 6810), sheet 27 *verso*, a collection of five poems, based on old legends, either Iranian or of Iranian derivation. It later became a kind of classical model in Moslem literature. The page reproduced here depicts the Caliph Haroun al Rashid in his bath, with the barber who proposed to his daughter, and the discovery of the treasure hidden in the barber's house. The miniatures in this wonderful codex are painted by Behzad. We have very few of his original works, though there are many imitations with forged signatures. The painter's career began in 1488–89 with the miniatures of the *Saadi Garden*, now in the Cairo Library, as a pupil of Husain Mirza of the Herat School; he appears here in his full maturity. Having freed himself from the prevailing conventions and formality of the Tabriz and Shiraz Schools, the artist went back to a simpler, fresher and more immediate vision of life. This serenely contemplative world includes lively details, but enfolds everything within a lucid composition which has purity of form as its highest goal; this is obvious here, for example, in the masterful arrangement of the various elements of the background and clear-cut architectural divisions.

ART OF TUN–HUANG. *Buddha in Prayer.*
This T'ang painting was found in 1907 by Stein in the Cave of the Thousand Buddhas. It represents the Buddha praying under the Tree of Enlightenment, seated on lotus flowers on Mount Sumeru, surrounded by four Bodhisattvas and other figures below are the donors who commissioned the painting, one of whom is missing. The painting is executed in several superimposed layers. The parts in relief are marked by sharp lighting, in a technique borrowed from Greek and Roman art. This is true also of the distribution of parts in the composition and of the spatial relations. Other peculiarities of T'ang style show a connection with Indian and Central Asiatic art. In spite of the poor state of preservation, we can appreciate the structure, in which some parts are clearly subordinated to others, resulting in a majestic and imposing whole. This work is particularly important because it reveals the influence of motifs from the Mediterranean on the art of the Far East. Such historical East-West connections became reciprocal in the Middle Ages.

ART OF TUN–HUANG
Buddha in Prayer
(mid 8th century)
Painting on silk.

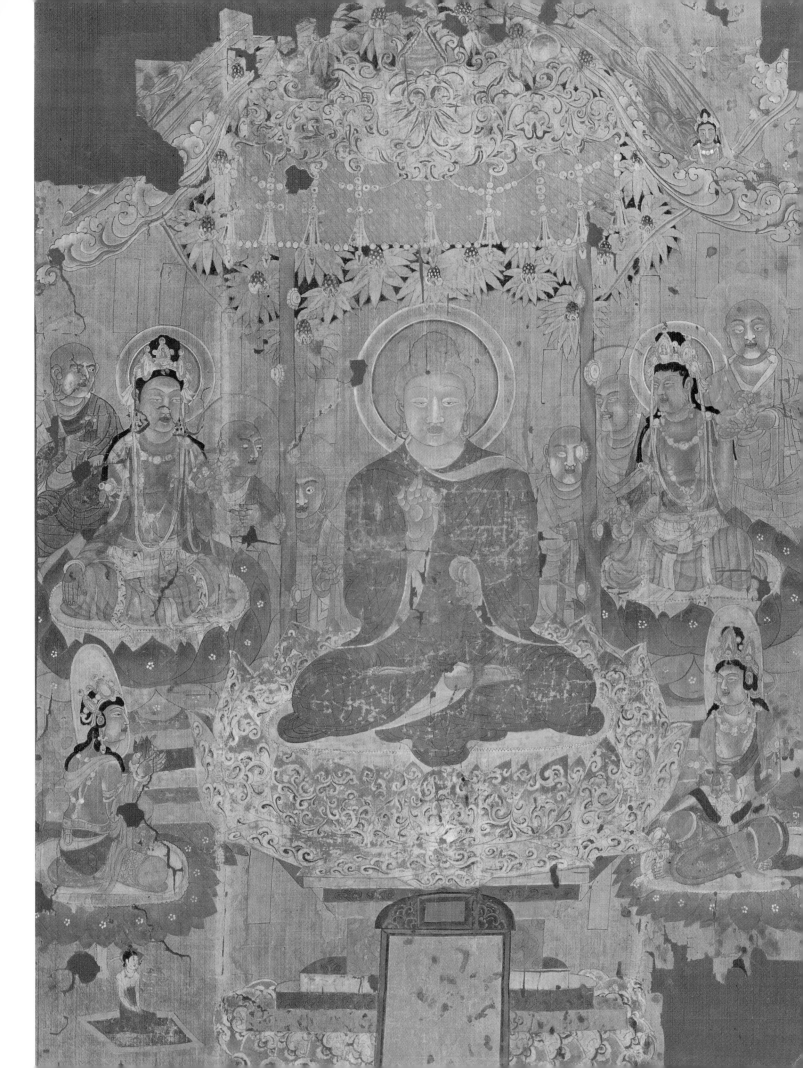

KU K'AI CHIH. *Instructions of the Governess.*

From the period of the Eastern Tsin (317–86) we have frescoes, drawings on stone and decorated objects; but this painted hand-scroll seems to be the earliest example of a portable painting. Its provenance is complicated. It was originally in the collection of the Ch'ing court; that is why, at the beginning of the scroll, there is a title written by the emperor Ch'ien Lung, with his seals and his sign, a painted orchid. Then the scroll, along with three others by the painter Li Lung-min of the end of the Northern Sung Dynasty, was in the possession of Ku Tsung-i, a famous collector of the late Ming Dynasty. All of these later came into the hands of the Ch'ing court, bearing the mark of Ch'ien Lung, in 1746.

The problem of attribution has been much discussed. For a long time the prevailing opinion was that this scroll was written by the calligrapher Wang I-chih and illustrated by Ku K'ai-chih. The latter was a painter, man of letters and also author of a treatise on painting. Originally from Kiangsu, he was born between 343 and 347, during the dynasty of the Oriental Tsin, and he died around 408. The hypothesis was then advanced that the writing on this scroll could have been done by Emperor Kao-tsung of the Southern Sung, and the illustrations executed by a painter of that time. Finally, some who believe that this scroll is a copy, going back at the latest to the beginning of the T'ang Dynasty, founded their opinion on the statement that this painting belonged to the emperor Huei-tsung (1082–1135) of the Sung Dynasty, who placed his seal on it, and also on the presence of a seal of the T'ang period and on the technique and characters of the calligraphy, which are not later than the T'ang period. The red and black drawing and the shading at the borders point to a time prior to the linear Sung style; they have a close relationship to the painting of the Six Dynasties. The text, about a third of which is missing, according to tradition was compiled by Chang Hua with an imaginary court Governess and refers polemically to

KU K'AI–CHIH
Instructions of the Governess
(c. 344–408)
Painting on silk.
Four details; height 9⅞ in (24.5 cm).

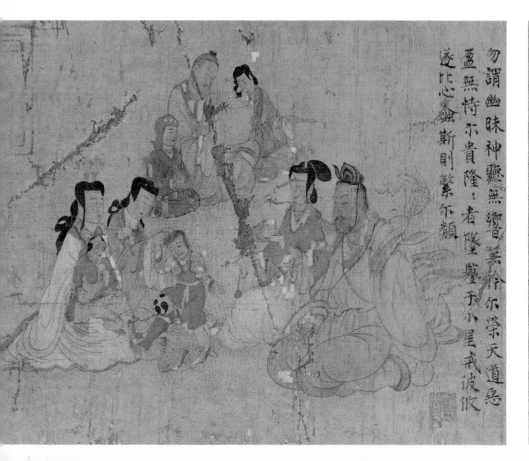

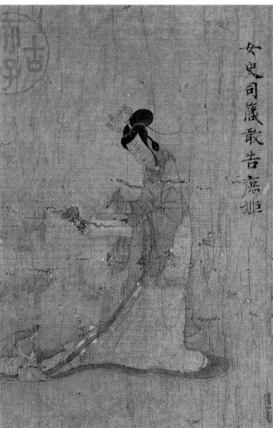

the insolence and licentiousness of the wife of the emperor Hui-ti of the Tsing Dynasty. The scenes illustrate the text. The text is missing for the first chapter. The third scene, with a hunter's figure, illustrates the idea that everything has its splendor and decadence; the fourth scene, that we must take care of the soul rather than the body; the fifth, that beautiful words are moving even at a distance of a thousand miles, but they are immoral, can create misunderstanding between husband and wife; the seventh scene, that those who grow proud because of a love will eventually lose it; the eighth, that through care and attention one can obtain happiness and through modest consideration one can attain glory. Calligraphic inserts divide the scenes. Traditional Chinese criticism used to compare Ku K'ai-chih's style to a silk thread made by a silkworm in the springtime, signifying, with this comparison, the subtlety, the elastic and continuous development, the delicacy and strength of his work.

The character of the drawing in these *Instructions* is inconceivable after the ink painting of the end of the T'ang period. Even the anthropocentric tendencies, according to which mountains and landscape are smaller than man, is an attitude connecting this work with the style of the period of the Six Dynasties, or before. Considering the extraordinary sensitivity and vitality present in this scroll, we must also exclude the possibility of a later copy; therefore the attribution to Ku K'ai-chih seems validated. This artist, in his writings on art and criticism, affirms he tried to use a line that would be valid for any exterior or inner representation. He joins such a line, in this scroll, to pure colors, particularly red and black, filling in some of the outlined figures, thus alternating colors and lines in a sophisticated rhythm. The master was appreciated, even in later times, for his linear rendering, flexible and exquisite, of undulating clothes, streamers or elaborate hairdos, with subtle accents of scarlet shading and outlining. Even in the T'ang period and later, he was considered to have initiated a great style.

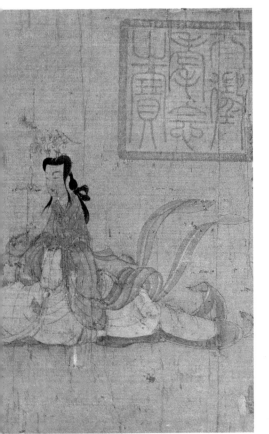

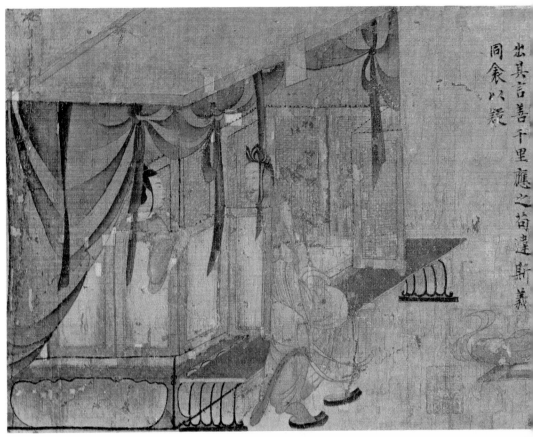

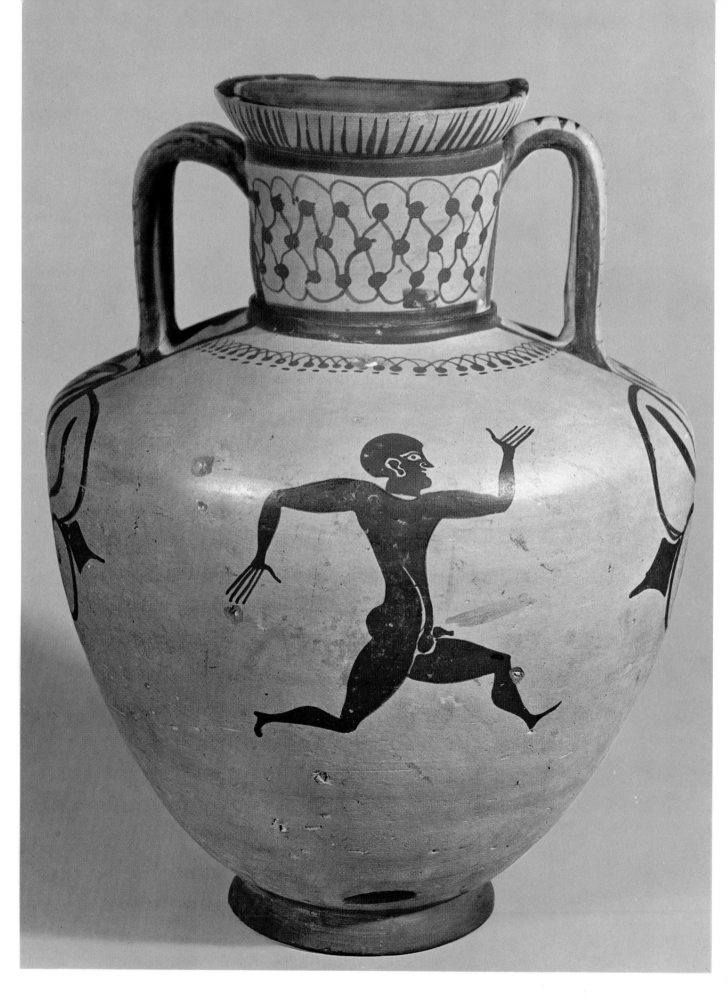

RUNNING MAN PAINTER. *Amphora with Figure of a Runner.*

The pottery named after Fikellura, near Kameiros in Rhodes, originated around 580 B.C. It was based, at first, on the animal and plant repertory of the earlier Rhodian production. The human figure appears around the middle of the 6th century, while the style imitates the more richly figurative examples of Ionian ware.

The work of the "Running Man Painter," so called because he repeated this motif in several works, contrasts to a certain extent with the more linear and ornamental Corinthian style, a style which influences even Attic black-figure ware and is mainly based on precise and well-defined outlines. We have here, on the contrary, a lively manner, a sort of "expressionism" which is in some ways deforming and humorous, but exceptionally powerful in its use of the free-hand technique; even anatomical details are not incised, but painted in light color on the dark background.

The artist can also transform conventional archaic details, like profile legs and frontal torsos, into more naturalistic positions: the shoulders, for example, are articulated through the movement of the open arms.

While it may be true that this figure of an athlete does not approach the classical Greek ideal, it certainly expresses the concept of speed in an exceptionally effective manner.

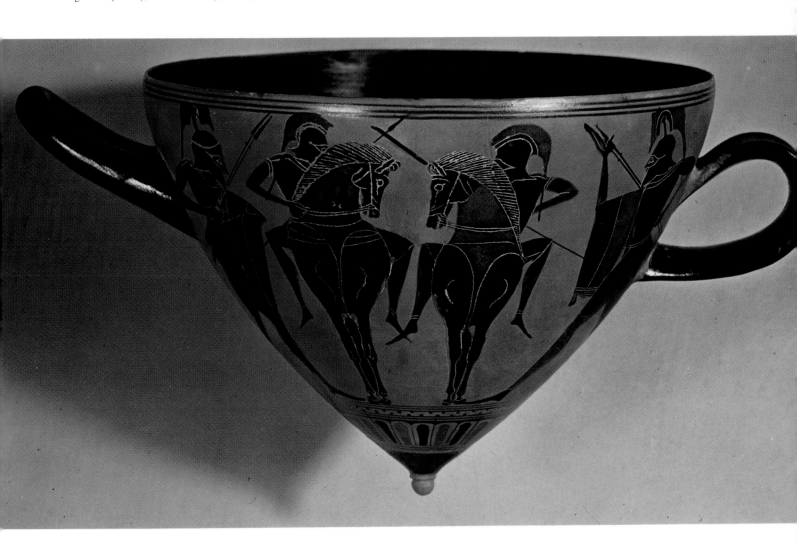

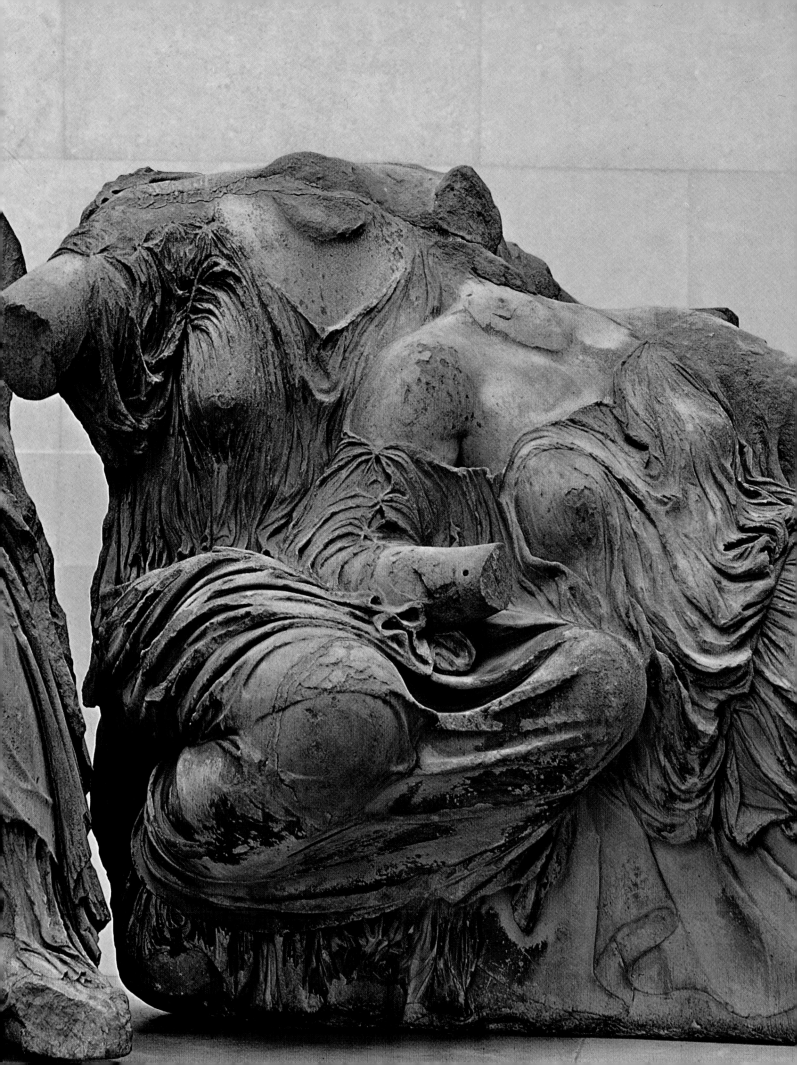

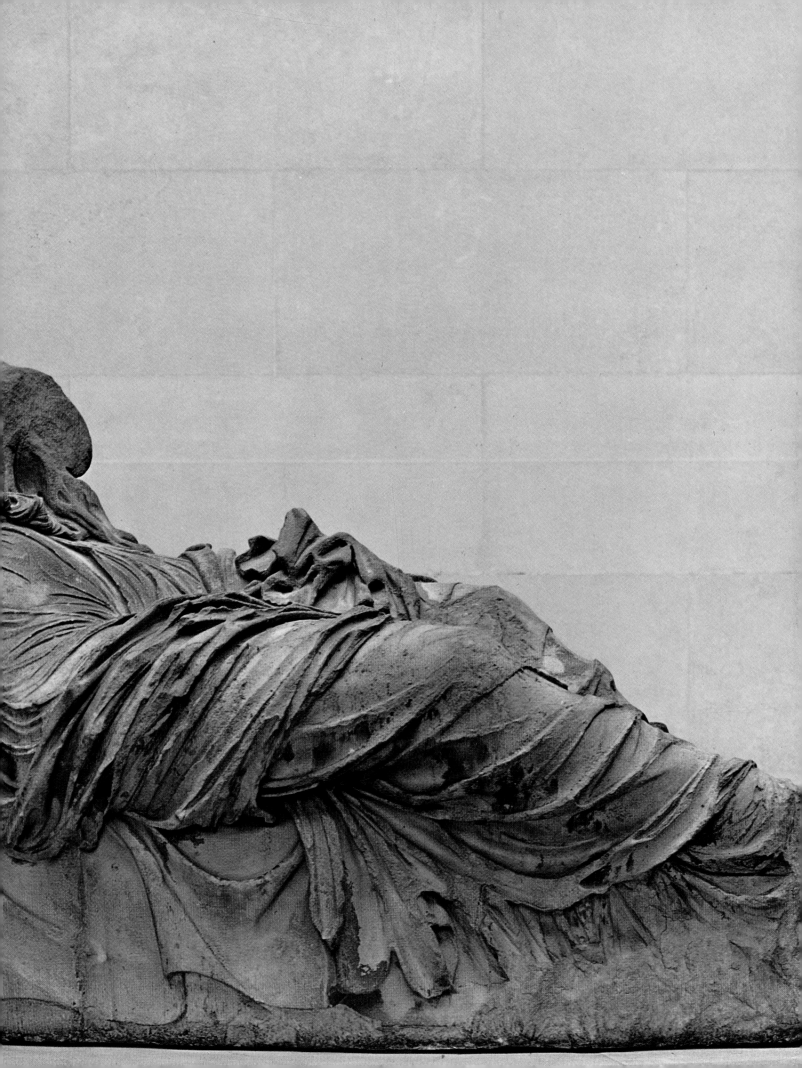

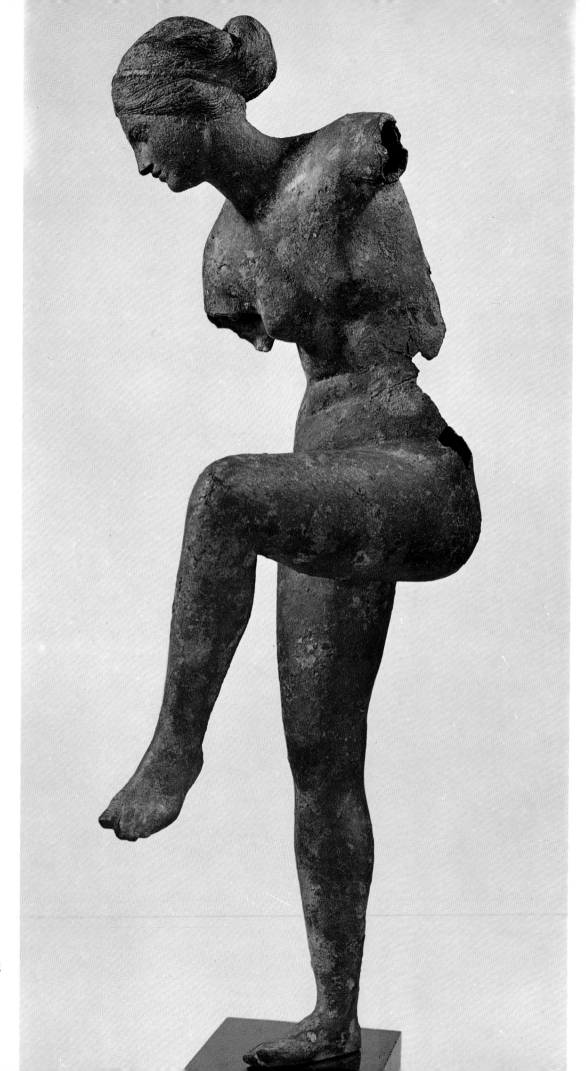

72

On pages 70–71:
GREEK ART,
PHIDIAS AND ASSISTANT
Dione and Aphrodite
(*c.* 435 B.C.)
Pentelic marble; height 43 in (107.5 cm).
From the east pediment of the Parthenon,
Athens.

GREEK ART OF THE HELLENISTIC
PERIOD
Aphrodite
(*c.* 200 B.C.)
Bronze; height 21½ in (53.75 cm).
Found near Patras.

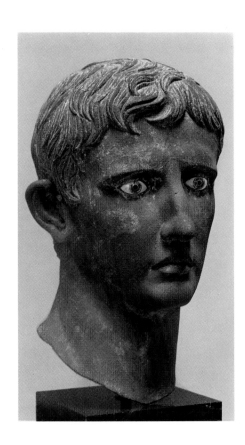

ARCHAIC GREEK ART. *Attic "Mastos."* p. 69

The *mastoi* (breasts) were footless cups which, once filled, could not be put down before being completely emptied.

The well-balanced scene painted on this *mastos* is composed of four figures, two horsemen fighting in the center and two footsoldiers at the sides. It shows how the influence of the Amasis Painter and of Exekias was felt by lesser artists. Frontality is thoroughly respected: notice the unusual frontal view of the horses, each of which is exactly inscribed in a wedge-shaped space.

PHIDIAS AND ASSISTANT. *Dione and Aphrodite.* pp. 70–71

The east pediment of the Parthenon, which represented Athena's birth, was conceived and executed earlier than the western one, representing the contest between Athena and Poseidon for the soil of Attica. The central group of the east pediment had been removed before the 1687 explosion; in fact the drawings of 1674 show only the side groups of gods and goddesses who were present at the contest. The two goddesses at the right end of the pediment have been identified as Aphrodite reclining on her mother's lap. This group can be considered to come closest to the pictorial style which is realized in the western pediment. The folds have been treated with exceptional freedom and the "wet" drapery molds the contour of the bodies with naturalistic effects.

GREEK ART OF THE HELLENISTIC PERIOD. *Aphrodite.*

This rather damaged statuette represents a nude Aphrodite of rare elegance. A comparison with a bronze statuette in the Louvre, which is similar to this one, though rougher, allows us to reconstruct the goddess' pose. She stands, without any support, as she fastens or unfastens a sandal, either before or after the bath, while her left hand gropes in the air to maintain her balance.

HELLENISTIC ROMAN ART
Head of Augustus
(27 B.C.–14 A.D.)
Bronze; height 18¾ in (47 cm).
Found in the excavations at Meroe in the Sudan,
1910.

HELLENISTIC ROMAN ART. *Head of Augustus.*

This superb *Head of Augustus*, once part of a full-length statue, is obviously the product of an Alexandrian workshop. In comparison to heroic portraits of Alexander the Great, it reveals considerable individualization of Octavian, the man, while adhering to the Roman tradition, and to the iconography of Augustus. If, however, this iconography originated in Alexandria itself, this head from Meroe could well be close to the archetypical example.

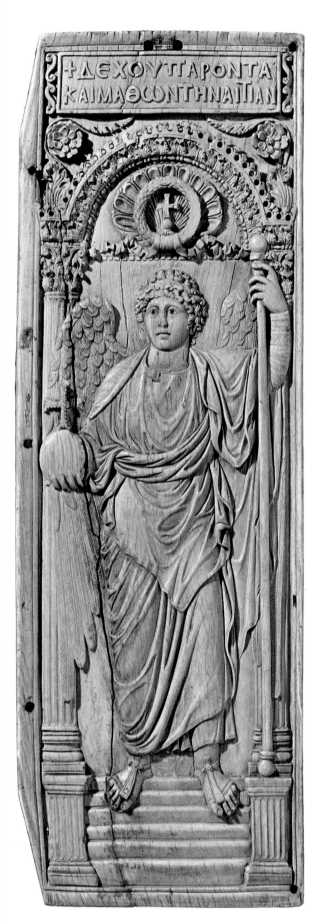

EARLY CHRISTIAN ROMAN BYZANTINE ART. *Archangel.*
This large ivory plaque, which had probably been in Canterbury since the 14th century, is an outstanding example of the rich early Christian and Byzantine ivory production. It is usually dated between the 5th and 6th century, though some scholars have tentatively suggested the 8th. The most probable date is, however, the 5th century: the features of the face, the attitude of the figure, the setting in a frame, are similar to those of the consular diptychs and of several works of art of that century, such as the *Angels* of the mosaics at Ravenna. The minute folds, the detailed and pointed architectural decoration are less common, though not inconsistent with that style. Notice the classic correctness of this figure, solemnly placed under an arch. The artist, however, does not appear to be concerned with a plausibly spatial setting for the figure. While the Archangel's feet, for instance, are represented as though seen from the spectator's eye level, the steps on which they tread are seen in perspective from a lower level.

EARLY CHRISTIAN
ROMAN BYZANTINE ART
Ivory Panel with Archangel
(c. 5th century A.D.)
Originally part of a diptych;
height 16¾ in (42 cm).

LATE CELTIC ART
Mirror Back
(end of 1st century B.C.)
Incised and patinated bronze, with handle of
linked, soldered iron rings;
height 13¾ in (34 cm).
From Desborough, Northants.

LATE CELTIC ART. *Mirror Back.*
The decoration of the back of this mirror is extremely elegant, composed of spirals and curving lines which were engraved by burin on the surface, with crosshatch motifs. This mirror is one of the finest examples of the Celtic metalwork technique, together with a similar example in the Gloucester Museum. The spirals are evidently stylized aquatic motifs and seem to give to the surface a full range of shades and reflections. Mirrors in ancient times were made by polishing a metal or ivory surface: their nature was therefore illusory and imaginative, just as the images they reflected were vague and unreal.

LATE CELTIC ART. *Ceremonial Shield.* *p. 76*
In this object, we see how the typical Late Celtic goldsmith's art reached a neo-classical, sophisticated purity. The shield itself is shaped in a complex geometrical figure. Three ornamental disks are connected by metal buttons along the vertical axis; these disks are decorated by embossed curving lines, which are beautifully stylized. Small metal plaques, on which a swastika is marked, are placed in the volutes. It is not easy to describe so abstract an art; it is enough to notice that a delicate, almost musical decorative alternation flows into the symmetrical structure of the whole. Many similar objects have been found in river beds, mostly in good condition. The position of the handle on the back of the shield, as well as the delicate, fragile decoration of the front, has lead scholars to believe that it was used for ceremonial purposes, as an offering or "ex-voto" to the gods of rivers.

FLEMISH ART. *Decorated Shield in Gilded Wood and Tempera.*

This splendid example of a courtly tournament shield, with a socket for the lance, is divided into two panels, like a diptych. It represents a love scene. To the left stands an elegant lady; to the right, a warrior on bended knee with his head uncovered is being presented by a skeleton. In the ornamental scroll is inscribed his motto: "You or death." It was probably commissioned for a special event, since the faces of the characters, especially the one of the knight, seem to be portraits.

76

onginned godspell æfter matheus
Incipit euangeli um secundum matheu∴
cryster

þ i ii iii iiii v vi

uutedlice ruæt þær cristes cneu reo

godlice

cynnreccenire t cneuresu ruæt suæ þis mid hy

RATIOXICENERATOM

þær bi poeddes t beboden t bewarnud t betaht

ESTCHOBONFAI

moder hir

MATEREIUSMARIACUOEBR

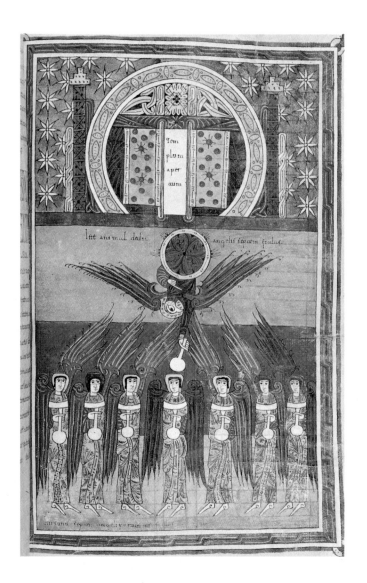

EADFRITH OF LINDISFARNE. *Gospel Book.* *p. 76*

Presented in this chapter are some of the notable illuminated manuscripts from the collection of documents kept in the Department of Manuscripts of the British Museum. The collection consists of more than 150,000 pieces, with many works of great artistic and historical value.

Among the Celtic manuscripts, the *Lindisfarne Gospel* (ms. Cotton Nero D. IV) is outstanding. Both the text and the miniatures probably were executed by Bishop Eadfrith of Lindisfarne, which was one of the most important religious and cultural centers in Christianized Great Britain.

Illustrated here is a full-page reproduction of the X–P (*chi-rho*) leaf, from the beginning of the Gospel according to St. Matthew. The larger framework consists of horizontal and vertical lines, intersecting at right angles: this pattern is enclosed by the outlines of the decorations, the lines of script itself and the straight lines of the letters. It should be noted that the framework does not consist of uniform sections but is, instead, composed of lines repeated at varying intervals, forming a complex, articulated rhythm. The curving motifs of the capital letters — the X (*chi*) and P (*rho*)

Above left:
SPANISH MINIATURE
*The Open Temple, the Eagle
and the Seven Angels with Phials*
from the *Commentary on the Apocalypse*
by Beatus of Liebana
Ms. Additional 11695, sheet 172/r.
S. Domingo de Silos, 1091–1109.
Miniature on parchment;
9¼ × 13 in (23 × 32.5 cm).

Above:
SPANISH MINIATURE
The Four Horsemen of the Apocalypse
from the *Commentary on the Apocalypse*
by Beatus of Liebana
Ms. Additional 11695, sheet 102/v.
8 × 12½ in (20 × 31 cm).

WINCHESTER MINIATURE
Capture of Christ; The Flagellation
from the *Psalter of St. Swithun,* or
of Henry of Blois
Ms. Cotton Nero C. IV, sheet 21/r.
Winchester, middle of 12th century.
Miniature on parchment;
7 × 10¾ in (20.6 × 21 cm).

ICI ... EL ... COST...

— relate to the rectilinear framework in swirling rhythms which are in a constant state of transformation. So all straight lines, which are limited to the letters and the frame, eventually become incorporated into the complex system of curving and spiral interlacings. These traceries, upon closer inspection, can be seen to consist of intertwined serpents, dragons and other fantastic animals, endlessly animating the length of the letters and the decorations. The whole complex is like a poem based on the varied repetition and linking together of the individual forms, in the rhythm of its lines, colors and forms that repeat themselves continuously, in an incessant oscillation from motif to motif. This reduces the myriad of rhythms to a single, very elaborate, yet figurative pattern. All this is, at the same time, a consistent reworking of ancient motifs, inherited from the Celts of East Europe and Central Asia, and adapted to rhythms partly derived from the Hellenistic Roman style with a new, disciplined sense of formal pattern and design.

BEATUS FROM SAN DOMINGO DE SILOS.

Two Scenes of the Apocalypse. *p. 78*

The *Commentary on the Apocalypse* by Beatus of Liebana from the monastery of San Domingo de Silos, to be dated 1091–1109, is one of the most remarkable examples of the so-called "Mozarabic" miniature. In this as in similar products, the figurative repertory relates to those in Carolingian codices, joined to elements derived from the whole Islamic world, from Syria to Spain. These two cultures both derived from Hellenist Rome, yet there is no doubt that at this point, when they meet, they produced a very strange, strong figurative style. In the pages illustrated here, the formation of patterns by the use of flat colors in the backgrounds is evident. This color pattern results in rhythmically ordered series of horizontal bands, often equal in size, which conform to the lines of script forming the basic pattern of the page. The rendering of drapery and shadows is derived from Syrian art, but, following the Hellenistic Roman tradition, they are presented as series of lines creating brief, independent rhythms. Color rhythms prevail in the extreme simplification of the contours of the figures, strong contrasts, or an affinity of colors and shades, result in lively distinctions and violent dissonances. The contours of the figures, which are extremely simplified, connect with each other by means of hooked patterns which join them; yet in the end it is the alternation and contrast of the colors which dominate.

PSALTER OF ST. SWITHUN.

Two Scenes from the Passion, Capture and Flagellation of Christ. *p. 79*

In the manuscript known as the *Psalter of St. Swithun* or *of Winchester* or *of Henry of Blois*, which dates from the middle of the 12th century, the connection with the preceding products of that school of miniature painting is clear. In this page with the *Capture of Christ* and *The Flagellation*, the almost monochrome, graphic style accords with the Winchester tradition, but there are also strong connections with the art of more ancient times, as, for example, with Salzburg illuminations and Northern French miniatures.

THE NATIONAL GALLERY

LONDON

THE BUILDING

The National Gallery's building is not commonly considered one of William Wilkins' most felicitous architectural achievements. Erected between 1832 and 1838 at Trafalgar Square, it was intended to blend into John Nash's town-planning scheme for the visual linking of some of the key points in central London. Wilkins designed a long Academic façade, using some of the elegant forty-year-old Corinthian columns from Carlton House, and crowning the building with a small dome of Byzantine inspiration. The interior has been considerably altered over the years. In 1876 E.M. Barry designed a new wing for the Vernon collection, and in 1885–87 the central stairs and the vestibules were added. Today the Gallery is laid out in a sequence of national divisions by schools of paintings.

KEY

1	Early Italian painting		15	Dutch painting
2	Early Italian painting		16	Dutch painting
3	Early Italian painting		17	Dutch painting
4	Early Italian painting		18	Dutch painting
5	Early Italian painting		19	Dutch painting
6	Early Italian painting		25	Dutch painting
10	Early Italian painting		26	Dutch painting
11	Early Italian painting		27	Dutch painting
12	Early Italian painting		28	Dutch painting
13	Early Italian painting		32	French painting before 1800
7	Italian painting 1500–1600		33	French painting before 1800
8	Italian painting 1500–1600		40	French painting after 1800
9	Italian painting 1500–1600		43	French painting after 1800
14	Italian painting 1500–1600		44	French painting after 1800
30	Italian painting 1500–1600		45	French painting after 1800
29	Italian painting after 1600		46	French painting after 1800
34	Italian painting after 1600		35	British painting
22a	Early Northern painting (German and early Dutch)		36	British painting
			37	British painting
23	Early Northern painting (German and early Dutch)		38	British painting
			39	British painting
24	Early Northern painting (German and early Dutch)		41	Spanish painting
			42	Spanish painting
20	Flemish painting			
21	Flemish painting			
22	Flemish painting			

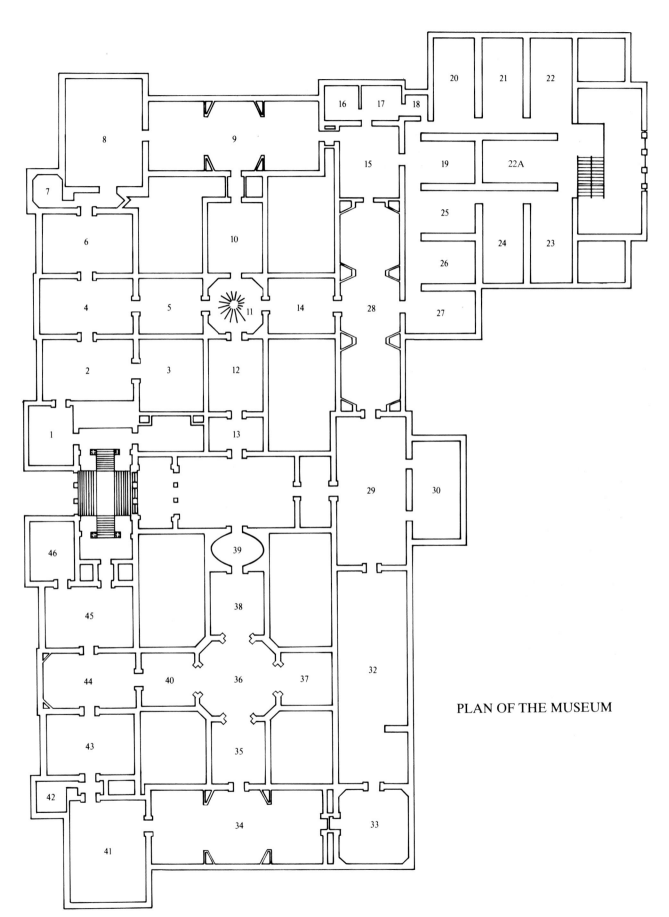

PLAN OF THE MUSEUM

83

PAOLO UCCELLO. *St. George and the Dragon.*

In the popular legend the dragon remains outside the city in return for eating some of the inhabitants. When the turn of the king's daughter comes she is rescued by St. George, who slays the dragon. This painting shows the artist's interpretation of the story. In an earlier painting of this subject (now at the Musée Jacquemart André in Paris) a vast landscape extends behind the battling figures in the foreground. The compositional elements are identical in this later version, but here the cave and the trees blend into the clouds, delimiting the farther planes from the battle area. The figures of St. George and the dragon draw the eye along converging lines to the outer picture space. Slight suggestions of irony enliven the painting: the princess appears to be holding the dragon on a leash, and the saint's lance is unnaturally elongated.

84

PAOLO UCCELLO
Florence 1397 — Florence 1475
St. George and the Dragon (*c.* 1455)
Tempera on canvas; 22½ × 28¾ in (57 × 73 cm).
Formerly in the Lanckoronski collection in
Vienna.

PIERO DELLA FRANCESCA
Borgo San Sepolcro *c.* 1410—
Borgo San Sepolcro 1492
The Baptism of Christ (*c.* 1440–50).
Tempera and oil on panel with rounded top;
65¾ × 45¾ in (167 × 116 cm).
The surface is cracked and worn.

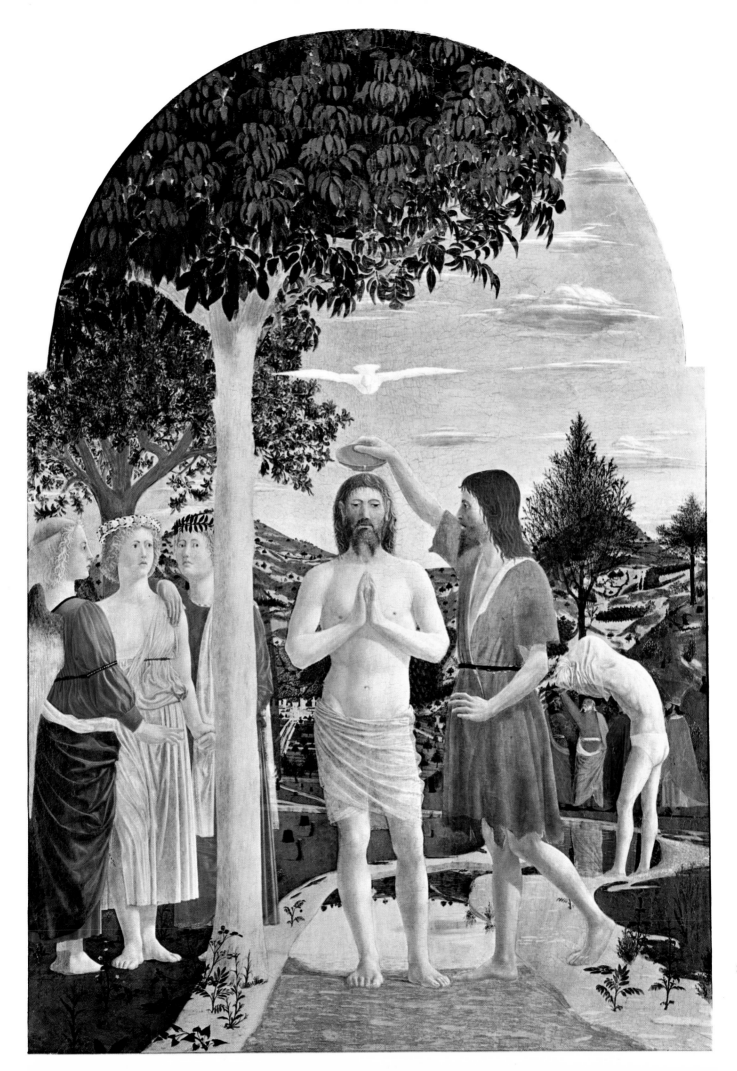

85

PIERO DELLA FRANCESCA. *The Baptism of Christ.* *p. 85*
This picture was one of Piero's first commissions after he returned to his
native San Sepolcro in Umbria in around 1442, following a period spent
working in Florence. It was originally painted as the central panel of a trip-
tych which adorned the high altar of S. Giovanni Battista in San Sepolcro,
which is the town depicted in the background of the picture. Piero has
captured the moment in time just before the baptism of Christ. In absolute
immobility, the figures and the smooth trees stand firmly planted; the dove
is poised with spread wings; and the still water of the river reflects the lines
and colors of the landscape. John the Baptist's rustic garb, the loincloth
that barely covers Christ's robust body, the shirt that the catechumen is
pulling over his head as he undresses, and the angels' tunics — all fall in
compact folds or are loosely gathered. The entire composition is homo-
geneous, and harmony reigns in this shining world. The light reveals the
limpid volume of every element, traces the movements of the composition,
and establishes the distances in the clearly defined space.

GIOVANNI BELLINI. *The Doge Leonardo Loredan.*
The spirituality and timeliness of this portrait is unusual. Very different
from the artist's outdoor scenes, with their vibrant atmosphere and chang-
ing skies, this painting has a crystalline clarity. The portrait conveys the
indomitable energy of the Doge Leonardo Loredan, who was elected in
1501 at the age of 65, and guided the Venetian Republic "with more than
human valor" during the turbulent years until 1521. The form is that of a
sculpted bust, the plain background and lack of additional detail serving to
emphasize the character and expression of the old man's face.
The painting was probably painted at the beginning of the 16th century
shortly after Loredan's election.

GIOVANNI BELLINI
Venice *c.* 1426 — Venice *c.* 1516
The Doge Leonardo Loredan (1501–02)
Panel; 24 × 17¾ in (61 × 45 cm).
Signed on the scroll:
JOHANNES BELLINUS.
Acquired early in the 19th century by Lord
Cawdor from Palazzo Grimani, Venice. The
Gallery bought it from the Beckford collection in
1844.

LEONARDO DA VINCI.
The Virgin and Child, St. Anne and the Infant St. John. *p. 88*
This drawing poses a complicated question of identification. In a letter to
Isabella d'Este on April 8, 1501, Fra Pietro da Novellara described a study
executed by Leonardo for an altarpiece commissioned by the Servites of
Florence. It is likely that Leonardo's *Virgin and Child with St. Anne*, now
in the Louvre, is the altarpiece in question, but the work minutely described
in the monk's letter differs in many respects from both this cartoon in the
National Gallery and the picture in Paris. Since it is known that the London
cartoon came from Milan, it may have been the study for an earlier version
of the painting, now lost. In any event, the cartoon has always, as Vasari
tells us, been considered a great work of art. On its completion, it was put
on exhibition and attracted admiring crowds. Certainly it is one of the most
important works in the development of 16th-century art and represents a
combination of two themes popular with Florentine artists of the time: the
Virgin and Child with St. Anne (the Virgin's mother) and the Virgin and
Child with St. John the Baptist. This unusual composition — in which the

86

IOANNES BELLINVS

LEONARDO DA VINCI
Vinci 1452 — Amboise 1519
The Virgin and Child, St. Anne and the
Infant St. John (*c.* 1500)
Charcoal on paper;
54¾ × 39¾ in (139 × 101 cm).
From the Resta collection in Milan, it passed to
the Marchese Casnedi's collection in the late 17th
century. In 1722 it was bought by the Sagredo
family in Venice, from whom Robert Udny,
brother of the English ambassador to Venice,
bought it in 1763. In 1791 it appeared in an
inventory of the Royal Academy. Bought by the
National Gallery from the Royal Academy in
1966.

figures make a composite form but keep their identity, and the limited space is made to seem broad — influenced painters from Raphael, Fra Bartolomeo and Andrea del Sarto to the Mannerists. Leonardo's new departure, along with Raphael's paintings of the Holy Family and Michelangelo's *Holy Family*, established the classicism of the High Renaissance. The cartoon has a particular beauty. St. Anne, depicted as being almost the same age as her daughter, smiles at the Virgin, who in turn looks at the Christ Child, who blesses the Infant St. John. Sigmund Freud has suggested that the artist's particular portrayal of the subject, and the fact that both women are of a similar age, may relate to Leonardo's personal life as a child. Leonardo was illegitimate and spent his infancy with his peasant mother, however, he was later adopted by his father's wife. So, in a sense he had two mothers, perhaps the Virgin and St. Anne of his pictures.

RAPHAEL
Urbino 1482 — Rome 1520
St. Catherine of Alexandria
Oil on panel; 28 × 20¾ in (71 × 53 cm).
This may be the painting that Pietro Aretino, in
a letter of August, 1550, said he sent to Agosto
d'Adda. A preliminary drawing is in the Louvre.
Day acquired if from the Borghese collection
around 1795, after which it was taken to England.
Bought by the National Gallery in 1839.

89

RAPHAEL. *St. Catherine of Alexandria.* *p. 89*

This magnificent painting is one of the major examples of the new "serpentine" form in the High Renaissance. It was executed at Florence in 1506–07, the years when the artist was most interested in Leonardo's repertory of forms and manner of painting. It is from Leonardo — perhaps his *Leda* — that the strong torsion of the figure of the saint and the subtle filtered effect of the light are derived. What Raphael has originated is the measured correspondence of figure and landscape, in which the figure is the supporting element of an architectural structure.

MICHELANGELO. *The Entombment.*

The attribution of this painting (which is unfinished) to Michelangelo is questioned by some critics. Yet even those scholars who assign it to Battista Franco or a hypothetical Master of Manchester (after the Madonna of the same name), do not deny that Michelangelo had an important role in its execution. According to an undocumented tradition, the idea for the composition of *The Entombment* derives from Mantegna. But there is a more obvious iconographic connection with Dürer, in the splendid tension of the central group of St. John on the spectator's right, St. Mary Magdalen on the left and Joseph of Arimathea behind, all supporting the figure of Christ.

In the bottom right of the painting an area has been left blank, possibly intended for the Virgin. The smaller unpainted area at top right probably shows the tomb being prepared by two figures. The picture was possibly painted in two stages: the two figures on the left are smoother and more in keeping with Michelangelo's earlier work than the rest of the picture, which employs a different technique.

MICHELANGELO
Caprese 1475 — Rome 1564
The Entombment (1506–11)
Oil on panel; 62½ × 58¾ in (161 × 149 cm).
Formerly in the Farnese collection, the panel was bought by the National Gallery in 1868.

ANDREA DEL SARTO. *Portrait of a Young Man.* *p. 92*

This famous painting may be a portrait of the sculptor Baccio Bandinelli, a friend of Andrea's. The object he is holding appears to be a block of stone; however, it is more likely that it is a book. There is a marked similarity between the features of this figure and those of the so-called self-portrait and the St. John in the *Madonna of the Harpies* (both in the Uffizi). Evidently the master used his own face as a masculine model, just as he adopted the features of his wife, Lucrezia del Fede, for all his women. The picture was probably executed in 1517–18, crucial years in the artist's development that culminated in the creation of the *Madonna of the Harpies* and the *Disputation on the Holy Trinity* (Pitti Palace, Florence). This portrait is the poetic highpoint of the period. In pose and characterization, worked out in a series of splendid preliminary drawings now in the Uffizi, there is a sensual and emotional quality that is carried on a clear architectonic structure. Head and torso turn in a succession of precisely defined planes, and the hands frame the block-like form of the stone or book. Shadowy effects derived from Leonardo — such as the eye sockets, from which a questioning, almost forlorn glance emerges — have been transmuted into a sensual, bitter awareness.

90

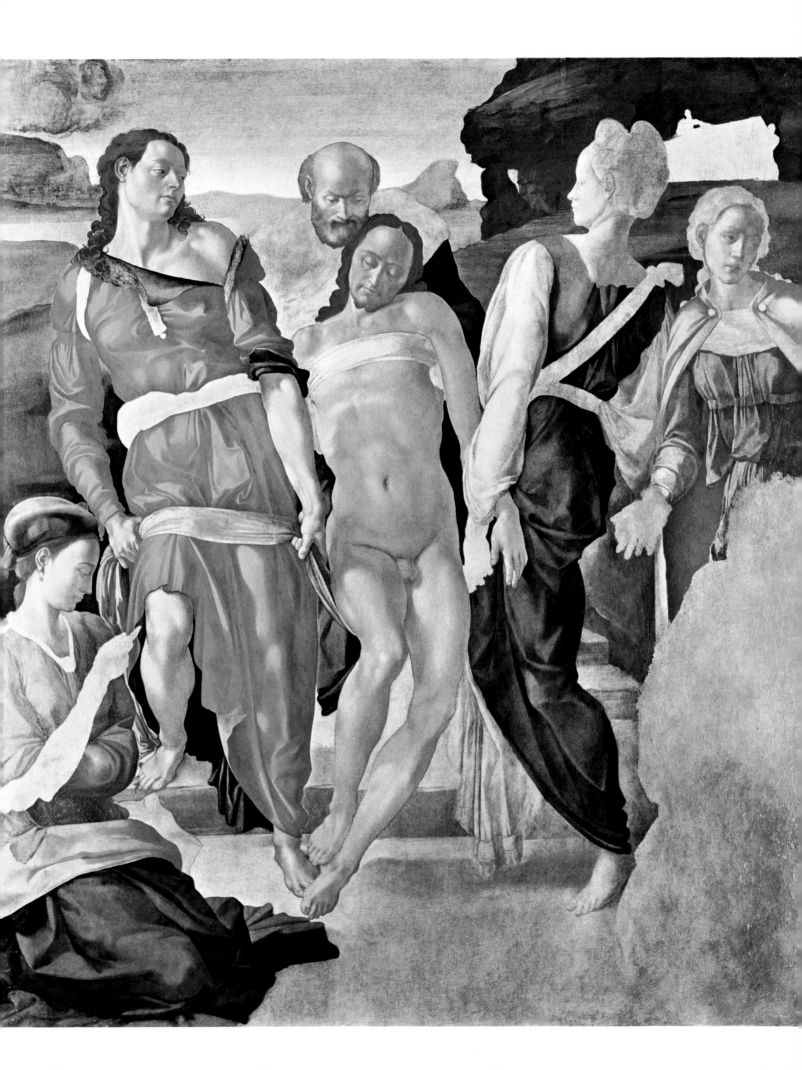

ANDREA DEL SARTO
Florence 1486 — Florence 1530
Portrait of a Young Man
Oil on canvas; 28 × 21¾ in (71 × 55 cm).
The painting is signed with the artist's monogram
in the upper left. Acquired from the heirs of
Cavaliere Niccolò Puccini of Pistoia.

PAOLO VERONESE
Verona 1528 — Venice 1588
Allegory of Love: Respect (c. 1570–75)
Canvas; 73¼ × 78¼ in (185 × 183 cm).
One of a series of four paintings of allegories of
love, all of which are in the National Gallery.
They appear in the inventory of the Emperor
Rudolph II's collection in Prague, which was
compiled in 1637. After the sack of Prague, they
entered the royal collection of Sweden, belong-
ing to Queen Christina and subsequently to the
Duke of Orléans. The National Gallery acquired
them between 1890 and 1891.

PAOLO VERONESE. *Allegory of Love: Respect.*

It is not certain that the series to which this canvas belongs was painted for
the Emperor Rudolph II, but the erotic theme unquestionably would have
appealed to this sovereign, whose collection included many profane subjects
with the allegorical and intellectual complications of Mannerism. The
subject matter of these works has not been identified, but this painting is
often called *Respect*. A young woman is shown asleep on a canopied bed
covered with red-orange satin that emphasizes the delicate ivory of her skin.
The position of her body, with the knee raised and the arms relaxed, brings
out this chromatic counterpoint to the full. Against the background of the
arch, seen from below and cutting across blue sky, is the figure of a soldier.
His yellow costume creates a lively complementary effect. Cupid leads him
towards the sleeping young woman. Judging from the perspective, the
canvas must have been intended for a position high up on the wall of a room,
rather than as a ceiling decoration. Veronese's religious paintings aroused
the suspicions of the Inquisition; but here, in this profane subject, he was
free to express his felicitous lyrical vein.

93

JAN VAN EYCK.

The Marriage of Giovanni Arnolfini and Giovanna Cenami.

An outstanding work of the 15th century, this painting reflects the influences of French and Rhineland sculpture, Sienese color and light techniques, and European court art. But the linear and decorative aspects of these influences have been replaced by a seamless, living continuity, which is also evident in van Eyck's earlier portrait of Arnolfini (now in the Berlin-Dahlem Museum).

The man in the painting is Giovanni di Arrigo Arnolfini, a merchant from Lucca who lived many years in Bruges, where he was buried in 1472. The woman is Giovanna Cenami, the daughter of another merchant from Lucca, who lived in Paris.

In this double portrait, which is as solemn as an Annunciation, every element is included in a perspective system that has its vanishing point below the mirror. The intensity of visual truth invests each detail; the entire composition, in its limpid purity, creates a meaningful cosmos. Religious symbols abound in the picture; the rosary, the roundels on the frame of the mirror, and the post of the chair. The candle in the chandelier may be a nuptial symbol as well, and the little dog may represent fidelity. Scholars have debated the symbolism and meaning of the work, but it is generally accepted that it shows a marriage scene. In the early 15th century a couple could marry without employing the services of a priest, simply by mutual consent with appropriate words and actions witnessed by two other people, in this case by the two witnesses (who would be standing where the spectator stands) appearing in the mirror. By means of this ingenious device the witnesses do not intrude into the calm dignity of the ceremony: only the dog in the foreground appears to notice their presence.

The Latin inscription on the wall — "Jan van Eyck was here, 1434" — seems to confirm that one of the figures in the mirror may be a self-portrait.

JAN VAN EYCK
Active *c.* 1422 — Bruges 1441
The Marriage of Giovanni Arnolfini and Giovanna Cenami
Oil on panel; 32¼ × 23½ in (81.8 × 59.7 cm). The coat of arms of Don Diego Guevara originally appeared on the frame. He gave it to Margaret of Austria, regent of Flanders. It was inherited by Mary of Hungary, who took it to Spain in 1556. The Alcazar inventories of 1700, 1754 and 1789 mention the painting. Subsequently it passed through the hands of a French general, Bélliard, and an English Major General, James Hay, who sold it to the Prince Regent for his collection at Carlton House in 1816–17.

HIERONYMUS BOSCH. *Christ Mocked.* p. 96
Bosch's many paintings of the Passion of Christ inspired numerous derivations and copies. This panel is one of his most outstanding works. The figures are composed on a system of diagonals that intensifies the impression of closeness created by the crowding of the foreground. Bosch has produced a grouping of grotesque and caricatural faces, whose cruelty and alienation contrast violently with the meek and patient suffering of the central sacred figure of Christ.

The painting shows numerous corrections by the artist, especially in the hands and the upper part of Christ's robe.

REMBRANDT VAN RIJN. *A Woman Bathing in a Stream.* p. 97
The model for this masterpiece was probably Hendrickje Stoffels, Rembrandt's common-law wife. Although the scarlet and gold robe on the bank suggests the biblical theme of Bathsheba, Rembrandt's concern is not a world of fantasy and history but rather the intimate feelings of a single

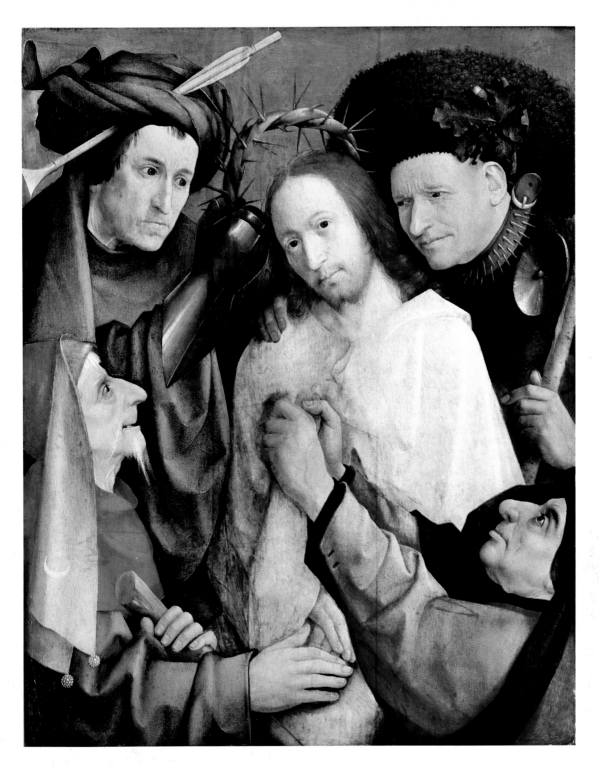

human presence: a woman alone, finding her footing as she wades into a stream in the sunlight. This is a purely personal painting, executed for himself rather than for the market.

PETER PAUL RUBENS. *The Château de Steen.* p. 98
This painting was probably painted shortly before Rubens died in 1640 at the age of 63. In this affectionate rendering of his own country house and lands, which he bought only five years before his death, Rubens has given vitality to a landscape composed mainly of flat and uninteresting fields. The view is to the north and the town on the horizon is probably Antwerp. From

HIERONYMUS BOSCH
s' Hertogenbosch (?) 1450 —
s' Hertogenbosch 1516
Christ Mocked (*c.* 1480)
Oil on oak panel; 29 × 23¼ in (73.5 × 59 cm).

REMBRANDT VAN RIJN
Leyden 1606 — Amsterdam 1669
A Woman Bathing in a Stream
Oil on oak panel; 24¼ × 18½ in (61.8 × 47 cm).
Signed and dated 1654 (?).
From the Rev. W. Holwell Carr Bequest, 1831.

the position of the sun it would seem likely that it is early in the morning. Although a return to the type of landscape he favored in his youth, here Rubens does not represent the violence of nature but the quiet atmosphere of broad distances receding to the horizon.

The painting is a mass of detail: flowers, birds and fruits fill the foreground, and a heavily laden cart sets off to market. The picture is a true celebration of rural life as Rubens saw it towards the end of his life when he could relax and enjoy it. The figure with the gun in the foreground could even be a self-portrait.

PETER PAUL RUBENS
Siegen 1577 — Antwerp 1640
The Château de Steen (1635)
Oil on oak panel; 78 × 92 in (137 × 234 cm).
Rubens bought the castle and lands (between Brussels and Malines) depicted in this painting in May, 1635 as a summer residence. Presented by the Sir George Beaumont Gift to the Gallery in 1823–28.

JAN VERMEER. *A Young Woman Seated at a Virginal.*

This painting and its companion, *A Young Woman Standing at a Virginal* (not illustrated here), are generally dated at around 1671, towards the end of the artist's brief career. They represent the consolidation of past achievements rather than the inspiration and innovations of many of Vermeer's earlier masterpieces. In both paintings the composition is unsatisfactory, since the figure is crowded in by other objects in the picture, and the relationship of the spectator to the picture as a whole is ambiguous. Nevertheless, the essential values of Vermeer's style are present: every element has a full three-dimensional form, the lyric quality of the light is sustained, and a mundane interior has been made into something sublime.

In this picture, the painting hanging on the wall in the background, which also appears in *The Concert* in the Gardner Collection, Boston, is *The*

JAN VERMEER
Delft 1632 — Delft 1675
A Young Woman Seated at a Virginal
Oil on canvas; 20¼ × 17¾ in (51.5 × 45.4 cm).
George Salting Bequest, 1910.

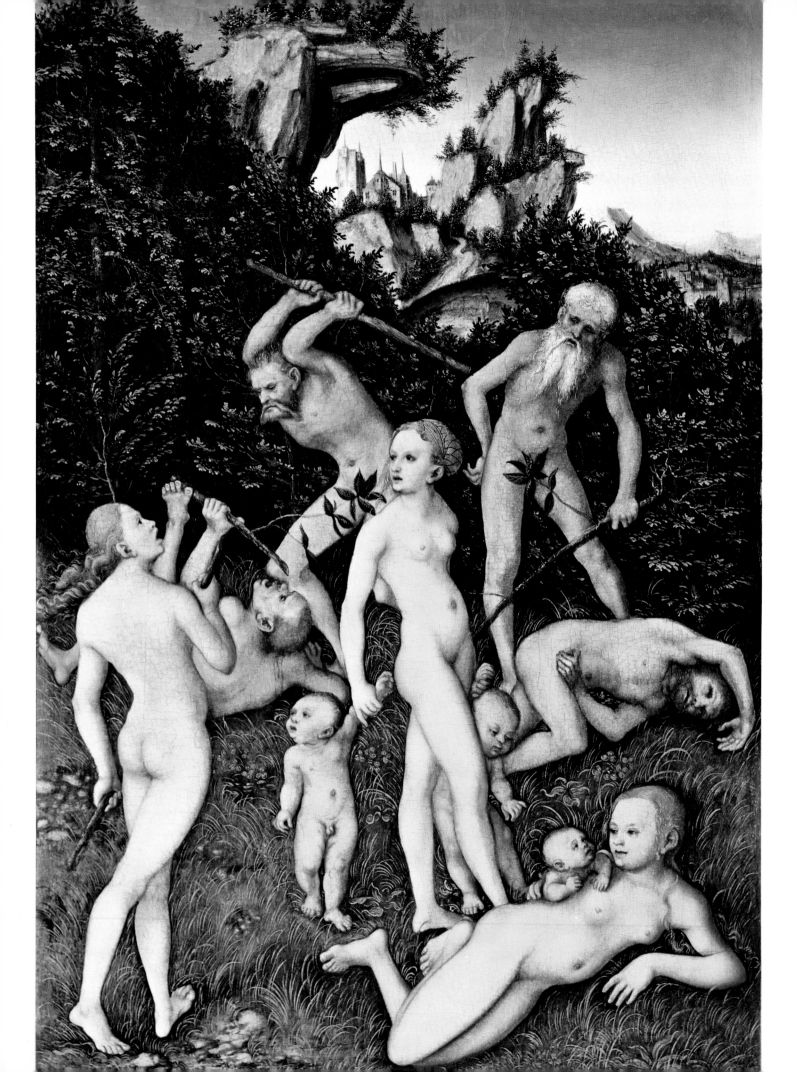

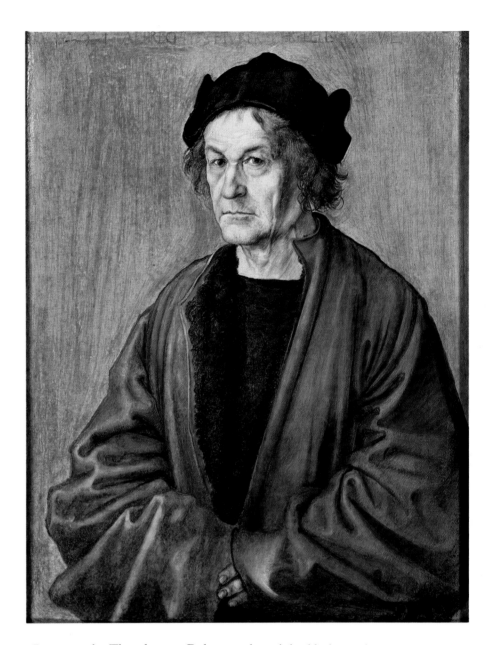

Procuress by Theodor van Baburen; the original belonged to Vermeer. The virginal (a musical instrument popular in the 17th century), is very similar to the one represented in *A Young Woman Standing at a Virginal*, but there are some differences in the landscape painted on the lid. The instrument has been identified as one produced by the Ruckers factory in Antwerp. Iconographically, the player derives from a popular type of St. Cecilia which had been adapted for portraiture by Dirk Hals and Jan Miense Molenaer.

LUCAS CRANACH THE ELDER. *Jealousy.*
In this magnificent painting, hooked rocks of impossible shape, pointed crockets and thorny scrub create an audacious landscape against the clear sky above. The foreground is limited by the screen of dark foliage, enlivened by golden glints, which forms a finely worked tapestry. Arranged **101**

in various attitudes and positions, the little nudes also make a pattern of contrasting rhythms and sinuous cadences. The figures rotating around the woman in the center create an intricate but controlled composition whose movement is underscored by the positions of the clubs. Cranach's qualities are so individual that it is often difficult to discover a specific mythological subject in his work.

Two other versions of this painting are still in existence and are housed in the museums of Weimar and Augsburg.

ALBRECHT DÜRER. *The Painter's Father.* *p. 101*

Today this painting is generally accepted as the oldest and best of several versions of the same subject, the artist's father. Not all critics, however, agree that the artist was Dürer as all but the head and face is not of the same quality that is usually associated with this great artist.

Dürer's father, a goldsmith, was born in Hungary but settled in the free city of Nuremberg. While still a boy, young Albrecht was apprenticed to the painter Michael Wolgemut, who had been influenced by Flemish art. Dürer would have been 26 when he painted this portrait, which shows Flemish and Italian influence in the pyramidal composition, the balance of the masses around a central core and the architectonic relationship of arms, body, shoulders and head. In this imperiously simple and imposing structure, the artist has subtly incorporated asymmetrical passages and unexpected changes of direction that animate the otherwise static figure. These details are most evident in the bony development of the head, the wrinkles and the serpentine locks.

HANS HOLBEIN THE YOUNGER.

Jean de Dinteville and Georges de Selve ("The Ambassadors").

Jean de Dinteville, French Ambassador to England, is on the left. His friend, Bishop Georges de Selve, on the right, served as ambassador to the Emperor, the city of Venice and the pope. On the lower shelf is a German Protestant hymn book, open to two Lutheran hymns. This unusual element in a painting of two Catholic diplomats is explained by the fact that de Selve sympathized with the Reformation. This large, imposing and somewhat hieratic double portrait is an extraordinary compendium of geometry and perspective in pictorial representation. The geometric pattern of the mosaic pavement, copied from 14th-century Cosmatesque work in Westminster Abbey, defines the plane on which the figures and the shelves stand. Objects of complicated shape — a lute with a broken string, the astronomical and chronological instruments — are depicted with virtuosity. The anamorphic skull, which seems to be an unidentifiable object suspended in space, until viewed from the extreme right of the painting, is a visual game.

There are many theories on the meaning of this picture. The elaborate detail would suggest that these are rich, powerful and learned men. However, the skull and broken lute string probably symbolize death and the transience of human existence.

HANS HOLBEIN THE YOUNGER
Augsburg 1497 — London 1543
*Jean de Dinteville and Georges de Selve
("The Ambassadors")*
Oil and tempera on panel;
81½ × 82½ in (207 × 209.5 cm).
Signed and dated 1533.
Taken to France by de Dinteville, it was sold by
his descendants in 1787 to the dealer J.B.P.
Lebrun. It then entered the collection of the
Earls of Radnor at Longford Castle, and was
bought for the Gallery in 1890.

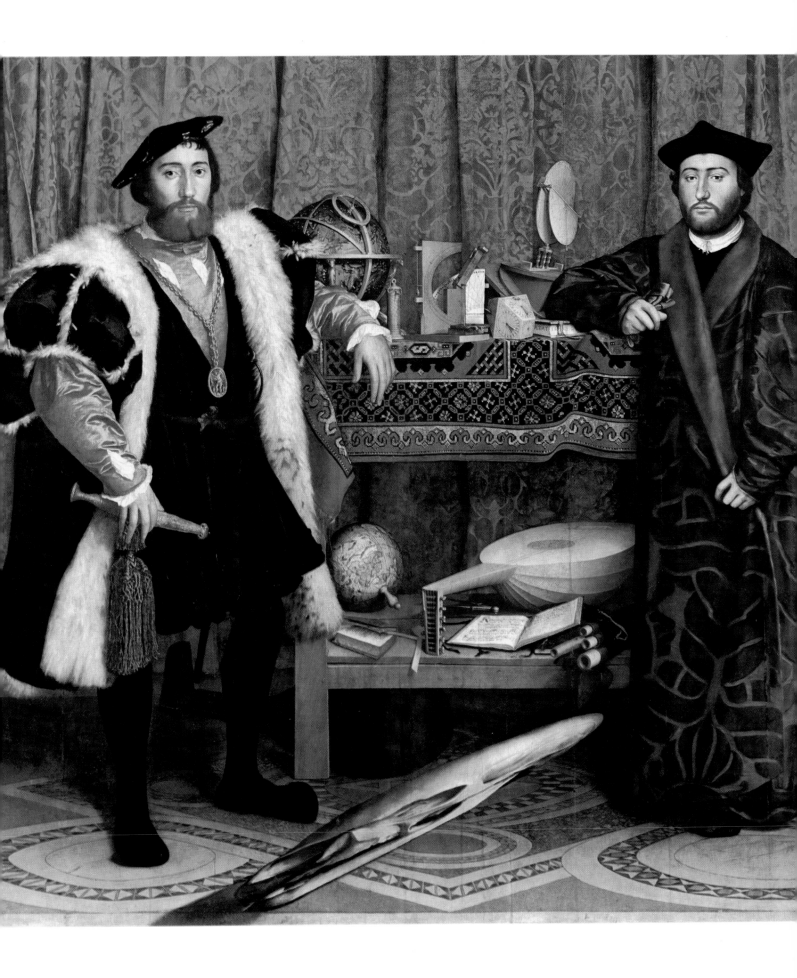

CLAUDE LORRAINE.

Landscape: The Marriage of Isaac and Rebekah ("The Mill").

With its companion piece, *Seaport: The Embarkation of the Queen of Sheba,* this painting was executed by Claude in 1648. Other versions are in the National Museum in Budapest and in the Doria Pamphili collection, Rome. As with Claude's other works, the composition follows a very simple scheme. Like the sweep of a compass, the movement swings from the "wing" of trees on the right to the opposite grove. From the waterfall and the distant bridge, two new directions of movements are created which involve the entire luminous spread of the horizon. The figures do not hamper the recession of the space, from the broad shaded foreground to the infinite sea of noonday light.

CLAUDE LORRAINE
Champagne 1600 — Rome 1682
Landscape: The Marriage of Isaac and Rebekah ("The Mill")
Oil on canvas; 58¾ × 77½ in (149 × 197 cm).
The title is inscribed on a tree trunk in the center. Signed and dated 1648 below. Commissioned by Camillo Pamphili in 1647, it was sold instead to the Duc de Bouillon, who in turn sold it to Fitzinger. Subsequently it belonged to the Angerstein collection, from which it was acquired by the National Gallery in 1824.

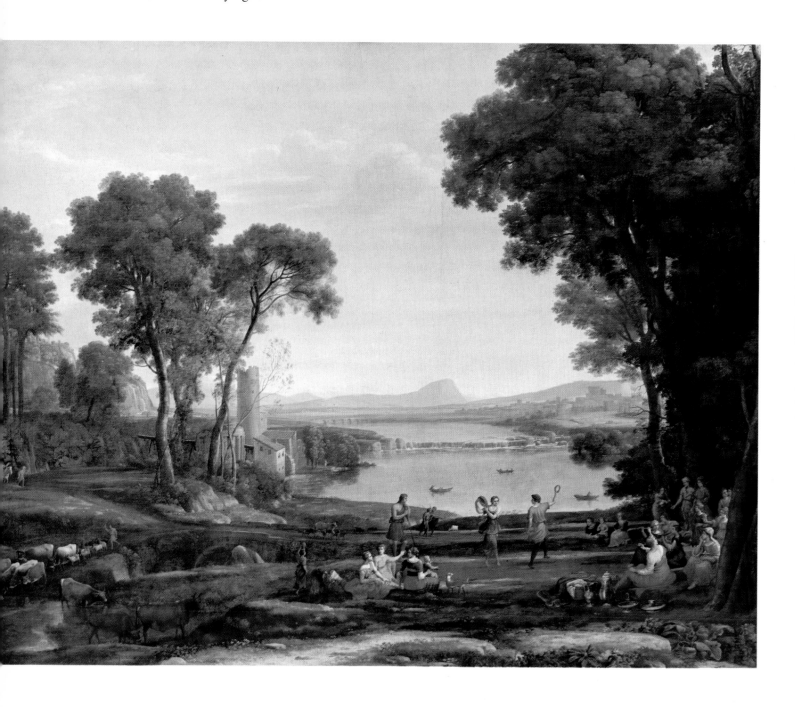

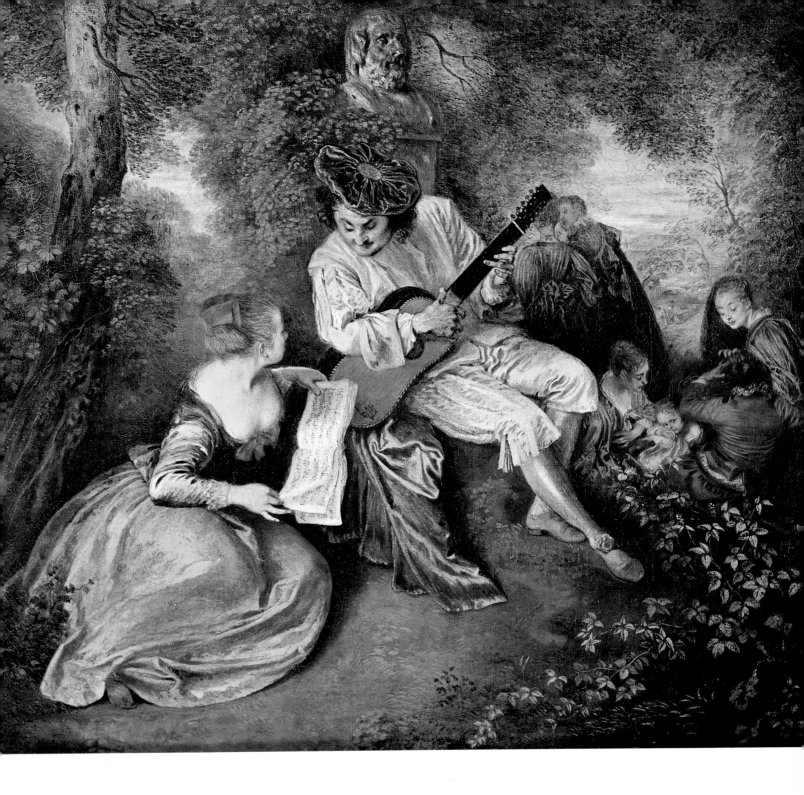

ANTOINE WATTEAU
Valenciennes 1684 — Valenciennes 1721
"La Gamme d'Amour"
(The Gamut of Love) (c. 1717)
Oil on canvas; 20 × 23½ in (51 × 60 cm).
A number of engravings were made from this
painting, and there are many free interpreta-
tions by Pater. Numerous preliminary drawings
exist in various museums and collections. After
leaving the Denys Mariette collection the paint-
ing changed hands frequently before its acqui-
sition by Sir Julius Wernher, who bequeathed it
to the Gallery in 1912.

ANTOINE WATTEAU. *"La Gamme d'Amour" (The Gamut of Love).*
This luminous painting stands out in particular for its composition, which involves multiple movements in depth and on the surface. There is a double recession in depth toward the luminous distance and in the diagonal disposition of the main group. The figures show an alternation — without weight or stability — of forms, carrying the play of color that helps to create the almost phosphorescent atmosphere. Although critics do not agree on the meaning of the figures placed in the hollow among the trees on the right, they are participants in the warm idyllic scenes, benevolently presided over by a pillar with the head of Pan.

105

EDOUARD MANET. *The Waitress ("La Servante de Bocks").*
In 1878 Manet started on a large, ambitious canvas which he subsequently cut in two. The present work was the right-hand part of the larger composition; the left-hand part, *At the Cafe,* is in the Reinhart collection. The original painting had been rather statically balanced, which did not suit the vibrant, discontinuous brushwork and color. The two separate parts of the picture were considerably changed by the artist; they took on the immediacy of snapshots. The model is a waitress from a cafe Manet frequented in the Boulevard Rochechouart, Reichshofen's *Cafe-Concert.* She agreed to pose for the artist in his studio only if she could bring along a chaperon — he appears in the painting as the man smoking a pipe in the foreground.

EUGÈNE DELACROIX. *Portrait of Baron Schwiter.*
In this incredibly sensitive and sympathetic portrait of a fellow painter and friend, Delacroix broke with classical polish and used more intense colors than was customary among his contemporaries. Lawrence may have influenced the general composition and approach. The work apparently looked too unprofessional to be accepted for the 1827 Salon and the Romantic style of painting was opposed to the Classicism popular at the time; after this rejection, Delacroix made some changes, especially on the parapet, and only completed the picture definitively in 1830. According to Moreau, the landscape was in part painted by Paul Huet, who had been Delacroix's fellow student in the studio of Guèrin. A well-known landscape painter, Huet was a follower of the English landscapists, Bonington and Constable. The subject, Baron Louis Auguste Schwiter, who would have been only 21 when this portrait was painted, was himself a landscape and portrait painter; thus the portrait was probably not a commissioned work but a mark of the life-long friendship between the two men. So strong was the friendship, in fact, that Delacroix named Schwiter as one of the people he wished to take charge of and classify his paintings after his death. He also bequeathed him a number of paintings by Watteau and Chardin.

EUGENE DELACROIX
Charenton-Saint-Maurice 1798 — Paris 1863
Portrait of Baron Schwiter
Oil on canvas; 85¼ × 56¼ in (218 × 143 cm).

106

PAUL CÉZANNE. *Bathers.* p. 108
In the last ten years of his life Cézanne painted three large versions of this subject. The other two, which are bigger, are now in the Barnes Foundation at Merion, Pennsylvania, and in the Philadelphia Museum. Alterations in the dimensions and in the color show that this canvas was probably painted after the Philadelphia version. The conclusion is borne out also by the unity and compactness of the figures, which are as simplified and reduced to essentials as Cycladic idols. They are gripped in the powerful framework made by the violent color and intense light of their "natural" setting. Cézanne went over the work again and again, creating a thick crust of paint; nevertheless, every brushstroke is essential.
This is one of the most "abstract" of Cézanne's paintings. Severe yet sensual, it epitomizes the simple solidity of the female bodies and the burning color of the Mediterranean light. Apparently, Cézanne was unable

to find a nude model in Provence and was unwilling to scandalize the neighborhood by painting nudes from the life; so for his pictures of bathers he used studies of nudes which he had made many years earlier while still a young man. In spite of this the figures of the women remain very distorted. This painting combines the wild romanticism and the patient research in composition and color that coexist in all of the artist's work.

PAUL CÉZANNE
Aix-en-Provence 1839 — Aix-en-Provence 1906
Bathers
Oil on canvas; 50 × 77¼ in (127.2 × 196.1 cm).
Bought in 1964 from the collection of Mme.
Lecomte, daughter of Auguste Pellerin.

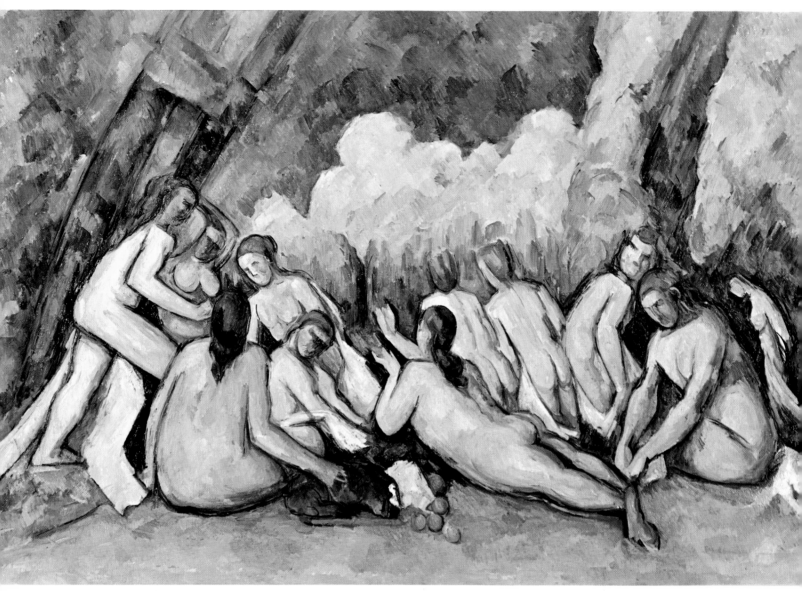

AUGUSTE RENOIR. *Dancer With Tambourine* and *Dancer With Castanets.* Typical of the artist's late works, these two canvases were painted in the summer of 1909 for Maurice Cangnat's dining room in Paris. They were placed at sides of a mantelpiece surmounted by a large antique mirror, as though they were caryatids. The head of the *Dancer With Castanets* is a portrait of Renoir's favorite model, Gabrielle Renard, who was the cousin and nurse of his son Jean. The model for the two bodies and the face of the *Dancer With Tambourine* was Mme. Georgette Pigeot, a dressmaker and friend of the family. Renoir's joy in life and color is fully expressed here, unhampered by the crippling infirmity of his hands at this period of his life.

AUGUSTE RENOIR
Limoges 1841 — Cagnes 1919
Dancer With Tambourine and
Dancer With Castanets
Oil on canvas; each 61 × 25½ in (155 × 64.8 cm).
Signed and dated: "Renoir 09."
Acquired from Philippe Cangnat in 1961.

EL GRECO. *Christ Driving the Traders from the Temple.*
The inventory of the artist's goods compiled after his death lists four versions of this subject. Numerous replicas, variants and copies also attest to the popularity of the composition. An earlier version, painted before El Greco's arrival in Toledo in 1577, includes portraits of Michelangelo, Titian and Raphael. The artist was greatly influenced by contemporary Italian painters: Michelangelo and Tintoretto inspired the poses of almost all the

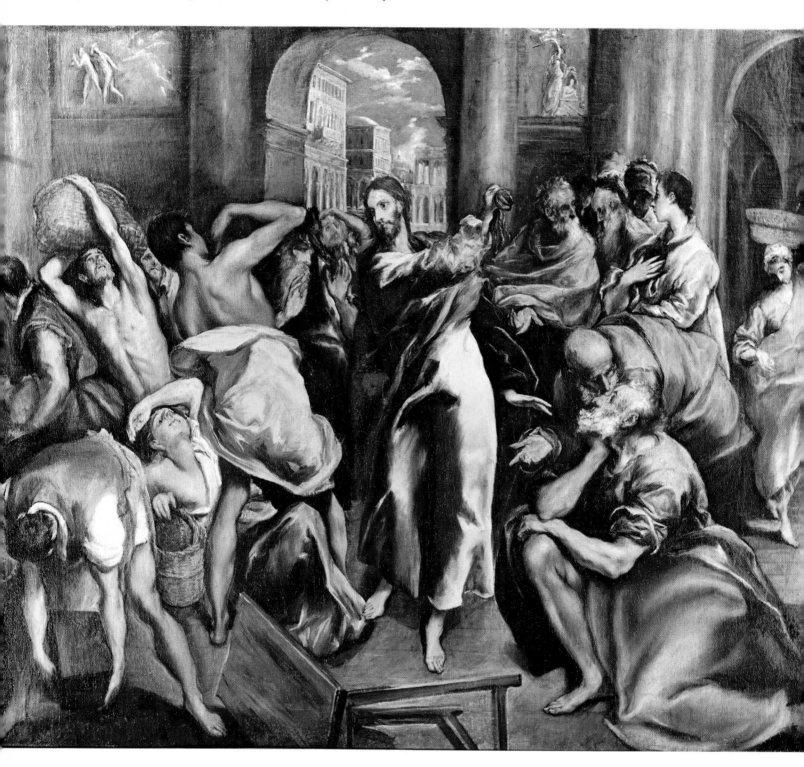

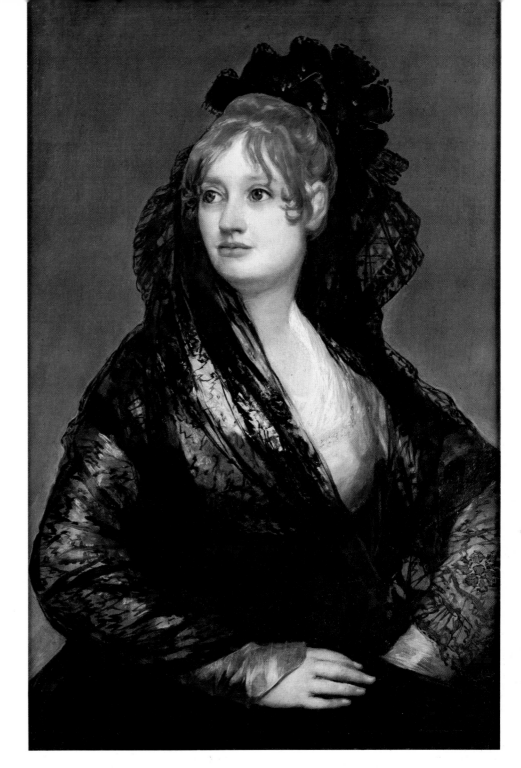

FRANCISCO DE GOYA
Fuendetodos 1746 — Bordeaux 1828
Doña Isabel Cobos de Porcel
Oil on canvas; 32¼ × 21½ in (82 × 54.6 cm).
In the family of the sitter until 1887, it was sold
to Don Isidoro Urzaiz; acquired by the National
Gallery from Urzaiz heirs in 1896.

EL GRECO
(DOMENICO THEOTOKOPOULOS)
Crete 1541 — Toledo 1614
Christ Driving the Traders from the Temple
Oil on canvas; 41¾ × 51 in (106.3 × 129.7 cm).
Sir J.C. Robinson presented the painting to the
Gallery in 1895.

figures in the painting, however, the artist's own portrayal of them was highly individual. The perspective of the background recalls Palladio and Veronese, and the organization of the whole composition shows an assimilation of Italian High Renaissance devices. The spiraling torsion of the figure of Christ starts the agitated gesticulating movement, which turns on an axis placed left of center. The groups are set into a radiating fan-shaped system of movements. But the architectonic solidity of the Italian tradition is transformed by the flickering of El Greco's light and color. This new insubstantial character creates the excitement and visionary aspect of his work.

111

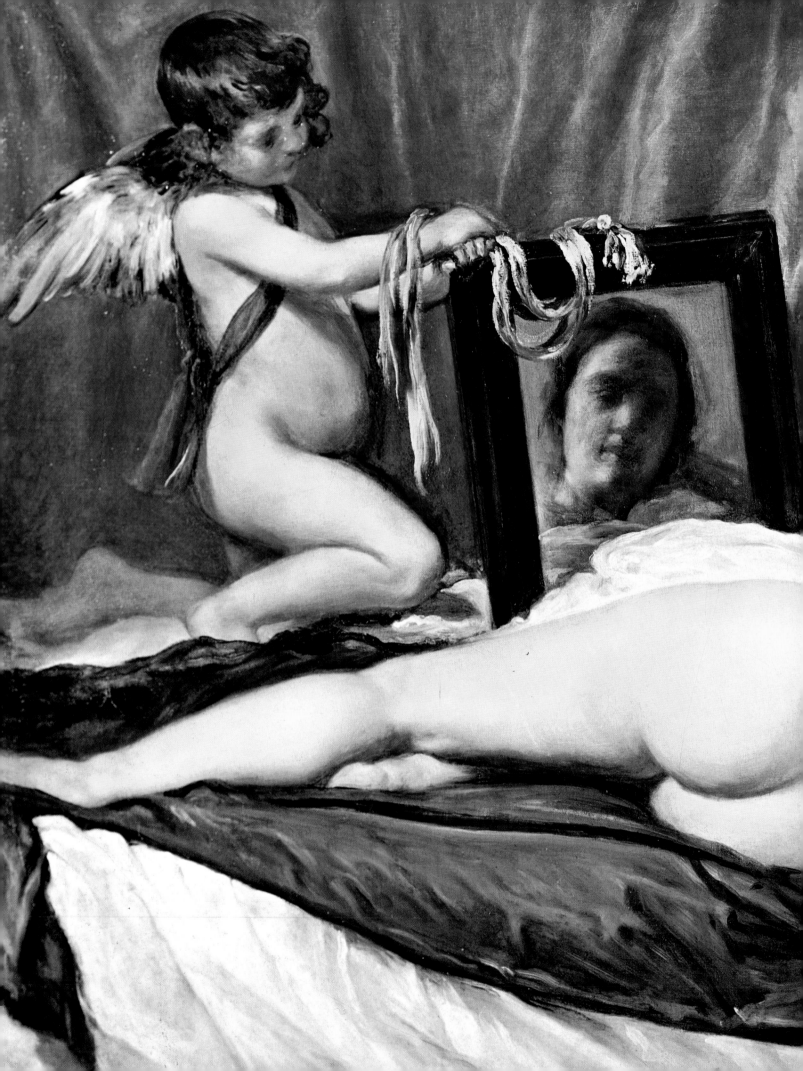

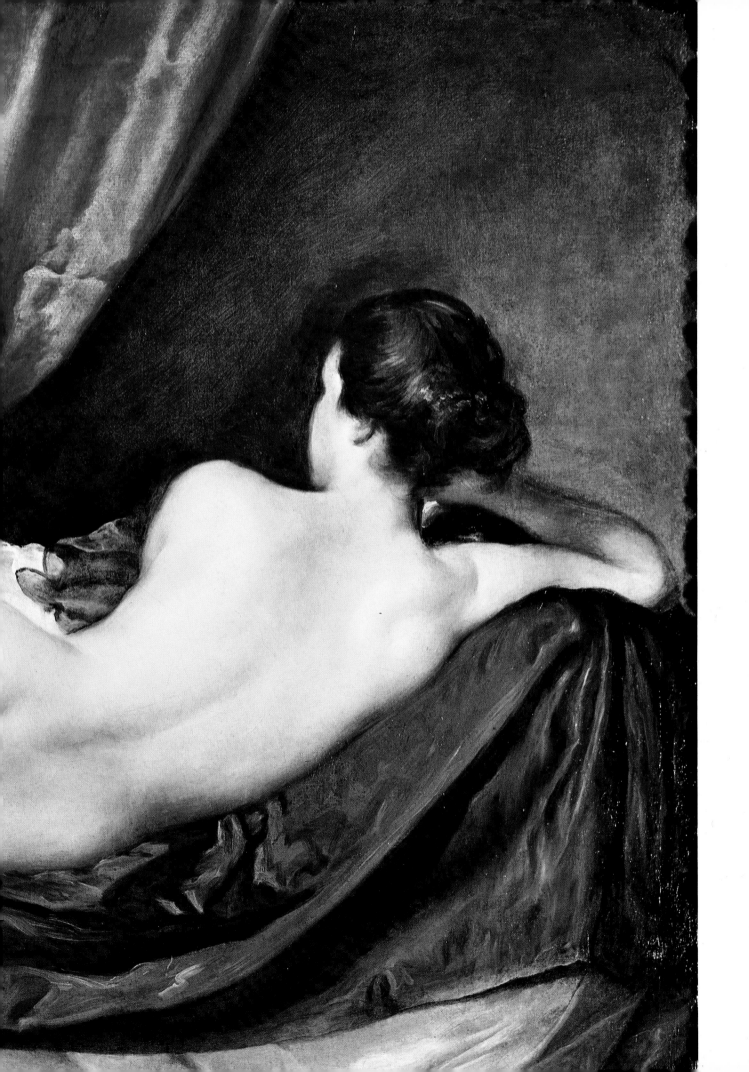

FRANCISCO DE GOYA. *Doña Isabel Cobos de Porcel.* *p. 111*

This work is usually dated 1806, as this is the year inscribed on the portrait of the subject's husband, Don Antonio Porcel (now in the Jockey Club, Buenos Aires). But that painting is not a companion to this one, and was probably executed a few years earlier. The blond Castilian is dressed in the folk costume of the *Maja*, and has been posed in a self-assured way that emphasizes her imperious beauty. The composition is a rhomboid, diagonally divided by the black lace mantilla. Beneath the lace are seen the fiery glints of her red silk dress. In this celebration of surging vitality, Goya harks back to Titian and Velázquez for his expressive means. This portrait belongs with the series of queenly figures in modern Western art that represent the Romantic idea of the "eternally feminine."

DIEGO VELAZQUEZ.

The Toilet of Venus ("The Rokeby Venus"). *pp. 112–13*

Although the painting of nudes was not encouraged in Counter-Reformation Spain, Velázquez did at least four other such pictures that have not survived. Critics debate whether this work was painted before, during or after the artist's second visit to Italy in 1648–51. The influences he acquired at that time do not necessarily have a bearing on the painting since, apart from the theme and the presence of the winged cupid, it is not derived from classical idealism. It shows instead a spontaneous participation in human life and experience, with no sacred or scholarly references. The point of view is detached and meticulously observant. In composition, the curve of the slim youthful body is echoed in the bed clothes and the curtain. These movements are countered by the figure of the cupid and by the mirror which reflects the secret image of Venus' face. On closer examination it is possible to see that the reflection in the mirror is, in fact, unreal as, held at such an angle it would not reflect the face of Venus but probably just a part of her head. Color and tone subtly record every change in contour and texture, creating a sensitively vibrant picture.

WILLIAM HOGARTH. *The Shrimp Girl.*

A central figure in English art, Hogarth is best known for his moralizing and satirical outlook. With a mass public for his engravings, he was also in demand as a portrait painter of the prosperous middle class. He was Court Painter and a supporter of Parliament's program to reform morals. Hogarth was self-taught, at first following the examples of Jan Steen and Flemish genre painting, then looking toward such diverse painters as Rubens, Chardin and Rembrandt. This portrait is exceptionally impressive and immediate in its effect. The broad brushwork looks as if it had just been laid down and the paint appears still wet. The elementary strength of Hogarth's range of greens and reds emphasizes the vigor of a style in which the simplicity achieved is a mature interpretation of imagination.

On pages 112–13:
DIEGO VELAZQUEZ
Seville 1599 — Madrid 1660
The Toilet of Venus ("The Rokeby Venus")
Oil on canvas; 48¼ × 69¾ in (122.5 × 177 cm). Considerable repainting has been done, some of which covers the cuts made by a suffragette in 1914. In 1651 it belonged to Don Gaspar Méndez de Haro, Marqués del Carpio, who may have commissioned it. Acquired by the Gallery from Thomas Agnew in 1906.

WILLIAM HOGARTH
London 1697 — London 1764
The Shrimp Girl
Oil on canvas; 25 × 20¾ in (63.5 × 52.5 cm). Probably executed as the model for an engraving around 1740, it was inherited by Mary Lewis from the artist's widow. Bought by the National Gallery at the Sir Philip Miles sale.

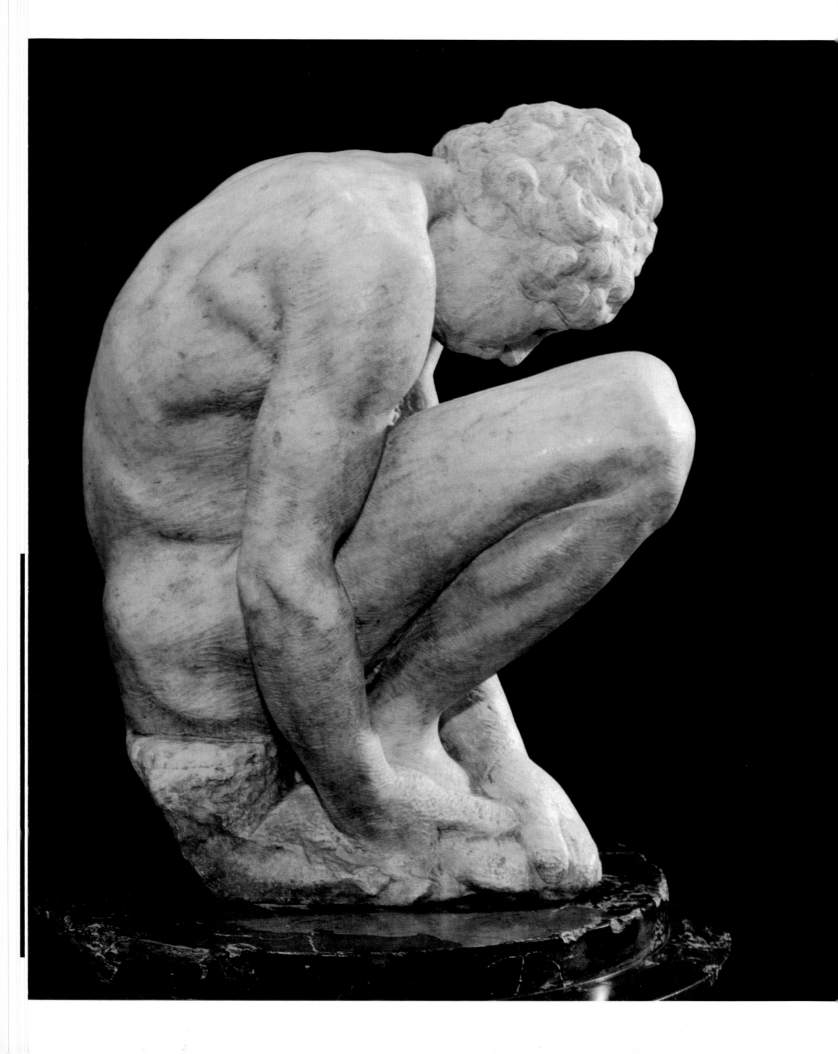

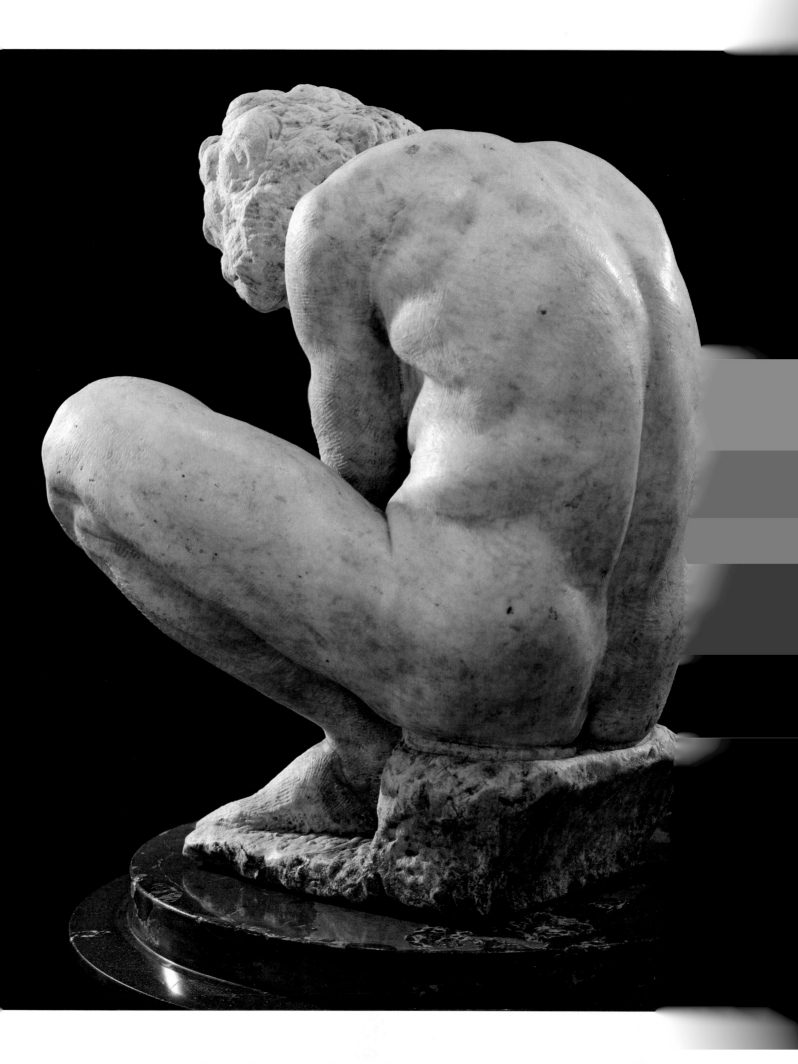

Perseus stands victor over the dead body of Medusa, holding her severed head in his left hand.

The bronze in the Hermitage gives an exact idea of the statue. But rather than being actually based on the monumental statue, it is more probably a replica of the bronze model by Cellini now in the National Museum of Florence. The superb craftmanship of the Hermitage bronze also seems to confirm that it is itself the work of Cellini. However, its base, decorated with the figures of Jupiter, Mercury, Athene and Danaë with the young Perseus, although an exact copy of the pedestal beneath the statue on the Loggia dei Lanzi, was obviously made at a much later date.

BENVENUTO CELLINI (?)
Florence 1500 — Florence 1571
Perseus
(mid 16th century)
Bronze; height (with pedestal) 35⅞ in (91 cm);
height of figure alone 22⅝ in (57.5 cm).

RAPHAEL. *Madonna and Child (Conestabile Madonna).*
The *Conestabile Madonna* is one of Raphael's earliest works, painted about 1502. The composition was suggested by a drawing by Raphael's teacher, Perugino, depicting the *Madonna and Child holding a Pomegranate.* In 1881, when the painting was transferred from wood to canvas, it was discovered that in the original version, Mary was holding a pomegranate out to the child. As he worked, the young artist changed his mind, without however modifying the final meaning of the painting in any way.

Countering the circular form of the tondo, which called for a deep understanding of composition, Raphael brilliantly resolved the problem. The curve of the frame harmonizes with the gentle contours of the mantle covering the Madonna's head and shoulders. The traditional theme is treated simply and poetically. The spring landscape echoes the pure and feminine visage of the Madonna.

Before its transfer onto canvas, the wooden base and its gilded frame — no doubt also made by Raphael himself — were still all in one piece. The intricate, heavy carving of the frame beautifully sets off the delicate miniature painting.

The picture retains the typical Quattrocento tendency to narrative — details such as the boat crossing the lake, and the buildings on the shore are carefully done. Yet at the same time the crystal clarity of the forms and of the composition, and the beauty of line in this early work portend the future founder of the monumental style of the Roman school of painting.

CARAVAGGIO. *The Lute Player.* *p. 130*
"He also made a painting of a youth playing a lute which was quite well drawn from nature; in it is a carafe of flowers filled with water in which one can easily distinguish the reflections of a window and other objects in the room. On the flowers is fresh dew which is rendered with exquisite accuracy. And this, he said, was the most beautiful painting he ever made." (Giovanni Baglione, translated by Walter Friedlaender, *Caravaggio Studies,* Princeton, New Jersey, 1955).

RAPHAEL
Urbino 1483 — Rome 1520
Madonna and Child (Conestabile Madonna)
Tempera on canvas, transferred from wood;
6⅞ × 7⅛ in (17.5 × 18 cm).

Although this is a picture of a youth singing to the accompaniment of a lute, it is not, like the artist's earlier works, a genre painting. Although it treats the same idea of love and harmony, linked with poetry, the approach is realistic. The youth, who was probably one of the young artist's friends, together with the objects surrounding him, is depicted just as the artist sees him, following his principle of art reflecting nature as if in a mirror. Caravaggio was particularly fond of still-life. In one of the music books is copied the beginning of a popular 16th-century madrigal "*Voi sapete ch'io v'amo*" (You know I love you).

129

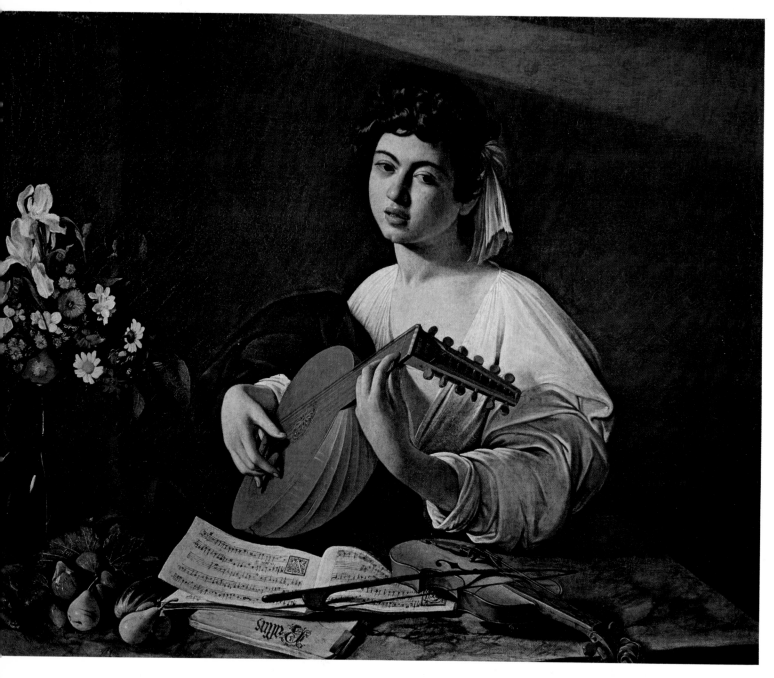

The Lute Player is probably the first work by the artist in which he makes full use of light and shade, a technique which was to become his speciality. Commissioned by Cardinal Franceso Maria del Monte — in whose house he was living at the time — the picture subsequently entered the Marquis Giustiniani's collection, where it remained until the collection was sold at a Paris auction in 1808. With the help of Vivant Denon, director of the Louvre, the picture was purchased at this auction for the Hermitage.

CARAVAGGIO
Caravaggio 1573 — Porto 'Ercole 1610
The Lute Player
Oil on canvas; 37 × 46⅞ in (94 × 119 cm).

CANALETTO. *Arrival of the French Ambassador in Venice.*

Views showing Venice, Rome and London, which Canaletto was the first to paint, were in great demand all over Europe. *The Arrival of the French Ambassador in Venice* and its sister picture *The Departure of the Venetian Doge from the Ceremony of the Blessing of the Adriatic Sea* (Pushkin Museum, Moscow) stand out as two of Canaletto's greatest works.

With his characteristic eye for topographical detail, Canaletto depicts the center of Venice with the Doge's Palace, the Piazzetta, the San Marco Library, the Church of Santa Maria della Salute. A master of composition, drawing, color, the artist depicts the very texture of the air, the horizon shrouded in damp mist, the sky stretching into infinity, the rippling water. With acute sensitivity he observed the transparent shadows cast by the clouds on the palace wall and reflections from the water penetrating the darkness beneath the arch of the bridge.

The canvas shows the ceremonial reception of the French Ambassador Jacques Vincent Languet, Comte de Jersey, on November 4, 1726. Judging by its style, it would seem likely that the picture was painted a little later than this date.

CANALETTO
Venice 1697 — Venice 1768
Arrival of the French Ambassador in Venice
Oil on canvas; 71¼ × 102⅛ in (181 × 259 cm).

131

ROGIER VAN DER WEYDEN. *Saint Luke Drawing the Virgin.*
The subject of this painting is the apocryphal legend about the Apostle Luke
drawing a miraculous portrait of the Virgin when she appeared to him in a
vision. In the 14th and 15th centuries, St. Luke was considered the patron
saint of artists, and numerous painters' studios and guilds were named after
him. It is an established fact that Rogier van der Weyden painted an altar-
piece called *St. Luke Drawing the Virgin* for the chapel of the painters' guild
in Brussels. The picture was very popular in the 15th century, and many
versions were produced, the best of which are now to be found in the Boston
Museum, in Bruges, in Munich, and in Leningrad. The Boston picture is

132

ROGIER VAN DER WEYDEN
Tournai 1399 — Brussels 1464
Saint Luke Drawing the Virgin
Oil on canvas, transferred from wood;
40⅛ × 42¾ in (102 × 108.5 cm).

considered by many to be the original; however it seems highly probable that they are all copies, and that the original has not survived.

St. Luke is depicted in early 15th-century costume, it could well be that his figure is actually a portrait of van der Weyden himself. He was wonderfully captured the inspiration of the artist at work. Rogier van der Weyden, like most artists of the Netherlands, worked in oils, using the techniques first introduced by van Eyck. He uses bright colors to reproduce the richness of the materials and the golden embroidery. Precious stones gleam around the hem of the Virgin's dress — rubies and sapphires, casting little aureoles of red and blue light.

In the background, beyond the turreted wall of the hanging garden, a vast landscape sweeps off into the distance. The river winds its way, lapping at sandy banks. On rising ground lies a large town crammed with tiny houses, winding streets, and numerous people moving around, providing a view of the daily life of a medieval town.

PETER PAUL RUBENS
Siegen 1577 — Antwerp 1640
Landscape with a Rainbow (1632–35)
Oil on canvas, transferred from wood;
33⅞ × 51³⁄₁₆ in (86 × 130 cm).

PETER PAUL RUBENS. *Landscape with a Rainbow.* *p. 133*

In the 1630s Rubens' landscape painting was at its height of perfection. *Landscape with a Rainbow* in the Hermitage, painted between 1632 and 1635, is one of the most notable works of the artist from that period. Rubens has chosen a rare moment in nature. A storm has just blown over and in the distance, caught in the rays of the sun, the heavens are illumined by an enormous rainbow, which seems to enclose the buildings and the landscape in the background. In the foreground is seen a rural idyll — young lovers listen to a shepherd playing a pipe while sheep graze peacefully around them. The *Landscape with a Rainbow* could be considered the rural counterpart to Rubens' gallant picture of *The Garden of Love* (Prado Museum, Madrid, and the Rothschild Collection, England), with just one difference; in one case the characters are beautifully dressed cavaliers and ladies, while in the other they are shepherds and shepherdesses.

Landscape with a Rainbow differs from Rubens' landscapes of the preceding decade, which were typically charged with electric vitality. Here, the painting is enveloped in a spirit of harmony, a well-balanced composition following the basic rules of design, reflecting Rubens' study of the classical works of the Italian Renaissance, in particular of the Venetians, especially Titian. In the works of these masters can be traced prototypes of the overall composition and individual motifs in this canvas. However, the heightened luminous effects, the intermittent patches of light and shade, the dynamic color lend a tension to the picture that is not found in the classical works of the Renaissance.

REMBRANDT VAN RIJN. *Descent from the Cross.*

REMBRANDT VAN RIJN
Leyden 1606 — Amsterdam 1669
Descent from the Cross
Oil on canvas; 62¼ × 46 in (158 × 117 cm).
Signed and dated, bottom center:
"Rembrandt f. 1634."

Rembrandt's depiction of the tragic gospel story is amazingly lifelike. Christ's death has plunged the characters into profound agony. Mary, his mother, has lost consciousness, the women are sobbing, the men suffer in silence.

The face of Joseph of Arimathea, one of Christ's most faithful disciples, is particularly expressive — in it we read a mixture of physical tension and spiritual torment. The action takes place at night by torch and candlelight. Three sources of light, each of differing strength, break through the darkness to illuminate the three main groups. Rembrandt's use of light to draw together and unite a composition of many different figures, together with his depiction of the feelings and expressions of each individual are his supreme achievement.

The picture in the Hermitage was Rembrandt's second on this theme. The first version, which is dated 1633 and now housed in the Alte Pinakothek, Munich, was part of the series of *Passions* painted for the Stadholder of the Netherlands. The picture was favorably recieved by its high-ranking purchaser; but it seems that the artist was not satisfied with his work, for a year later he painted another, the version which now hangs in the Hermitage. This one was more successful — at least Rembrandt thought so — and it remained in his house until 1656. In it Rembrandt managed to express that "elevated and truly natural flow of movement" which he talks about in one of his letters and by which he means not so much exterior expression as that of the inner soul.

134

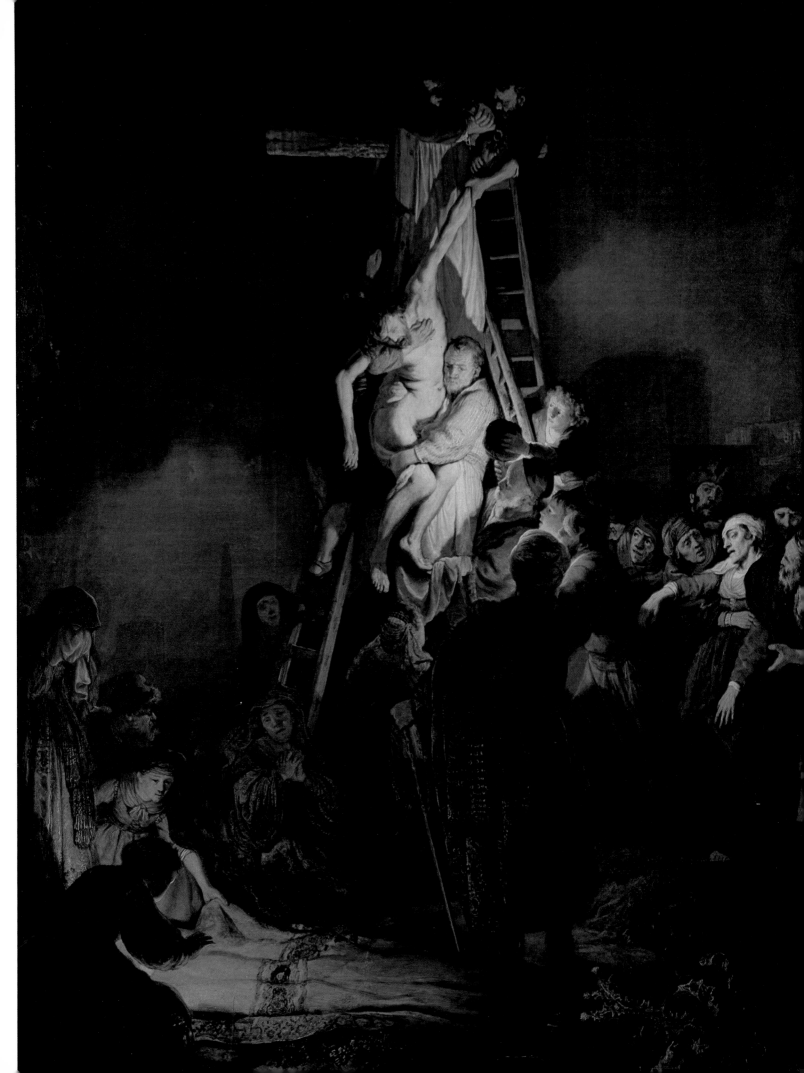

GERARD TER BORCH
Zwolle 1617 — Deventer 1681
A Glass of Lemonade (1663–64)
Oil on canvas, transferred from wood;
26⅜ × 21¼ in (67 × 54 cm).

GERARD TER BORCH. *A Glass of Lemonade.*

In the works of Ter Borch, Dutch genre painting reaches its classic expression. His bare interiors, sparsely peopled subjects who always blend in with their surroundings, became the model both for his contemporaries and for subsequent generations of artists. Ter Borch and other artists in his circle defined the course of Dutch art throughout the second half of the 17th century. Their art doubtlessly reflects the changes in the tenor of life and the tastes of the aristocratic Dutch elite.

A Glass of Lemonade is one of Ter Borch's best and most famous works, and is a real masterpiece of Dutch painting. The artist's mastery —; his superb draughtmanship and feeling for the finest shades of color, is manifest in his portrayal not only of silk and velvet, but also of glass and metal, fur and wood. With the same inimitable style he uncovers the inner, intimate world of his characters. Not until Ter Borch did genre painting become capable of expressing the most complex, barely perceptible human emotions.

VINCENT VAN GOGH.

Memory of the Garden at Etten (Ladies of Arles).

In this picture — painted in 1888 when van Gogh and Gauguin were living together at Arles — van Gogh borrowed Gauguin's motif in *Ladies of the Garden* (Chicago Art Institute) of a winding, narrow road as a background to his painting of two Arles ladies, who appear in the lower left-hand side of the composition. Nevertheless, the pictures, despite their common

elements, are very different. While the path in Gauguin's picture cuts past a gate in the foreground in a straight line between small pyramid-shaped bushes, van Gogh's path leading from the Arles Hospital is like a tumultuous river, and his cypresses like tongues of fire. The traditional distinction between figures and background disappears in this picture, where everything merges in the same restless rhythm, and behind the "flaming gothic" in which there is a tension of violent emotion pushed to the extreme. As if to counteract Gauguin's evenly applied color, van Gogh gives an excessive texture to his paint surface, loading the canvas to the point where it has become one of the most difficult works to preserve.

Memory of the Garden at Etten also reflects the impressions left on van Gogh by Seurat's and Signac's pictures. However, this work, rather than confirming their technique of juxtaposing small dots of contrasting and complementary colors, actually refutes the canons of Neo-Impressionism, inasmuch as van Gogh does not use it for optical mixtures, but rather to energize the color to an extreme degree.

VINCENT VAN GOGH
Groot Zundert 1853 — Auvers-sur-Oise 1890
Memory of the Garden at Etten (Ladies of Arles),
(1888)
Oil on canvas; 29⅛ × 36⁹⁄₁₆ in (74 × 93 cm).
This canvas, which the artist kept for his bedroom, was not painted from life but was inspired by memories of the Arles hospital garden, as well as his parents' garden in his home town of Etten.

EUGENE DELACROIX. *Lion Hunt in Morocco.*

This picture is one of the most important in the series of hunting pictures which Delacroix painted in his later years. The artist concentrates on the dynamism and expressiveness of pose and gesture rather than accuracy of drawing and form. The excitement of the lion hunt is conveyed to us through sharply contrasted colors, and through the uneven, free and generous brush strokes. Despite the fact that the picture is not based on an actual impression but on the artist's creative imagination, and despite the fact that the rules of proportion and perspective have been cast aside, the figures of the hunters are full of life and vitality.

An entry in Delacroix's diary would seem to refer to this picture. On April 23, 1854, the artist wrote: "The study I made of the trees along my road has helped me to return to the picture of the *Lion Hunters*, which in my bad frame of mind yesterday I had got into an unfortunate state, although it had

EUGÈNE DELACROIX
Charenton-Saint-Maurice 1798 — Paris 1863
Lion Hunt in Morocco
Oil on canvas; 29⅛ × 36¼ in (74 × 92 cm).
Signed and dated lower right:
"*Eug. Delacroix 1854.*"

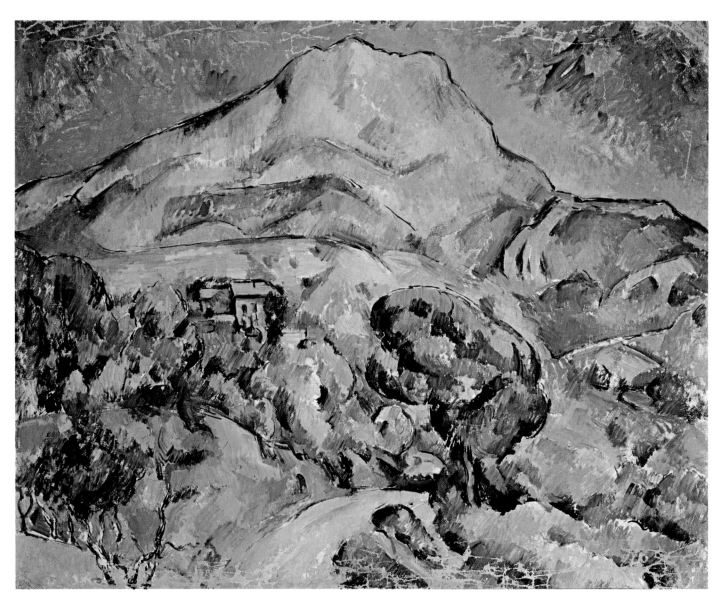

PAUL CÉZANNE
Aix-en-Provence 1839 — Aix-en-Provence 1906
Mont Sainte-Victoire (1896–98)
Oil on canvas; 30¾ × 15¾ in (78 × 99 cm).
Experts on Cézanne are not all in agreement on
the date of this canvas, but most concur with
Rewald on the date 1896–98. Later, around 1904,
Cézanne painted another view of Mont Sainte-
Victoire (now in the Cleveland Museum of Art),
in the foreground of which are some umbrella
pines and the road to Toulon.

been going well the day before. I was seized with inspired rage, like the other day when I reworked the *Clorinde*, not that there were changes to be made, but the picture had gotten into that languishing and dull state which simply points a finger at lack of ardor in working. I feel sorry for the people who work tranquilly and coldly."

Finally on June 22 of that same year, the painter noted: "I have finished the canvases of *The Arab on the Lookout for a Lion*, and *Women at the Fountain*." Although Delacroix gave various titles to his works, the former of these titles is probably a reference to the same canvas, date 1854, which is today in the Hermitage.

PAUL CÉZANNE. *Mont Sainte-Victoire.*
There is no theme that Cézanne loved more than Mont Sainte-Victoire, which he saw out of his studio window and painted again and again. For him

this mountain stood for all the magnificence, simplicity and indestructibility of nature. Cézanne's habit of working "around the motif" very often meant working around the Mont Sainte-Victoire; in contrast to the Impressionists, he always sought definitive form.

In the picture exhibited in the Hermitage, Mont Sainte-Victoire is such a dominating element that all the rest of the landscape is subordinate, yielding to the rhythms which it imposes. Cézanne does not sacrifice his picture to optical exactness. Both the linear and atmospheric rules of perspective are broken — the mountain is too much in relief and excessively close to the observer. Yet even with such proximity, many details are omitted. The modeling of the mountain itself becomes the plastic theme of the picture.

EDGAR DEGAS. *After the Bath.*

The woman in this picture is in a pose quite often used by Degas. (Apart from various paintings, he also produced a bronze version in 1896–1911). This picture was painted around 1895. The preparatory study, now in the Georges Viaud collection in Paris, still has traces of the original horizontal and vertical lines on it corresponding to those seen here. However, as the work proceeded, he added two more lines, one at the right and one above. Moreover, the study lacks the richly colored background. The colors of the Hermitage picture are bold and original. The emphasis is placed on such details as the red hair against the yellow-ocher background, the relationship between the ocher tones of the body and the foamy effect of the towel, and the violet-colored armchair.

Degas had no need of mythology as an excuse to portray female nudes, although he did once confess that had he been born earlier, he would have painted Susanna bathing, and not a woman in a bathtub. However, it is not celebrated goddesses or beauties who appear in Degas' work, but rather his own, ordinary contemporaries. Their proportions do not conform to the old pattern, they never pose and so never look elegant in a studied way. Degas wanted to depict them as they were with natural gestures and movements, not emotively charged poses. Whether he portrays dancers or jockeys, laundresses or women at their dressing tables, they are all equally uncomplicated and natural.

PAUL GAUGUIN. *Conversation (Parau Parau).* p. 142

During his first eighteen months on Tahiti, Gauguin painted about fifty canvases, but he considered that only nine of these would be of any interest to the European public as examples of his new direction. The first of these works, which was sent to a Copenhagen exhibition on the 8th of December 1892, was this picture, *Parau Parau*. In a letter to his wife, the artist translated the title as "*Parole, Parole*" (Words, Words), and in a letter to Daniel de Monfreid as "*Conversation, ou les Potins*" (Conversation, or Gossip). There is some confusion whether this was the actual painting sent to Copenhagen, as another later version (1892) exists under the same title.

140

EDGAR DEGAS
Paris 1834 — Paris 1917
After the Bath (c. 1895)
Pastel and gouache on board;
32½ × 28⅜ in (82.5 × 72 cm).
Signed above right: "*degas.*"
The pose of the figure in this pastel is found in a number of works by the artist — besides various versions of the years 1896–1911 there is also a bronze statuette.

This is now in the Whitney Collection, New York. However, the unity of composition, with the attention directed at a group of ordinary, yet rather enigmatic Tahitians, whom the artist tried to portray just as they were, as opposed to the European artists' custom of using exotic Parisian models, leads us to suggest that it was in fact this picture (i.e., the one in the Hermitage), which went to Copenhagen. This opinion is given further credence by the fact that Gauguin himself wrote the titles in Tahitian on his paintings (as he mentioned in his letters to his wife and to Monfreid), and there is some doubt as to whether the handwriting on the later picture is in fact genuine.

But quite apart from the question of whether or not this picture was shown at the exhibition, the artist, trying to make the public interested in the secret hidden in these foreign words, nevertheless created a simple and natural composition, which he obviously copied straight from life. The theme of the picture is not a genre theme, but rather a pictorial representation of the atmosphere and the calm, unhurried way of life on the island, the age-long natural harmony between Man and Nature.

PAUL GAUGUIN
Paris 1848 — Atuana, Marquesas Islands, 1903
Conversations (Parau, Parau)
Oil on canvas; 26⅜ × 36⁷/₁₆ in (67 × 92.5 cm).
Inscribed lower left:
"Les Parau Parau — P. Gauguin 91."

HENRI MATISSE. *The Dance.*

The idea for this famous decoration, comprising two panels (together with *Music*, also in the Hermitage), gradually crystallized over a period of five years. In composition, *The Dance* is similar to *The Joy of Life*, 1905–6 (Barnes Foundation, Merion, Pa.), in which a round dance is shown in the background. In the beginning of spring 1909, when Matisse was working on the first version of *The Dance* (Museum of Modern Art, New York), Serge Shchukin, who already had some of Matisse's works in his collection, commissioned a panel on the same theme for the stairwell of his private residence in Moscow. The watercolor study for *The Dance*, given to Shchukin by Matisse, is now in the Pushkin Museum of Fine Arts, Moscow.

The apparent simplicity of *The Dance* hides a complicated web of thoughts and associations. Having set the piece in the far distant mythological dawn of mankind, Matisse produced a metaphorical structure charged with symbolic meaning. Scholars specializing in primitive cultures tell us that dances in which people all hold hands symbolize the unity of earth and sky. And in Matisse's dionysiac round dance the earth and the sky are not merely the background, but an integral part of the action.

HENRI MATISSE
Le Cateau 1869 — Nice 1954
The Dance
Oil on canvas; 102⁵⁄₁₆ × 153⁷⁄₈ in (260 × 391 cm).
Signed and dated lower right:
"Henri Matisse 1910."
In an interview published in the Paris newspaper *Les Nouvelles*, April 12, 1909, Matisse explained his idea for the great decorative scheme he intended to realize for the Shchukin palace in Moscow: "I have a stairwell to decorate. It is three stories high. I put myself in the place of a visitor arriving from outdoors. He finds himself on the first floor. Some gesture of greeting must be made, a feeling of ease imparted. My first panel represents a dance, that wild round taking place on a hilltop. On the second floor the heart of the house is reached; in its spirit and silence I imagine a scene of music with attentive listeners … I plan to realize all this in the simplest way and with the most primal, irreducible means, those which allow an artist to express his interior vision with perfect relevance."

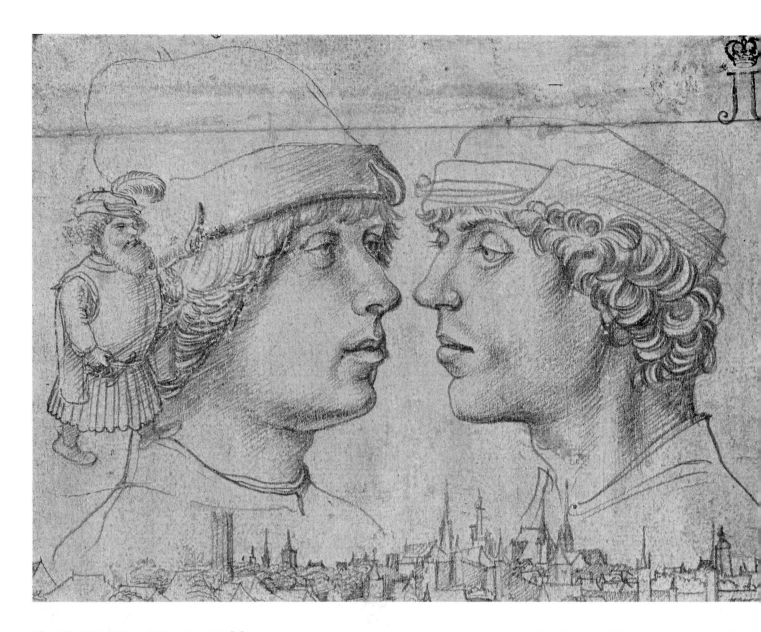

HANS HOLBEIN THE ELDER [?].

Portrait of the Artist's Sons Ambrosius and Hans the Younger.

On the right is the artist's elder son, Ambrosius, and on the left his youngest, Hans. The town depicted below is a view of Augsburg. A dwarf similar to the one appearing in this drawing is found in another Hans Holbein the Elder drawing, now in a private collection in Paris.

A comparison between this drawing and another, now in the Kupferstichkabinett in West Berlin, dated 1511 and also showing the artist's sons — where they appear younger — enables us to date the Hermitage work at approximately 1514.

The painstaking care and rather dry execution of this drawing leads us to believe that this may well be a copy, made perhaps by one of his sons, and that the original is no longer in existence. Franz Winzinger tends towards attributing the work to Hans Holbein the Younger, and consequently dates it from the period just before Hans the Younger left Augsburg for Basel. He also refutes the idea that this is a portrait of Hans the Elder's sons.

HANS HOLBEIN THE ELDER (?)
Augsburg c. 1465 — Isenheim 1524
Portrait of the Artist's Sons Ambrosius and Hans the Younger (c. 1514)
Silverpoint on white prepared paper;
4⅞ × 6⁷⁄₁₆ in (12.3 × 16.3 cm).

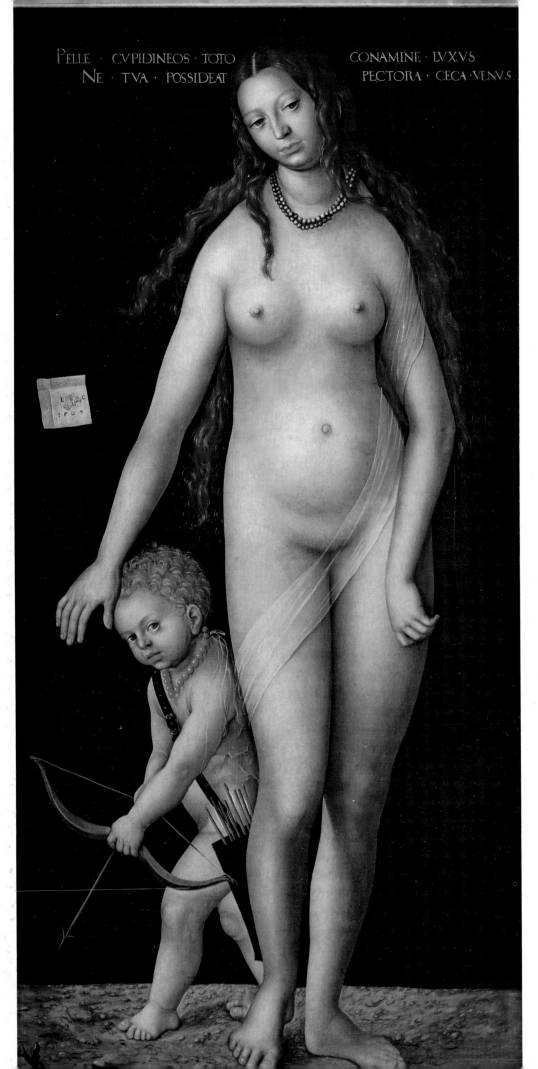

PELLE · CVPIDINEOS · TOTO CONAMINE · LVXVS
NE · TVA · POSSIDEAT PECTORA · CECA · VENVS

LUCAS CRANACH
THE ELDER
Kronach 1472 — Weimar 1553
Venus and Cupid
Oil on canvas,
transferred from wood;
83¹³⁄₁₆ × 40⅛ in (213 × 102 cm).
Signed at left center: *"LC"* with the
insignia of the dragon and the date.

145

LUCAS CRANACH THE ELDER. *Venus and Cupid.* *p. 145*

Lucas Cranach the Elder, one of the greatest artists of the German Renaissance, embodied in his *Venus* his view of the ideal of feminine beauty and perfect proportions of the human body. His picture is the first example in Northern European art of depicting the classical goddess nude. Cranach's Venus is a tall woman, slightly angular, with long legs and a small head. The gentle rhythm and smooth, flowing lines of the figure, which Cranach inherited from late Gothic art, give her an appealing expressiveness.

Venus and Cupid indicates the artist's wide range of interests and his sympathy with the humanistic ideas spreading through Germany in the 16th century. Cranach gives us the German interpretation of one of the popular themes of the Italian Renaissance. For Italian artists, Venus was the quintessence of sensual beauty, boldly and openly celebrating with her naked body. Cranach's picture has a moralistic air, warning the onlooker against sweet temptation in a Latin verse inscribed at the top of the picture: "Try with all your might to ignore Cupid's voluptuousness/ Otherwise Venus will take hold of your poor, blind soul."

The coloring of the painting is fairly uniform, confined to yellow and golden tones. The only bright accent is the necklace of red beads around Cupid's neck.

There are numerous versions of this picture both by Cranach himself and by his pupils, disciples and imitators.

In 1509 Cranach produced a wood engraving of the subject which differed in a few details from the painting, and had a landscape background.

CASPAR DAVID FRIEDRICH. *On a Sailboat*

Friedrich was one of the most important European artists to emerge at the beginning of the 19th century. His work represents all the best features of German Romanticism. It is imbued with the idea of an integral unity between Nature and the spiritual world of Man. This general philosophical idea can be seen in Friedrich's personal outlook, as in this picture, as well as through actual events in the artist's life. Painted in 1818, this canvas is an amazingly bold work for its time, anticipating the achievements of Impressionism. The artist painted himself and his wife on their honeymoon and this painting has a happy, light atmosphere. The extremely detailed and lifelike foreground (Friedrich's travel journals are full of painstakingly detailed studies of sailing ships), contrasts with the background which is illusive, weightless and bewitching, fantasy rather than fact, what is sometimes called "floating architecture." It is precisely this contrast, in addition to the lack of anything to link the background to the foreground which creates the very special, romantic atmosphere, which somehow seems to draw the spectator into the artist's world. But his intention becomes clear when one compares this picture with two others, also in the Hermitage, *Moon Rising over the Sea*, and *The Harbor at Night*. All three works were painted at approximately the same time and form a special sort of romantic triptych, of which *On a Sailboat* is the left wing.

This picture was acquired by the Russian Emperor Nicholas I in 1820 on a visit to Friedrich's studio in Dresden.

CASPAR DAVID FRIEDRICH
Griefswald 1774 — Dresden 1840
On a Sailboat
Oil on canvas; 27¹⁵/₁₆ × 21⅝ in (71 × 55 cm).

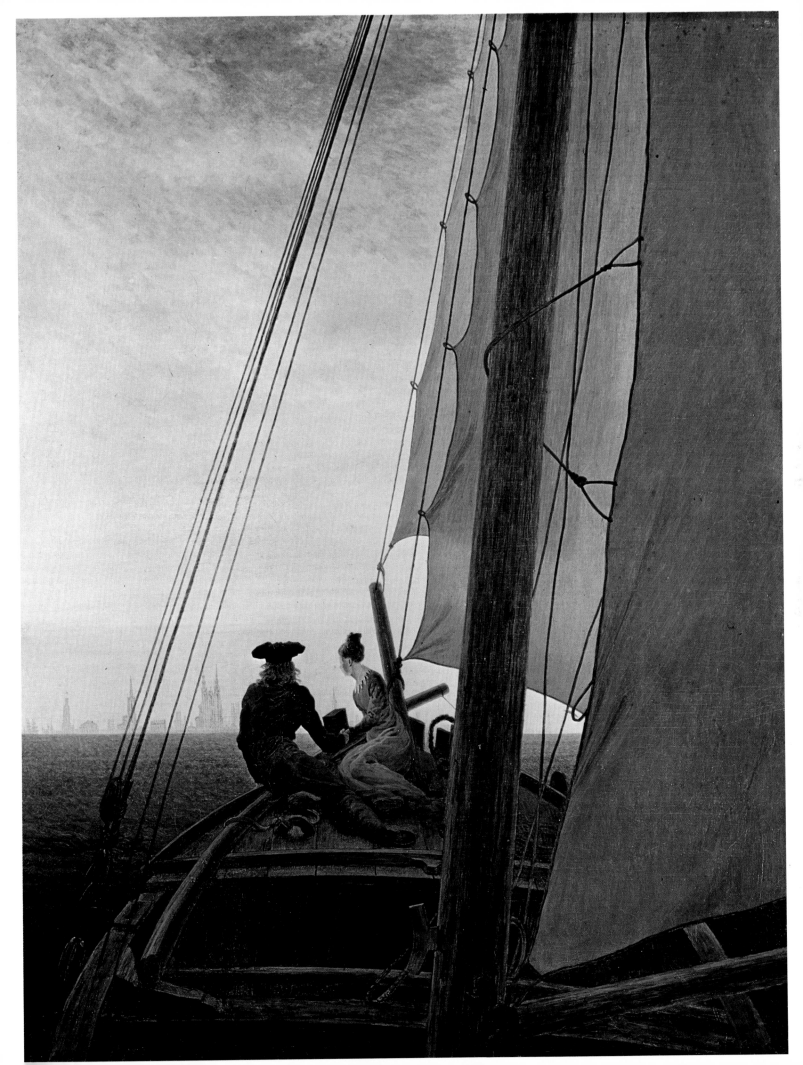

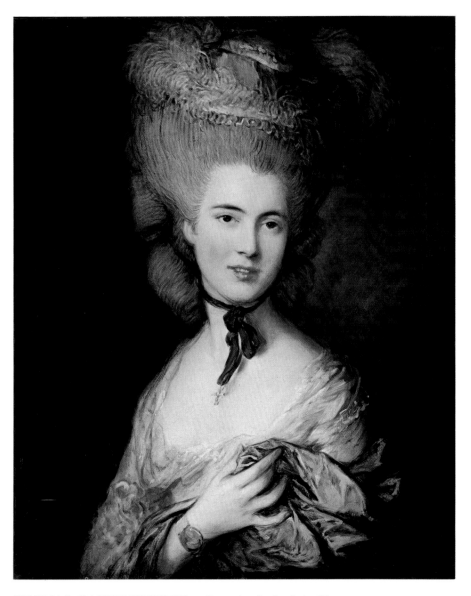

THOMAS GAINSBOROUGH
Sudbury 1727 — London 1788
Portrait of a Lady in Blue (c. 1880)
Oil on canvas; 29¹⁵⁄₁₆ × 25³⁄₁₆ in (76 × 64 cm).
The Hermitage acquired the portrait in 1916 from
the Khitrov collection. For a long time it was
thought to be the portrait of the Duchess of
Beaufort, but there has been no positive proof to
support this.

THOMAS GAINSBOROUGH. *Portrait of a Lady in Blue.*

Portrait of a Lady in Blue is one of Gainsborough's most perfect portraits. The charming silvery blue colors have the same effect on the viewer as listening to a virtuoso musician playing a piece of music in which every note contributes to the harmony. The feeling of peace and serenity emanating from the portrait is due to the precision and sense of rhythm with which the graceful feminine figure, with its pale blue, pink, white, light brown and pearl-gray tones, is placed in the rectangle of the canvas. Thanks to this, the coquettish pose of this fashionable lady, holding up her shawl as it falls from her shoulders, takes on an air of refinement and nobility. Gainsborough's light, flowing brush stroke gives the picture an almost indiscernible movement; and brings the charming figure of the young woman to life.

There has never been any doubt about the date of the portrait. The perfection of its execution indicates that it must have been painted at the height of the artist's powers. His preference for blue tones places the picture in the 1770s or 1780s, which the costume and the high hairstyle topped with a tiny hat with a ribbon and ostrich feathers would also indicate.

148

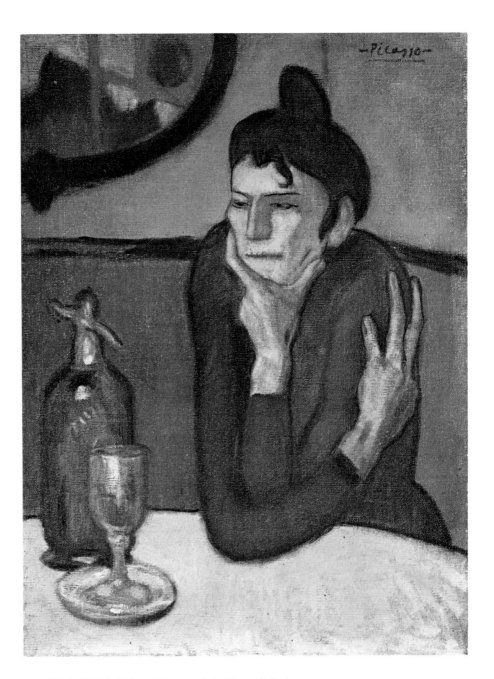

PABLO PICASSO
Malaga 1881 — Mougins 1973
Woman Drinking Absinthe
Oil on canvas; 28¾ × 21¼ in (73 × 54 cm).
Signed above right: *"Picasso."*
In the summer of 1901 Picasso put on exhibition
at Vollard's a picture called *Absinthe* (Jaffe
Collection, New York), which was the starting
point on the road which led to *Woman Drinking
Absinthe.* The model for this picture is not
known, although it would seem to be the same
woman as the one portrayed in *Woman with a
Chignon* (Fogg Art Museum, Harvard
University), and also in *Girl with her Hands
Crossed on her Breast* (Obersteg Collection,
Geneva).

PABLO PICASSO. *Woman Drinking Absinthe.*

This picture was painted in the autumn of 1901 in Paris, although its compositional elements had already been previously developed, using different models. During this relatively short-lived early period, called his "Blue Period," Picasso was much under the influence of both Toulouse-Lautrec and Gauguin. Picasso had already painted a woman in a café in Barcelona in 1899–1900.

The subject of the café scene, which the Impressionists were so fond of, is treated in an anti-Impressionist manner by Picasso, not only as regards the form, but more essentially as a psychological study of the woman in this canvas. Her whole face expresses loneliness and waiting. Behind her is a wall, in front of her a table — she is surrounded on all sides, wedged into a corner both literally and metaphorically. Her blue dress highlights the unhealthy yellow pallor of her face and hands, which seems to "compress" the figure even more. The dirty red color of the walls not only renders the atmosphere of a cheap café, but also provides a cheerless background, emphasizing the woman's drab existence.

149

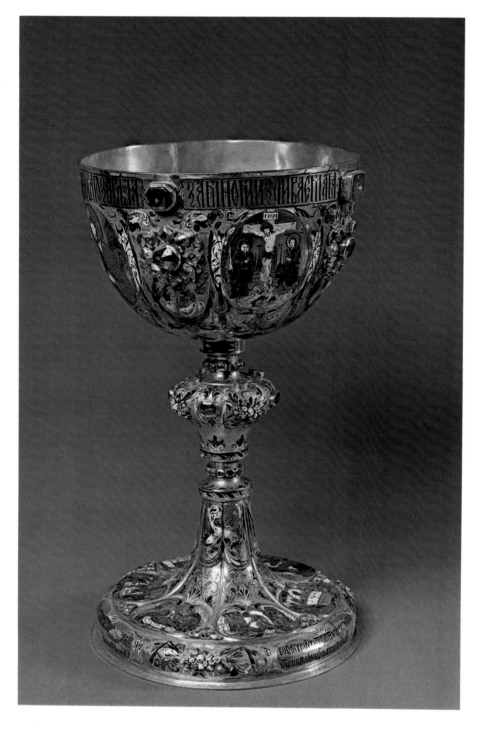

ART OF MOSCOW
Chalice (1677)
Gold, precious stones, enamel, niello;
height 11½ in (29.2 cm);
diameter 6⁹⁄₁₆ in (16.7 cm).

NOVGOROD SCHOOL
Saints Theodore Stratelates and Theodore Tiron
(15th century)
Egg tempera on wood; 21 × 15 in (53.5 × 38 cm).

ART OF MOSCOW. *Chalice.*

The chalice is a church vessel used in the celebration of the Eucharistic liturgy. The gold chalice in the Hermitage collection is a masterpiece of Russian jeweling from the end of the 17th century. It is lavishly decorated with precious stones and multicolored enamel. Around the upper edge of the chalice and on the base are inscriptions in niello inlays regarding the chalice, stating that it was made by the artists of the Moscow Kremlin, and that it was commissioned by the Czar Feodor Alekseevich for the palace Church of the Divine Savior.

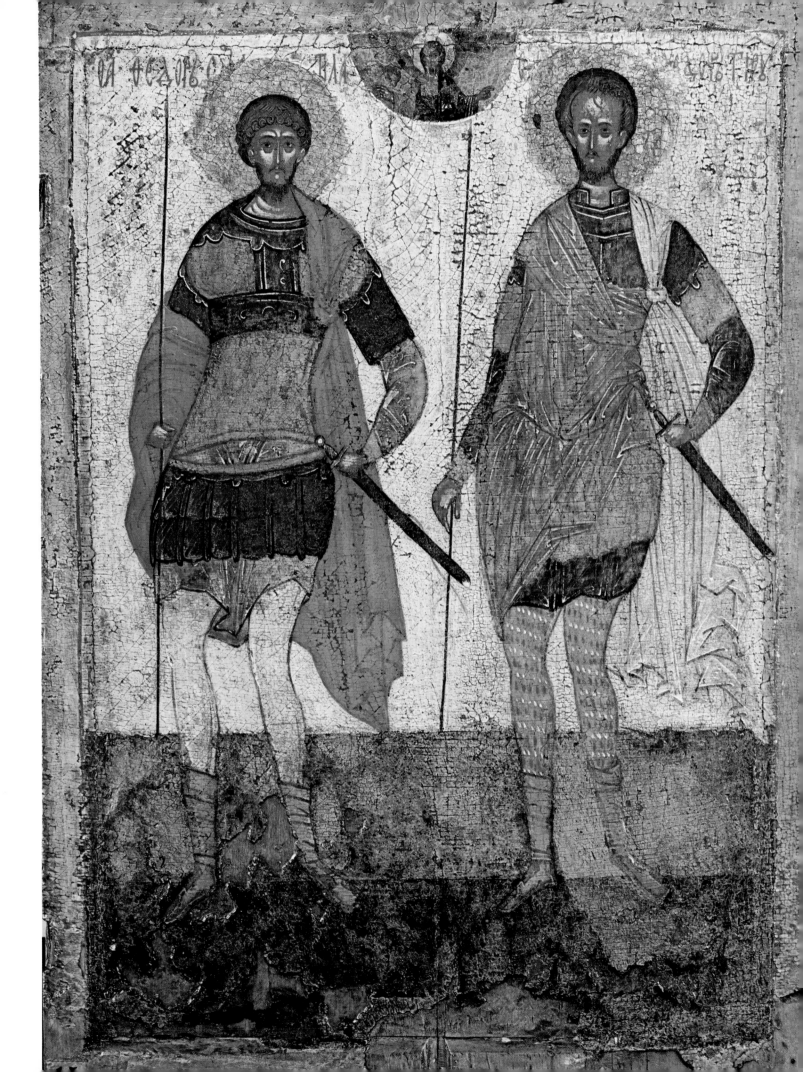

The elegant inscriptions, the flowers and fruit executed in relief which decorate the surface of the chalice, as well as the medallions in painted enamel with pictures of saints and religious scenes — all these elements combined with the sparkle of precious stones (diamonds, emeralds, garnets, sapphires) and the noble splendor of the polished gold surface create a vivid, festive range of colors.

Moscow gold- and silversmiths were famous; the best of them worked in the Kremlin workshops. The objects which they made were mainly for the Church: chalices, mitres, goblets, icon frames, missal mounts. They all have a strongly pronounced national character corresponding to the general trend of Russian art of that period with its predilection for bright polychrome and splendid decoration.

NOVGOROD SCHOOL.

Saints Theodore Stratelates and Theodore Tiron. *p. 150*

The Novgorod school has a very special place in Old Russian painting. It differs from the other schools in that the influence of traditional peasant art is very strongly felt — the simplicity of subject matter, the laconic composition, the bright and impulsive colors.

The icon in the Hermitage collection shows two warrior-saints, Theodore Stratelates and Theodore Tiron. The composition is clear and simple. The figures of the warriors are portrayed frontally without unnecessary symbolism. Their poses are identical, which gives a singular rhythm to the composition. The figures are long and remarkably light, endowing them with a feeling both of elegance and of spirituality. The relationship between the outlines of the two figures and the background of the icon is perfect. The fine, dark features of their faces, characteristic of the Novgorod school, are beautifully painted with quite a developed use of light and shade.

The color of the icon is sparkling, pure and remarkably sonorous. The artist has boldly contrasted yellows, reds, browns and greens, among which the cinnabar cape of Theodore Stratelates stands out. The perfection of line, the expressiveness of the figures, the classical simplicity of the composition and the vivacity of the colors all make this a magnificent example of Novgorod school painting in the 15th century.

LOUVRE

PARIS

THE BUILDING

The Louvre, like the collections it houses, shows traces of almost four centuries of French kings, all of whom, almost without exception, made some additions to the enormous palace. The nucleus of the building goes back to Francis I. This is the south-west section of the "Square Court" or "Cour Carrée" (the plan was that of the fortress of Philippe-Auguste, which had been destroyed), designed by the architect Lescot and adorned by statues by Jean Goujon. At the beginning of the 17th century all the south wing of the palace, along the Seine, was finished; it was planned to reach the new palace of the Tuileries on the west. In 1624 Louis XIII decided to carry out the original plan for the "Cour Carrée," to enclose it on four sides, according to plans by Lemercier. This new project was carried out in 1661–63. Then Louis XIV, who had torn down what remained of the old fortress, as well as many surrounding buildings, commissioned Le Vau to complete the "quadruplement," still basically in the style of Lescot.

These 16th-century plans, however, could not give the monumental effect called for by the new "Porte d'Honneur" of the east side. The minister Colbert, ignoring the plans of Le Vau, Lemercier and Mansart, called in Bernini from Rome. In 1665, Bernini presented a baroque plan for the long façade. This was never carried out, since the taste of Louis XIV's court was by this time more classical: the style which was typical of all the production of this artistic center in the second half of the 17th century was already flowering. The suggestion put forward by a committee, Perrault, Le Vau and Le Brun, to have a long, continuous colonnade with a single row of columns, was taken up, and the façade was carried out along the south side of the palace as well. The decorations Le Brun executed for the "Petite Galerie" and in the rooms of the "Colonnade" also belong to this period.

When Louis XIV settled permanently in Versailles in 1678 the work had not yet been finished, and the palace was nearly abandoned. It was used only for meetings of the Academy, as a residence for members of the court, for offices and storerooms. Only at the end of the century, with the future Museum in mind, work started again under the supervision of the architects Gabriel and Soufflot. It was left to Napoleon to complete Perrault's "Cour Carrée" and "Colonnade" in the early years of the 19th century, as well as a wing on the north, along the Rue de Rivoli. The latter was continued by Napoleon III, 50 years later. He hired the architects Le Fuel and Visconti in an effort to make the west side, at last, harmonize with the whole. But when the work of so many centuries was finished at last, the palace of the Tuileries, ironically enough, burned down in 1871; and the original plan, to have a single complex tied to the façade of the palace in a unified perspective, was never realized.

PLAN OF THE MUSEUM

GROUND FLOOR

1 Oriental antiquities
2 Egyptian antiqujities
3 Greek and Roman antiquities
4 Medieval, Renaissance and 17th- and 18th-century sculpture

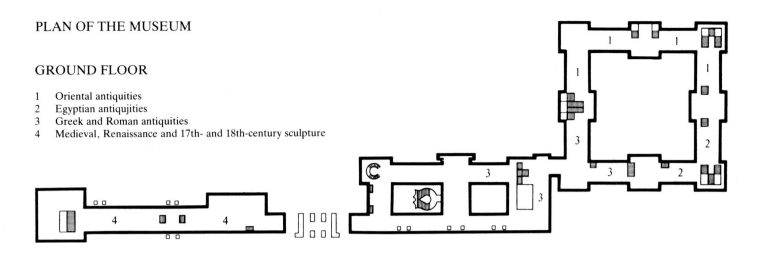

FIRST FLOOR

1 Paintings
2 Egyptian antiquities
3 Greek, Roman and Etruscan antiquities
4 Furniture and art objects

SECOND FLOOR

1 Painting from 1700–1800
2 Special exhibitions

The unnumbered areas are closed to the public. **155**

EGYPTIAN ART
Seated Scribe
(5th Dynasty: *c.* 2500 B.C.)
Painted limestone; height 21 in (53 cm).
From Sakkara.

EGYPTIAN ART. *Seated Scribe.*

This famous statue of an unnamed scribe was discovered in the course of a disorganized excavation conducted by the famous 19th-century French Egyptologist Auguste Edouard Mariette at Sakkara. In 1921, it was found to bear a close resemblance to a seated statue of the monarch Kai which had been shipped to the Louvre after the same excavation. This Egyptian official has thus survived in two monuments.

The statue is considered one of the masterpieces of Egyptian art. On the one hand it is intensely realistic, particularly in the level gaze of the eyes, which are inlaid with highly polished hard stone. On the other hand, and in striking contrast to this realism, the sculptural forms are severely geometric. The figure is adamantly frontal, preserving something of the origial four-sided block of stone from which it was cut. It is as if the artist had thought in terms of four juxtaposed bas-reliefs instead of a monument in the round. This peculiarly Egyptian attitude towards the block leaves its traces in almost all Egyptian sculpture, and is evident, for example, in the flat planes of the scribe's back.

Egyptian art is characterized by the artists' attempts to seek out and depict a figure's most typical or most significant view. Hence we find profile heads with eyes shown frontally, and frontal torsos with legs and arms in profile. This approach is connected with man's normal vision and is always present to a greater or lesser extent in primitive arts. Yet one cannot call Egyptian art "primitive."

It is with civilizations of the ancient periods that certain rules for principal views (in painting and for reliefs) and for frontality (in sculpture in the round) become binding. These two aspects stem from one and the same phenomenon, based on a new need for architectonic order and pictographic clarity. The mastabas and pyramids of Old Kingdom Egypt expressed this need for geometric and architectonic order, while the development of hieroglyphic writing did the same for pictographic, narrative clarity. From then on, the canon affected every branch of Egyptian art, its repertory lasting for many thousands of years. The sculptor of the 5th dynasty, however, while working in a tradition which was already centuries old, was not subdued completely by the system. He accepted parts of the code, but he felt free enough to make a few choices on his own, filling out a given scheme with his own aesthetic experience. Thus he was able to add realist touches to the otherwise abstract figure of the *Seated Scribe*.

EGYPTIAN ART, OLD KINGDOM
Raherka and Mersankh
(5th Dynasty)
Detail of a family group.
156 Painted limestone; height 21 in (53 cm).

EGYPTIAN ART, OLD KINGDOM. *Raherka and Mersankh.*

A characteristic Old Kingdom type of statue is the family group, in which the figures were conceived as separate entities and juxtaposed. There is also the "false" group, in which two statues representing the same person are paired. In the latter, the image has become a definitive symbol: no longer are two "objects" occupying the same space, but an idea is repeated twice within the same context. The group Raherka and Mersankh, on the other hand, is distinguished by a more explicit intention to represent reality by giving the pair a more naturalistic appearance, with the woman leaning confidently on the man.

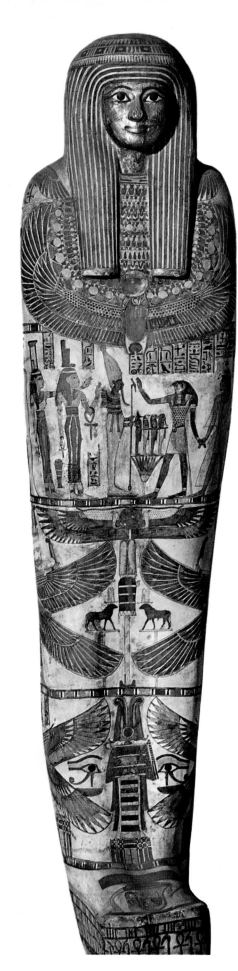

EGYPTIAN ART, MIDDLE KINGDOM.
Sarcophagus of Djedkhonsouioufankh.
The most ancient mummies had faces painted on the wrappings around the deceased persons' heads. Later the sarcophagus itself, like the wrappings, was given the form of the mummy and painted with human features. Often the mummy was contained in multiple sarcophagi, each one shaped like the body and painted. Wooden anthropomorphic sarcophagi generally date no earlier than the New Kingdom. The painted decoration is always religious in character, depicting the soul's voyage to the afterlife and the deities it will meet, as well as the judgment to which it must submit. The Egyptians also wrote various exorcisms and entire chapters of *The Book of the Dead* are devoted to sarcophagi. Apart from their religious significance, they are extraordinary artistic creations, their anthropomorphic character abstracted and reduced to an elegant stylization. The mummy became an idol, covered with a lively polychrome decoration executed by an artist with a sure sense of composition and a profound understanding of the medium he was using.

EGYPTIAN ART, MIDDLE KINGDOM
Sarcophagus of Djedkhonsouioufankh
(16th Dynasty: *c.* 660–525 B.C.)
Mummy cover. Sculptured wood, stucco and polychrome; length 63 in (160 cm).

EGYPTIAN ART, OLD KINGDOM
Preparations for a Banquet
(5th Dynasty)
Painted limestone; height 14 in (35 cm).

EGYPTIAN ART, OLD KINGDOM. *Preparations for a Banquet.*
The detail illustrated here comes from a series of reliefs which decorated the walls of the funerary chapel of the Mastaba of Akhuthotep. Banquet scenes like this were conventional in Egyptian funerary art, and they served to project earthly pleasures into the afterlife. Apparently Akhuthotep died before the decoration of his chapel was finished. The registers above the portion illustrated here still bear traces of squared-off guidelines which served either as a guide for enlarging a smaller drawing of the banquet scene or as modules for an artist working with canonical proportions. Either possibility demonstrates the academism of pharaonic art, which, more than in any other art, tied artists to traditions established by the past. Yet at the same time Egyptian art was not static. To the casual observer there may be no difference between this work and that of the New Kingdom, but closer examination of this relief compared to that of Amenmes is instructive. Two butchers grasp the leg of an ox and one of them slices it with a large knife. Their torsos are shown in profile from the shoulder down, while Amenmes' torso is shown frontally; at the same time the legs and heads of all three are in profile. The attempt to show the butchers in complete profile heightens the strong diagonals of the composition, which combine with the rectilinear forms of the bodies and curves of the animal's leg to create a subtle interplay of linear motifs and triangular spaces.

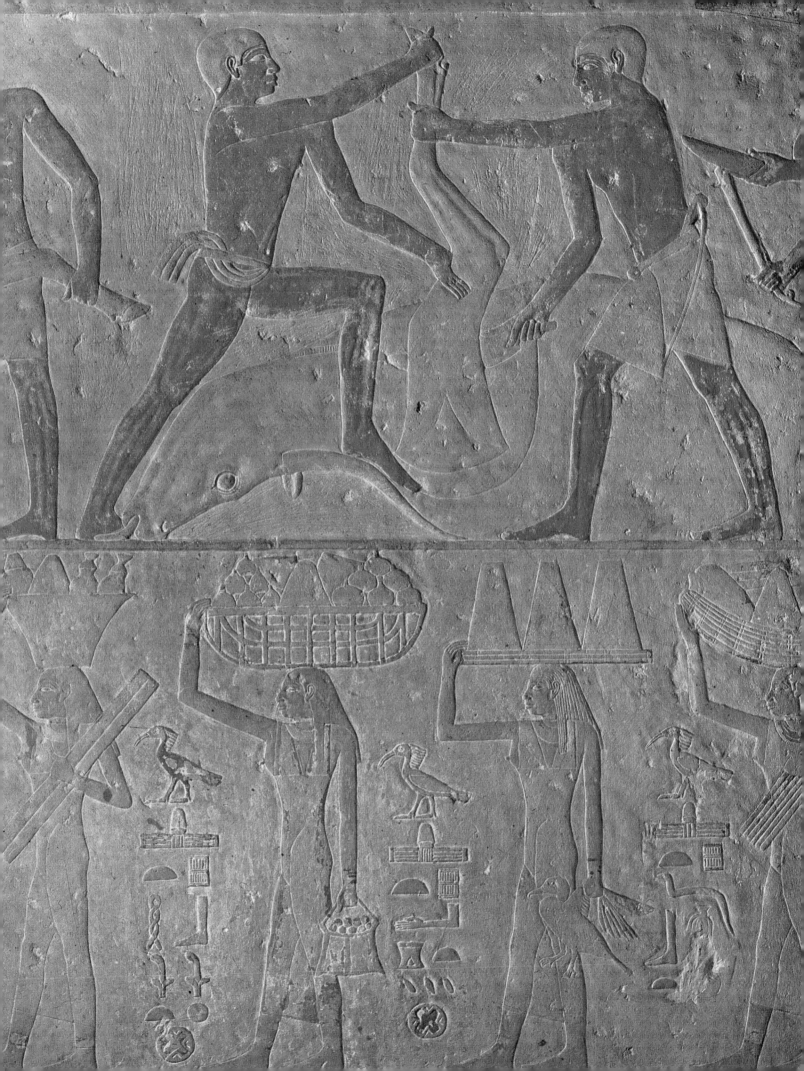

ASSYRIAN ART
Stele of the Victory of Naramsu'en,
King of Akkad
(Sippar: period of Akkadian Rule; phase III:
c. 2389–53 B.C.)
Pink sandstone; height 78⅖ in (2 m),
width 41⅓ in (1.05 m).
Commemorative stele from Susa; taken as war
plunder in the 12th century B.C. by King
Shutruknahhunte, after the Babylonian conquest
of Sippar and other cities.

160

ASSYRIAN ART. *Stele of Naramsu'en.*
The Akkadians ruled Mesopotamia without seriously disrupting Sumerian culture during the two centuries between the Proto-Dynastic and the Late Sumerian periods. Akkadian sculptors, however, when faced with the heavy, rough figure style of the older civilization (which did influence them at times) and the stiff formality of its representations in relief, proved themselves closer, more attentive observers of nature than were their Sumerian counterparts. The Stele of Naramsu'en is an exceptional monument, and is probably the oldest work of art we know in which the artist attempted to represent the idea of space. He clearly intended to show a natural, realistic relationship between the human figures and their topographical setting rather than succumbing to a traditional stylization. His task was rendered easier in part by the conformation of the place represented, a mountainside; and by the scene shown, an assault by the Akkadians on a hill tribe. The foothills appear as undulating lines building up to the mountain peak. Thus the sculptor had an excuse for showing one figure on top of the other. In a normal representation of a crowd standing in a flat area, artists traditionally projected the idea of several rows of people using this same disposition, without the visual rationale of a sloping terrain. Similarly, the sculptor gave a certain movement to the background by placing various warriors on successively higher foothills. He indicates that the higher a person is the farther away he is from the viewer by showing him behind someone on a foothill lower in the relief. The sculptor has not yet reached the point of showing that mountains and hills can hide or half-hide human figures. For this sophistication, one must wait another 19 centuries until the appearance of the Argonaut Krater (also in the Louvre).

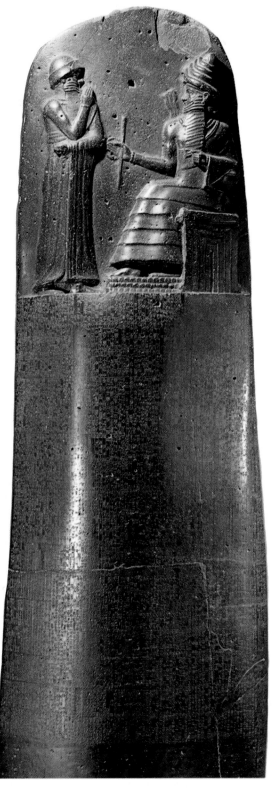

ASSYRIAN ART
Code of Hammurabi, King of Babylonia
(Late Larsa period: 1930–1888 B.C.)
Detail.
Black basalt; height 88½ in (2.25 m).
Stele from Susa: taken as war booty by Elamite
King Sutruknahhunte in the 12th century B.C.

ASSYRIAN ART. *Code of Hammurabi.*
Hammurabi's famous Code of Laws is carved on most of the surface of this large basalt block. The discovery in Susa of the remains of a second example leads one to think that the code was carved on a number of such monuments and thus published among the principal cities of the kingdom. On the upper portion of the stele, King Hammurabi stands in front of a seated divinity and raises his right hand in a gesture of devotion. The god appears to be handing him a scepter, the sign of power. This motif of adoration is common on seals and has numerous antecedents in Late Sumerian monuments. Hammurabi's artists pay due homage to the culture he conquered, adopting the stylized schemes inherited from the monuments of the period of Gudea.

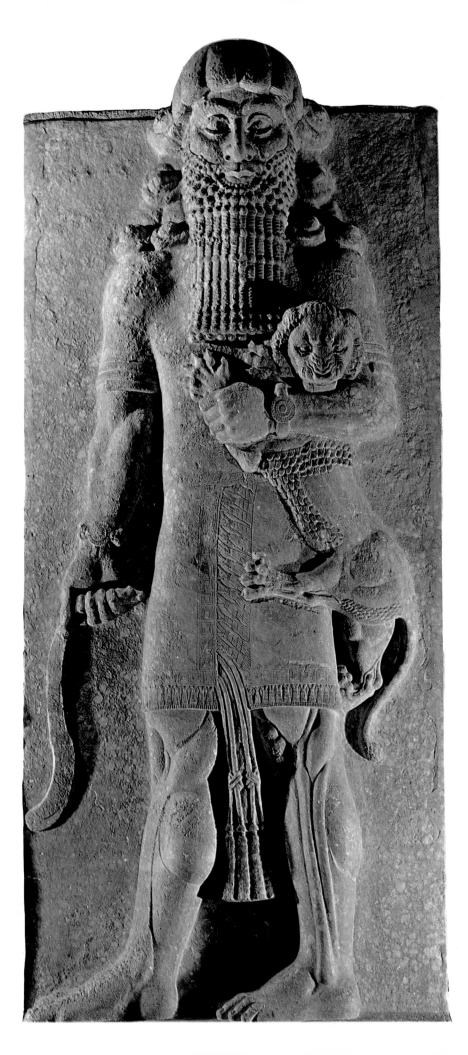

ASSYRIAN ART
Propitiatory Genius of a Hero (usually identified as the *Gilgamesh*)
(Late Assyrian period;
Reign of Šargon: 721–05 B.C.)
Alabaster; height 13 ft 10½ in (4.7 m).
From the palace of sargon II in Dur Sharruukin (Khorsabad): from the front of the throne room in one of the inner courts.

ASSYRIAN ART. *Propitiatory Genius of a Hero.*
During the reign of Sargon II, Assyrian sculptors reached the height of their artistic expression in the powerful isolated figures of divinities, heroes, princes or genii. The genius illustrated here, linked by some with the hero Gilgamesh, exemplifies the massive strength of these figures. Although the figure is essentially geometric and frontal, it is animated by the coloristic carving of the hair (animal and human) and cloth, and the artist's feeling for expressive anatomical details.

ASSYRIAN ART. *Archers of the Persian Guard.*
The ancient Mesopotamian tradition of enameled brick, which had been used by the Late Babylonians in Nebuchadnezzar's monumental Ishtar gate, was resumed by the Persian kings in the decoration of their luxurious palaces. Here, in stylized repetition, are shown the archers of Susa, the famous "Immortals," carrying lances with gold and silver tips.

ASSYRIAN ART
Archers of the Persian Guard
(Archemenide age: 5th century B.C.)
Enameled bricks;
height of each archer 57⅘ in (147 cm).
Frieze from the Palace of Darius in Susa.

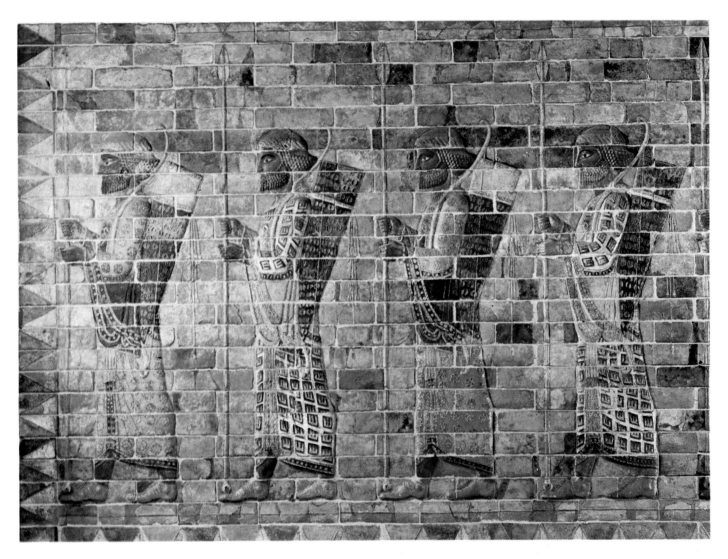

ETRUSCAN ART. *Sarcophagus from Cerveteri.*

The Etruscan civilization blossomed from the 7th to the 3rd century B.C. in the region of Italy between Florence and Rome, approximating to modern Tuscany. Despite much research little is known of its religion and language; its art, however, is magical in its unusual freshness and unique use of color.

Found in the necropolis of ancient Caere, this painted terra-cotta sarcophagus is covered by a lid decorated with the figures of a wife and husband reclining on a Greek couch *(kline)*. The Etruscans saw these as representations of the deceased at an everlasting banquet since their idea of an afterlife was a prolongation of everyday life after death. The wife's brimmed hat and her shoes with their upturned toes *(calcei repandi)* are Etruscan. These figures can be related to elements of Greek art, but basically they are products of Etruria, if for no other reason than the masterful use of terra cotta on a monumental scale. Stylistically, the monument relates to Ionic art in the clean profiles, slanting, almond eyes and "archaic smile."

The particular strength of this group lies in the expression of a warm human relationship between man and wife, and the ease with which the viewer can relate it to the reality of everyday life.

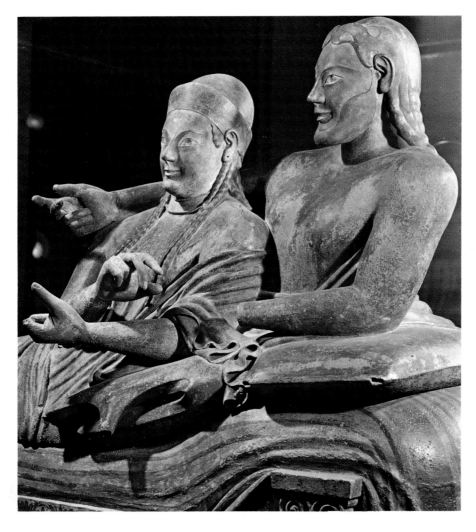

ETRUSCAN ART
Sarcophagus from Cerveteri (*c.* 500 B.C.)
Painted from terra cotta;
length 78 in (198 cm), height 46 in (117 cm).
From Cerveteri.

GREEK ART
Victory of Samothrace (*c.* 190 B.C.)
Parian marble; height 9 ft (2.75 m).
Discovered in Samothrace in 1863.

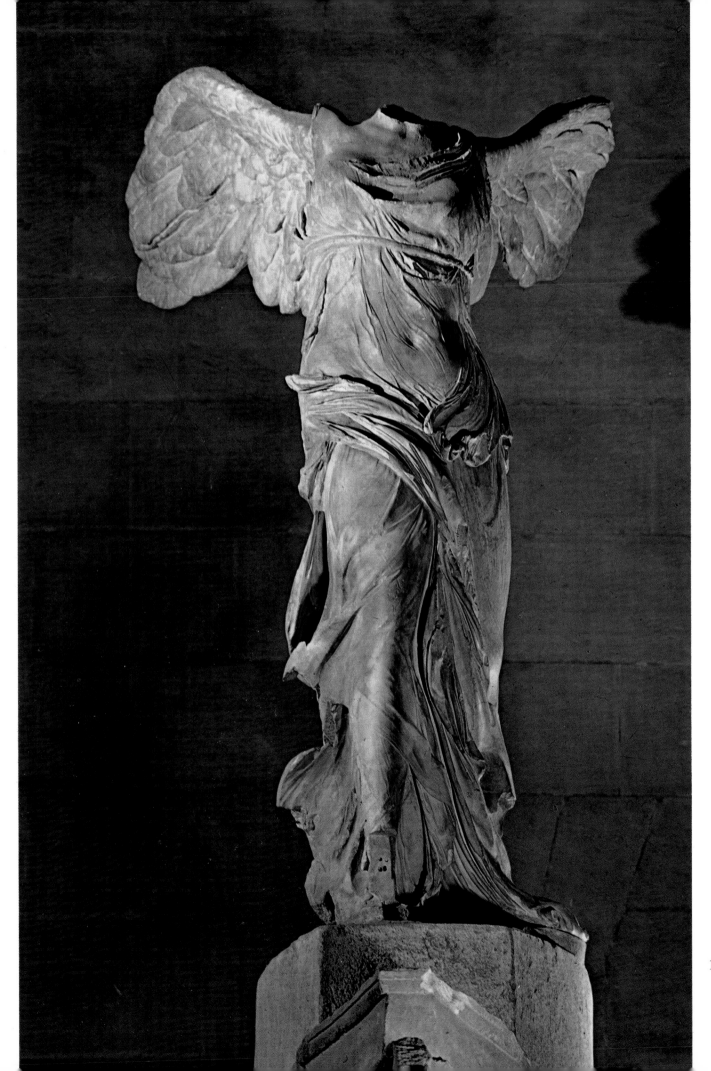

GREEK ART. *Victory of Samothrace.* *p. 165*

The Winged Victory of Samothrace was connected for a number of years with the naval victory of Demetrius Poliorcetes in 306 B.C., and then more persuasively to the Rhodian conquest of Antiochus III (222–187 B.C.). The style justifies the later dating. The Victory is a spectacular piece. Her body is thrust forward by the giant wings and the sea wind catches her drapery which, dampened by the salt spray, clings to her body. The light chiton adheres to her breasts, and her cloak, slipping from her shoulders, wraps around her legs and billows out behind her. The treatment of the cloth is related to the so-called "wet drapery" of the post-Phidian period, but in its exaggerated curves and chiaroscuro effect it is almost baroque, which again justifies the later dating.

WORKSHOP OF PHIDIAS. *Panathenaic Procession.*

The continuous frieze which ran around the cella of the Parthenon (within the peristyle) was executed by a team of sculptors and craftsmen under the direction of Phidias. The marbles of the Parthenon represent the high point of Greek art, when a perfect balance had been achieved between realism

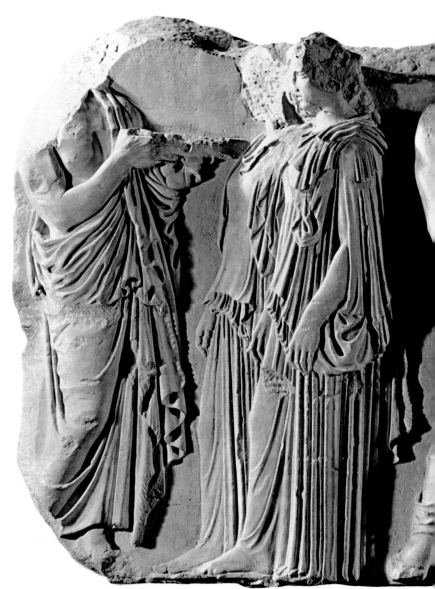

WORKSHOP OF PHIDIAS
Panathenaic Procession (447–32 B.C.)
Pentelic marble; height 41⅓ in (105 cm).
Section from frieze of the eastern part of
Parthenon with maidens giving two officials of
the procession the official robes as an offering to
Athena.

166

and the architectonic elements. The artists were still working within the stylistic conventions developed in the Archaic period, but they were elaborating on their heritage. The Panathenaic frieze characterizes the Greek concept of relief, which is born of a graphic tradition and seeks to give itself sculptural rather than two-dimensional, linear forms. The relief field is only two figures deep. When the artists wished to enlarge this shallow field, they used the old convention of indicating a horizontal expansion rather than penetrating the background visually. This is evident in the thrones of the gods at the east end of the frieze. Thus the background retains the same spatial value of every point in the frieze.

Every figure and every group has the same value in the balance between occupied and unoccupied spaces throughout the frieze. This harmony is exemplified by the magnificent series of *peplophoroi* (wearers of the ceremonial Panathenaean festival robes) and the strong verticals of their drapery, which mark the rhythm of the whole procession honoring Athens' Athena.

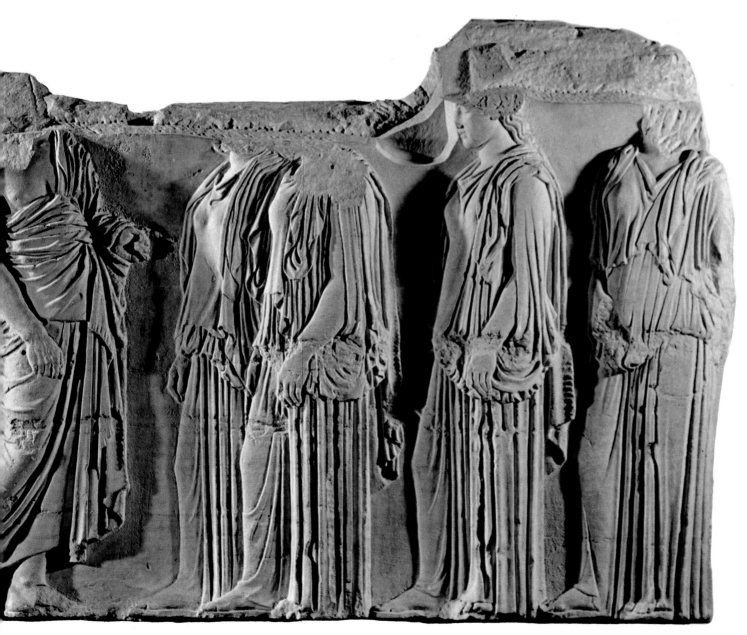

167

ANONYMOUS FRENCH MASTER.

The Beautiful Gabrielle and the Maréchale de Balagny.

During the 16th century in France, portrait painting enjoyed a special favor in court circles. It became extremely fashionable for portraits to be sent as gifts to celebrate numerous occasions, above all weddings. In this painting, Gabrielle d'Estrée and her sister are shown taking a bath together, a popular theme at the time. The picture probably contains an allusion to the fertility of Gabrielle and her projected marriage with Henry IV. The ivory-like figures are framed by the curtains held back over their heads. A domestic scene in the background shows a woman sewing, seated in the warmth of a fireplace.

The influence of Clouet is strong in this work, which belongs to the later

years of the School of Fontainebleau, perhaps around 1596, when Gabrielle, the king's mistress, was expecting a baby. At the latest, the picture could date from 1599, when she died in childbirth. The portrait is more interesting perhaps from the point of view of cultural history than of art, and projects a sense of intimacy, allowing an insight into the lives of these elegant French ladies.

LOUIS LE NAIN. *Peasant Family in an Interior.*

This is the most famous rustic scenes in which Louis Le Nain specialized. The painting represents the interior of a peasant's home just before the

family sits down to dinner, its members having gathered together from

various tasks. The old man has left off cutting the bread for a moment, his wife holds the glass of wine she has just poured from the jug resting on her lap, a child plays a few notes on a shepherd's pipe, and the other figures have momentarily paused, all intent on looking towards the entrance of the room, with an air of mild diffidence, of gentle surprise. In the background, two people can be seen, however, they are preoccupied by the fire and do not participate in the main scene.

The balanced disposition of the figures, the suspended movement and the serenity of the scene clearly relate it to still-life compositions. Also evident is the poetic influence of Caravaggesque painters — Guercino, Reni, the Bamboccianti. In contrast to its genre character, however, is the poetic, almost Virgilian sense of tenderness and bucolic melancholy.

LOUIS LE NAIN
Laon 1593 — Paris 1648
Peasant Family in an Interior (1642)
Oil on canvas; 44½ × 62½ in (113 × 159 cm).

ETIENNE–MAURICE FALCONET. *Bather.*

The *Bather* is a typical example of Rococo decorative statuary, destined to adorn the boudoirs of ladies and cardinals. The girl stepping into a pool is more a nymph than a real figure, inspired by the mythological imagination of the period, as in the poetics of Boucher. Already, however, one can sense a breath of cool Neo-Classicism.

In the year he finished this famous statue, Falconet found his true vocation. He became the director of the celebrated porcelain factory at Sèvres. His patroness was Mme. de Pompadour, whom he once portrayed as Venus Anadyomene. His works of this type, although drawing-room frivolities, are distinguished by their harmonious elegance and poetic delicacy.

FRANÇOIS BOUCHER
Paris 1703 — Paris 1770
Diana Resting (1742)
Detail.
22½ × 28¾ in (47 × 73 cm).

ETIENNE–MAURICE FALCONET
Paris 1716 — Paris 1791
Bather (1756–57)
Marble; height 32 in (82 cm).
Once thought to have been sculpted for Tiroux d'Epersenne (allegedly exhibited in the *Salon* in 1757), it is now believed to have belonged to the Countess du Barry and to have come to the Louvre after the confiscation of her property during the Revolution.

FRANÇOIS BOUCHER. *Diana Resting.*

A pupil of Watteau, Boucher was a highly gifted, hard-working painter, a virtuoso of the brush. Five years after Diana was exhibited at the Salon, he was granted the patronage of Mme. de Pompadour, and to a certain extent became the paradigm of the Louis XV style. Diderot was his only opponent, expressing a preference for Chardin.

Diana Resting appears to reflect Boucher's Italian visit, especially in the goddess's golden nudity, of an impalpable softness inspired by Correggio and of a delicate fantasy inspired by Ricci's Arcadian visions.

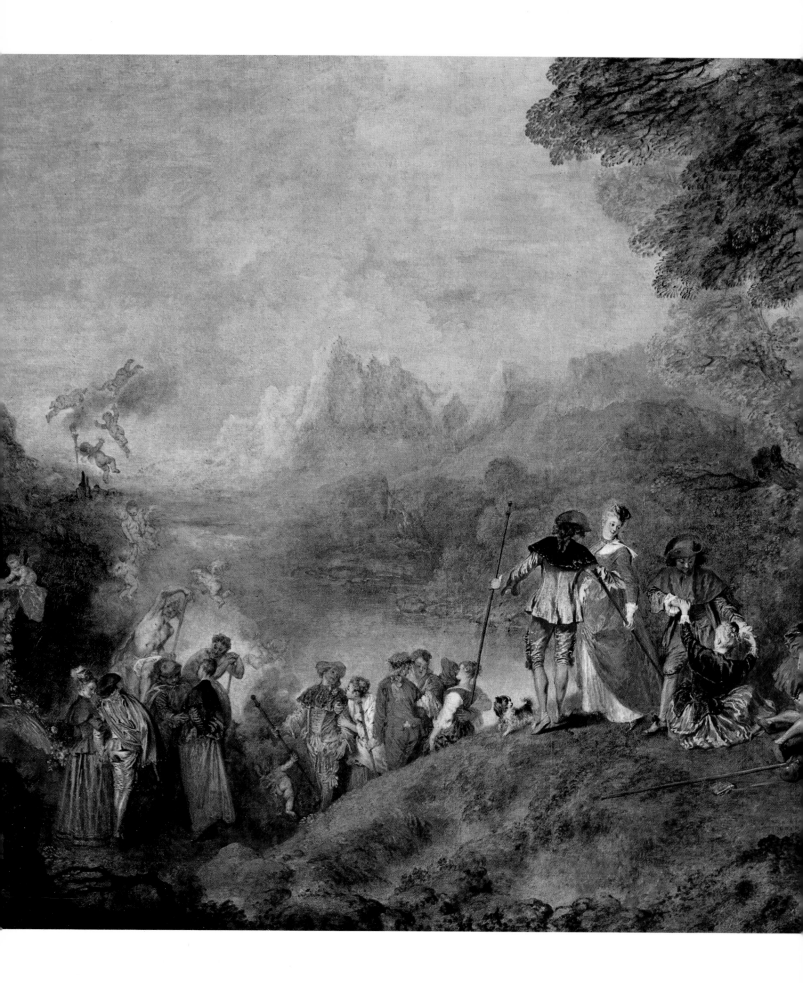

ANTOINE WATTEAU. *The Embarkation for Cythera.*
With this picture Watteau was admitted to the Royal Academy of Painting and Sculpture in 1717. For this honor, he had waited since his original application in 1712. It took him five years to present this work to the Academy, and even then it had not assumed its final form. A little after 1717, resuming this same theme, he created a more finished work which was purchased by Julienne. This painting is now in Berlin. The picture has enjoyed wide fame, as echoed in the words of the Goncourts, who in their book on 18th-century art called it the masterpiece of French masterpieces.

In this picture, Watteau reveals that he has matured through a study of Rubens, whose influence is evident in the thick brushstrokes, and of the drawings of Bassano, Titian and van Dyck. The theme was perhaps based on a comedy by Dancourt. Watteau always retained a taste for the theater, which he learned from Gillot, a painter of scenes from the *Commedia Italiana* and one of his first teachers.

Watteau painted with a light brush, as is noticeable in the foliage, while the figures are drawn and emphasized with a slightly heavier touch.

ANTOINE WATTEAU
Valenciennes 1684 — Valenciennes 1721
The Embarkation for Cythera (c. 1717)
Detail.
Oil on canvas; 50 × 75½ in (127 × 192 cm).

EUGENE DELACROIX. *Liberty Leading the People.* p. 174–75
Like many of Delacroix's paintings, this one was inspired by a current political event, the 1830 insurrection of Paris. Almost to emphasize his enthusiasm as a liberal, the artist identified himself with the man brandishing a gun on the overturned barricade, while the armed mob is glimpsed through the smoke of the explosions that veil the city. (Six years earlier, Delacroix had painted, with parallel force, and on the same politically liberal theme, *Massacre of Chios*, inspired by the Greek struggle for independence.) Delacroix's rhetorical tone is compelling and the movements, the settings of the figures and, above all, the two bodies that almost completely dominate the foreground, reveal his emphasis on the theatrical. But the deep passion that motivated the artist more than redeems the violence of the scene. Two years later Delacroix made a long voyage to Morocco and Spain, a trip that proved crucial to his future.

JACQUES–LOUIS DAVID. *Portrait of Madame Récamier.* p. 174
This painting belongs to David's high period, when he was the official painter to the Napoleonic age. It dates 16 years after his famous *Oath of the Horatii* which was immediately recognized as a masterpiece with a message, an invitation to aesthetic and political revolt, and later as one of the main documents of Neo-Classicism. By 1800 the revolutionary thrust of the new style was but a memory, and David's big mythological works, magnificent and brilliant as they may be, are considered by some critics to be overly doctrinaire. The portraits, on the other hand, remain among the highest products of his personality and style. The *Portrait of Madame Récamier* is

one of the most significant, together with those of Count Potocki, the architect Desmaison, the Lavoisiers and the two magisterial self-portraits of 1790 and 1794. The delicate, soft figure — which offers a glimpse of what would be the fluid line of Ingres — turns a sensitive head towards the spectator. In the purity and sharpness of space (the tripod at the left is an important compositional element) there is a vibrant pictorial harmony, far removed from that "frigid execution" for which Delacroix reproached David. Note the touches of color on the cushions, on the gown, on the braided hair, scattered with quick glimpses of light.

JACQUES–LOUIS DAVID
Paris 1748 — Brussels 1825
Portrait of Madame Récamier (1800)
Oil on canvas; 59 × 94½ in (170 × 240 cm).

EUGENE DELACROIX
Charenton-Saint-Maurice 1798 — Paris 1863
Liberty Leading the People (1830)
Oil on canvas; 8 ft 6 in × 10 ft 8 in (260 × 235 cm).
Exhibited at the Salon of 1831, the painting was
acquired by the French Government.

JEAN–AUGUSTE–DOMINIQUE INGRES. *The Turkish Bath.* p. 176
The Turkish Bath was to have been the property of Prince Napoleon, but his wife considered the work immoral, so the Bonapartes bought a self-portrait instead. Ingres, after recovering the painting, altered the format to its circular shape and made a number of changes in the figures at the edges. Before coming to the Louvre, the painting was owned by the Turkish

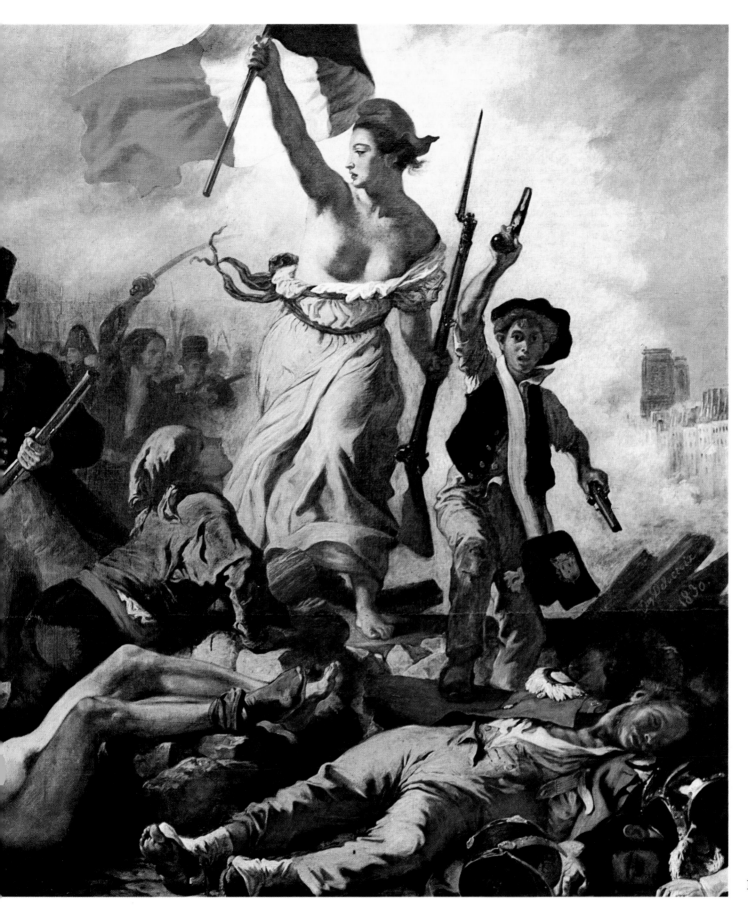

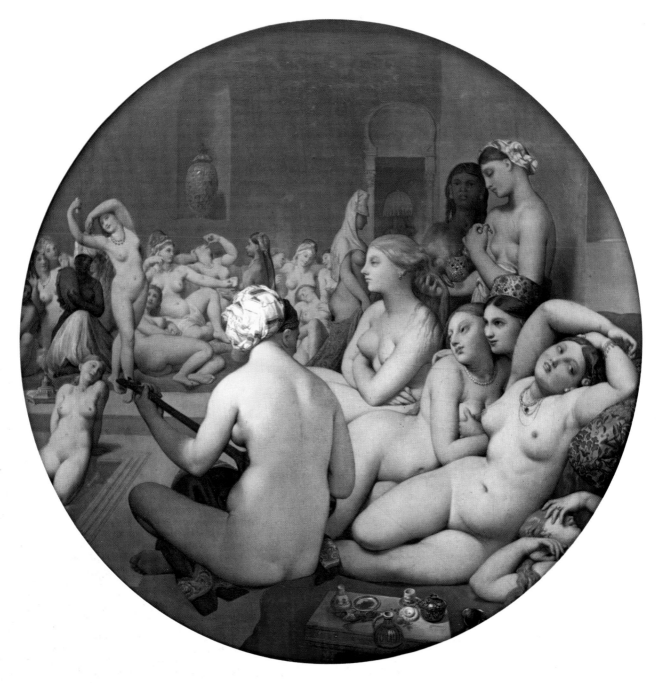

Ambassador to France and later by Prince Amédée de Broglie. Ingres had the theme of *The Turkish Bath* in mind for years. Jean Alazard has pointed out that in one of his notebooks the artist cites a few sentences from the letters of Lady Mary Wortley Montagu (published in 1764): "There were 200 women ... The sofas were covered with cushions and rich carpets, on which sat the ladies, all being in the state of nature, that is, in plain English, stark naked ... yet there was not the least wanton smile or immodest gesture among them." Ingres' *Bathers* of 1828 is an early statement of the idea. But the definitive version of *The Turkish Bath* dates from about 1860 and was finally finished in 1863, when the artist was 84. It can be considered his purest masterpiece; a sort of summation of the subject matter, content and problems he had treated many times before. The artist reveals himself, as always, conscious of the history of his own long artistic development. And it is extraordinary that none of this feeling of recapitulation detracts from the freshness of his inspiration. Many drawings show how specifically Ingres

JEAN–AUGUST–DOMINIQUE INGRES
Montauban 1780 — Paris 1867
The Turkish Bath (1826)
Oil on canvas; diameter 41½ (105 cm).
Signed and dated.
Before entering the Louvre, it was owned by the Turkish Ambassador to Paris and later the Prince de Broglie.

studied each figure, experimenting with them and visualizing them separately and in groups. The creative process was therefore long, and the power of abstract expression can be called absolute. The artist was completely immersed in his search for that depth and mastery of image to which he subordinated all other values. In this work are revealed some of his clearest and most daring intuitions, like that of "distorting" anatomy, and not losing himself in details, but forcing a central idea. The nude in the right foreground shows how Ingres found harmony in "deformation."

FRANÇOIS MILLET. *The Gleaners.*
The Angelus, 1859, and *The Gleaners*, 1857, continue to move the public today just as they did when they were executed. They are typical of the struggling Millet, who grew up on a farm in Normandy, and who, until he was almost 35, could not find his artistic direction. He hated the noise and frantic atmosphere of Paris and found a refuge in the little village of Barbizon in 1849. There he met, among other painters, Théodore Rousseau, whose friend he became. This was a happy and active time for Millet. He followed the style of rural Realism introduced in *The Gleaners*, especially in the three

FRANÇOIS MILLET
Gruchy 1814 — Barbizon 1875
The Gleaners (1848)
Oil on canvas; 21¼ × 26 in (54 × 66 cm).

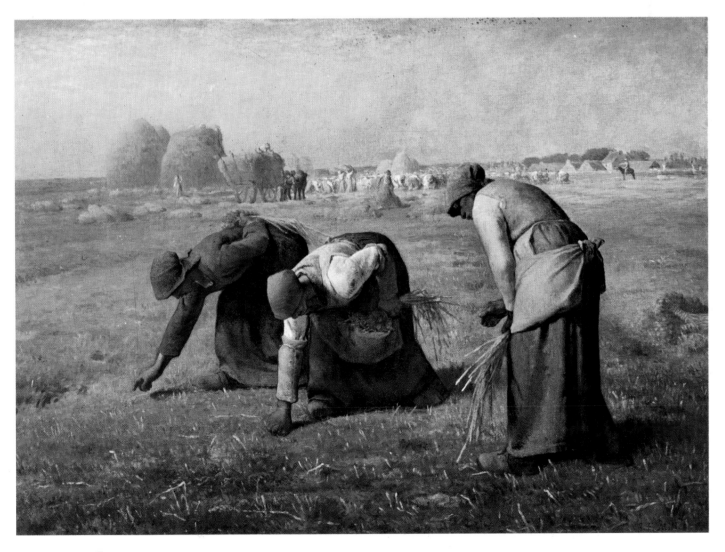

177

figures that stand out against the deep expanse of mowed fields. Note the firmness of the simple design, the absence of anecdote and details not essential to the dignity of the scene. The tiny figures in the background — wagon, horses, houses, trees, hay stacks — are an integral part of the wide landscape where man wears himself out in toil and suffering. In Millet's art, man is almost always in the center, and in this he distinguishes himself from his Barbizon friends, who were trying to understand "the language of the forest." It is indicative that, much later, van Gogh admired and copied Millet.

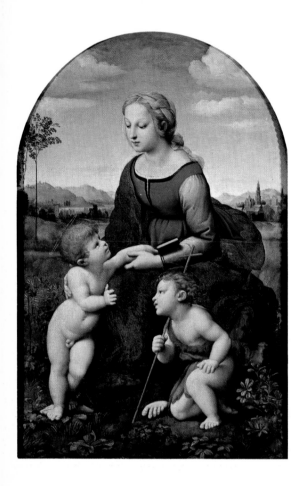

RAPHAEL
Urbino 1483 — Rome 1520
Madonna and Child and St. John the Baptist
(1507)
Oil on panel; 48 × 31½ in (122 × 80 cm).
The work is signed and dated; it can be identified with a *Madonna* which Vasari says Raphael painted in Florence for Filippo Sergardi.

LEONARDO DA VINCI
Vinci 1452 — Amboise 1519
Portrait of Mona Lisa (La Gioconda) (c. 1505)
Oil on panel; 30¼ × 20¾ in (14 × 59 cm).

178

RAPHAEL. *Madonna and Child and St. John the Baptist.*
This is perhaps the work which best reveals the influence on Raphael of Leonardo's mature work, as represented, for example, by the Louvre cartoon for *St. Anne*. Raphael painted this *Madonna* during his stay in Florence, in 1504–09. He deliberately chose certain Leonardesque motifs, and discarded others. Leonardo fragments matter and brings movements into it in an attempt to represent the dynamic aspect of the cosmos, with its infinite possibilities for transformation; Raphael insists instead on a clearly defined articulation of objects represented in their immutable, crystalline inter-relationships. This is why the fluid, descending pyramidal structure of Leonardo's *St. Anne*, which was the pattern Raphael was following, is here completely changed. The resplendent colors form a measured, clear space. Within this space the lines of limbs and garments, uninterrupted by jewels or other decorative motifs, form a clear pattern.

LEONARDO DA VINCI. *Portrait of Mona Lisa (La Gioconda).*
The surface of the picture has suffered from overpainting. The paint has oxidized and today we see the figure through a greenish haze, completely altering the original colors. The significance of the figure, too, has suffered from over-interpretation and false interpretations. Yet somehow the Mona Lisa has, almost miraculously, survived all these vicissitudes. Its meaning is not easy to understand; but neither is it impenetrable, if one studies Leonardo's figurative motifs in the context of his scientific interests. In painting the Mona Lisa, Leonardo was reacting against a 15th-century concept of space which, after having been the focus of scientific and aesthetic investigation during the whole of the century, was tied to a rigid Aristotelian classification. He has swept aside the traditional division of the horizontal plane by converging radial lines and the subordination of the single elements to a single vanishing point, and substituted, in their stead, a gradation of light and color. The frame no longer limits the figure; even the wooden panel loses its solidity. The viewer finds himself before an open window, as Alberti said, or as Leonardo himself put it, "a glass wall"; just beyond is the figure, placed in three-quarter profile, with hands together, the arm of the chair at a slant. There is movement in the evanescent, crinkly folds of the dress, the veil, the hair. A barely perceptible smile touches the curve of the mouth and the eyelids. Everything breathes and trembles imperceptibly: the waves of the water, the mist, the clouds, even the scaly rocks in the infinite, vaporous landscape.

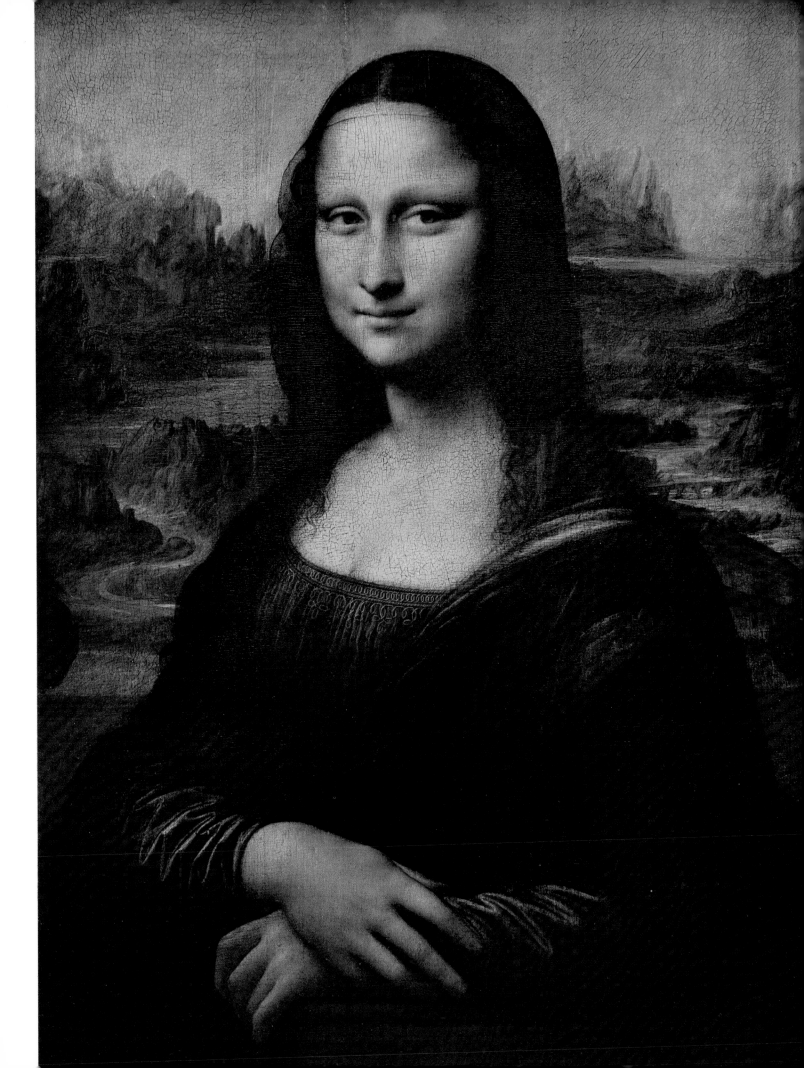

MICHELANGELO. *Bound Slave.*

The figure was executed for the base of the Tomb of Pope Julius II, an ambitious project, several times interrupted and reduced in scale by those who had commissioned the work. Michelangelo struggled with it for 40 years. It was never completed; but the magnificent figures of the *Bound Slaves* bear witness to the incredible effort, both intellectual and physical, which Michelangelo expended upon it. It is in these figures that we can see the concentration he put into this work and the sense of commitment with which he carried it out. In fact, it is just in this instant when he applies himself to hew the human form out of the raw block of marble that we can sense the basic theme of his creative process. The long, almost serpentine, sinuous figure is blocked out by three angles — the elbows, and the knee bent forward, expressing extension in height, width and depth. The figure suffers, in a long, slow spasm, constrained as it is by tight bonds and almost, it would seem, by the unyielding marble itself. Yet the artist in effect has conquered the material, transforming it by means of subtle modeling, lovingly emphasizing the swelling forms of the muscles, and achieving thereby luminous effects reminiscent of Praxiteles.

MICHELANGELO
Caprese 1475 — Rme 1564
Bound Slave (c. 1513)
Marble sculpture; height 90¼ in (229 cm).
Originally planned for the base of the Tomb of Pope Julius II. It was given by the artist to Roberto Strozzi, then living as an exile in France, along with the other *Slave* in the Louvre, at the time of oneof the numerous interruptions and changes in the Pope's monument.

JACOPO TINTORETTO
Venice 1518 (?) — Venice 1594
Paradise (1565–94)
Detail on left side.
Oil on canvas; 56¼ × 142 in (143 × 362 cm).

JACOPO TINTORETTO. *Paradise.*

The subject is similar to that of the huge canvas painted for the Great Council Hall in the Doge's Palace in 1590. This smaller work cannot, however, be considered to be a sketch for the mural: at least it is not its preparatory study. Certain differences in style show that it probably should be dated 30 years earlier, to coincide with Tintoretto's work in the church of the Madonna dell'Orto. Perhaps it was a project for a commission which was never carried out, or perhaps the artist simply painted it for himself. The latter seems probable in view of the free flowing style. Groups of saints and of the blessed are placed within the rolling hemicycles, illuminated by a great light. We watch from below, while above, at a dizzying height, in the center of the "mystic rose," Christ is crowning the Virgin. In the "petals" of the rose all is transformed by color: clouds, figures and drapery are expressed in rapid strokes which define neither by outline nor by shadow, but by bright touches of gold on the rose and red colors, on the greens, above all on the predominant light blue and white. Tintoretto, who never pays too much attention to the solidity of his forms, here surpasses himself in the imaginative, fantastic reconstruction of the heavenly crowds, where any corporeal reality is denied and destroyed. All plastic values evaporate in this world where the successive widening of the "eternal circles" extends to the infinity of time and space.

PAOLO VERONESE. *The Wedding at Cana.*

Veronese liked the theme of the banquet or supper. Many of his pictures show this motif, the best-known being the famous *Feast in the House of Levi* in the Accademia, Venice. He always transformed the theme, setting the various episodes of the religious story into the luxurious surroundings of 16th-century Venice, with its colorful, cosmopolitan crowds of lords and ladies, servants, buffoons, exotic animals and pets, precious silverware and plate, embroidered tablecloths, all within architectural frames — colonnaded porticoes, staircases, terraces — triumphantly open to the light of day. The background is Venice, with marble palaces reminiscent of the local architectural tradition following Coducci, and also of the contemporary classical architecture of Andrea Palladio.

It is within such a context that we must look at this painting. It has been compared unfavorably to other works of the artist, especially to his *Feast in the House of Levi.* It is true that the *Marriage at Cana* is less grandiose compressed as it is between the two rows of huge columns. There are too many

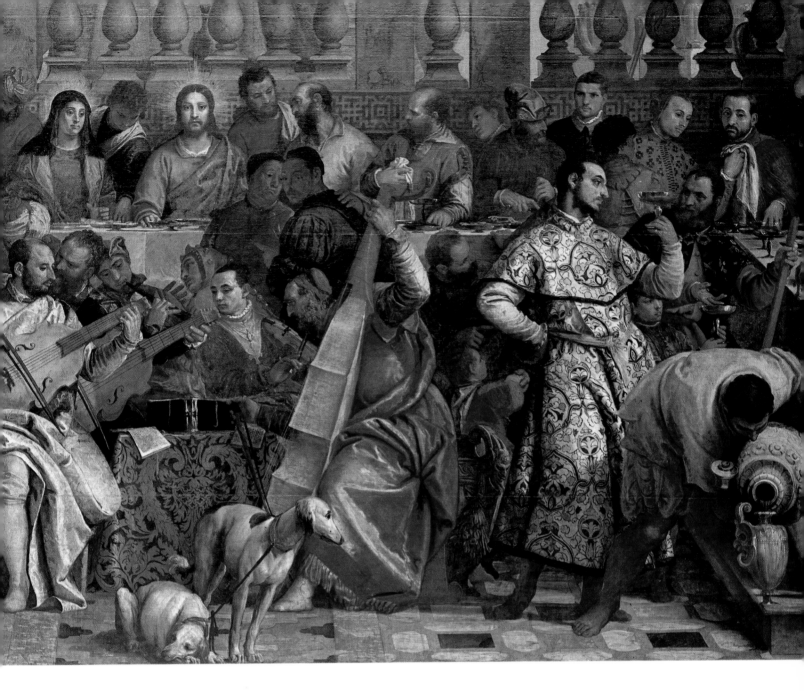

PAOLO VERONESE
Verona 1528 — Venice 1588
The Wedding at Cana (1562–64)
Detail.
Oil on canvas;
21 ft 7¾ in × 32 ft 5¾ in (660 × 990 cm).
Painted for the Refectory of the Convent of
S. Giorgio Maggiore, Venice.

different types of guests, of servants, musicians and paraphernalia in general. Yet the painting is of interest precisely for its experimental quality. It marks a moment of change, after which Veronese expressed himself in a different way, extending the use of quiet, white architectural frames to contrast with the bright colors of human figures.

BENVENUTO CELLINI. *The Nymph of Fontainebleau.* p. 184

Cellini went to France in 1540, invited by Francis I. He could not have found a climate more favorable to his tastes than the School of Fontainebleau. There Rosso Fiorentino together with Primaticcio and others were giving a new impetus to the local school; their taste, as a result of both classical and of persistent late Gothic influence, ran to imaginative sometimes deformed or grotesque forms. It is in such an ambience that we can understand the elongated silhouette of the Nymph, with crescent-shaped forms echoing each other across the bronze plaque: the curved border of the mantle and **183**

the curve of the stag's horns. The decorative quality of the background —
thickly dotted with animals, flowers, leaves, fruits and waving water trans-
formed into a soft resting-place — can only be explained within this same
context in which spatial problems were sacrificed to decoration.

QUENTIN METSYS. *The Moneychanger and His Wife.*
This is one of the best and most characteristic examples of the influence of
early Flemish painting which is such a typical element in the style of Metsys.
Here he almost exactly repeats a painting of Jan van Eyck (which is lost,
but known to us from the description of Michiel). At the same time the
work harks back to Petrus Christus' *St. Eligius*, similar in its detailed, almost
precious rendering of the background, contrasting with the monumental
detachment of the figures. Metsys combines with delicate grace a variety of
stylistic elements taken from Gothic miniatures, from Memling, Gérard
David (the great German artist of his time) and Italian art. He uses these
elements with critical understanding, disciplining contrasting features with-
in a unified vision, and so removing any literal meaning, by adopting them
into his own coherent style.

PETER PAUL RUBENS.
The Arrival of Marie de' Medici at Marseilles. *p. 186*
In spite of the enormity of the task and the speed of its execution, the entire
series celebrating the Queen is from the artist's own hand; so, too, are the
sketches, most of which are in Munich. Only minor help from assistants
could have been contributed towards the final completion of the paintings.
In this picture of the young Queen's disembarkation on French soil, Rubens
has clearly divided the story into two horizontal zones, marked off by the
diagonal line of the gangplank connecting the ship's deck with the not yet
visible shore. Above, in the background — composed of fluctuating and
intersecting decorative elements — can be seen foreshortened, the group
of ladies-in-waiting and attendant mythological subjects, their figures
softened by the pearly glow of the delicate colors and made even more
lyrical by the rhythmic pattern of their gestures. The main episode below
has far more emphasis. Rubens has used the mythological group of sea-
divinities emerging from the glassy waves of an impossible sea, to realize
one of the most daring, remarkable compositions of his career. We see

bursting forth opulent naked forms, intertwined in incredible contortions, hurled forward by agitated waves of violent rhythms, of blazing colors occasionally frozen in sudden crystal light. The ornate, shining section of the ship on the left connects the two scenes with a solid, vertical movement. The immobile, static figure of the gentleman on deck, aloof from both action and participation in the scene, is almost a personification or symbol of detachment from any kind of engagement and of the emotional and formal control the artist, apparently so magnificently spontaneous and impulsive, constantly exercises in his paintings.

FRANS HALS. *The Gypsy.*

This is one of the gayest and most lively characters of that every-day world of the people and of the middle classes which Hals has set down for us: a variety of commonplace scenes expressed with the precipitous force of his imagination, with a boldness of form which seems almost fantastically modern. The brushstroke, itself modeled with skillful variations of thick-

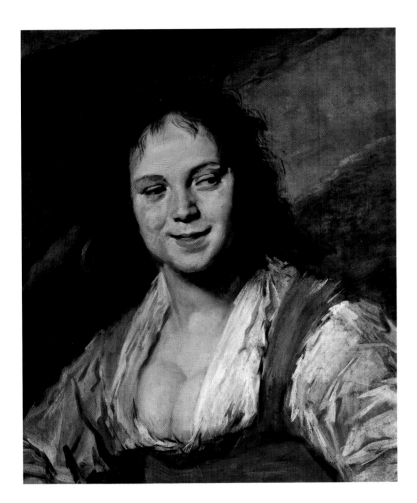

ness and width, impetuous yet fluid, forms the charming figure with only a few simple touches. This portrait is one of the best and most successful examples of the real character of Hals' painting. A clear, sharp light illumi- **187**

nates the figure from the front. The shape is formed by color relationships rather than by light and shade; each stroke expresses at the same time depth, luminosity, movement and material (this is the way Manet understood the use of the brushstroke). The laughing girl, clear and sharp as the light, seems to turn to the viewer with a spontaneity which parallels the artist's own; a spontaneity which is, however, firmly controlled by the artist's sure hand.

JAN VERMEER. *The Lace Maker.* *p. 185*

The figure is placed in the foreground, together with all the secondary elements; it is so close to the viewer that it is difficult to pick out the forms. This is a rare type of composition for the artist, who liked to put large, empty, airy spaces between the viewer and his subject. The placement of the light source to the right is also rare. On the other hand, the low angle of vision, here emphasized by the way the figure is cut off and fitted into the frame, was frequently used by the artist. Both theme and subject are from contemporaneous or earlier genre painters. The extraordinarily "impressionistic" technique and the formal technique in general point to a familiarity with earlier and contemporaneous figurative traditions (for example, Velàzquez). But every historical reference, every traditional element, immediately loses its identity in Vermeer's personality. He is always able to see and to record the unchangeable and inexpressible beauty in everything, the eternal delight of those moments of absolute reality which men are able to feel only rarely, and then never so clearly, strongly and permanently as in his work. In few other works are his exceptional sensibility so realized.

THE METROPOLITAN MUSEUM OF ART
NEW YORK

THE BUILDING

The dynamic growth of the Museum's collections, notably during the past 40 years, is reflected in the history of the building. From the original Calvin Vaux Ruskinian Gothic structure initiated exactly a century ago, through Richard Morris Hunt's colossal Neoclassic plan for the extension of the building along Fifth Avenue and his Great Hall (1895), followed by McKim, Mead, and White's grandiose Fifth Avenue façade and large open courts, to subsequent structural additions, the successive plans of the Museum have never been able to keep pace with the demands for accommodating the continuing flood of acquisitions, nor the incredible growth of attendance and related activitites.

To meet this demand, the Trustees in 1967 approved the formulation of a Master Architectural Plan for the Metropolitan's second century. The firm of Kevin Roche John Dinkeloo and Associates was given the commission to develop the Plan.

PLAN OF THE MUSEUM

The shading indicates offices or areas in the process of being renovated.

SECOND FLOOR

22 Islamic Art
23 Greek and Roman Art
24 Ancient Near Eastern Art
25 Special Exhibition Area
26 Drawings, Prints and Photographs
27 European paintings
28 Far Eastern Art
29 Musical instruments
30 Japanese galleries
31 Chinese paintings
32 19th-century European Paintings
 and Sculpture

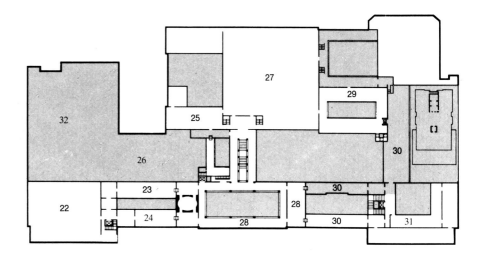

FIRST FLOOR

8 Restaurant
9 Greek and Roman Art
10 Library
11 Velez Blanco Patio
12 European Sculpture and
 Decorative Arts
13 French rooms
14 English rooms
15 Robert Lehman Collection
16 Medieval Art
17 Entrance, information, bookshop
18 Arms and Armor
19 Grace Rainey Rogers Auditorium
20 Egyptian Art
21 Sackler Wing, Temple of Dendur
21a Michael C. Rockefeller Wing

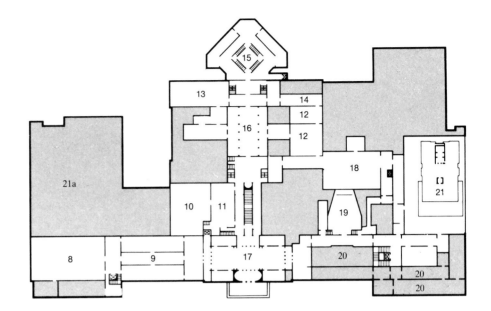

GROUND FLOOR

1 Car Park
2 Snack bar
3 Junior Museum Library
4 Junior Museum Auditorium
5 Photographic Library
6 European Decorative Arts
7 The Costume Institute

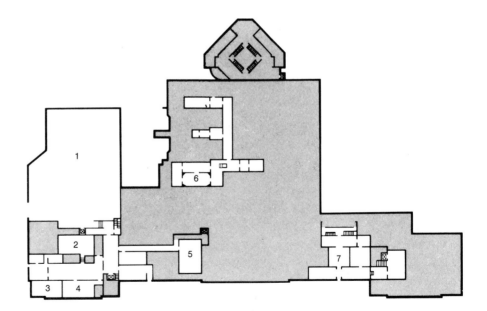

EGYPTIAN ART, MIDDLE KINGDOM. *King Senwosret I Striding.*
Made up of no less than 16 pieces of cedar skillfully joined together, this figure of Senwosret I depicts him advancing forward, wearing the red crown of Lower Egypt and a short kilt, and holding the *hk3* scepter in his left hand. This statue, which is a good example of the art of the Middle Kingdom, *projects* the aura of majesty and restrained energy. Although subject to the rules of the Egyptian tradition in art, i.e. carved to be viewed only from the front, this figure shows beautiful modeling and a very careful attention to detail, which is rarely seen even in larger sculptures in the round.
Senwosret I, the second king of the 12th Dynasty, was one of the greatest rulers of Ancient Egypt. He ascended to the throne after quashing an attempted coup d'état in which his father, Amenemhat I, was assassinated. Senwosret I enlarged the boundary of Egypt beyond the Third Cataract in Nubia, re-established the central control of the Pharaoh all over the land, and continued the renaissance of the arts — architecture, sculpture, painting and writing — during the Early Middle Kingdom.

EGYPTIAN ART, MIDDLE KINGDOM
(11th, 12th and 13th Dynasties:
c. 2134–1700 B.C.)
King Senwosret I Striding (1972–28 B.C.)
Painted cedar, and stucco; height 23 in (58.4 cm).
From Lisht, South Pyramid.
Found in a secret chamber in the wall around the tomb of Senwosret's High Priest of Heliopolis, Imhotep.
Edward S. Harkness and Rogers Funds, 1914.

EGYPTIAN ART, NEW KINGDOM
(18th Dynasty: *c.* 1570–1320 B.C.)
Queen Hatshepsut Seated (*c.* 1495 B.C.)
White indurated limestone;
height 77 in (195.5 cm).
A seated statue of the Queen, wearing the royal headdress (*nemes*) and Uraeus. Traces of paint are noticeable on the headdress, eyes and eyebrows, the broad collar and the inscriptions.
From the Mortuary Temple of Hatshepsut, Deir el-Bahri, Western Thebes.
Rogers Fund, 1926–28.

EGYPTIAN ART, NEW KINGDOM. *Queen Hatshepsut Seated.*
Hatshepsut, the female Pharaoh, is very well presented in the Metropolitan Museum of Art's collection. This seated statue, done in indurated limestone, is one of the best examples of the sculpture in her time. The Pharaoh is uniquely depicted as a woman with delicate facial features, slim body and small breasts. Her attitude and her attire are those traditionally used in the representations of royal figures.
The statue, though heavily restored, is a magnificent example of the Theban art tradition at the beginning of the 18th Dynasty.
Hatshepsut, one of Egypt's female rulers, lived during a period of Egyptian ascendancy. Her father, Thutmosis I, was the first Egyptian ruler to campaign into Mesopotamia and her nephew, Thutmosis III, who succeeded her to the throne, established the first Egyptian empire in Asia.

GREEK ART, HELLENISTIC PERIOD. *Sleeping Eros.*
Eros, the young attendant of Aphrodite, began to be truly popular in Greek
art during the 5th century B.C. It was in the Hellenistic Period, however,
that the characterization of Eros developed from that of a small youthful
person with wings into that of a child. This work illustrates the achievement
admirably. A young boy with a soft fleshy body is shown lying on a base (re-
made in stone) in a position in which only a child can sleep. His wings alone
distinguish him from an ordinary mortal. The immediacy and naturalism of
the rendering depends to a great extent on the technical mastery that bronze
workers had acquired by the 3rd century B.C. The sculpture was cast by the
"lost wax process" in six pieces (including the left arm, now missing) that
were then carefully joined. Equally accomplished was the cold-working of
surface detail in the boy's hair and wings.

ROMAN ART, POMPEII. *Kithara Player.*
This figure formed part of the mural decoration in a villa at Boscoreale,
situated on the foothills of Mount Vesuvius and destroyed by the volcanic

GREEK ART, HELLENISTIC PERIOD
Sleeping Eros
(3rd century B.C.)
Bronze; length 33⁹⁄₁₆ in (85.2 cm).
Said to be from the Island of Rhodes.
Rogers Fund, 1943.

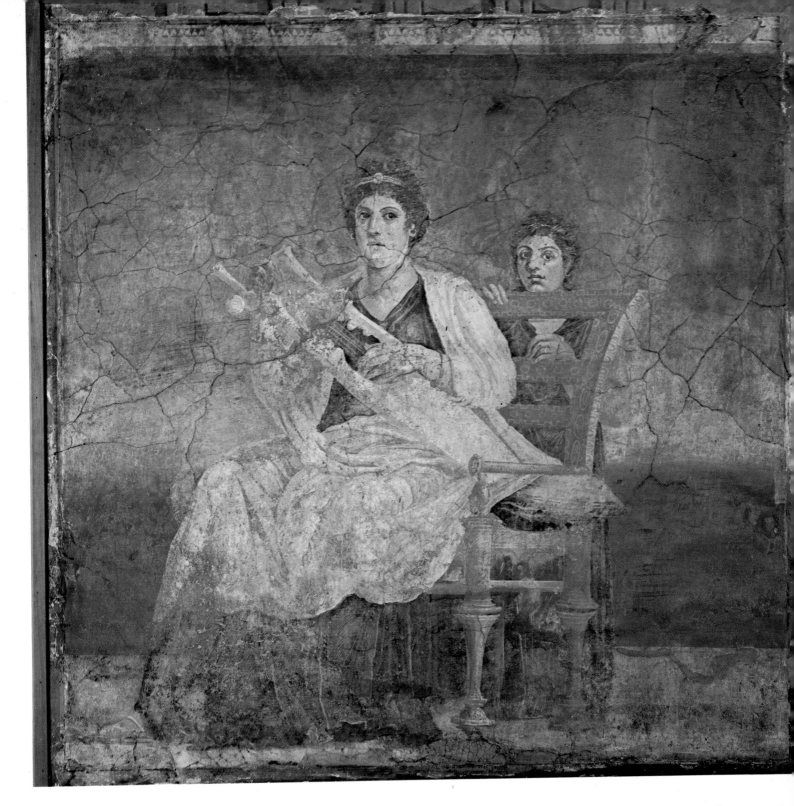

ROMAN ART, POMPEII
Kithara Player (c. 40–30 B.C.)
Painted on plaster; 71½ × 71½ in (187 × 187 cm).
From the east wall of a large room in a villa near
Boscoreale, buried by the eruption of the
Vesuvius in A.D. 79. Two other paintings from
the west wall are in the National Museum,
Naples.
Rogers Fund, 1903.

eruption of A.D. 79 that overwhelmed and buried the towns of both Pompeii and Herculaneum.

The painting is one of three in the Museum from the same room; none of the subjects, however, have been conclusively explained. Here, in any case, we see a Roman lady richly dressed and bejeweled, seated in a throne-like chair with a young girl behind. She holds a kithara, but seems more intent on something before her than on her instrument. The sumptuous effect of the painting is created not only by the subject, but also by the rich and luminous colors that are well preserved. Given the dearth of ancient painting preserved to us, such Roman frescoes are as important to us as they are beautiful.

195

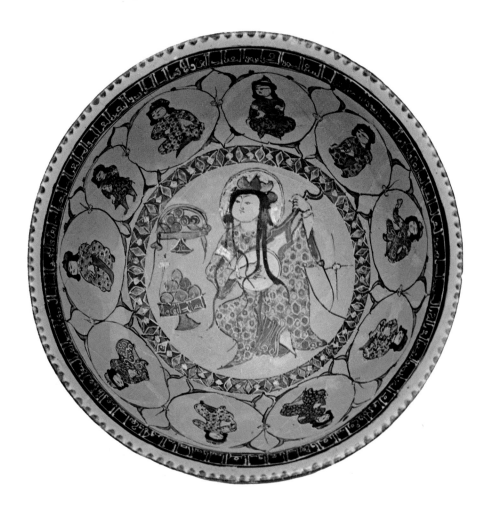

SELJUQ ART
(late 12th — early 13th century)
Dish with Seated Musician
Overglaze polychromy and gilt on turquoise
glaze; height 3½ in (8.9 cm),
diameter 7¾ in (19.7 cm).
Henry G. Leberthon Collection.
Gift of Mr. and Mrs. A. Wallace Chauncey, 1957.

SELJUQ ART. *Dish with Seated Musician.*

The conquest of the Islamic lands by the Seljuq tribes beginning in 1038 brought active signs of technical and formal renewal in every field of representational art. Similar to the work from Rayy, this wide bowl or dish of the so-called *"minai"* type, dating from the late 12th or early 13th century, has the characteristic monochrome turquoise ground often used. Of special interest is the setting for the principal figure, here achieved with great effect by the insertion of two bowls of fruit, a real "still-life." The decoration of the wide border is also typical, in the recurrent motif of ovals and stylized plant forms aligned between two slender bands, enclosing various little seated figures acting as if in a chorus for the central figure, a woman playing a musical instrument which has been identified as a member of the lute family. *Minai* is the Persian word for enamel, in a process in which stable colors were stain-painted in the glaze and fired, then less stable colors applied and the object re-fired at a lower temperature.

CHINESE ART, NORTHERN WEI DYNASTY. *Maitreya.*

Buddhism, a religion founded in India in the 6th and 5th centuries B.C., slowly spread to Central Asia and eventually reached China about the 1st century A.D. It became firmly rooted in China under the T'o-pa, a Hsien-pi Tartar people who invaded and ruled north China as the Northern Wei dynasty from 386–535 A.D. Many Northern Wei emperors were fervent Buddhists and actively encouraged Buddhism. In 460 A.D. Emperor

Right:
CHINESE ART,
NORTHERN WEI DYNASTY
(late 5th century)
Maitreya
Stone with traces of polychromy;
height 51 in (130 cm).
Gift of Robert Lehman, 1948.

Far right:
NORTHERN INDIAN ART
(first half of 7th century)
Standing Buddha
Bronze; height 18½ in (47 cm).
Bequest of Florance Waterbury, 1969.

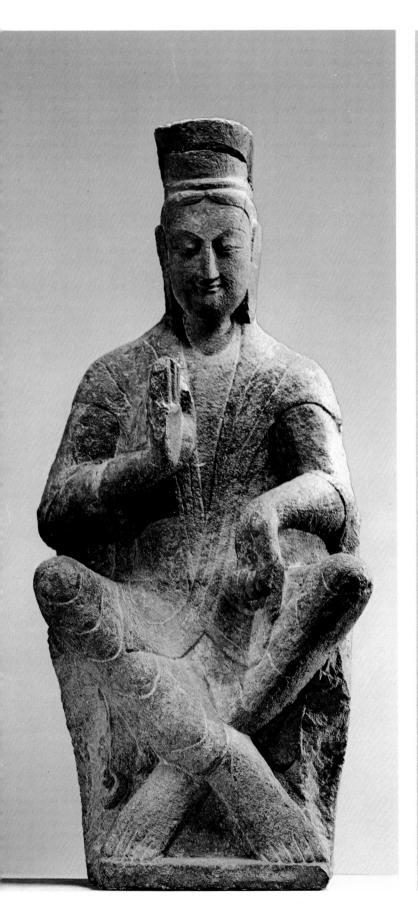
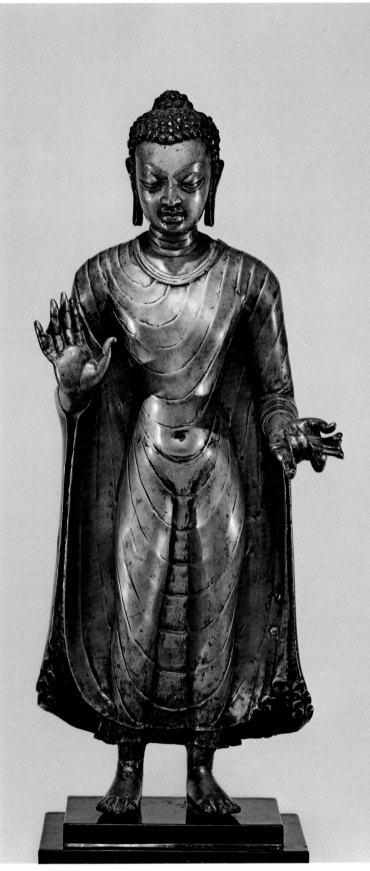

Wen-ch'eng ordered the carving of the greatest monument of early Buddhist art in China: the cave temples of Yün-kang in Shansi province, near the capital Ta-t'ung.

For close to 40 years, thousands upon thousands of sculptors and craftsmen labored to hew a vast complex of some 20 major cave temples out of the sandstone mountain ridge of Yün-kang, under the shadow of the Great Wall. Each of the five earliest caves contains a colossal image of Buddha, the tallest measuring over 50 feet in height, filling almost the entire excavation; while the later caves are more architectural in concept with intricate ground plans and walls arranged in several stories. The interior walls of the caves were carved into niches and galleries filled with images of Buddhas, Bodhisattvas, apsaras or celestial musicians, donors and guardians.

This image from Yün-kang probably once graced a niche in Cave XVA. It represents Maitreya, or Mi-lo-fo in Chinese, the Buddha of the Future who will descend from the Tushita Heaven to save all living creatures. His true right hand is in the *abhaya mudra*, signifying "fear not"; while his left hand is in the *varada mudra*, a gesture denoting charity.

The broadly rendered sculpture, with a serene and spiritual face and a body carved in a flat and slender manner, is conceived as an abstract diamond pattern with the tall crown as the apex and the knees and crossed ankles as the other cardinal points.

Originally many of the sculptures at Yün-kang were brightly painted with polychrome. Traces of red and white pigments remain on the lower portion of the piece, giving added warmth to this superb icon.

NORTHERN INDIAN ART. *Standing Buddha.* *p. 197*

Dating from the late Gupta period, this image is stylistically dependent on types developed in Madhya Pradesh and Uttar Pradesh (Central and North Central India) during the 6th century.

The sculptural styles of the great Gupta empire are well preserved by rich remains in stone, but relatively few bronzes have survived. When the aesthetic qualities of a surviving bronze sculpture are on a particularly high level, its importance is considerably enhanced.

Here, the Buddha stands in a slight hip-shot position, his left hand holding a portion of his outer robe; his right, raised in the fear-allaying gesture, clearly shows the webbing between the fingers, one of the supranatural physical marks of a Buddha. This tall and elegant image with its large, powerful head is the kind of North Indian sculpture that played a major role in the formulation of the early Nepali style. Indeed, part of the long history of this particular sculpture included a stay of unknown duration in Nepal.

CAMBODIAN ART. *Kneeling Queen.*

This regal female is superbly modeled in soft generalized forms, with a surface made taut as if by an inner expanding energy. The composition of the figure suggests an organic expansion, the narrow contour of the legs, hips and waist blossoming to full shoulders supporting a large head framed by the raised arms.

Strong but harmonious visual rhythms and contrasts of form are established

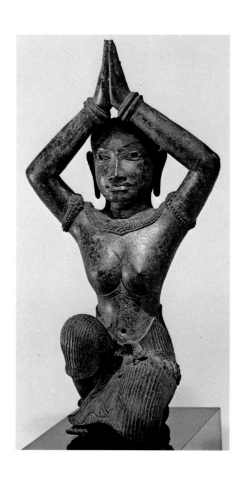

CAMBODIAN ART, ANGKOR PERIOD
(Angkor period, Baphuon style,
c. mid 11th century)
Kneeling Queen
Bronze, with traces of gold, eyes inlaid with silver; height 17 in (43 cm).
Bequest of Joseph H. Durkee, by exchange, 1972.

by the sharp, diamond-shaped silhouette of the raised arms and the graceful arrangement of the masses of the lower part of the body. The upward visual thrust of the hands has its counterpart in the thrust of the right knee towards the spectator. Altogether this is a magnificently poised and balanced sculpture, successfully conceived from every viewing angle.

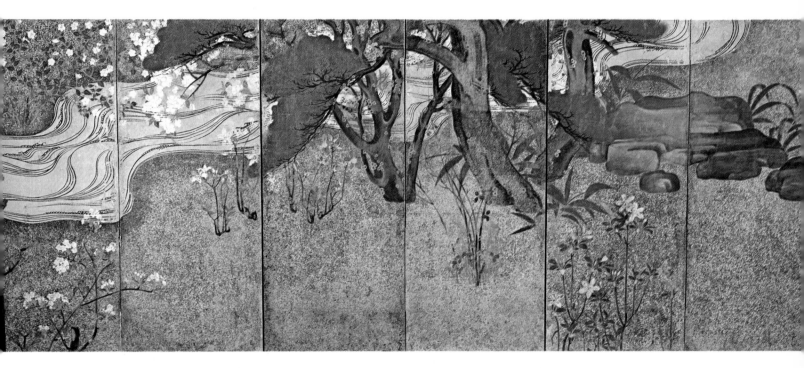

JAPANESE ART, EDO PERIOD
(Sotatsu-Korin School, 17th century)
Trees and Flowers by a Stream
Color on mounted paper;
48 × 123 in (122 × 313 cm).
One of a pair of 6-fold screens on the "Four Seasons," the companion of which had been acquired by the Museum 34 years earlier.
Gift of Horace Havemeyer, 1949.

The "Queen" wears a pleated *sarong* secured by a sash with jeweled pendents. The left hem of the *sarong* is folded over, creating a frontal panel of cloth resting between the legs and terminating in the "fishtail" silhouette reminiscent of earlier Khmer styles. The precision of detail of jewelry, dress, and hairdo shows a particularly high level of metalworking technique, surely the work of a major imperial workshop.

The statue dates to around the middle of the 11th century, and is in the style of the Baphuon temple (*c.* 1010–80), which can be considered the "classic" phase of Khmer architecture and sculpture, rooted in the transitional style of Banteay Srei (*c.* 967–1000) and contrasting strongly with the more iconic art of the 9th and first half of the 10th centuries.

JAPANESE ART, EDO PERIOD. *Trees and Flowers by a Stream.*
As early as the mid-8th century an anthology of poetry, *Manyoshu*, mentions flowers and trees, which in the Japanese mind denote specific seasons. This subtle connection between flora and the seasons has for centuries been a part of the Japanese artist's repertoire. In this screen — one of a pair on the Four Seasons — the mood of spring is created by light-colored blossoms of *yamabuki*, pear, cherry and iris, and accented with tiny red azalea blossoms. Thus, the feeling of the season is conveyed not with one but with several spring plants. The river running behind the pine trees and through blossoms creates the feeling of a balmy spring day.
The pine trees in the center overlapping the river project a certain amount of **199**

realism and suggest depth. Yet some abstraction is still displayed in this painting: massive open space, big clumps of pine leaves and stylized waves are conceived in a style reflecting the influence of Sotatsu (first half of the 17th century) and Kōrin (1658–1716).

The screen bears neither signature nor seal. Although Fenollosa and some others considered this pair of screens to be original works of Kōetsu (1558–1637), modern scholars discredit this attribution.

PRE-COLUMBIAN ART, PERU. *Storage Container.*

Nathan Cummings has recently presented a fine pair of storage jars to the Metropolitan Museum to add to the outstanding collection of Peruvian pottery previously donated. The top part of these large jars is incised and painted with trophy head demons typical of the late Paracas style. The two jars, said to be from the site of Chucho below the Pisco River drainage, are examples of the magnificent flowering of so-called Rio Grande pottery tradition which in the period between 300 and 100 B.C. established itself as the richest and most original form of production on the south coast of Peru. These jars are of exceptional interest in that they have survived centuries of burial intact. They are identical in shape, size and decoration. The only difference is the nubbin which is the relief head of a falcon, its unfurled wings painted on the jar.

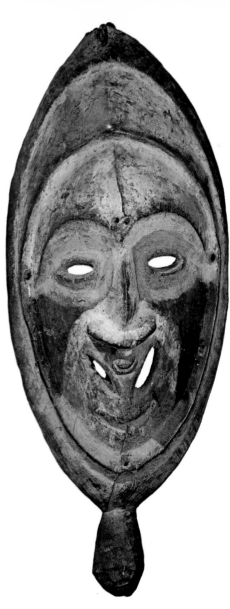

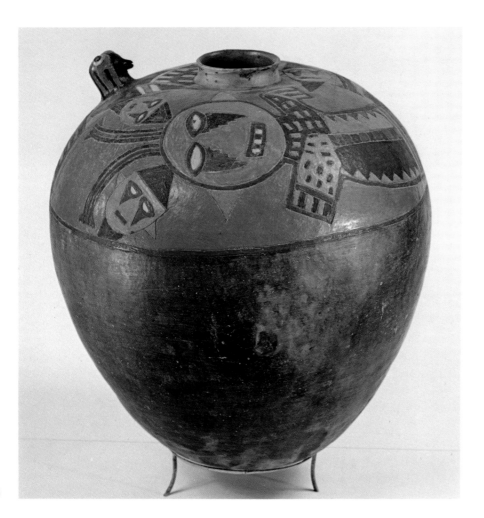

PRE-COLUMBIAN ART, PERU
(300–100 B.C.)
Storage Container
Resin-painted clay blackware, with upper surfaces in colored pigment; painted bird-figures have three-dimensional heads;
height 17½ in (44.4 cm), width 17 in (43 cm).
Gift of Nathan Cummings, 1974.

200

OCEANIC ART, PAPUA NEW GUINEA. *Mask.*

Papua New Guinea — the eastern half of the island of New Guinea — is famous for its traditions of mask-making using a wide variety of materials. The wooden mask illustrated comes from the Ramu River valley, an area close to the Sepik River valley (which is well-known for its mask production) and shares a number of characteristics with masks from the mouth of the Sepik. It is probably from the Rao tribe, a little-known group of the middle Ramu River.

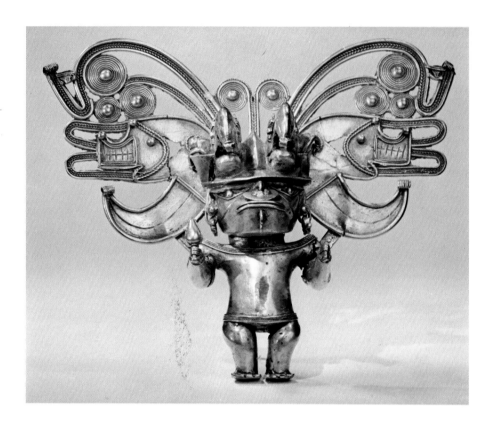

PRE-COLUMBIAN ART, COLUMBIA. *Figural Pendant.*

The fascinating and varied metalwork of Colombia played an important part in the lively and fruitful interchange between ancient South American civilizations. We do not yet know the full extent of Colombia's contribution to ancient South American civilization. In the northeast, the peoples of the Sierra Nevada de Santa Marta formed a distinct cultural entity and this highly sophisticated pendant is a superb example of its so-called "Tairona" style (A.D. 1200–1500). The figure with its enormous headdress is one of several which share like features. The frontal figures hold similar objects (here rattle-like) in each hand, and the large headdresses consist of lateral spirals and paired stylized profile bird and animal heads. From the visor of the figures' caps there are pairs of long-beaked bird heads. Representational differences among the figures are in the details of the face, nose rods, lip plugs, and ear ornaments, are variable. A major distinction, however, occurs when the figure appears with a crocodile head. As in many other Pre-Columbian cultures, the Tairona alloyed gold with copper, and many of these elaborate works were cast in that alloy.

201

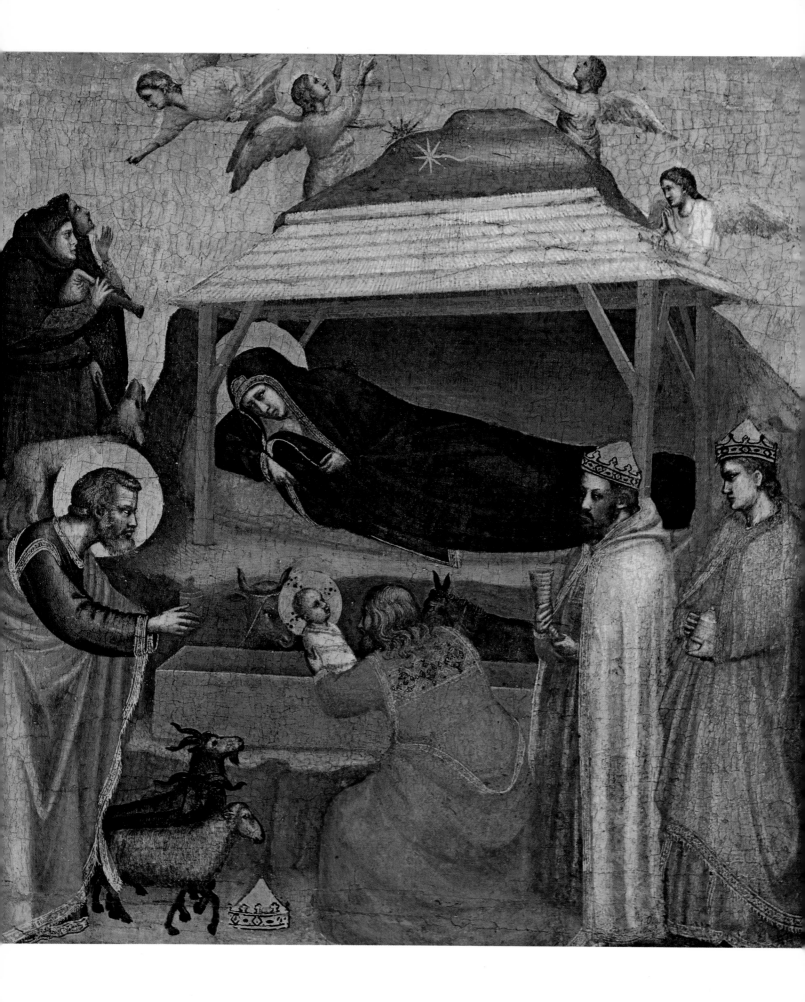

GIOTTO. *Nativity and Adoration.*

This panel is one of a series on the *Life of Christ* of which six others survive: *The Presentation in the Temple* (Boston, Isabella Stewart Gardner Museum), *The Last Supper*, *Crucifixion* and *Christ in Limbo* (Munich, Alte Pinakothek), *The Entombment* (Settignano, Berenson Collection), and *The Pentecost* (London, National Gallery). This series is related stylistically to Giotto's frescoes in the Peruzzi chapel in S. Croce, Florence, and it has been suggested that the scenes were part of a set of panels for the altar of that chapel or for the adjoining Bardi chapel. According to another theory these scenes from the *Life of Christ* may have been part of an altarpiece in Borgo San Sepolcro, which Vasari reports was dismembered and subsequently brought to Florence in the 14th century.

GIOTTO DI BONDONE
Colle di Vespignano 1267 (?) — Florence 1337
*Nativity, Adoration of the Shepherds
and the Magi*
Tempera on wood, gold ground;
17¾ × 17¼ in (43.8 × 45 cm).
John Stewart Kennedy Fund, 1911.

GIOVANNI BELLINI
Venice *c.* 1430 — Venice 1516
Madonna and Child (*c.* 1460)
Tempera on panel; 21⁵⁄₁₆ × 15⅝ in (54 × 39 cm).
Formerly in the collection of the Potenziani
princes, of Rieti and the Marches.
Robert Lehman Collection, 1975.

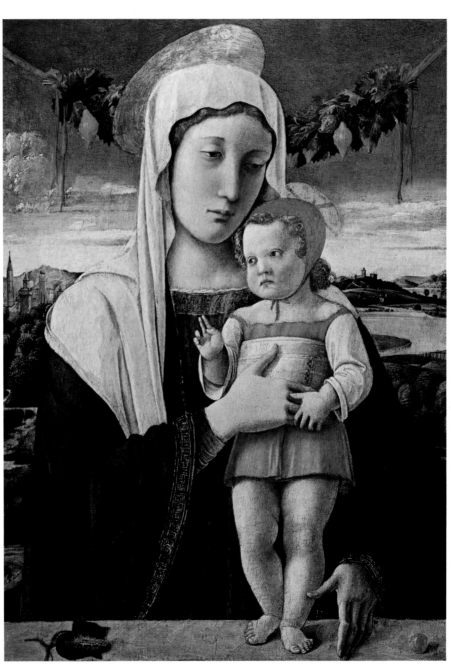

This group of almost square panels, if completed by other scenes usually included in such traditional treatments of the *Life of Christ* as the decorations of the Arena chapel, might have numbered as many as 24. If divided into two sets they might have constituted the doors of the kind of cupboards one often finds in church sacristies. In the surviving seven pictures, Giotto, now in his full maturity, reduces the plastic forms to essentials and creates a subtly balanced composition of monumental masses.

GIOVANNI BELLINI. *Madonna and Child.* *p. 203*
The Potenziani Madonna (so-called because of its provenance) is qualitatively one of the greatest testaments to Bellini's youthful period. The light, shafting in from the left, gives form, life and vibration to the static group in the foreground and highlights the deep colors, as well as the suspended green garland, which forms a small inner framework within which the figures are shown as though in high relief, carved out of hard, precious materials. In the arrangement and modeling of its three-dimensional forms, the work clearly shows its debt to the contemporary master of Padua, Andrea Mantegna. And this is also true of the landscape, stretching some way behind the Madonna's shoulders; it spreads out in marked contrast in the depths of the background up to the wide sweep of the river. Compared with Mantegna's stony, archeological impassivity, Bellini's *Madonna* — dated about 1460 — communicates a penetrating and emotional intensity.

TITIAN
Pieve di Cadore 1488–90 — Venice 1576
Venus and the Lute Player
Oil on canvas; 65 × 82½ in (165 × 209.5 cm).
Frank A. Munsey Fund, 1936.

TITIAN. *Venus and the Lute Player.*
This example of a subject so beloved by Titian was painted in his later years, around 1560, and seems to be the prototype for an almost identical version in the Fitzwilliam Museum, Cambridge.
The hypothesis that a number of years passed between the beginning and the completion of this painting is unconvincing. There is in it an evident link with the two versions of *Venus and the Organ Player*, one of which, the

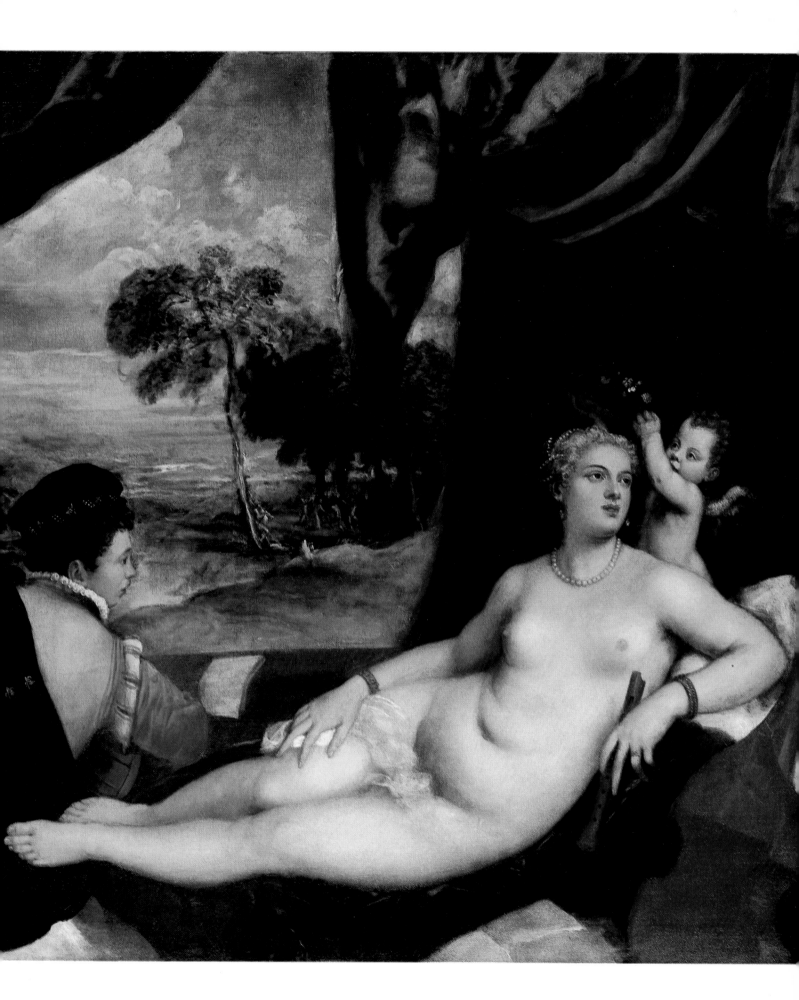

AGNOLO BRONZINO
Florence 1503 — Florence 1572
Portrait of a Young Man
Oil on wood; 37⅝ × 29½ in (95.5 × 75 cm).
Bequest of Mrs. H.O. Havemeyer, 1929.
The H.O. Havemeyer Collection.

PAOLO VERONESE
Verona 1528 — Venice 1588
Mars and Venus United by Love
Oil on canvas; 81 × 63⅜ in (205.7 × 161 cm).
Signed (on marble fragment at bottom):
PAVLVS VERONENSIS. F.
The earliest recorded owner of this painting was
Empror Rudolf II, Prague, and then his successor
Ferdinand III; it was subsequently in the
collection of Queen Christina of Sweden; later,
the Dukes of Orléans, including Duke Philippe
d'Orléans, Paris.
John Stewart Kennedy Fund, 1910.

Prado picture, can be dated 1548 on reliable documentary evidence. This entire group is characterized by Titian's adoption of a large crescent-shaped form, which unifies the entire composition against a bold background. Other examples are the *Dresden Venus* (a work by Giorgione which Titian finished), Titian's *Venus of Urbino* of 1538, and the many others he did within a relatively short period of time at the height of his maturity as an artist.

AGNOLO BRONZINO. *Portrait of a Young Man.*
This portrait was identified as a Duke of Urbino by the legend on an old engraving by Pietro Fontana. The sitter, however, bears no resemblance to authenticated portraits of Guidobaldo II, who was Duke of Urbino at this time. This portrait is usually dated in the 1530s, immediately following Bronzino's return to Florence from Pesaro, where he undertook several

commissions for the Duke of Urbino. The portraits of a *Young Man with a Lute*, the *Bartolomeo Panciatichi* in the Uffizi and the *Ugolino Martelli* in Berlin are approximately contemporary with the Metropolitan's portrait. The striking figure stands in the center of a noble setting of an architectural interior. The diagonal composition and the general prismatic delineation show further how Bronzino was returning, like Rosso and Pontormo, to the art of the Quattrocento. The head, precisely rendered and sculptural in its modelling, goes back to the classical manner, not with sentimental nostalgia but rather in the search for aesthetic truth, the full meaning of which is proudly rediscovered in this extraordinary renewal of the ancient equation of architecture, sculpture and painting.

PAOLO VERONESE. *Mars and Venus United by Love.* *p. 207*
Although this painting appears to illustrate a simple fable of love it may actually be laden with complicated symbolism. This signed work dates from about 1570, when Veronese was at the height of his powers. For a long time it has been thought to have been part of a series of allegories painted for the Emperor Rudolph II in about 1576, and later in the collection of Queen Christina of Sweden. In fact, it may be from another series, mythological rather than allegorical, or perhaps an isolated work.

On several occasions, most notably in 1575, in the decorations for the Sala del Collegio of the Doge's Palace in Venice, Veronese experimented on the walls and ceiling with unusual formats, using broken, curved shapes. The scenes look fleeting and ephemeral, but their composition and perspective are firmly rooted in a knowledge of 15th-century proportion and measure.

This picture of Mars and Venus is rendered as a light-hearted Arcadian scene with a hint of Ariosto-like irony. Yet underlying the mood, and without destroying it, a web of structural relationships combines the figures and their setting in a brilliant, animated whole.

JEAN-BAPTISTE-SIMÉON CHARDIN. *Boy Blowing Bubbles.*
Chardin's technical mastery was perfected during his long and rigorous apprenticeship with masters such as Coypel and van Loo, and he was also influenced by Dutch still-life and genre painting. The delicate tonalities and refined compositional style that he assimilated in Paris from the work of the early 18th-century French artists harmonize successfully in the pleasing domestic and anecdotal scenes that form the main body of his work until 1771. Like Liotard, Chardin stands apart from his contemporaries, because he decisively rejected 16th- and 17th-century artistic formalism.

The version of the *Boy Blowing Bubbles* in the Metropolitan Museum is one of the earliest of the various paintings Chardin did of this theme. Another version, now unaccounted for, was exhibited in the 1739 Salon in Paris, and there are others in Washington, Kansas City and in private collections. This painting suggests the impermanence and futility of human existence (and possibly also female inconstancy) and made a pair, at least in the 1779 sale of the Trouard collection, with the *Boy Playing Cards* that is now in the Oskar Reinhart Collection in Wintherthur.

JEAN-BAPTISTE-SIMÉON CHARDIN
Paris 1699 — Paris 1779
Boy Blowing Bubbles
Oil on canvas; 24⅞ × 24 in (63.2 × 61 cm).
Signed (on stone at left): J. Chardin.
Before World War II successively in the collections of D. David-Weill, Paris, and Fritz Ingres P. Amsterdam; then confiscated by the Nazis and sent to the Führer Museum, Linz.
Wentworth Fund, 1949.

EDOUARD MANET. *Boating.*

The Museum's outstanding collection of the works of Edouard Manet
ranges from paintings of Spanish subjects, for example the famous *Spanish
Singer*, to juvenile studies after Delacroix (*The Bark of Dante*) and Carracci
(*Fishing in Saint-Ouen*), and to the portraits and still-lifes on which the artist
concentrated in his last years.

Particularly happy, and representative of his most important period, when
he was associated with Renoir and Monet, is this double portrait. The man
may be his brother-in-law, Rodolphe Leenhoff; the identity of the woman
is unknown. It was painted, together with the picture called *Argenteuil* in
the Tournai Museum, during the summer of 1874, but unlike the latter, on
which he worked for a long time, this canvas is said to have been completed
in a very short time. So we are told by the painter Mary Cassatt, who
persuaded the collector Mrs. Havemeyer to acquire it immediately, when
they saw it on exhibition at the Salon. The speed at which it was painted
gives the picture the freshness and spontaneity of a sketch.

EDOUARD MANET
Paris 1832 — Paris 1883
Boating (1874)
Oil on canvas; 38¼ × 51¼ in (97.2 × 130.2 cm).
Signed (lower right): Manet.
Exhibited at the Salon of 1879.
Bequest of Mrs. H.O. Havemeyer, 1929.
The H.O. Havemeyer Collection.

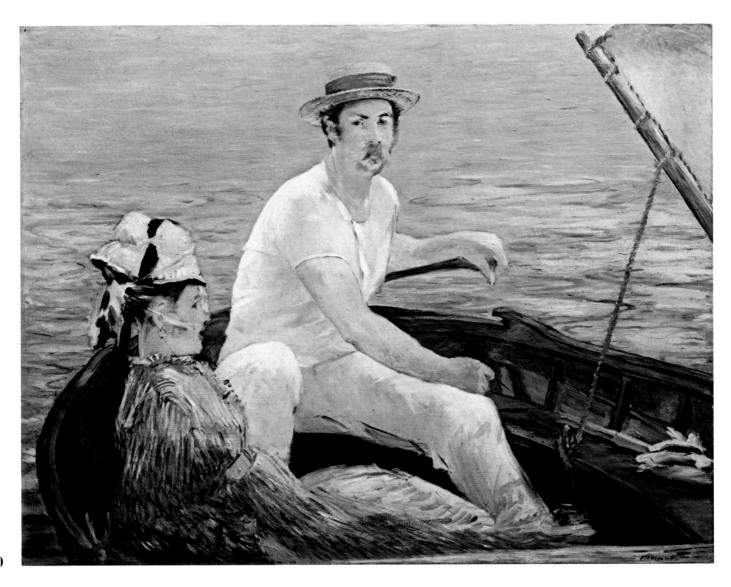

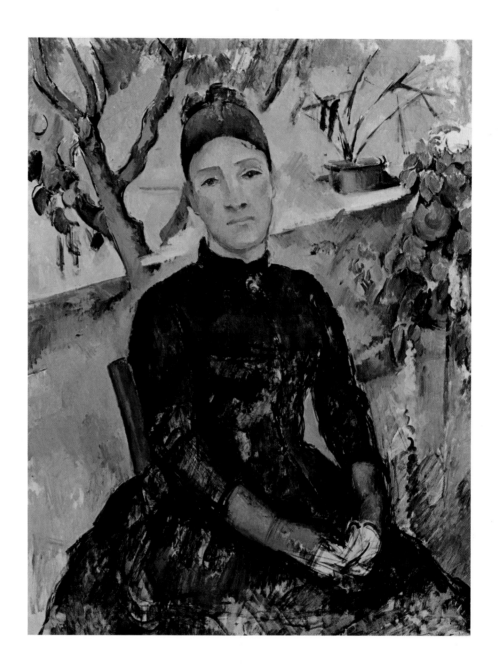

PAUL CÉZANNE
Aix-en-Provence 1839 — Aix-en-Provence 1906
Madame Cézanne (*c.* 1890–91)
Oil on canvas; 36¼ × 28¾ in (92 × 73 cm).
Bequest of Stephen C. Clark, 1960.

CÉZANNE. *Madame Cézanne.*

The Metropolitan Museum of Art possesses several major works by Paul Cézanne, from the early *Uncle Dominic* (1865–66) to *The Gulf of Marseilles* (1883–85), *Madame Cézanne in a Red Dress* (*c.* 1890) and the famous *Card-Players* (*c.* 1892). This portrait of *Madame Cézanne* was probably painted in 1883–84 and is one of the finest examples of his work at the moment of his artistic maturity.

The brush strokes retain their initial freshness, the color its organic nature and the image is endowed with calm and serenity. It is unfinished only in the technical sense, for it is a vivid portrait, suggesting the essential qualities of the model, the painter's wife, Hortense Fiquet.

HENRI ROUSSEAU. *Repast of the Lion.*

Of all the pictures of animals, ranging freely or in conflict, of magical dreams or transfigured biblical and allegorical scenes, that the Douanier set in the mysterious yet firm and flowery greenery of the jungle, this *Lion* is one of his most solid, best constructed works. The rhythm of the palm fronds — which in pictures of this kind almost always create a sort of stage space in the extreme foreground — is here divided exactly in the middle like two opposite stage curtains, and behind, even the trees and the shrubs are aligned in an unusual pattern of verticals. The tawny beast and his prey, an almost immobile element, are anchored to the ground like plants amid the foliage of this fabulous forest. This painting is usually dated in the first decade of the 20th century.

HENRI ROUSSEAU
(LE DOUANIER)
Laval 1844 — Paris 1910
Repast of the Lion
Oil on canvas; 44¾ × 63 in (113.6 × 160 cm).
Signed (lower right): Henri Rousseau.
Dated 1907 by Dora Vallier and cited as inaugurating the complex spatial arrangements of the later exotic landscapes.
Bequest of Samual A. Lewisohn, 1951.

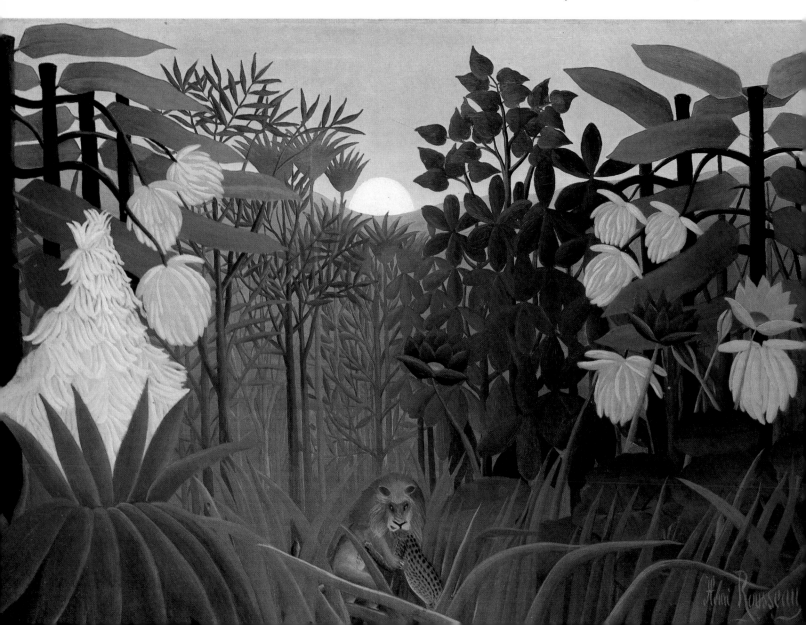

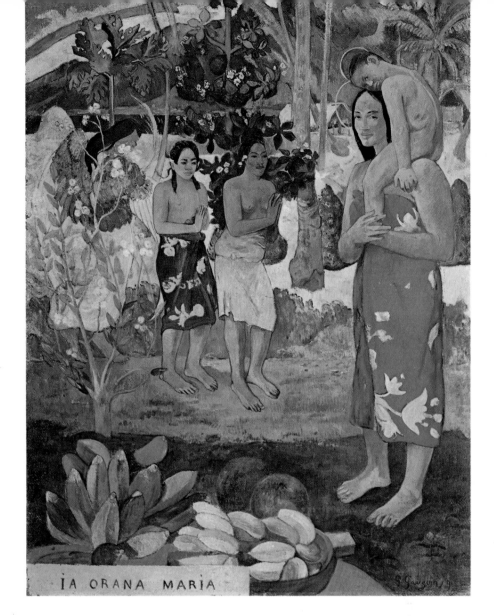

IA ORANA MARIA

PAUL GAUGUIN
Paris 1848 — Atuana, Marquesas Islands, 1903
Ia Orana Maria (1891)
Oil on canvas; 44¾ × 34½ in (113.6 × 87.6 cm).
Inscribed (lower left): IA ORANA MARIA.
Signed and dated (lower right): P. Gauguin, 91.
Gauguin wrote to his friend, de Monfreid, that
Ia Orana Maria, or *Hail Mary*, was the first work
of importance, as distinct from sketches and
studies, that he executed after his arrival in
Tahiti.
Bequest of Samuel A. Lewisohn, 1951.

GAUGUIN. *Ia Orana Maria.*

This was the first important picture that Gauguin painted in Tahiti, just after his arrival in what he hoped was to become his final refuge in an "innocent world" (1891). The firm discipline of the composition, the pure colors within the clearly outlined areas give form to a scene deliberately simple but full of interesting decorative elements, based actually on diverse sources, notably from Egypt and India, from Japanese prints and Peruvian art.

The sacred subject of the Annunciation, dressed up with exuberant Tahitian flora and peopled with impenetrable Maoris, was often used by Gauguin as a subject, in a watercolor, a charcoal drawing, and in engravings and monotypes. The figure of the woman appears alone in paintings entitled *Te Faruri, Parau Parau, Haere Pape*. It has been rightly pointed out that the source for the two figures praying in front of a flowering tree was a bas-relief in the temple of Boro-Budur which the artist knew from a photograph. This work is of fundamental importance in his artistic development, and was indeed regarded as such by Gauguin himself; he wanted to offer it to the Luxembourg Museum, but the director, Léonce Bénédite, refused it.

213

ALBRECHT DÜRER. *The Virgin and Child with St. Anne.*
Signed with the artist's monogram in the bottom right-hand corner, this is a splendid example of Dürer's painting in the years 1516–20. This *Virgin and Child* was in the collection of the Electors of Bavaria at Schleissheim. In the Albertina in Vienna there is a drawing by Dürer for the "St. Anne," dated 1519, in which some scholars have recognized the features of his wife Agnes. This work is representative of the period in which Dürer was intentionally trying to rid himself of the artistic influences that he had absorbed during his first and second visits to Italy, and when, in attempting to preserve the compositional integrity of his art (about which he developed many theories in his tracts on painting and geometry), he reverted to a much more Germanic type of characterization.

ALBRECHT DÜRER
Nuremberg 1471 — Nuremberg 1528
The Virgin and Child with St. Anne (1519)
Tempera and oil on canvas, transferred from
wood; 23⅝ × 19⅝ in (60 × 49.8 cm).
Signed with monogram and dated (on
background at right): 1519 A.D.
Previous owners include Gabriel Tucher,
Nuremberg (until 1628); Maximilian I, Elector
of Bavaria; the Royal Picture Galleries, Castle of
Lustheim, near Schleissheim.
Bequest of Benjamin Altman, 1913.

HUGO VAN DER GOES. *Portrait of a Man Praying.*
The donor of an unknown altarpiece is shown with his hands joined in prayer in this fragment, probably from the left wing of a diptych, which would have been combined with an image of the Virgin and Child. It has been cut to an oval and the background was at one time painted over. The picture was once attributed to Antonello da Messina but more recent research has shown it to be the work of the Flemish master, Hugo van der Goes. It was painted late in his career, at the same time as the Portinari triptych in Florence, and is certainly among the finest of Flemish portraits.

PETRUS CHRISTUS. *St. Eligius.* *p. 217*
In this unusually large 15th-century Flemish painting, the three almost life-size figures dominate the picture, in which a goldsmith sits at his counter in the open-street window of his shop, holding scales and a gold ring, while at his side stand a young couple in the bloom of youth, dressed in sumptuous wedding clothes. The subject has been traditionally identified as St. Eligius, Bishop of Noyon (the patron saint of goldsmiths) and St. Godeberta, whom the Bishop affianced to Christ in the presence of King Clothaire II of France. But the official form of this legend does not agree with the representation in this painting, which depicts the saint simply as an ordinary goldsmith (whose halo might have been a later pious addition) — not a bishop, but a craftsman selling a wedding ring to a noble couple.
According to tradition, the painting was commissioned from Petrus Christus by a goldsmith's guild, perhaps that of Antwerp, and in fact it was owned by the Guild of Antwerp until the middle of the 19th century. Because of the more than 30 detailed depictions of jewels and other precious objects, this painting is one of the most important sources of our knowledge of 15th-century goldsmith's work.

PIETER BRUEGEL THE ELDER. *The Harvesters.* *pp. 218–19*
This grandiose scene is one of a series — of which five paintings have survived — representing the months of the year. The others are the *Hunters in the Snow*, the *Gloomy Day*, and the *Return of the Herd* in Vienna, and the *Haymakers*, now in Prague. Bruegel dated four of them 1565. The series

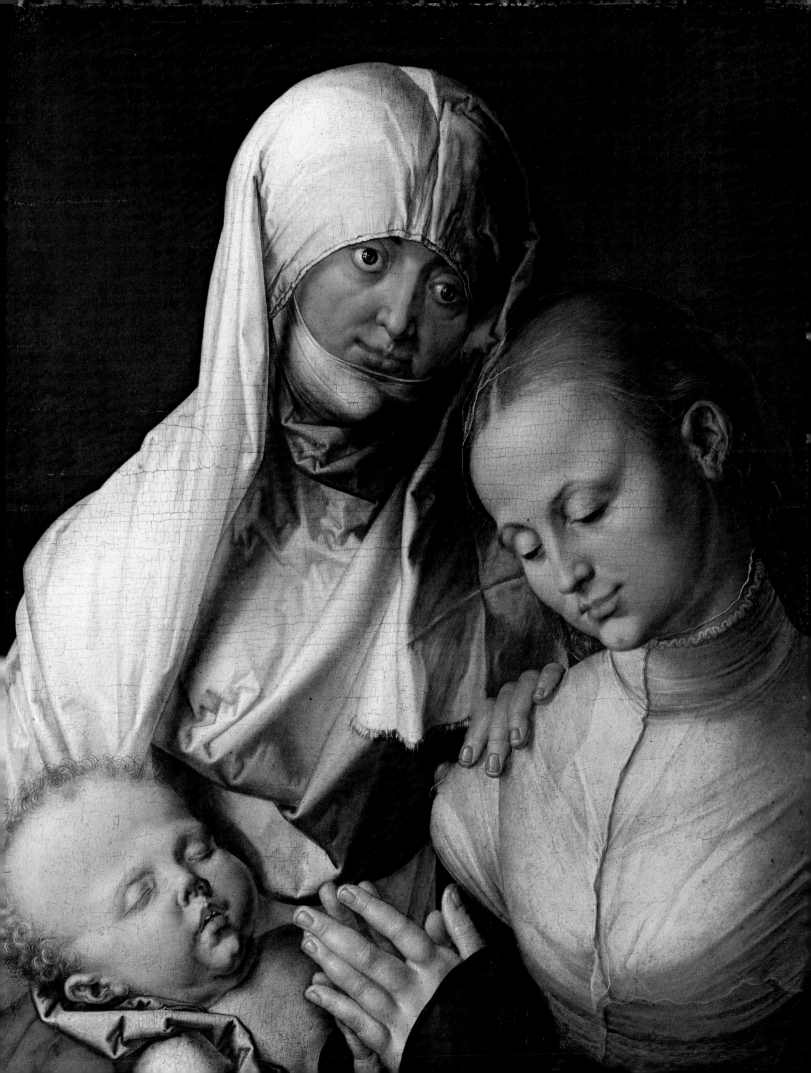

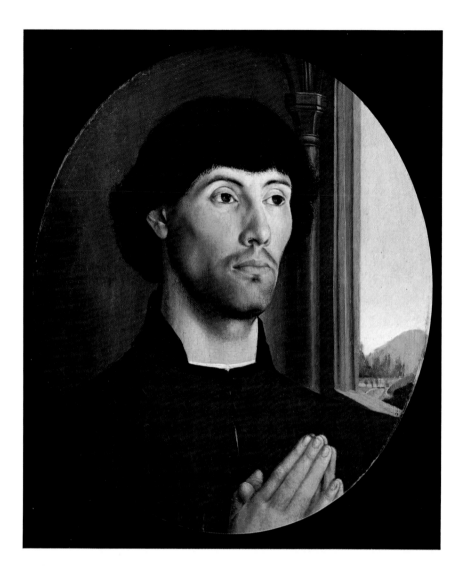

HUGO VAN DER GOES
Ghent 1440 — In 1467 he became a Master at
Ghent, where he worked until 1475;
subsequently he was in the monastery of Roode
Klooster, near Brussels, until his death in 1482.
Portrait of a Man
Tempera and oil on wood;
12½ × 10½ in (31.7 × 26.6 cm).
Painted before 1475.
Bequest of Mrs. H.O. Havemeyer, 1929.
H.O. Havemeyer Collection.

PETRUS CHRISTUS
Active in Bruges 1444 — Bruges 1473
St. Eligius (1449)
Oil on panel; 39 × 33⁷/₁₆ in (99 × 85 cm).
Signed and dated below, on the edge of the
workbench, *m petrus xpi me fecit a°* 1449 (Master
Petrus Christus made me in the year 1449),
followed by the artist's emblem, which resembles
a clock escapement over the outline of a heart.
Robert Lehman Collection, 1975.

may have been commissioned by the collector Niclaes Jonghelinck, for they
are included in his collection as early as February 1566, and they were
eventually acquired by the Archduke Leopold William.

In each one the men working and the landscape have a different rhythm,
and different colors and a different atmosphere evoke the seasons, yet they
still form a coherent group, and convey a profound sense of nature. In *The
Harvesters*, Bruegel's broad and fruitful landscape shimmers in the heat of
midsummer. This large panel is dominated by the tree at the right, and the
composition is organized around it. The eye is drawn upward, to the crown
of overhanging branches, as well as downward, to the peasants resting in
the foreground. Bruegel was to use the same device perhaps to even better
effect, in the Munich painting of 1567.

On pages 218–19:
PIETER BRUEGEL THE ELDER
Bruegel (?) *c.* 1525 — Brussels 1569
The Harvesters
Oil on wood; 46½ × 63¼ in (118 × 160.6 cm).
Signed and dated (lower right):
BRVEGEL /(MD)LXV.
Rogers Fund, 1919.

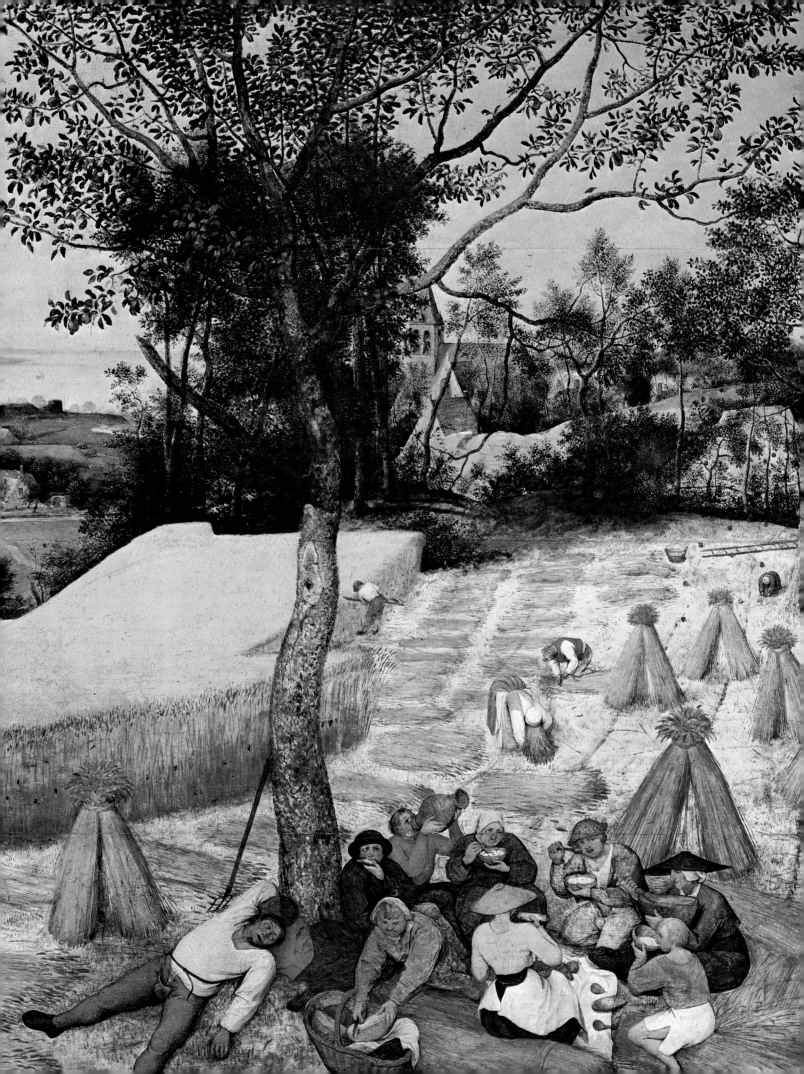

JAN VERMEER
Delft 1632 — Delft 1675
Woman with a Jug
Oil on canvas; 18 × 16 in (45.7 × 40.6 cm).
Gift of Henry G. Marquand, 1889.

VINCENT VAN GOGH
Groot Zundert 1853 — Auvers-sur-Oise 1890
Portrait of the Artist
Oil on canvas; 16 × 12½ in (40.6 × 31.7 cm).
The painting dates from the artist's Paris period,
c. 1886–87.
Bequest of Miss Adelaide Milton de Groot
(1876–1967), 1967.

JAN VERMEER. *Woman with a Jug.*

This is one of the most beautiful of Vermeer's renderings of light pouring through a window into an interior. These scenes often present one or two illumined figures that appear in various situations and moods.

Although there is much disagreement about the chronology of Vermeer's work, this painting is generally dated to the years between 1658 and 1663. The great charm of the painting is its unusual blend of blues and golden yellows with whites and misty grays, the recurrent shading that softens the folds and lines of the fabrics, as well as the quality of the light shown on smooth bare walls. The young woman's gesture indicates that the real theme of the painting is the sun suddenly streaming in as she opens the window, perhaps to water the plants outside.

VAN GOGH. *Portrait of the Artist.*

Van Gogh's numerous self-portraits, executed throughout his career, reveal the artist's constantly changing style. This self-portrait, painted just after van Gogh went to Paris in 1886, typifies the critical moment when he began to use a more extended chromatic range. The thick brush strokes in this

221

portrait with red beard and yellow straw hat give the impression of a bright sun sending out centrifugal rays. This is in direct contrast to the artist's earlier dark and more somber style, which can be seen on the verso, as van Gogh re-used an earlier canvas. On the other face the artist had depicted a sober seated figure peeling potatoes, which dates from his early years at Neumen (1883–84).

DIEGO VELAZQUEZ. *Juan de Pareja.*
Velázquez painted this extremely fine portrait of his trusted assistant, the mulatto Juan de Pareja, in 1650, while he was in Rome acquiring works of art on behalf of the Spanish King. It has been suggested that it was done as a sort of trial run for the more imposing and official *Portrait of Pope Innocent X*. We know for a fact that it was put on display at the annual exhibition at the Pantheon, and that it excited universal admiration: one

DIEGO VELAZQUEZ
Seville 1599 — Madrid 1660
Juan de Pareja (1650)
Oil on canvas; 32 × 27½ in (81.3 × 69.8 cm).
After belonging to William Hamilton, Palazzo Sessa, Naples, the painting was long in the collection of the Earls of Radnor, Longford Castle, England.
Fletcher Fund, Rogers Fund.
Bequest of Miss Adelaide Milton de Groot (1876–1967), supplemented by gifts from the Friends of the Museum, 1971.

PABLO PICASSO
Malaga 1881 — Mougins 1973
Portrait of Gertrude Stein (1906)
Oil on canvas; 39⅜ × 32 in (100 × 81.2 cm).
Bequest of Gertrude Stein, 1946.

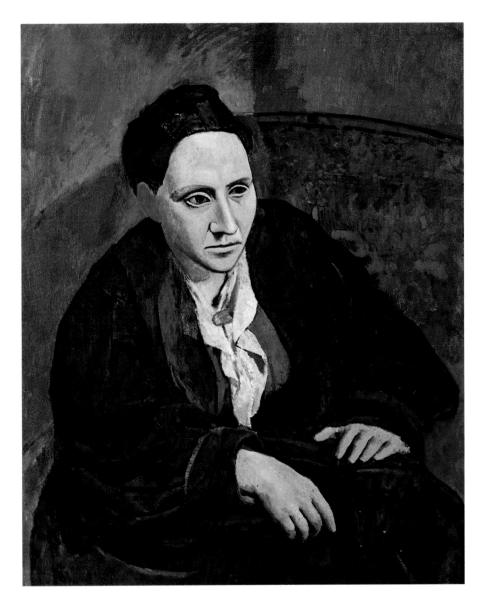

connoisseur is alleged to have exclaimed, "Everything else may be art, but this is Truth."

Though in this late portrait Velázquez still uses the strong illumination and light background typical of Caravaggio, his palette is limited to a dazzling sequence of grays and warm flesh tones. The composition is equally restrained. The imposing and proud figure is placed diagonally with the head almost frontal. The right arm crosses the torso to provide a firm base in a fashion reminiscent of some of Raphael's most famous portraits. This scene is enlivened by marvelously deft brush strokes.

PABLO PICASSO. *Portrait of Gertrude Stein.* *p. 223*

As far as can be gathered, the American expatriate writer (1874–1946) posed for this portrait more than 80 afternoons in the studio of Rue Ravignan during the winter of 1906. The following spring when the artist and the writer went their separate ways — Gertrude Stein to Italy and Picasso to the Pyrenees — the artist declared his dissatisfaction with the portrait and erased the face. Then on his return to Paris in the autumn he repainted it as it is now. Gertrude Stein wrote, "It is the only portrait that is all me." In fact it seems Picasso attempted less a character study than research into form, inasmuch as the painting was so drastically changed and repainted. Following his first attempts at planar stratification, he has shown Gertrude Stein in a shallow setting within a clear architectonic structure using a pyramid shape reminiscent of Raphael and the Italian tradition. Without an x-ray examination it is hard to tell what alterations were made between the first and second versions of the head, but it now appears as a flat plane with details modeled in chiaroscuro, as in other works he painted in 1908 as part of his interest in Negro art and his first steps towards cubism.

THE NATIONAL GALLERY

WASHINGTON

THE BUILDING

The National Gallery, Washington was built according to contemporary standards of museum construction and therefore does not have to cope with limitations imposed upon the old museums of Europe, so often housed in former palaces whose architecture is often inappropriate to the display of their treasures to a large public. One of the fundamental ideas in the design of the Gallery was to give as much room as possible to each painting, so that it is isolated in space and of easy access to the viewer. Also the works of art are maintained under conditions of controlled humidity and temperature. The building, which was designed by John Russell Pope and completed after his death by Eggers & Higgins, uses a classicizing design that harmonizes with the architecture of the Federal city and is vaguely reminiscent of the Neo-Classical American architecture of the beginning of the 19th century. The painting galleries are situated on the main floor and are arranged on the axis of two monumental sculpture halls and two garden courts.

KEY
1 Central Italy and the Florentine Renaissance
2 Northern Italy and the Venetian Renaissance
3 Italy — 17th and 18th century
4 Spain
5 Flanders and Germany
6 Holland
7 France — 17th and 18th century
8 England
10 America
11 Special Exhibitions
12 Sculpture

PLAN OF THE MUSEUM

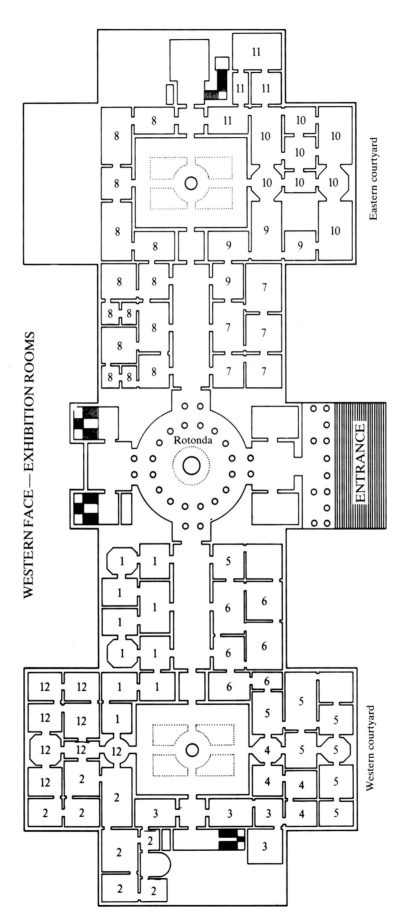

WESTERN FACE—EXHIBITION ROOMS

Eastern courtyard

Western courtyard

Rotonda

ENTRANCE

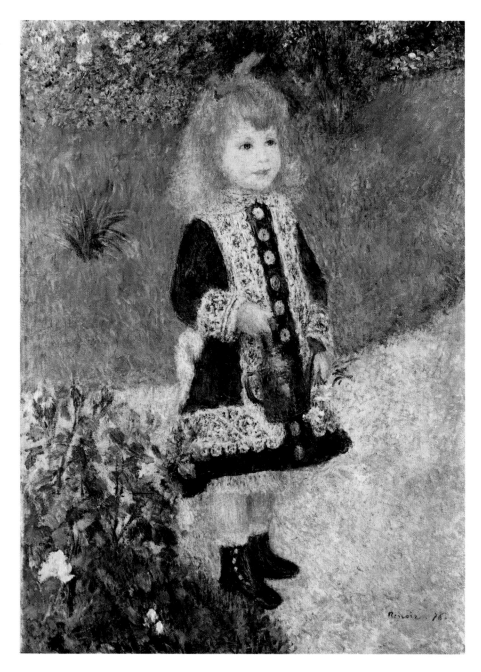

AUGUSTE RENOIR
Limoges 1841 — Cannes 1919
A Girl with a Watering Can (1876)
Oil on canvas; 39½ × 28¾ in (100 × 73 cm).
Signed and dated at lower right.
Chester Dale Collection, 1962.

The off-beat dynamism of the constituent elements and their strong counter-rhythms produced a scene of tremendous vivacity. The cascading wave of color echoes the movement of intersecting forms across the stage.

HENRI DE TOULOUSE-LAUTREC. *Rue des Moulins, 1894.* p. 238
Between 1892 and 1895, in both paintings and drawings, Toulouse-Lautrec copiously documented the life of the Parisian brothels. Shaped by the art of Degas more than by any other influence, Toulouse-Lautrec was *par excellence* a nonconformist and eccentric aristocrat, as is amply evident in this scene taken from life in the best brothel in Paris, on Rue des Moulins, in which the artist lived for a time. His approach to the subject is detached and free of any sensual overtones; in fact, his is a humane attitude shaped by tolerance for the "untouchable." The artist's genius for drawing is readily seen in the rendering of the figures and also in the background where the **236** fleet technique of execution reinforces the immediacy of the scene.

PAUL GAUGUIN. *Fatata te Miti.* *p. 239*

About 1890, after the failure of his scheme to go to Tonkin, Gauguin still "dreamed of solitude under a tropical sun" (Rewald). His determination was finally rewarded. With the proceeds of an auction sale at the Hôtel Drouot, he left Paris on April 4, 1891, for Tahiti where he passed some of his most impassioned and dramatic years. Masterpieces were produced in this period under impossible conditions of ill health, dire poverty and the hostility of the island's French authorities. The paintings nonetheless burst with vigor. *Fatata te Miti* illustrates Gauguin's innate decorative tendencies. "His art was at the threshold of Art Nouveau" (Marchiori). When confronted with such works as this it is difficult to understand why critics wished to see in Gauguin a barbarian or primitive. On the contrary, he was a master of refinement, as is clearly evident in the assurance of the picture's extraordinary interrupted rhythms at its edges and its effervescent color. There is

EDGAR DEGAS
Ballet Scene (c. 1907)
Pastel on cardboard;
30¼ × 43¾ in (78 × 111 cm).
Chester Dale Collection, 1962.

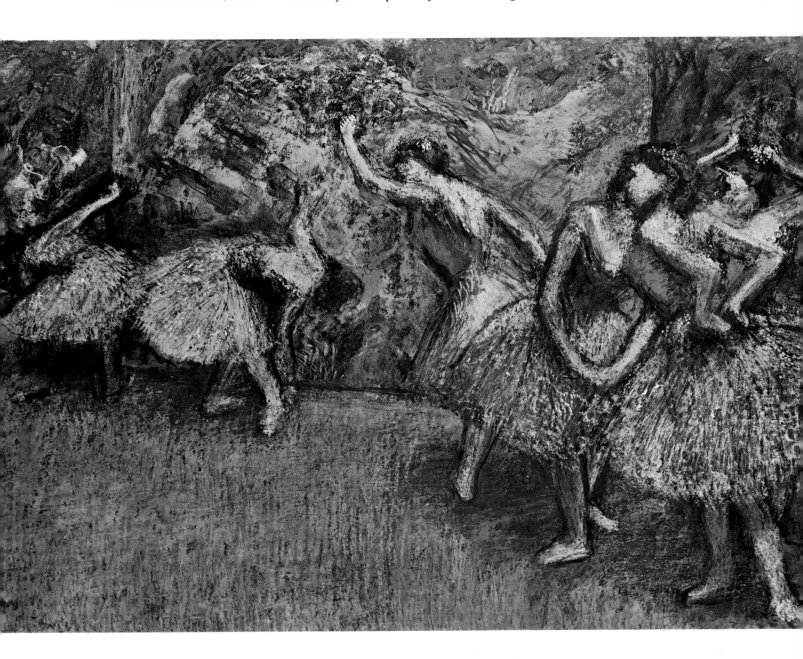

no doubt that Gauguin was not merely one of the innovators of modern art, but he also is a key to any understanding of much of the art of our time.

LUCAS CRANACH THE ELDER. *Portrait of a Woman.* *p. 240*
We know that Cranach the Elder was aided in the execution of his many portraits by numerous assistants. There even have been critics who felt that the suppression of the landscape backgrounds, the linear description of forms and the broad, simplified use of color were all devices adopted to make the pictures easier to copy! The years between 1520 and 1540 marked

HENRI DE TOULOUSE–LAUTREC
Albi 1864 — Malromé 1901
Rue des Moulins (1894)
Detail.
Cardboard mounted on wood;
32⅝ × 28⅛ in (83 × 61 cm).
Signed at lower right: "HTL."
Chester Dale Collection, 1962.

238

PAUL GAUGUIN
Paris 1848
Fatata te Miti (By the Sea) (1892)
Oil on canvas; 26¾ × 36 in (68 × 91.5 cm).
Signed and dated at lower right.
Chester Dale Collection, 1962.

the high point in Cranach's portraiture, of which this is a typical example. The flat, acute linear style rejects the classicizing trends seen in Dürer, Holbein the Younger, Pacher, Polack and Reichlich for a rigorous stylization reminiscent of Gothic art. The Humanist of Wittenberg thus abandoned his splendid early descriptive style, and as court painter to the Elector Frederick the Wise devoted himself to the supreme elegance reflected here in the rapid turn of the headdress under which the face glimmers like a white flame.

ALBRECHT DÜRER. *Madonna and Child.* p. 241
Of his early works, this is the German master's most obvious homage to Giovanni Bellini. The borrowings are evident in the features and placement of the figures, their relationship to the background and in the progression of the landscape. The Madonna's face is almost lifted from Bellini's *Madonna with St. Catherine and the Magdalen* in the Accademia, Venice. The faun-like face of the Child is a variant on the same picture. But in certain passages, like the landscape and the tassels on the cushion, Michael **239**

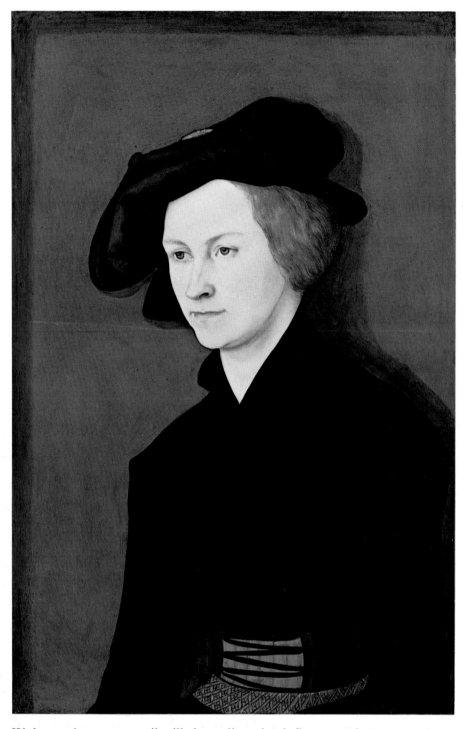

LUCAS CRANACH THE ELDER
Kronach 1472 — Weimar 1553
Portrait of a Woman (1522)
Panel; 22⅜ × 15 in (56.8 × 38.1 cm).
Pendant to a portrait of a man also in the National
Gallery and dated 1522.
From a Viennese private collection.
Samuel H. Kress Collection, 1959.

Wolgemut's recent pupil still shows lingering influences of an apprenticeship as an engraver and graphic artist.

Panofsky dates the painting, with some uncertainty, 1498–99, the year of Dürer's *Apocalypse with Figures*. However, the vividness of Bellini's influence as well as the painting's stylistic and iconographic links with such works as the *Lamentation of Christ* in Nuremberg suggest a somewhat earlier dating of 1495–96, immediately after Dürer's return from his first trip to Venice. Only Dürer's very late *Four Saints* in Nuremberg pays a similar homage to Giovanni Bellini.

ALBRECHT DÜRER
Madonna and Child (1495–96?)
Panel; 19¾ × 15⅝ in (52.6 × 42.9 cm).
On the reverse: *Lot and His Daughters.*
On the left, the arms of Haller von Hallerstein;
crest on the right is unidentified. Formerly
attributed to Bellini.
Formerly in the Thyssen-Bornemisza colection.
Samuel H. Kress Collection, 1952.

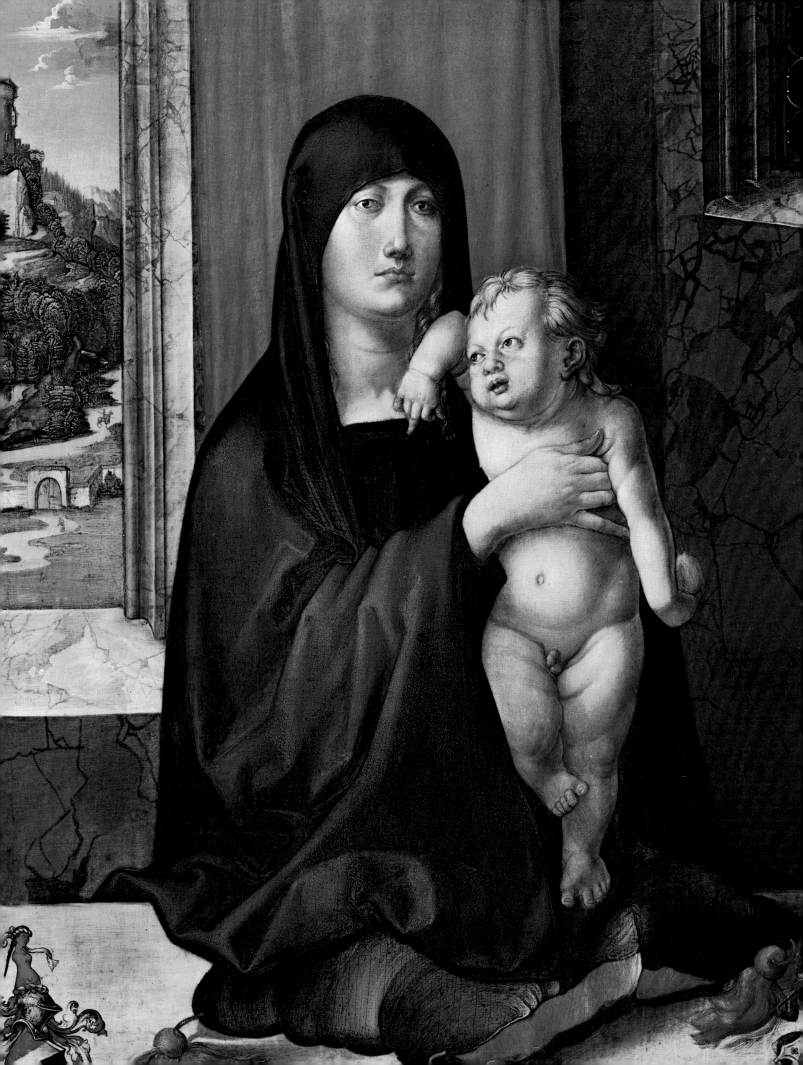

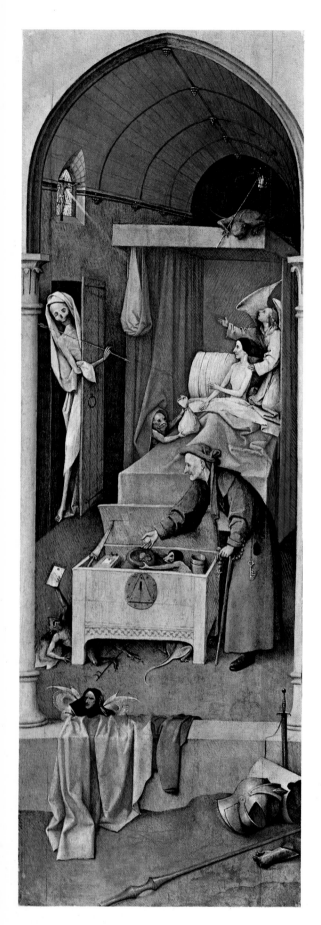

HIERONYMUS BOSCH. *Death and the Miser.*

Death is at the door, but the miser is still undecided between the angel gesturing towards a crucifix and the demon offering a sack of money. At the foot of the bed, a personification of his indecision clutches a rosary with one hand and with the other stores away coins in a strong box where a monster holds open a bag to receive them. This is a typical parable of Bosch's allegorical fantasy, but in this panel the interior architecture, so seldom seen in his work, lends the scene a special significance. A receding perspective created by the diminishing horizontals of the balustrade, chest and canopy and reinforced by the design of the vaulted roofing gives the fantastic story a real dimension. Thus the painting is not about dreams and symbols, but about life and human nature, that part of human nature that lies on the other side of reason. The fearsome specters of hell are in the creaking door and inky dark behind the bed, recalling the fears of a child's nighttime imagination.

There is a drawing of the composition in the Cabinet des Dessins in the Louvre, thought by some to be a preparatory sketch for the painting and classed by others as a copy. The direction of the spatial recession towards the right indicates that this panel might have been the left wing of a triptych. The rapid brushwork with which objects are minutely described suggests a date about 1510, contemporary to the Prado triptych and the *Ship of Fools* in the Louvre.

HIERONYMUS BOSCH
's Hertogenbosch (?) *c.* 1450 —
's Hertogenbosch 1516
Death and the Miser (1510)
Panel; 36⅝ × 12⅛ in (93 × 31 cm).
Formerly in the van der Elst collection, Bruges.
Samuel H. Kress Collection, 1952.

ROGIER VAN DER WEYDEN. *Portrait of a Lady.*

This is undoubtedly the most masterful likeness executed by Rogier, whose powers of portraiture we now rate equal to those of Jan van Eyck. It was painted about 1455 after the Italian journey that so affected the artist. The salient characteristics of his portrait style are amply demonstrated in this spare and intensely concentrated composition. The large white triangular coif functions as a background to the exquisite line and modeling of the face. In comparison to another masterpiece, the *Portrait of a Woman* in Berlin, this characterization is an aloof, abstract hyperbole that makes no attempt whatsoever to engage the spectator. The clasped hands are a kind of signature whose starkness is reminiscent more of Germanic Gothic portraiture than of van Eyck's.

ANTHONY VAN DYCK. *Marchesa Elena Grimaldi.* *p. 244*

This is one of the portraits of the Genoese nobility painted by van Dyck during his first sojourn in the city in 1622–23. Together with two full-length portraits of Paola Adorno, this painting is perhaps the most spectacular and

ROGIER VAN DER WEYDEN
Tournai 1399 — Brussels 1464
Portrait of a Lady (1455)
Panel; 14½ × 10¾ in (37 × 27 cm).
Formerly in the collection of the Gotisches Haus,
Wörlitz. The sitter may be Marie de Vallengin,
illegitimate daughter of Philip the Good, Duke
of Burgundy.
Andrew Mellon Collection, 1937.

important of the Genoese masterpieces whose formal vigor, so firmly inter-woven with a completely new courtly elegance, was never surpassed, even in van Dyck's English pictures.

The influence of Rubens, and through him of Venetian 16th-century paint-ing, is here transformed by van Dyck into a thoroughly personal statement far removed from the master's rhetorical and architectonic imagination. In van Dyck's aristocratic vision, Rubens' pulsating colors and hot reflections fade into the opulent monochromes of evening light. In this picture the artist has masterfully compensated for the lack of mass in the upper part of his composition by inserting the red parasol, held by the Negro page at an oblique angle that softens the repeated verticals of the colonnade.

243

DIEGO VELÁZQUEZ. *Pope Innocent X.*

The picture is one of the surviving 15 variants of the three-quarter length portrait of the pope in the Doria-Pamphili collection in Rome, painted in 1650 when Velázquez was in Rome to purchase works of art for King Philip IV of Spain. It is known that Velázquez took an autograph replica of bust length back to Spain, but dimensions and provenance make it seem unlikely that it could have been the picture reproduced here. Certain variations, the more severe and closed expression as well as the curious detail that the eyes here are more brownish than the blue of the Doria portrait, suggest that the Washington version may be a first sketch for the official portrait and therefore not only autograph but of great interest as documenting the genesis of a masterpiece.

ANTHONY VAN DYCK
Antwerp 1599 — London 1641
Marchesa Elena Grimaldi (1622–23)
Canvas; 97 × 68 in (246.4 × 172.2 cm).
Widener Collection, 1942.

DIEGO VELÁZQUEZ
Seville 1599 — Madrid 1660
Pope Innocent X (1650?)
Canvas; 19½ × 16¼ in (49 × 42 cm).
Acquired in England for Catherine the Great.
Later in the Hermitage, Leningrad.
Andrew Mellon Collection, 1937.

BARTOLOMÉ ESTEBAN MURILLO. *A Girl and Her Duenna.* p. 246

A frame within a frame, one of Murillo's favorite devices, shades a luminous and smiling image of a girl and her duenna, half-concealed behind a shawl. The picture demonstrates Murillo's marvelous technical virtuosity. His control of light and atmosphere as it falls tenderly on the girl, the measured rhythms of the composition stepped diagonally towards the left, and the assured choice of subject readily reveal his sympathetic and rich vitality. He achieves his effects so effortlessly and with such brilliant elegance that many have grievously mistaken his reserved, unrhetorical and unheroic mastery for mere sentimentality.

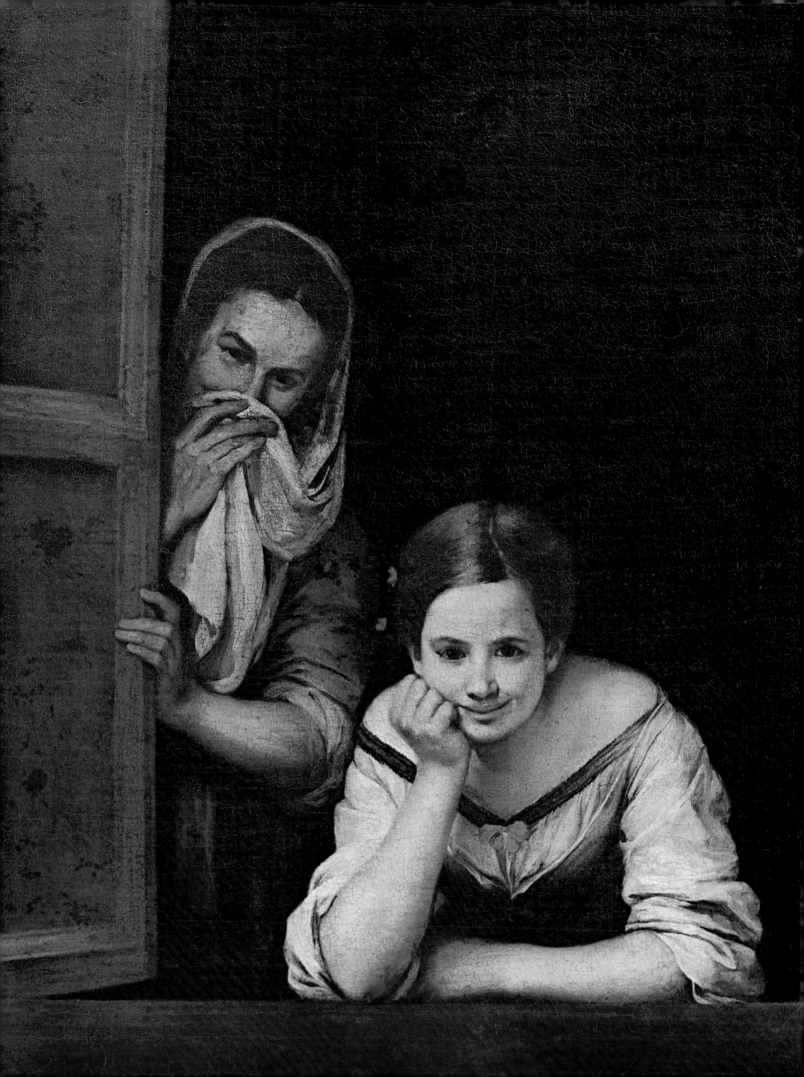

PABLO PICASSO
Málaga 1881 — Málaga 1973
Family of Saltimbanques (1905)
Canvas; 83¾ × 90⅜ in (222 × 234 cm).
Chester Dale Collection, 1962.

BARTOLOMÉ ESTEBAN MURILLO
Seville 1617 — Seville 1682
A Girl and Her Duenna (1670?)
Canvas; 50¼ × 41¾ in (127 × 106 cm).
Procured from the Duke of Almadóvar by the
British ambassador Lord Heytesbury.
Widener Collection, 1942.

PABLO PICASSO. *Family of Saltimbanques.*
The picture dates from Picasso's Rose Period, which in contrast to the preceding Blue Period, was characterized by a warmer range of colors and greater objectivity in his narratives. This is one of the most complex of the works executed in that year, most of which also treat strolling circus themes. Picasso's enthusiasm for the acrobats was genuine, but he used the motif as a pretext for depicting human situations wherein the external world is merely a mask laid over an underlying significance. Here an assortment of estranged, alienated figures with no compositional or emotional relationship to one another stare downwards to the right, towards some point outside the picture, a setting, without space and time, for the artist's refined drawing and treatment of color.

247

FRANS HALS
Antwerp c. 1581–85 — Haarlem 1666
Portrait of an Officer (1635–48)
Canvas; 33¾ × 27 in (86 × 69 cm).
In 1779, in the Walpole collection, Norfolk,
England.
Andrew Mellon Collection, 1937.

FRANS HALS. *Portrait of an Officer.*
This painting is one of Frans Hals's masterpieces, and was probably
executed between 1635 and 1648. In contrast to the festively colored works
prior to 1630–35, the pictures of this later period tend to have a harmonious
and intense golden tone, sometimes almost monochromatic, that is often
thought to reflect the influence of Rembrandt. But apart from their being
contemporaries, the two painters were quite different, as is immediately
evident in the rapid improvisation of Hals's unpremeditated brushwork. He
created his portraits directly on the canvas without preparatory studies. This
direct technique that so well captured the psychology and mood of his sitters
became his style, canceling out every other influence to which he might have
been exposed.

REMBRANDT VAN RIJN
Portrait of a Lady with an Ostrich-Feather Fan
(c. 1667)
Detail.
Canvas; 39¼ × 32⅝ in (143 × 111 cm).
Signed and inscribed at left:
"Rembrandt f. 166–(?)."
From the Youssoupoff collection, St. Petersburg.
Widener Collection, 1942.

REMBRANDT VAN RIJN. *Portrait of a Lady with an Ostrich-Feather Fan.*
This and its pendant, *Portrait of a Gentleman with a Tall Hat and Gloves,*
in the same collection, are among the greatest of Rembrandt's late portraits.
Light has a particular importance in the equilibrium of this composition,

both in defining planes and space and in generating emotion. In the detail reproduced here, the way the face emerges, suspended between the dark of the background and the luminosity of the ample collar, underlines the intensity of the characterization which is not a distracting psychological description but a sensitive inquiry. The internal cadence of the portrait is so profound and compelling that the earrings, pendant and jeweled bow become merely concentrations of light, not autonomous visual episodes.

GERARD TER BORCH
The Suitor's Visit (1660–70)
Canvas; 31½ × 29⅝ in (80 × 63 cm).
Formerly in the Alphonse de Rothschild
Collection, Paris.
Andrew Mellon Collection, 1937.

GERARD TER BORCH. *The Suitor's Visit.*
Courtly conventions and manners are the central themes of Ter Borch's art. The grace of the suitor's greeting in the foreground, accented by the little dog, is echoed in the background by a girl playing a lute. The inconsequential narrative is nonetheless rigorously structured by the exact divisions of space in the foreground and a clearly articulated perspective recession into the background. The off-centered emphasis on the left-hand portion of the picture underlines its narrative content. As in de Hooch and Metsu, light shimmers in the room and around the people in this finely calibrated human story.

VINCENT VAN GOGH
Groot Zundert 1853 — Auvers-sur-Oise 1890
La Mousmé (1888)
Canvas; 26⅞ × 23¾ in (74 × 60 cm).
Collections: J. van Gogh-Bonger, Amsterdam;
Carl Sternheim, La Hulpe, Belgium; Alphonse
Kann, St. Germain-en-Laye, France; J.B. Stang,
Oslo.
Chester Dale Collection, 1962.

VINCENT VAN GOGH. *La Mousmé.*

In July 1988, van Gogh wrote to Émile Bernard, "I have just now finished the portrait of a 13-year-old girl with brown eyes, black hair and eyebrows and yellowish gray skin. The plain background is strongly colored in the manner of Veronese. The girl is dressed in a jacket of blood red and violet stripes and a blue skirt with orange polka dots. In her hand is an oleander flower. I am so exhausted that I cannot even write." The artist also mentioned the picture in a letter to his brother, Theo, in which he also included a sketch of it.

The portrait was painted during what was perhaps van Gogh's only stable and happy period, during his stay at Arles in the summer of 1888. At that time he was experimenting with his language of "pure colors" set in pulsatingly sharp contrasts and applied with emotionally charged strokes. The results were exactly opposite to those gloomy meditations and self-doubts that weigh so heavily in much of his earlier work.

251

THOMAS GAINSBOROUGH
Sudbury 1727 — London 1788
Master John Heathcote (1770)
Canvas; 50 × 39⅞ in (127 × 101 cm).
Gift in memory of Gov. Alvan T. Fuller,
The Fuller Foundation, 1961.

THOMAS GAINSBOROUGH. *Master John Heathcote.*

Gainsborough's work provided an alternative to the elegant nobility of Reynolds' convention and illustrates that strain of Puritan reserve that distinguished English portraiture from its more frivolous Continental counterparts.

In his long and successful career, this self-taught artist seemed to hark back to only one, distant model, the grand example of van Dyck. Master Heathcote, incongruously seen in a girl's dress, is a direct descendant of van Dyck's English children, as they had been passed on to a younger generation by Sir Peter Lely. This picture was painted in 1770 in the artist's full maturity. In contrast to the "sentimental realism" of Reynolds' landscapes, the background here has a bleak air and a rustic simplicity. This convention, which in the hands of Gainsborough's numerous imitators became a formula, is here rendered with a coloristic transparency and a rapid touch that breathes the artist's characteristic freshness.

GEORGE STUBBS. *Colonel Pocklington with His Sisters.*

By 1769, the date of this picture, Stubbs was already famous for the *Anatomy of the Horse*, published in 1766, after eight years of preparation. That treatise was devoted to the noble form of the English aristocracy's favorite beast. Even in this intimate and civilized scene, the horse is the most important and deeply felt element. The simple landscape is based on Wilson's post-Italian models. Beyond the grandiose stage setting formed by the shadowy trees there glows the diffused, golden atmosphere so favored by Stubbs. The features and poses of the figures bespeak their gentility. Their somewhat mannered relationship to one another almost seems to spring from the pages of some dignified yet genial romance of the period.

GEORGE STUBBS
Liverpool 1724 — London 1806
Colonel Pocklington with His Sisters (1769)
Canvas; 39⅜ × 49¾ in (100 × 127 cm).
Gift of Mrs. Charles S. Carstairs in memory of
her husband Charles Stewart Carstairs, 1949.

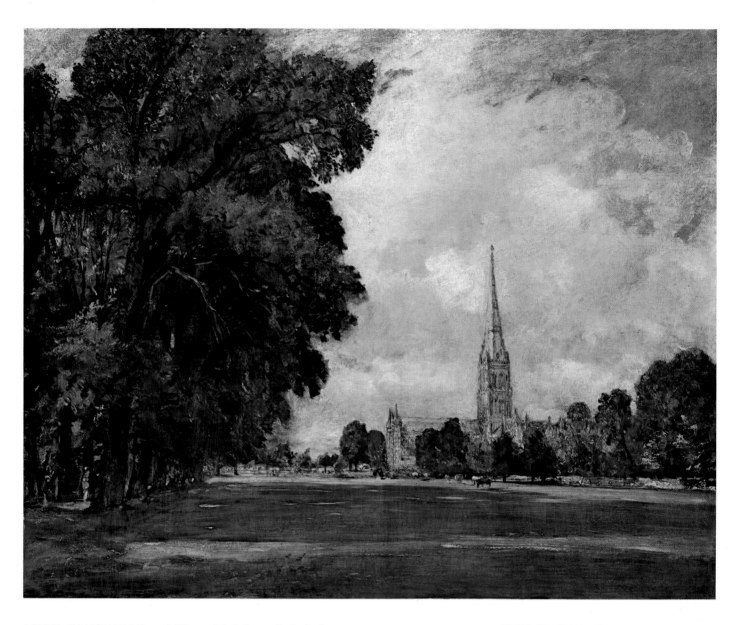

JOHN CONSTABLE. *A View of Salisbury Cathedral.*

The artist's long friendship with Archdeacon John Fisher and with his uncle, the Bishop of Salisbury, explains Constable's predilection for this theme that appears so frequently in his paintings, sketches and drawings, seen from every possible point of view and distance, and expressing so many different moods. In some cases the cathedral views were simply repetitions of earlier compositions for the sake of examining the effects of a different technique or format. The artist's approach to the theme in this instance is among his happiest. A magnificent lawn framed on the left by luxuriant trees rolls out towards the silvery cathedral, seen here, for all its historical connections, simply as a motif in a silent landscape.

Constable's summer or autumn holidays with Fisher, first documented in 1811, certainly had ended in 1829. But the latest known variant on the Salisbury theme is the painting in Lord Ashton's collection and the sketch for the same in the National Gallery, London. The Washington picture must also be late, judging by the firm balance of the composition that contrasts

JOHN CONSTABLE
A View of Salisbury Cathedral (1825?)
Canvas; 28¾ × 36 in (73 × 91 cm).
Andrew Mellon Collection, 1937.

254

with a diffuse, vibrating color, which once again finds its climax in the sky, a soft mass of moving white, touched with pink and gold and delicate shadows, a festive rivalry flowering in the translucent and infinite blue.

JOSEPH MALLORD WILLIAM TURNER.
Keelmen Heaving in Coals by Moonlight.
In the space of about 30 years between 1805 and 1835 when he painted this picture, Turner altered the language of his art without affecting his profound imagination. In this picture, the stated subject of the title is relegated to the far right as a secondary and minor episode. This is no different from Turner's earlier pictures; what has been altered is the dramatic content. The epic qualities of the early works are gone, along with the weightiness of mass, composition and color. This night scene in which the full moon is the protagonist, is simply an orchestration of light which moves through the vast space creating transparent reflections and inky silhouettes edged in silver. In this magisterial scene, the human activity picked out by torchlight is like the bustling of ants.

JOSEPH MALLORD WILLIAM TURNER
Keelmen Heaving in Coals by Moonlight (1835)
Canvas; 36¼ × 48¼ in (92 × 123 cm).
Widener Collection, 1942.

255

BENJAMIN WEST. *Colonel Guy Johnson.*
West was one of the most famous painters of his time. Among his most admired pictures was *William Penn's Treaty with the Indians* in which the episode from American history is enacted in togas within a Neo-Classical composition. The admiration West and other American artists entertained for Neo-Classicism and for the civic virtues of ancient Rome was linked with the republican aspirations of the emerging American nation. Among the artist's most important portraits is this one of Guy Johnson, English Super-intendent of Indian Affairs in the American Colonies. Next to him is the figure of an Indian set in an obscure background, as if to emphasize his remote origins and fantastic character.

JOHN SINGLETON COPLEY. *The Copley Family.*
Copley was the most original and vigorous of the American Colonial painters. He was born and grew up in Boston where the rigorous Puritanism of a mercantile society deeply affected the arts. Copley's early portraits, like his *Paul Revere* of 1765, have a solidity that many see as the "American" character of his talent. Before he left permanently for Europe in 1774, his portraits showed a strength and verisimilitude that was unequaled in his long and productive London years. The picture here was painted shortly after his arrival in England. The artist is seen standing in the background on the left, capping a compositional pyramid formed by his seated father-in-law and two of Copley's children. The painting is distinguished for its virtuoso transparency and the opulence of the satins, brocades and other such exquisite details.

257

JAMES McNEILL WHISTLER
Lowell (Mass.) 1834 — London 1903
The White Girl (1862)
Oil on canvas; 84½ × 42½ in (215 × 108 cm).
Signed and dated.
Formerly in the Thomas Whistler collection,
Baltimore.
Harris Whittemore Collection, 1943.

JAMES McNEILL WHISTLER. *The White Girl.*
After Benjamin West, Whistler was the most influential of the American expatriate artists in Europe. This picture from his Paris years was exhibited in the Salon des Refusés in 1863 and reflects his interest during that time in the portrait tradition of Spain, in the art of Manet and in Japanese prints. The large zones of simplified color and the masterful handling of the cold white and silver tones are reminiscent of Velázquez and illustrate Whistler's exquisite decorative sense that was to flower some years later in pictures called "Symphonies" and "Arrangements."

MARY CASSATT. *The Boating Party.* *p. 259*

A daughter of a Pittsburgh stockbroker, Mary Cassatt lived most of her life in France, which became her spiritual home despite the contacts she always maintained with her native country. Her art grew out of her Parisian contacts with the Impressionists, in whose exhibitions she participated. She was particularly influenced by Degas, her own style is a simplified version of his, and limited herself to a few recurrent themes, especially theater scenes and mother and child subjects. Although her work was virtually unknown in America, the advice she gave to certain American collectors led to the early exportation of many masterpieces to the U.S. In this painting the zones of vividly contrasting color give the figures a sharp definition and a two-dimensional effect that recalls Japanese prints and Monet. The vibrating blue of the sea animates and sets off the central group.

PRADO

MADRID

THE BUILDING

The grandiose Palace of the Prado is the work of the architect Juan de Villanueva, of Madrid. In 1787, Charles III commissioned him to design a building for the Museum of the Sciences, and he conceived it in the form of a temple in the Neo-Classical taste. Interrupted during the Napoleonic war, the construction was resumed in 1811, after the death of the architect, and the building was assigned to house the Royal Museum.

KEY

1	Entrance
2	Italian School — 15th and 16th century
3	Italian School — 15th and 16th century
4	Italian School — 15th and 16th century
5	Italian School — 15th and 16th century
6	Italian School — 15th and 16th century
7	Works in progress
8	Works in progress
9	Works in progress
10	Works in progress
7a	Works in progress
8a	Works in progress
9a	Works in progress
10a	Works in progress
8b	Works in progress
9b	Works in progress
10b	Works in progress
11	Velázquez
12	Velázquez
13	Velázquez
14	Velázquez
15a	Velázquez
16	Tintoretto and Veronese
17	Tintoretto and Veronese
18	Tintoretto and Veronese
16a	Spanish School — 17th century
17a	Spanish School — 17th century
18a	Spanish School — 17th century
16b	Titian
19	Goya — Cartoons for Tapestries
20	Goya — Cartoons for Tapestries
21	Goya — Cartoons for Tapestries
22	Goya — Cartoons for Tapestries
23	Goya — Cartoons for Tapestries
24	Spanish School — 16th and 17th century
25	Spanish School — 16th and 17th century
26	Spanish School — 16th and 17th century
27	Velázquez
28	Italian and French Schools — 17th century
29	Italian and French Schools — 17th century
32	Goya — Portraits and historical paintings
34	Goya — Portraits and historical paintings
35	Goya — Portraits and historical paintings
36	Goya — Portraits and historical paintings
37	Goya — Portraits and historical paintings
38	Goya — Portraits and historical paintings
39	Goya — Portraits and historical paintings
40	Temporarily closed
41	Temporarily closed
42	Temporarily closed
43	Temporarily closed
44	Temporarily closed
49	Spanish School — 15th and 16th century
50	Spanish School — 15th and 16th century
51a	Rooms for temporary exhibitions
51b	Rooms for temporary exhibitions
52a	Flemish School — 15th and 16th century
52b	Flemish School — 15th and 16th century
53	Works in progress
54	Works in progress
55	Works in progress
56	Works in progress
57	Works in progress
55a	Works in progress
56a	Works in progress
57a	Works in progress
55b	Works in progress
56b	Works in progress
56c	Works in progress
58	Lecture Room
60	Rubens
61	Rubens
61b	Rubens
62	Rubens
59	Flemish School — 17th century
60a	Flemish School — 17th century
61a	Flemish School — 17th century
62a	Flemish School — 17th century
63a	Flemish School — 17th century
63	Jordaens
62b	Van Dyck
63b	Van Dyck
64	Dutch School
65	Dutch School
66	Goya — Drawings and Engravings
67	Goya — Black Paintings
71	Temporarily closed
72	Temporarily closed
73	Temporarily closed
74	Sculpture
75	Rubens — Decoration for the "Torre de la Parada"

PLAN OF THE MUSEUM

MAIN FLOOR

GROUND FLOOR

The organization of the rooms and arrangement of the paintings are provisional as the museum is currently undergoing renovations.
This plan is reproduced by kind permission of the Prado, Madrid.

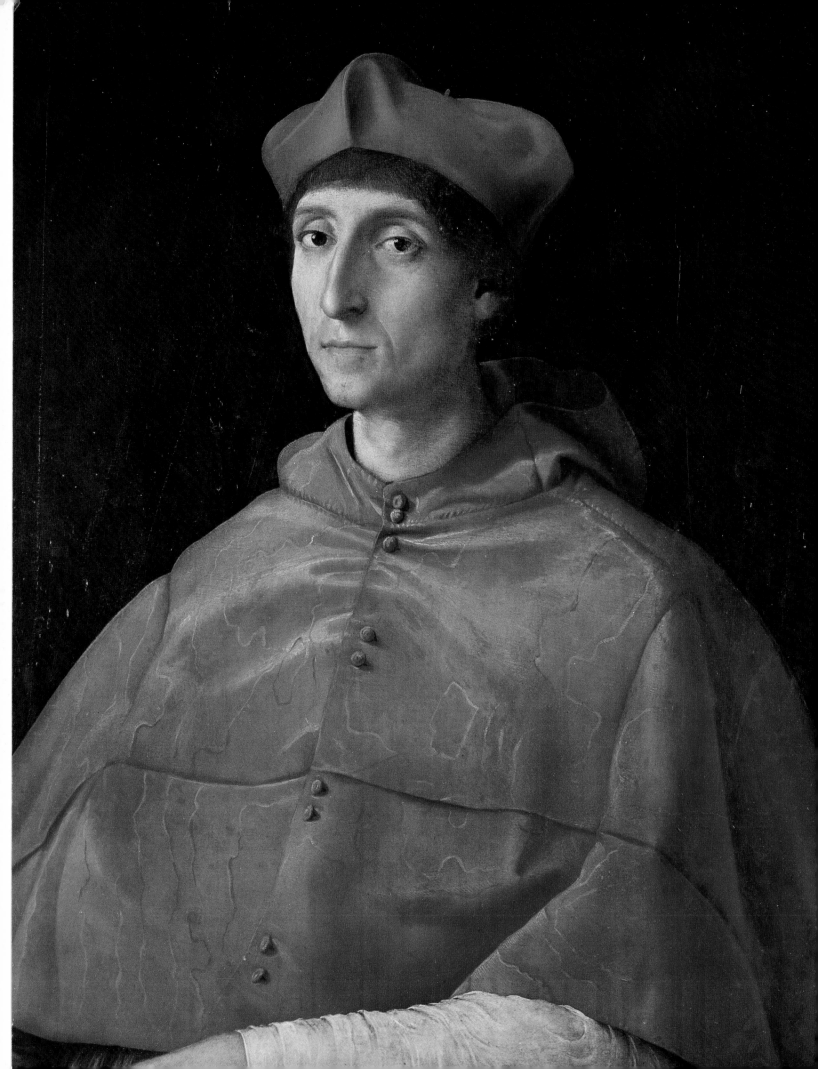

LORENZO LOTTO
Venice *c.* 1480 — Loreto 1556
Portrait of Marsilio and His Wife (1523)
Panel; 28 × 33 in (71 × 84 cm).
Signed: *"L. Lotus pictor 1523."*
It appears in the inventory of 1666 as belonging
to the collection of Philip IV and as hanging in
his bedroom.

found the opportunity to express himself with great freedom, breaking out of classicist schemes and letting himself go in a poetic climate of fantasy influenced by Northern painting. In this period he invented an acute psychological portraiture, subtle in its humor and choice of formal means. Indeed there is an admirable coherency in the careful description of the clothes, the jewels, the nuances of expression and the gestures. The dark notes of the groom's black clothes and the sonorous chords of the red silk that adorns the bride stand out against a basic gray tone. The mischievous little cupid places a yoke decorated with laurel on their shoulders.

CORREGGIO. *"Noli Me Tangere."* p. 268
The work belongs to Correggio's maturity, which he reached when he was a little over 30. A probable Roman sojourn between 1517 and 1520, or familiarity with some examples of paintings by Leonardo and Raphael,

RAPHAEL
Portrait of a Cardinal (1509–10)
Panel; 31 × 24 in (79 × 61 cm).

267

CORREGGIO
(ANTONIO ALLEGRI)
Correggio c. 1489 — Correggio 1534
"Noli Me Tangere" (1522–1523)
Panel; 51¼ × 40½ in (130 × 103 cm).
Vasari mentions it as being in the house of the
Ercolani family in Bologna. In the 17th century
it was acquired by Philip IV from the collection
of Cardinal Ludovisi.

helped him emerge from his provincial Emilian training, though that was already illuminated by the august precedent of Mantegna's activity and was rich in originality. The painting's place lies between the refinements of the Camera della Badessa in S. Paolo and the new creative impetus of the frescoes in S. Giovanni Evangelista. A desire to break certain rigid formal schemes is felt in the twisting figures. The "variety of curves," admired even by Mengs during his Spanish sojourn, provides the images with a rhythm of undulations, echoed by the rustling wooded landscape touched by the light of dawn. The pathos typical of Correggio is seen in the intense exchange of glances between the victorious Christ and the Magdalen, who kneels, overcome by emotion.

TITIAN. *Venus and Adonis.*
The work is mentioned in a letter from Titian to Prince Philip and was enthusiastically praised by Ludovico Dolce in his dialogue on painting (1557). Titian's creation is not only a complex of images that are beautiful in themselves and full of vitality, as Dolce, with his fully naturalistic Renaissance taste, understood, but it is a dramatic concept achieved with great stylistic coherence. The possession of a rich and subtle command of color, the ability

268

On pages 270–71:
JACOPO TINTORETTO
Battle of Corsairs (Abduction of Helen)
(c. 1580)
Canvas; 6 × 10 ft (186 × 307 cm).
Listed under the second title in the 1666
inventory of the Royal Palace of Madrid.

to bend the substance of the color to the most intense tonalities and the most refined nuances, permit Titian to place his figures in open space and articulate their contrapuntal movements — the impatient movement of the young hunter, the tender gesture of Venus, who attempts to hold him back, are almost a presage of the imminent tragedy. And meanwhile there are the dogs, "so naturally painted they seem to sniff, bay and be full of eagerness to confront any wild beast" (L. Dolce). Titian explained to Philip II that he had represented Venus from the back to distinguish her from the *Danaë*, which was to be its companion piece. Very likely, however, the painter has taken up a Hellenistic Maenad motive, echoed for example in the famous bas-relief of the *Ara Grimani*, which could be admired in the Venetian palace of the same name in the S. Maria Formosa district.

TITIAN
Venus and Adonis (1553)
Canvas; 6 ft 1¼ in × 6 ft 9½ in (186 × 207 cm). It was sent to London in 1554 for Prince Philip, on the occasion of his marriage to Mary Tudor, but was intended for the dressing room in the palace in Madrid, where the *Danaë* had already been hung.

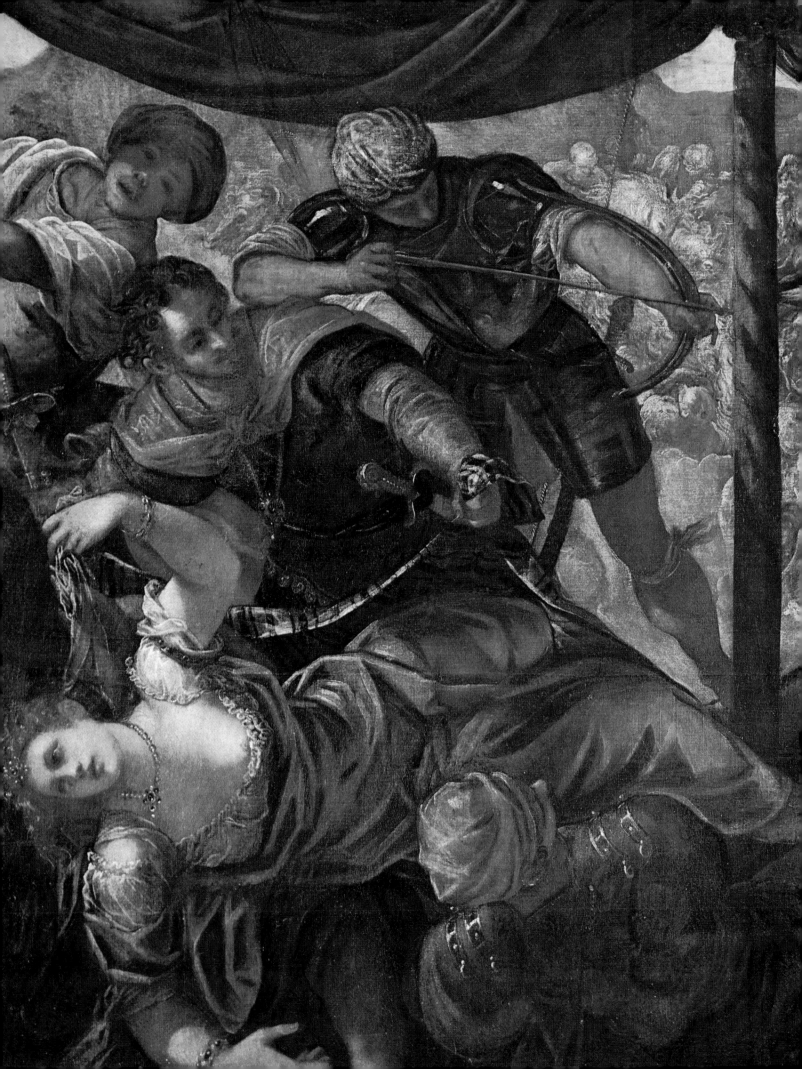

JACOPO TINTORETTO. *Battle of Corsairs.* *pp. 270–71*

This subject has been variously interpreted; the painting itself was brought to Madrid by Velázquez, who had been ordered by King Philip IV to collect the most beautiful works to be found in Italy (1649–51). A suggested identification with a *Battle* painted by Tintoretto for Ercole Gonzaga in 1562 is belied by the stylistic evidence; this is a much later work. Behind it is a long experience in the composition of masses in motion and the distribution of light effects. Similar problems, sharing the same iconographic points of departure, are resolved by the painter in the series of the *Annals of the Gonzaga* and in many commemorative canvases in the Palazzo Ducale, Venice.

All evidence dates the work around 1580. However, while in the series of the *Annals* and in the Palazzo Ducale Tintoretto employed considerable studio assistance, this battle of corsairs gives the impression that the hand of Jacopo predominated. The control — still Renaissance in character — that we find even in Tintoretto's most uninhibited compositional fantasies can be noted in the contained quality of the gestures, which is very far from the rhetoric that will be typical of the Baroque. The quality of the technique is high, as seen in the transparency of the flesh of the woman captive in the foreground. Profoundly skillful are the relationship between foreground and background and the strict register of the light effects.

It is perhaps useful to recall that the taste for epic descriptions, for battles, which in the succeeding century became a true and proper genre, had its enthusiastic pioneers: it was in 1581 that Tasso published his celebrated poem, *Gerusalemme Liberata*.

PAOLO VERONESE. *Venus and Adonis.*

Certainly a genius in painting, Paolo Veronese maintained from the beginning to the end of his career a number of constant factors. As interpreter of certain aspirations of the culture of his time, he risked alienation from the deepest and most uneasy currents of 16th-century spirituality, pursuing his own ideal of formal perfection, which in the end is an escape. The last of Paolo's production (1570–88), however, is touched by a breath of pathos and reflects the need for meditation, which is evident not only in his choice of themes but in the evolution of his style. But noble images were also produced in this period, such as the allegorical fables painted for Rudolph II and this idyll of Venus and Adonis. "The two protagonists are lost in the same enchantment as Tasso's Rinaldo and Amida," as R. Pallucchini says. And this is true especially for the enchanted atmosphere in which the artist immersed his figures: the diaphanously luminous Venus, Adonis relaxed in sleep, Cupid holding back the impatient dog. There is not, however, as in Tasso's poetry, a dramatic motive to Paolo Veronese's escapism. To appreciate this it is enough to compare the thematic development of Titian's *Venus and Adonis*, with its presentiment of death, and the somewhat fatuous gesture of Venus waving her fan and watching over her sleeping lover in Paolo's version. Certainly his classical inclinations, after the dissipation of his energies as a colorist in such canvases as the *Marriage of St. Catherine* and the *Rape of Europa* in the Palazzo Ducale, here again recover their beautiful equilibrium.

PAOLO VERONESE
Verona *c.* 1528 — Venice 1588
Venus and Adonis (*c.* 1570–75)
Canvas; 6 ft 11½ in × 6 ft 4¼ in (212 × 191 cm).
Acquired by Velázquez in Venice for Philip IV.

272

EL GRECO
The Resurrection
Oil on canvas; 9 ft ¼ in × 4 ft 2 in (275 × 127 cm).
Signed at lower right in Greek.
Companion piece to another painting called the
Pentecost.
A canvas of this theme is mentioned as being in
the church of the Virgen de Atocha, Madrid.
Provenance: Museo de la Trinidad.

FRANCISCO ZURBARAN
Still-Life
Oil on canvas; 18 × 33 in (46 × 84 cm).
Gift of Francisco A. Cambo, 1940.

EL GRECO. *The Resurrection.*
Christ with His banner, surrounded by an aura of light, forms a sort of
wedge that is perpendicularly aligned with the axis of the lower part of the
composition. There the eight figures of the soldiers are disposed along
diagonals centrifugal to the central axis, and in rapid, violent *contrapposto*
they fall over, flee or draw back — struck by the splendor of the Resur-
rected. The wedging in of the bodies is equal to the impetus of their precipi-
tous movements caught at the climatic moment, in contrast with the
composed, serene figure of Christ suspended in mid air. The lower part of
the picture is charged with tempestuous light as from a flash of lightning.

FRANCISCO ZURBARAN. *Still-Life.*
Like other still-lifes by Zurbaran which are also signed, this painting is first
of all an authentic re-interpretation of Caravaggio in one fundamental
aspect: the voluntary adoption of a 15th-century mode. The four objects
(which are found again in other still-lifes by the artist) are placed on a con-
tinuous plane that is fixed between two vertical planes — foreground and
background — with an extreme reduction of space. The vase and the dishes
share the same "pure" volumetric quality, and their composition on the
plane corresponds to an equally strict geometry, the lines of which can be
obtained by drawing a *plan* of this picture as if it were an architectural **275**

elevation. The dishes on the sides are disposed in strict symmetry, as are their shadows. In the center, the left double-handled vase is aligned along the axis of the dishes, while the one to the right is pushed back and placed at an angle whose diagonal, projected towards the spectator, is marked by the handles. Another oblique direction is marked by the handles of the vase to the right. At the same time there is a delicate, suspended rhythm of balances in the alternation of heights and sizes of the equidistant objects. Mechanical symmetry is avoided and the image is animated by an internal, almost breathing rhythm.

Beneath an apparent simplicity, the artist shows all the depth and awareness of compositional structure, while the unity of the lateral light isolates the forms in an immobility of contemplation that is continually renewed.

DIEGO VELAZQUEZ
The Surrender of Breda (1634–35)
Oil on canvas; 10 ft 1 in × 12 ft (307 × 367 cm).
Formerly in the Royal Palace of El Buen Retiro
(1635), then in the New Royal Palace (1772); in
the Prado since 1819. Executed in 1634–35 to
commemorate the surrender of Breda: Justin of
Nassau handed over the keys of the fortress to
General Ambrogio Spinola on June 5, 1625.

DIEGO VELAZQUEZ. *The Surrender of Breda.*

This is one of the most important and problematical works by Velázquez. Despite the probable existence of preliminary drawings (for example, in the National Library, Madrid), the canvas underwent a very complicated process of development in successive stages, as X-rays have revealed (changes in the position of the horse, the central group, the position of the lances seen against the plain and the cloudy sky, etc.). The artist's own interest in this masterpiece is shown by his inclusion, on the far right, of a self-portrait. The surface is divided into four parts in a sensitive proportional modulation that intensifies the general dynamic rhythm. Against this rectangular division, around the central group of Nassau and Spinola, there are two curved banks of figures (with the big horse that is turning away): the general staff and the soldiers. Beyond them is the encampment with other lancers sketched in, and in the distance the city and its burning fortifications in the plain that extends to the distant horizon. All the figures are powerfully individualized portraits; the atmosphere is that of an action-camera shot, with everything caught in motion. It is a sunny day; the scene is inundated with vivid transparent colors contrasting with the stupendous lances seen against the light, the halbards to the left, the moving shadows on the ground and the kaleidoscope of parade uniforms. There is neither rhetoric nor Spanish hauteur in this work; indeed, considering the time, it is a sort of calm and good-natured timbre that one registers, in part because Velázquez reduced but did not eliminate the original embrace of the victor and the vanquished.

DIEGO VELAZQUEZ
Prince Balthasar Carlos on Horseback
(1634–35)
Oil on canvas; 6 ft 10 in × 5 ft 8 in (209 × 173 cm).
Painted for El Buen Retiro, where it hung with
the equestrian portraits of Philip IV (Prado, No.
1178) and Queen Isabella (Prado, No. 1179).
Subsequently it was in the New Palace (1734–
1814); then in the Prado from 1819.

DIEGO VELAZQUEZ. *Prince Balthasar Carlos on Horseback.*

Painted between 1634 and 1635, the composition is intended to be immediately and swiftly perceived. There is the general diagonal disposition from lower right to upper left, and the dynamic reversed curves of the horse; and in the middle the young prince in ceremonial dress: star shaped with rays projecting to the horse's mane, harness and tail. The whole explodes against the oblique hollow of a steep-sided valley, and in the distance a receding mountain widens the background that fans out under a coruscating sky, where gray and white clouds pile on top of one another. The stylistic themes are an assembly of headlong, fugitive motives, made concrete by the brushwork. This is divided, directed, flying and sometimes (as in many other paintings by the master) reaching the point of broken impastos, thrown directly on the canvas for passionate, accidental effects.

DIEGO VELAZQUEZ
The Royal Family (Las Meninas or
"The Maids of Honor") (1656).
Oil on canvas; 10 ft 5 in × 9 ft 1 in (318 × 276 cm).

DIEGO VELAZQUEZ. *The Royal Family (Las Meninas).*

The personages are seen in a room in the royal palace with identifiable paintings on the walls — *Apollo and Pan*, school of Rubens; a copy of Jordaens by Mazo, both today in the Prado. Although a little scant of color in the upper part, it is evident how the composition is committed to the influx of light in the "proscenium" and from the background, in a contrast that

278

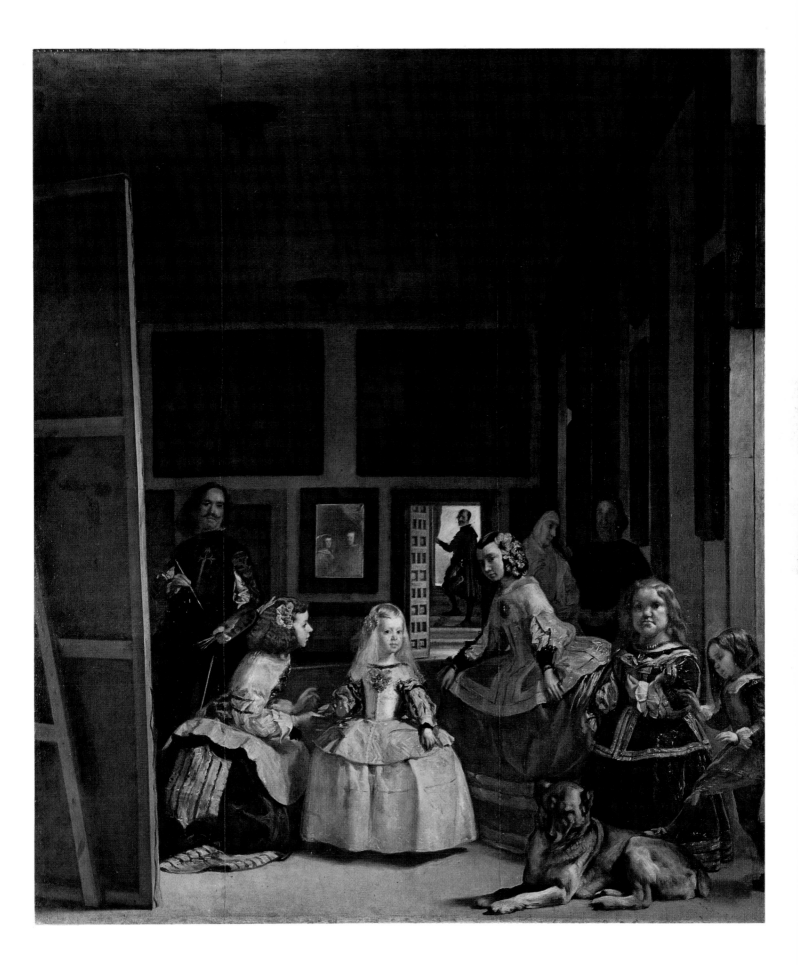

is barely resolved by the play of perspective: an oblique quadrangle in the foreground, the diagonally placed canvas, the background with its mirrored figures and openings against the light. It is an intimate room. Royalty is out of the picture and participates only by reflection, without altering the gentle, fresh atmosphere of the scene. Velázquez removed every restriction that might have obliged him to alter the tone of everyday life, it might be anyone's life, to that of the court's rituals. In fact, the artist himself assumes the part of the protagonist, with his dominating position and his look expressing a tranquil self-awareness. The scene of homage to the Infanta, through its dwarfs, its modest household members and its faithful dog, is

FRANCISCO DE GOYA
Fuendetodos 1746 — Bordeaux 1828
The Parasol
Oil on canvas; 41 × 59¾ in (104 × 152 cm).
Tapestry cartoon for an over-door in the dining
room of El Pardo; executed on August 12, 1777.

FRANCISCO DE GOYA
Man Drinking
Oil on canvas; 42 × 59½ in (107 × 151 cm).
Tapestry cartoon for an over-door in the dining
room of El Pardo; executed on August 12, 1777.

expressed in one of Velázquez's most delicate, refined and vibrant compositions — light in tone and application, with agile passages, contained, pearly touches and in general a supreme expression of expansive affection.

FRANCISCO DE GOYA. *The Parasol.*
By a wall, the elegant young Spanish girl sits in the sun, from which a *Maja* shades her with a green umbrella. With the tapestry cartoons of the same series, ordered from him by Charles III, this represents the first emergence of Goya's personality as a painter, reflecting in theme and background of woods and brush the French taste brought to Madrid by Houasse and even more the clear, fluent techniques of Giaquinto. It is a happy, sunny scene, with a gradation of colors which recalls the range of Tiepolo, especially in the abrupt dips in the blacks. In this and succeeding paintings, Goya's imagination is seen as luminously serene, in a climate without clouds or doubt, torment or pain; a manifestation of joy in life and a paean to its fullness and beauty.

FRANCISCO DE GOYA. *Man Drinking.*
This is another scene of genre or Spanish manners, executed for the same series, and conceived and carried out by Goya in terms of contrasts between the various canvases. Compared to the preceding painting, this one has a more dramatic tone. Against a background sky that is equally clouded and vaporous stand the figures, at the edge of a wood traversed by rays of light that animate the colors. In theme there is recourse to Dutch genre scenes, but the technique is liquid, thin, pearly, with a fanciful and rich choice of colors that are concentrated in full sunlight, especially on the three figures of the *Majas* to the right.

On pages 282–83:
FRANCISCO DE GOYA
The Nude Maja
Oil on canvas; 38¼ × 75 in (97 × 190 cm).
Companion piece to the following painting, and like it painted during the years 1797–98. In the inventory of its owner, the royal favorite Godoy, the two figures are called "Gypsies." Formerly in the Academia de San Fernando; in the Prado since 1901. Despite their strong resemblances and the identical pose, perhaps two different models were employed.

T.12

FRANCISCO DE GOYA. *The Nude Maja.* *pp. 282–83*

On a functional green ottoman, the *Maja,* disposed along a simple diagonal, lies on silken cushions and finely worked sheets; her expression is more naked than her beautiful body. It is one of the most disconcerting images in all art, in which the exaltation of life in the feminine being is triumphant. Goya completely identifies himself with this celebration of beauty, which is not abstract nor an ideal canon, but an enthusiastic participation. The resplendent body lives in the embrace of the light, which seems to love her, as in the ancient myth. The light is a mobile element in the room, and it creates hollows of secret shadow and unexpected radiance; it dazzles and skims, slips along the body and the textures of cloth, shines with palpitations and respirations — forming an indescribable flow of satisfied and exuberant life. This creation of Goya's, though it may have distant ancestors from Titian to Correggio, is disconcertingly new. In climate and in form it established the model by a projection — without pretexts or screens — of the sensibility and vision of an artist, which will be understood by artists of the following century, especially the French.

FRANCISCO DE GOYA. *The Clothed Maja.*

The Clothed Maja repeats the composition of the preceding work, both in the diagonal and in the crescent arc formed by the arms behind the head. There are considerable differences, however, in the general harmony and color. The moment chosen is towards evening; the lights and shadows are more marked and intense, the grounds more golden and transparent. The body has less effect of effusing an aura, but is strongly stated in the splendor of a white dress which takes the full impact of the light. Although apparently

FRANCISCO DE GOYA
The Clothed Maja
Oil on canvas; 37 × 75 in (95 × 190 cm).
Same circumstances and date as the preceding painting.

284

FRANCISCO DE GOYA
The Family of Charles IV
Oil on canvas;
9 ft 2¼ in × 11 ft ¼ in (280 × 336 cm).
Painted at Aranjuez in the spring of 1808, after
several individual portraits and sketches, also in
the Prado. All the subjects except two have been
identified. In 1814 it was in the Royal Palace,
Madrid.

identical, the figure's pose is different from that of the nude *Maja*; it is more relaxed — not slightly contracted — and rests on the calves rather than the feet, which project over the edge of the divan. Repose is complete, without the slightest tension, the waiting air, of the nude. The position appears to be drawn farther back, with no cushion behind the head. It does not have the nude's tendency to turn towards the spectator; it is more comfortably

settled, in a different equilibrium. The two subtly suggested moments explain the different positions of the heads — even though the more extended, inviting attitude of the nude's has been charged, through misunderstanding, with being anatomically incorrect.

FRANCISO DE GOYA. *The Family of Charles IV.* *p. 285*
The 13 figures (and the self-portrait of the painter in the background to the left) are placed, as if on an ideal checkerboard, in "wings" that are balanced with respect to Queen Maria Luisa and the King, but following diagonal axes and disposed in uneven masses. A movement and displacement are thus created in the composition, which is accentuated by the almost revolving central group; while the background is also sectioned unequally by the canvas hanging on the wall. The magnificence of the ceremonial costumes is almost vulgar; they glitter with silks, gold and silver embroidery and masses of bejeweled and reribboned decorations. Cast shadows and thick hollows of shadow form a lowering, clouded atmosphere, an unquiet and, in places, anxious climate, reflected in the poses of the figures, some of which have been caught in attentive and others in distracted attitudes. It is a group portrait of royal personages who, perhaps because of the burning vitality they emanate, forgave the artist his aggressive exposure of their characters. Goya's insight borders on cruelty as he parades the series of masks, some of which (the old Maria Josefa, the Queen) are carried boldly close to the grotesque. In all the figures there is something hooked, occasionally feral, that reveals vitality but even more the repressed or inarticulate violence of weak aristocratic temperaments — the vices of a decadent race.

FRANCISCO DE GOYA
The Aquelarre
Oil on plaster; transferred to canvas;
4 ft 7 in × 14 ft 5 in (140 × 438 cm).
Detail of one of the 14 oils executed by Goya on
the walls of the *Quinta del Sordo*. In the Prado
since 1881.

FRANCISCO DE GOYA. *The Aquelarre.*
Our detail represents a group of hags and other women listening to the goat dressed as a monk. It is a lacerated image of Goya's reaction — he had been persecuted before his exile — to the forces of reaction that defeated the hopes of enlightenment brought in by the French Revolution. The figures are feral, avidly reaching for blind irrationalism, unleashing elementary and destructive passions. The monochrome tonality, kindled here and there by flashes of color, adds power to this burning expression of despair. In solitude Goya gave vent to an emotionally lucid and suffering confession of the

286 catastrophe of his time.

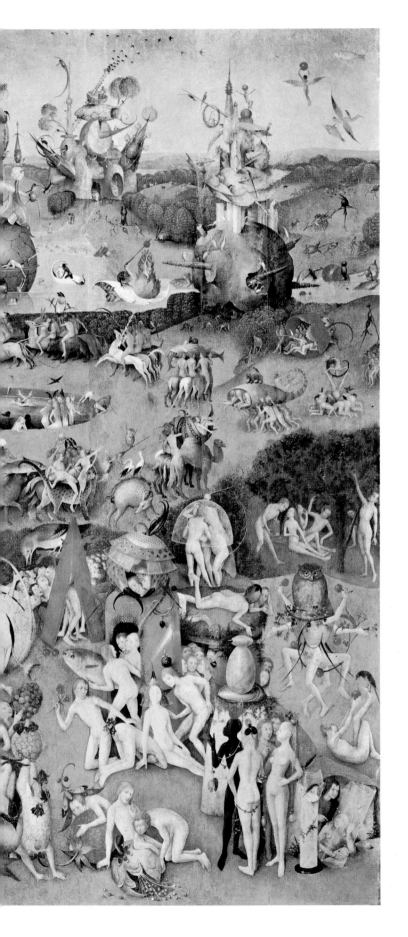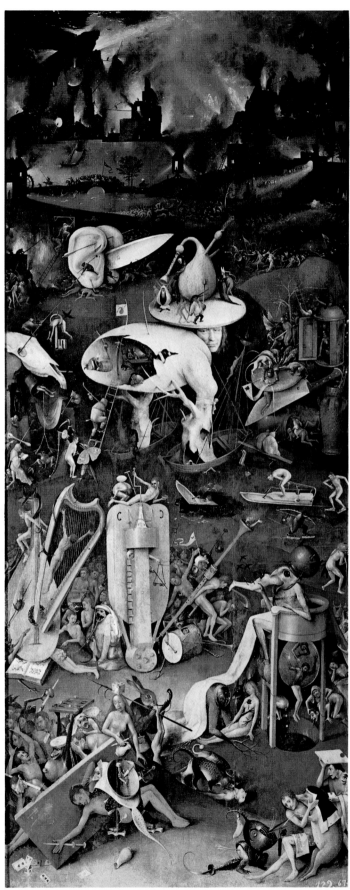

HIERONYMUS BOSCH.

Triptych of the Garden of Delights. *pp. 288–89*

This exceptional triptych is of crucial importance in correcting the usual picture of Bosch as a participant in the supernatural and the apocalyptic, in magic, alchemy and witches, in a time of bloody persecutions and trials. According to the out-moded view, in depicting enigmas and hieroglyphs, monsters and hybrids, dreamlike juxtapositions and symbols of sin and folly, Bosch is the painter of the demoniac, of obsession with sexuality and all that perturbs the religious spirit. A great mass of literary interpretations has diverted attention from Bosch's style and prevented an authentic understanding of his work. If he sometimes intentionally loaded his art with representational functions (*Christ Carrying the Cross* in Ghent, where he rivals Metsys in the adoption of Leonardo's grotesques), he based them on a rigorous and "rational" tendency to be found in Holland (Geertgen and followers, Master of the Virgo inter Virgines, etc.), and which is also connected with such French painters as Fouquet, the Master of Moulins, the Master of St. Sebastian. Furthermore, in working from the earliest Flemish masters, Bosch does not hesitate to learn from Jan van Eyck, the founding father of the tradition. There is no doubt that a fanciful intellectual climate, rich in myth and passions carried to the point of nightmare visions, gave Bosch the opportunity to insert a marvelously free kind of painting into an established idea of subject matter. The persistence of the Temptation of St. Anthony theme is better explained by the wealth of fabulous detail permitted by the legend, than by any veneration of the saint in the master's native town of 's Hertogenbosch. And his inventive faculty was undoubtedly immense, inexhaustible, to such an extent that it has favored an almost exclusive attention to his ever-surprising subject matter and reduced his work to a matter of anecdotes. The forms of his paintings, however, are not all obscure or sunk in details; their clarity is carried to a point of transparent lucidity: the "demoniac" is crystalline in every supposedly tortured image. The transformation of the real into an autonomous vision is not accomplished through an iconography of the impossible, but first of all in terms of pictorial expression. The three parts of this triptych are unified by three large concentric perspective rings (to which the terrestrial globe on the outside of the wings corresponds), while below, the rigorous distribution of details along diagonals (and the corresponding perspective levels) makes an extremely dense elaboration of subordinate motives possible, without dispersion or lapses in the narrative or illustration. All the individual forms are marked by a geometric purity which, in close correspondence to the rhythm, unifies each part; the part in turn is spontaneously linked with and flows into the next, with a continual transformation that is also an internal form of the highest coherency. A close rein is kept on the imaginative representation, and its reduction to basic, controlled modules. Accordingly, it is hard to know how to speak of the anxious, the troubled and the diabolic before these joyous sequences, in places somewhat ironical or frivolous, where life is seen in its infinite guises, in its hidden connections, in its possible transformations and passages, in all its impetus that pervades every creature, animate or not. Here the nature of man is exalted; it is not an orgiastic vision, but lyrically contained by a style that personalizes and harmonizes every part of the work, which is meant to be read attentively

throughout its clearly marked courses, where movement and rest alternate, and everything is of equal intensity, from the choral ensemble to the most secret detail.

PETER PAUL RUBENS. *The Three Graces.* p. 291
This mythology is generally dated in the last years of the artist's career, when he altered his technique by the use of oil diluted with turpentine to gain greater fluidity of tone and brushstroke. The group of the three nudes among trees (the one on the right is his wife, Hélène Fourment) is inspired by ancient models, a continual stimulus for Rubens, who was educated and nourished on classical and Italian art. But the basic theme is a celebration of physical beauty, the majestic size and brimming vitality of the three women. Their vibrant flesh is animated by the pulse of life and by the sun.

ANTHONY VAN DYCK. *The Artist and Sir Endymion Porter.*
In London around 1635, the mature aristocratic art of van Dyck became more and more refined, tending towards a pervasive, sensuous taste. In this exquisite conversation portrait, two paragons of polite and educated culture are depicted in an extremely subtle choice of colors. Their clothes are in silvery blacks and grays, while in the ocher background, dark grays and a coruscating sunset comment on the melodic song of the figures, heightening their elegance. In this period, van Dyck spiritualized his painting, which also took on nuances of ingratiating preciosity and decadence.

LUCAS CRANACH THE ELDER.
Hunting Party in Honor of Charles V at the Castle of Torgau. pp. 294–95
Numerous replicas and variants of this composition commemorating a deer hunt with crossbows were probably ordered by the Elector Palatine and executed by Cranach in his studio with the assistance of his sons Hans and Lucas the Younger. Cranach's early experiences were with the Danube School, with its agitation and Far Eastern exoticism, and with the humanistic ideas in Vienna and then at Martin Luther's Wittenberg. After he became Court Painter, he turned more and more to the subtle and fabulous world of the Late Gothic. He revived its nervous, undulating, broken forms, he progressively left behind Italian as well as Flemish cultural innovations. He preferred dense compositions in which to recount fables of a polite and knightly world; his taste for spectacles always included the extraordinary, the marvelous and the dramatic.

ALBRECHT DÜRER. *Eve.* p. 295
Certainly painted in Venice, as indicated by the epithet *Almanus* ("German"), which would not make sense in Germany, *Eve*, along with

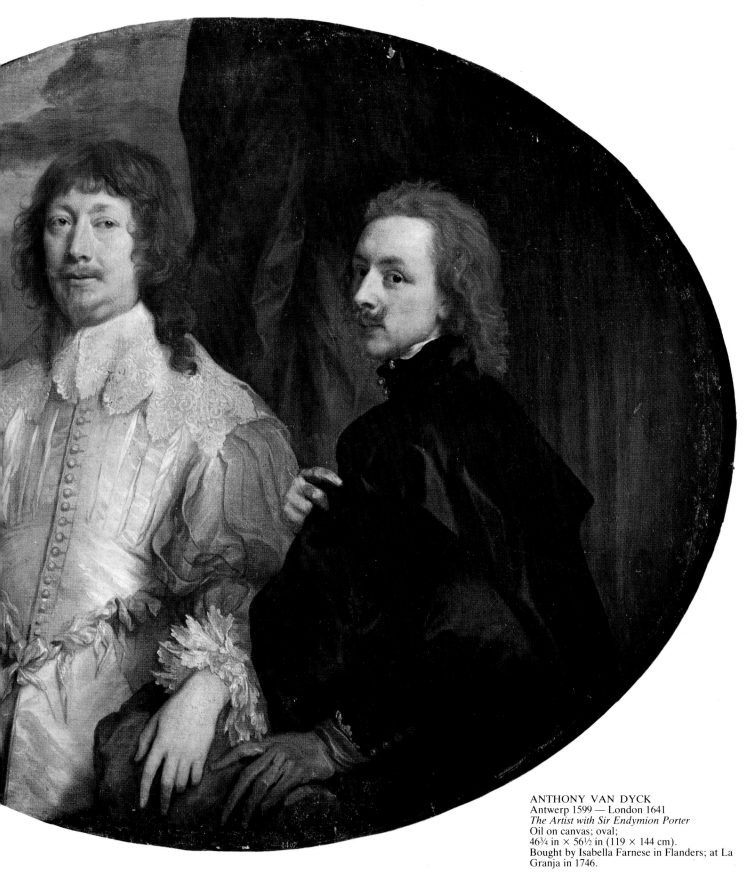

ANTHONY VAN DYCK
Antwerp 1599 — London 1641
The Artist with Sir Endymion Porter
Oil on canvas; oval;
46¾ in × 56½ in (119 × 144 cm).
Bought by Isabella Farnese in Flanders; at La
Granja in 1746.

293

LUCAS CRANACH THE ELDER
Kronach 1472 — Weimar 1553
Hunting Party in Honor of Charles V at the Castle of Torgau
Oil on panel; 44¾ in × 69 in (114 × 177 cm).
Signed with initials and dated 1545.

Its companion piece (No. 2175) is dated 1544.
Replica in Lord Powerscourt's collection; other
Hunts by Lucas and his son are in Vienna (1544),
Stockholm (1546), Copenhagen and Moritzburg
(1540). Inventory of La Granja, 1746; from the
collection of Isabella Farnese.

294

ALBRECHT DÜRER
Nuremberg 1471 — Nuremberg 1528
Eve
Tempera on panel;
7 ft 9 in × 2 ft 7½ in (209 × 80 cm).
Signed and dated: "Albertus dürer almanus/
faciebat post virginis/partum 1507 A.D."

295

Adam, is of particular importance as a cultural influence. It comes at the culmination of the artist's Italian experience and reflects the ideal or proportion and harmony that will later (1528) be systematically propounded in the *Four Books of the Human Proportions*, illustrated with his drawings. Dürer openly competes with the compositional and structural standards of the Italian artists of the 15th century, as can be seen in his sculptural plasticity, in the balanced and measured correspondences of the nude elements, in the neo-antique poses (*Adam's* stance follows a Hellenic module), in the distribution of the static and dynamic balances and in the tendency towards "pure" forms within rigorously defined volumes.

The "rhetoric" does not however absorb the dancing lightness of the image between tree and branch, with its undulating hair and its body dappled by fugitive shadows.

UFFIZI

FLORENCE

THE BUILDING

The building that now houses the Uffizi Gallery was constructed by order of Cosimo I de' Medici in order to bring together the thirteen principal magistratures of the State, whose offices had to be in the vicinity of Palazzo Vecchio, which was his residence. In 1546 demolition started in the thickly built-up area, and a street was opened between Arnolfo's Palazzo Vecchio and the Arno, destroying in part the church of S. Pier Scheragio (the remains of which are visible in the Via della Ninna and in the ticket office of the Gallery) and the Zecca (Mint) which stood opposite. Vasari was asked to draw up plans in 1559, and in the following year he notes in his memoirs that building had started on the Zecca side. Because of Cosimo's afterthought of including a corridor to link Palazzo Vecchio with the Pitti Palace, construction went on for much longer than anticipated, and in 1574, when Cosimo and Vasari himself died, it was still in progress. Alfonso Parigi and Bernardo Buontalenti (the creator of the bizarre doorway called the Porta delle Suppliche) who were commissioned to complete the job did not alter the original conception. This was based on a strict multiple reprise of Michelangelo's architectural motives on the Capitoline, combined with some suggestions taken from Mannerist architects ranging from Peruzzi to Vignola.

Vasari's inventiveness lies less in the decorative elements and the stylistic features of his deliberately toned-down architectural design, than in his plan seen as an urban design. In this he reveals an extreme sensitivity in inserting the gigantic complex of the Uffizi into the ancient center of Florence, without destroying its delicate fabric of history. By having his building turn to make symmetrical wings on either side of the Via dei Magistrati, he created a spyglass which instead of emphasizing its own value enhances the two farthest views, of Palazzo Vecchio on one side, and the green hill of the Costa di S. Giorgio on the other. Working with a structure made up of light membering and transparent effects, Vasari created a town-planning solution that is astonishingly modern.

PLAN OF THE MUSEUM

KEY

A Vestibule
D First Gallery
1 Sala dell'Ermafrodito (statue of the
 Hermaphrodite, Roman copy of a
 Hellenistic original)
2 13th-century and Giotto Room
3 14th-century Sienese Room
4 14th-century Florentine Room
5 and 6 International Gothic Room
7 Early 15th-century Florentine Room
8 Lippi and Pollaiolo Room
9 Piero del Pollaiolo Room
10–14 Great Botticelli and
 Van der Goes Room
15 Umbrian and Leonardo Room
16 Sala delle Carte Geografiche
 (Leonardo's *Annunciation*)
17 Mantegna Room
18 Tribuna (ancient statuary and portraits
 by Pontormo, Bronzino, Vasari, etc.)
19 Perugino and Dürer Room
20 Dürer Room
21 Giovanni Bellini and Giorgione Room
22 Holbein and Altdorfer Room
23 Coreggio Room
24 Cabinet of Miniatures
E Second Gallery (Classical Sculpture)

F Third Gallery (Classical Sculptures and
 Series of Tapestries)
G Vasari's Corridor (Display of 17th- and
 18th-century Schools, Self-Portraits)
25 Michelangelo Room
26 Raphael Room
27 Pontormo Room
28 Titian Room
29 Parmigianino Room
30 Emilian Room
31 Dosso Dossi Room
32 Sebastiano del Piombo Room
33 Corridoio del '500 (works by Vasari,
 Bronzino, Allori, etc.)
34 Veronese Room
35 Tintoretto and Baroque Room
41 Rubens Room
42 Sala della Niobe
 (*Niobe and her Children*, Roman copy
 of a Hellenistic original; works by
 Watteau, Nattier, Chardin, Longhi,
 Guardi, etc.)
43 Caravaggio Room
44 Flemish Room
45 18th-century Room

The numbering and designation of the rooms are the official ones employed by the Gallery. As a connection between the Uffizi Gallery and the Pitti Palace by means of the corridor across Ponte Vecchio is planned, readers are cautioned that the positions of some works may be changed over the next few years. Today Rooms 11 to 14 form part of the Great Botticelli room. Rooms 36 to 40 no longer exist. In their place is the Vestibule that leads into the exit staircase constructed in 1968. The works originally exhibited in them are now to be found in Vasari's corridor and in Rooms 43, 44 and 45.

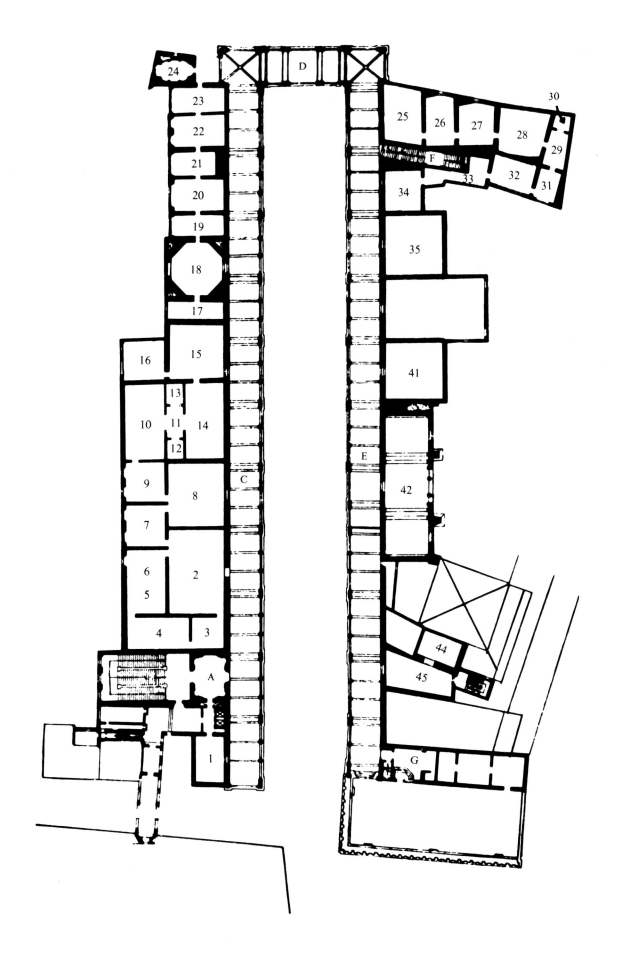

CIMABUE
(CENNI DI PEPO)
Florence 1240 (?) — Pisa *c.* 1302
Madonna and Child in Majesty
Tempera on panel;
12 ft 7½ in × 7 ft 3¾ in (385 × 223 cm).
From the High Altar of S. Trinità, Florence.

CIMABUE. *Madonna and Child in Majesty.*
Completed a little later than the Assisi frescoes of around 1280 which
marked the dramatic peak of the master's imagination, this *Madonna and
Child in Majesty* represents the golden maturity of Cimabue, colored by his
courtly neo-Carolingian and neo-Byzantine nostalgia. Placed in the same
room as the two similar works by Duccio and Giotto, it does not lose by
300 their presence, but gains in fascination, as the comparison confirms the

greatness of the personality of the painter, who must have been the master
of the other two artists.

With respect to Giotto's revolutionary humanism, which lay in the future,
and Duccio's somewhat later neo-Alexandrian lyricism, Cimabue's *Majesty*
remains the greatest among the incunabula of Italian painting. This has been
understood since Vasari, who said of Cimabue how marvelous it was that
he "should see so much light in the midst of so great darkness." But nowhere

301

on earth is there a better illustration of Dante's idea of a competition between Cimabue and Giotto than in this bringing together of the works of the three masters, though Dante's lines might have been too hasty in their judgment on Cimabue. In this painting Cimabue introduces certain features — apart from the actual expressive means — that will remain constant in Florentine painting, and in the Italian art that follows. These embrace not only the epic serenity of his psychological atmosphere, but also the masculine and forceful aspect of his figures. Compositionally, the work follows a Byzantine scheme, which is, however, completely transformed. It is interpreted in a fantastically hyperbolic form. The human scale of the figures below is equated with that of the spectator, and by comparison emphasizes the gigantic, towering proportions of the enthroned Madonna. She seems as tall as a bell tower, and with the human tower formed by the angels creates a space like an immense vessel. This is emphasized by the two perspective vanishing points, above and below, which are linked by the illusion that is created by the ambiguous form of the throne carried on arches.

GIOTTO DI BONDONE
Florence 1267 (?) — Florence 1337
Ognissanti Madonna (c. 1300)
Tempera on panel;
10 ft 8 in × 6 ft 8 in (325 × 304 cm).
From the church of Ognissanti, Florence.

DUCCIO DI BUONINSEGNA. *Madonna and Child in Majesty.* p. 301
Duccio di Buoninsegna's *Majesty* is dialectically opposed to the Cimabue type, expressing a quite different system of values. Its sweet and idyllic intimacy, however, is set in the same unreal and liturgical context as Cimabue's so that only such a totally complete personality as shown here is able to break through. The extraordinary fact is that Cimabue himself was fascinated by this intervention and sought to adopt it in his late Pisan *Majesty*, which is now in the Louvre. There too, however, the old master confirms the courtly aspect of his art in the highly sophisticated ivory-like illusion of the image. Duccio's version is clearly much more modern, because of his ability to combine human sentiment and agreeable form, creating a musically and pictorially vibrant image that is weightlessly suspended in the heavens.

GIOTTO. *Ognissanti Madonna.*
This great panel painted at the beginning of the 14th century, which belongs stylistically between Giotto's cycles at Assisi and Padua, inaugurated a new trend in Florentine art. As revolutionary as Masaccio and Caravaggio in their times, Giotto powerfully and violently expresses here the sense of a changed conception of the world. An affirmation of an unknown truth, beyond the astonishing novelty of the pictorial invention, it inevitably involved a new ideological content and sweeping new attitudes of mind.
In this painting, perhaps the work most completely executed by the master's own hand, Giotto propounds his new realism. Man and history are no longer outside but "within" the icon, whose specialized terms are dissolved in the name of a living and pulsating humanity. This is a humanity that has taken place on the throne, a concrete symbol of the terrestrial city in development, free of myths and firmly believing in itself and its own forces.

On pages 304–5:
PAOLO UCCELLO
Florence 1397 — Florence 1475
The Battle of San Romano (c. 1456–69)
Tempera on panel;
5 ft 11½ in × 10 ft 7 in (182 × 323 cm).
Signed in Latin at lower left: PAULI UGELLI OPUS ("The work of Paolo Uccello"). It was in "Piero's Room" in the Palazzo Medici (later Riccardi), then in the Grand Ducal Wardrobe until 1784, when it came to the Uffizi. Companion panels with similar subjects are today in the Louvre, Paris, and the National Gallery, London.

303

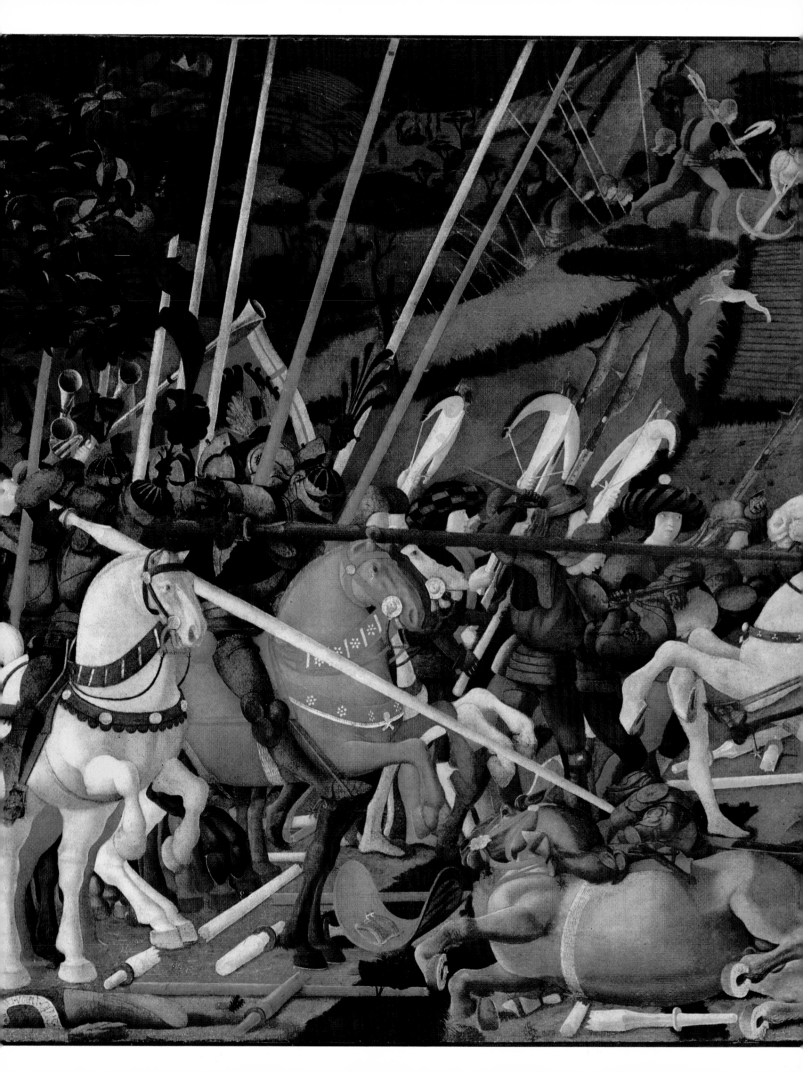

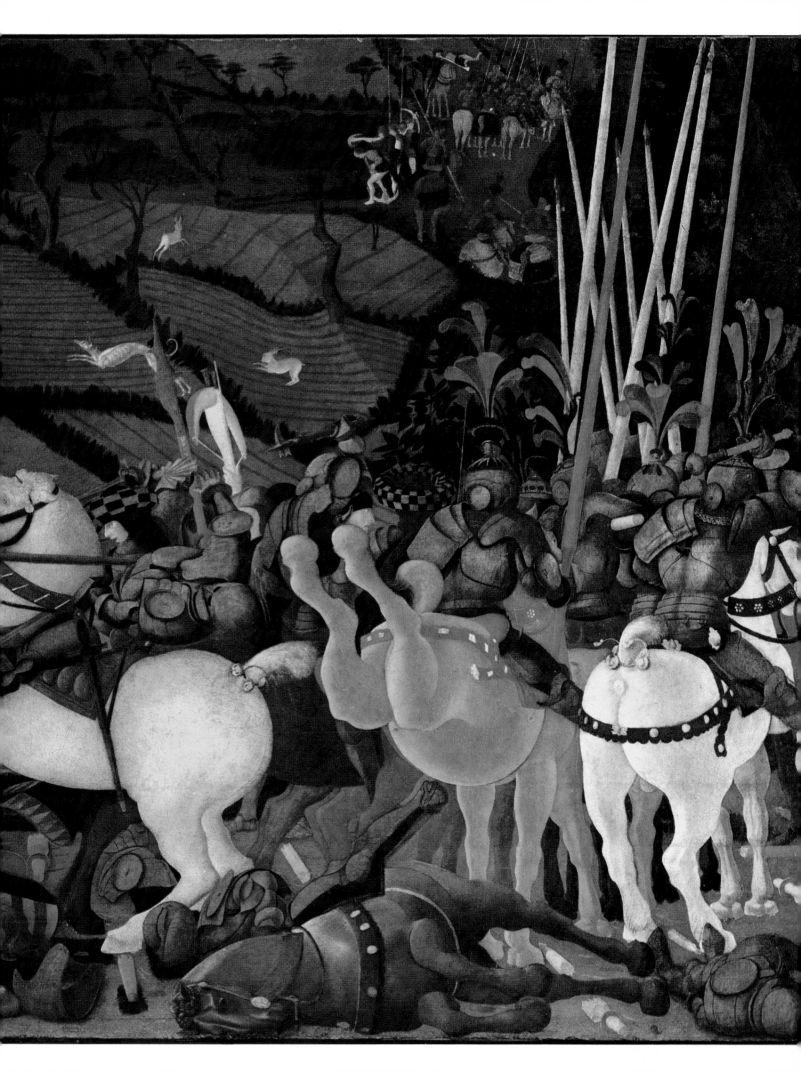

PAOLO UCCELLO. *The Battle of San Romano.* *pp. 304–5*

The Florentines, led by Niccolò Maurucci da Tolentino, and the Sienese, led by Bernardino della Ciarda, clashed near S. Romano on June 1, 1432. The conflict was resolved by another famous captain, Micheletto Attendolo da Cotignola, who intervened in favor of the Florentines and thus decided their victory. In three great panels commissioned by the Medici for their palace in the Via Larga, Paolo Uccello commemorated the event, placing one of the leading *condottieri* at the center of each scene. The panel in the National Gallery in London depicts the beginning of the battle, with the Florentines arrayed around Niccolò da Tolentino. The panel in the Louvre shows the unexpected arrival of Micheletto. More directly based on the combat itself, the composition in the Uffizi catches the decisive moment, when Bernardino is hit and thrown from the big white horse, which rears before the compact ranks of the enemy. In the background little groups of Sienese retreat towards the hills, pursued by Florentine archers, and in an obvious parallel, their flight is interwoven with that of the hares being chased by grayhounds across the fields.

Without dwelling on the commemorative and illustrative aspects of the theme, the artist has elaborated each form: warriors encased in armor, heavy-hoofed horses, shields, lances, trumpets, crossbows, facted head-gear, crested helmets. He has studied the degree of foreshortening in terms of the specific perspective graduation, both in the figures still involved in the conflict and in the objects and figures lying on the ground. Selecting concave or convex planes and crescent-shaped profiles, he has stripped every structure of its accidental aspects to transform it into a metaphysical component of an affray, one that is shorn of its historical significance and assimilated to an exclusively mathematical and figurative reality.

FRA FILIPPO LIPPI. *Madonna and Child with Two Angels.*

This painting is one of the most refined examples of 15th-century devotional art, executed probably for one of the Medici. If it was not commissioned by Cosimo the Elder, who was an affectionate and understanding client of Filippo Lippi and more than once had him pardoned for his amorous affairs, then it was ordered by one of his relatives. This work was criticized for a certain lack of unity and measure, but in reality Lippi is an artist whose imagination is too quick to kindle and an experimenter too open and too receptive to novelty, for him to be judged according to any classic formulas. He seizes every pretext to enrich pictorial reality, and he accepts, assimilates and immediately abandons any fact of experience or culture to go in pursuit of another. Thus he arrives at solutions that perhaps are lacking in rigor, but nevertheless teem with invention and have the ability to communicate flights of the imagination with exceptional immediacy. Here the stone frame seems barely able to contain the over-abundant figurative material. The composition is compressed, however, in the group of divine figures: in the pleating of the Virgin's robes and veils, and in the interlacing of the solid limbs of the Child and the angels. The most mobile elements of the latter — hands, eyes, laughing mouths — are emphasized. Silvery reflections skim the hair, the embroidery and the gems, and touch the land-scape that extends in a close succession of rivers, rocky peaks and cities.

FRA FILIPPO LIPPI
Florence *c.* 1406 — Spoleto 1469
Madonna and Child with Two Angels
(c. 1455–60)
Tempera on panel; 36¼ × 25 in (92 × 63.5 cm).
On the back is a sketch for a half-length female
figure. From the Villa of Poggio Imperiale, it
came to the Uffizi in 1796.

PIERO DELLA FRANCESCA. *Triumphal Diptych.* *pp. 308–9*

The famous diptych of the rulers of Urbino includes the representation of
Duke Federico II (1422–82) and his wife Battista Sforza (1446–72) on the
two faces. On the back the same subjects are shown riding in triumphal cars,
with Federico accompanied by the cardinal virtues and crowned by Victory;
while Battista, escorted by the theological virtues and other allegorical
figures, is drawn by a pair of unicorns, symbolizing chastity. In showing the
two figures on the obverse of the panel in profile — aside from the practical
reason that the duke had lost an eye — the artist wished to underscore the
commemorative nature of the picture by associating it with the tradition of
medal design. This is confirmed by the Saphic strophes in Latin painted at
the base of the two triumphs in large capital letters. Piero, however, does
not accept indiscriminately the stylistic modes connected with the repre-
sentation of figures in profile, which were graphic and linear even in the **307**

PIERO DELLA FRANCESCA
Borgo San Sepolcro *c.* 1410 —
Borgo San Sepolcro 1492
Triumphal Diptych
Left: Portrait of *Battista Sforza.*
Right: Portrait of *Federico II da
Montefeltro* (*c.* 1465)
Tempera and oil on panel;
18 × 13 in (47 × 30 cm).
The surface of the painting has
yellowed because of deterioration
in the glazes. Formerly in the ducal
palace of Urbino, it came to
Florence with the Della Rovere
inheritance and entered the Uffizi
in 1773.

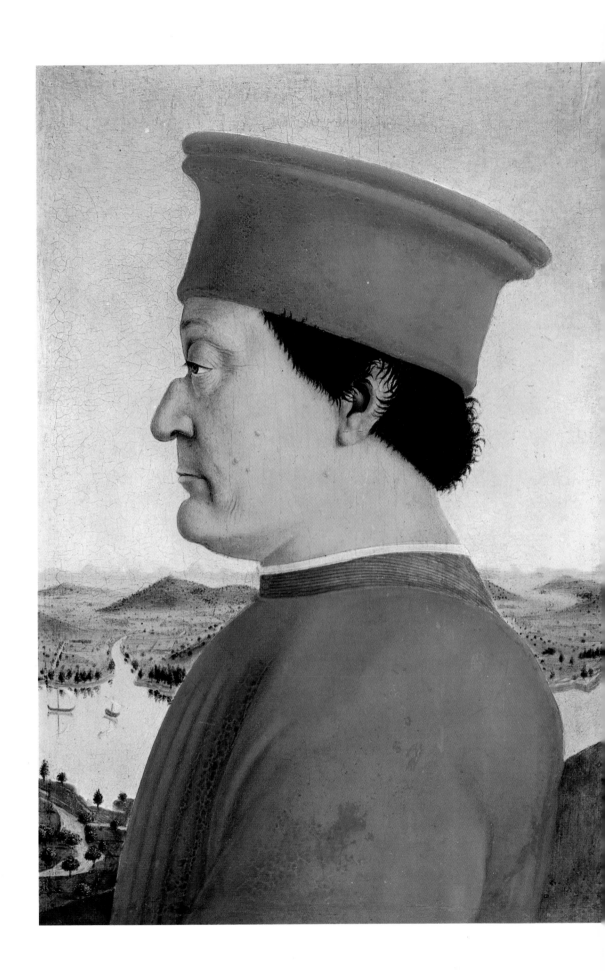

illustrious examples of Pisanello. He gives volumetric definition to the faces and shoulders, concentrating the value of the forms in a few key elements, such as Federico's cylindrical hat, and the collar and medallions on Battista's head and breast. The structures emerge in absolute immobility, scanned along their sharp contours and curved planes by a uniformly diffused, hard, clear light. The result is a certain detachment from the landscape, which is partially hidden and extends into an indefinite distance.

This painting is perhaps the most famous work of that splendid civilization of Urbino that brought together personalities like Piero, Leon Battista Alberti, Luca Pacioli and Francesco di Giorgio.

SANDRO BOTTICELLI. *La Primavera* (Spring).

The most persuasive interpretation of the allegorical meaning of the work, despite numerous alternative proposals, remains that in which the passage from one figure to another is seen as the progressive sublimation of sensual love in intellectual contemplation. This is a process in accordance with the harmony which governs the cosmos, and which is here evoked in the figure of Venus. The cycle, of Neo-Platonic inspiration, is based on symbols and episodes in classical literature, from Hesiod to Ovid, as well as on contemporary interpretations such as those of Leon Battista Alberti and Marsilio Ficino. It begins on the right, where Zephyrus (the West Wind) pursues and

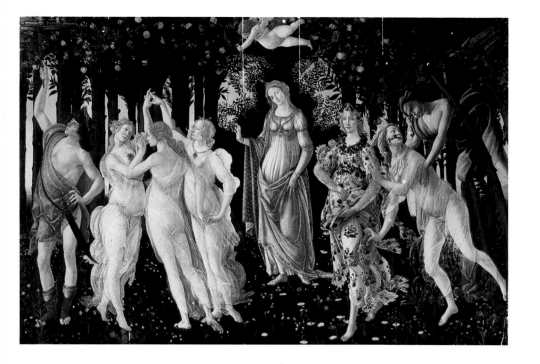

SANDRO BOTTICELLI
Florence 1445 — Florence 1510
La Primavera (Spring) (c. 1475–78)
Tempera on panel;
10 ft 3½ in × 7 ft 8 in (314 × 203 cm).
Like the *Birth of Venus* it was executed for a room in the Villa di Castello, recently acquired by Lorenzo di Pierfrancesco, a cousin of Lorenzo the Magnificent belonging to a cadet branch of the Medici family, whose teachers were the philosopher Marsilio Ficino and other members of the Accademia di Careggi. Botticelli illustrated Dante's *Divine Comedy* for the same patron. On Lorenzo's death the painting, and the villa, went to Giovanni delle Bande Nere. In 1815 it was moved to the Uffizi, then to the Accademia and back again to the Uffizi in 1919. Restoration work on the painting was finished in 1982.

Opposite page: Flora's face after restoration.

seizes Chloris, the nymph who will be transformed into Flora, mother of flowers. At the center, through the meditation of Eros and Venus — Ficino's *Venus Humanitas* who arouses passion but also converts it into contemplative activity — the passage to the Three Graces is effected. This triad is an ancient symbol of liberality (Aglaia who gives, Euphrosyne who receives, Thalia who returns), and in the most properly Platonic sense alludes

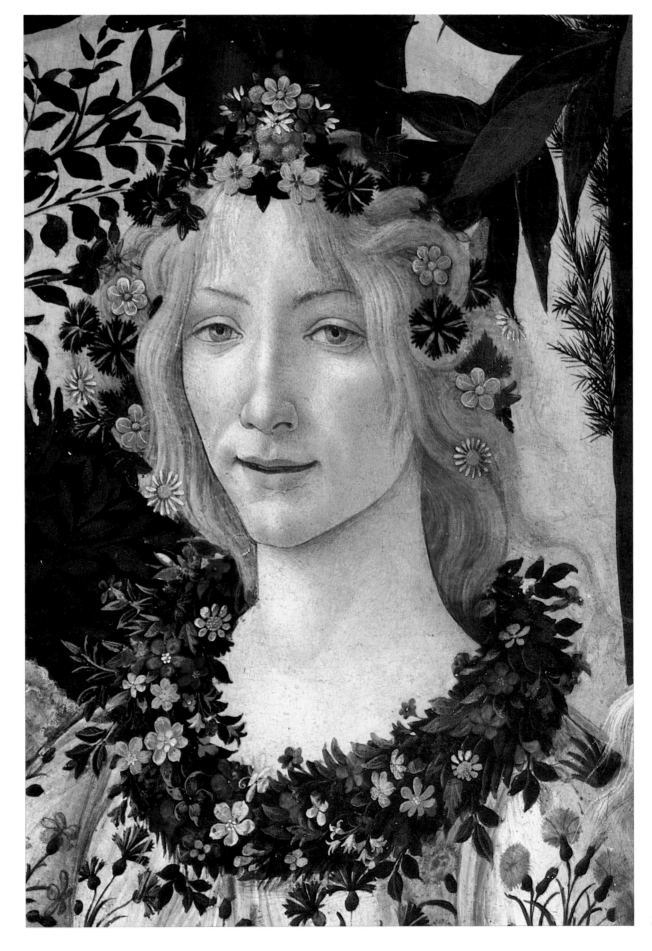

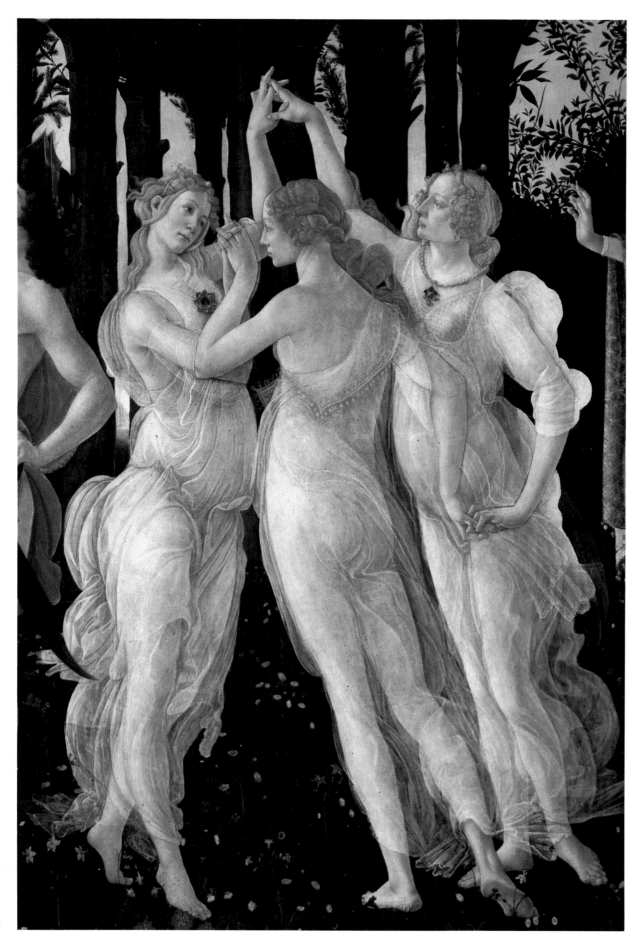

to the relationship between the divine element and the human. On the left, Mercury dispersing clouds marks the definitive arrival of the spiritual moment. Put in these terms the program of the picture, probably elaborated at the Accademia di Careggi for Lorenzo di Pierfrancesco, appears pedantic. But Botticelli cut off the didactic embellishments, leaving the solution to the picture's extrinsic meaning enigmatic, and still controversial.

LEONARDO DA VINCI. *Annunciation.*
Traditionally ascribed to Domenico Ghirlandaio, it was only attributed to Leonardo in 1869 and subsequently to Ridolfo Ghirlandaio and to Verrochio. In fact the work is characterized by a partial acceptance of traditions and by innovations in interpretation, and thus it lends itself to conflicting readings, although it is today unanimously given to the young Leonardo. The perspective system, for example, has been constructed with great nonchalance. At the vanishing point (near the jagged mountain) there is a convergence from the right of a large number of diagonals marked by the profiles of the stone quoins, the step, the window and the top of the

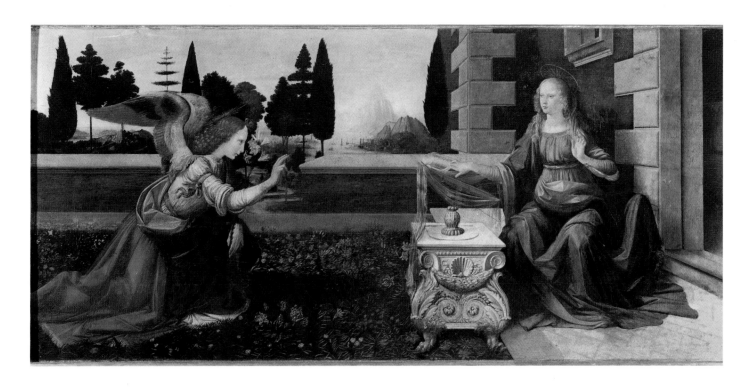

sarcophagus. From the left, however, there is only one such line, the one that marks the opening of the parapet. The plan of the composition is also asymmetrical. It is laid out with a double point of view on the right, where the figure of the Madonna is articulated in pyramidal form. Then it extends freely to the left, where the low wall counts not as an element of separation but as a link between the garden and the background. Here the possibility of having the angel correspond in rhythm to the Madonna was discarded, the figure being constructed on a system of variously oriented diagonals.

313

Although the sarcophagus introduced as a support for the lectern is a homage to well-known examples used by Verrochio and Desiderio da Settignano, its plastic consistency is annulled by the outpouring of claws, leaves and volutes. The misty city by the sea and the port dotted with ships are of a Northern type, and there is Flemish inspiration in the elaboration of the sumptuous draperies. But the minutely realistic effects that had come from Flanders are defiantly rejected in the fantastic flora of the lawn, which is full of luminous corollas and leaves flickering like flames. A work that poses problems, this painting expresses some of the most precocious and imperious statements of the master.

MICHELANGELO. *Holy Family.*

MICHELANGELO
Caprese 1475 — Rome 1564
Holy Family (1504–05)
Tondo: resin and tempera on panel;
47¼ in (120 cm) in diameter.

The symbolism of this painting is still being debated. Tolnay's reading seems accurate: the nude figures in the background represent humanity before the Law (that is, before God gave Moses the tablets) united through St. John to Mary and Joseph, symbol of humanity under the Law. The Child, looming over the two figures, represents humanity under Grace; He wears a headband, the ancient symbol of victory.

It is the only panel painting definitively attributable to Michelangelo that has come down to us. Executed in all likelihood after the *Pitti Tondo* (National Museum, Florence) and the *Taddei Tondo* (Royal Academy, London), both of which are in marble, this work concludes or at least radically modifies the master's thinking in terms of circular composition. In comparison with the two sculptures, here an articulated relationship with the background (nudes and exedra) has been added. Two vanishing points control the composition. A lower one determines the perspective of the exedra, while a slightly higher one (indicated by the direction of the cross on St. John's shoulder) gathers the lines on which the main figures are set. This doubling, determined probably by the work's original position in the house of the Doni family, is made inconspicuous through the junction made by the step on which Joseph rests.

The lively relationship of the planes reinforces the twisting movement of the central group. Around this complicated structure revolves the band of the frame. In it the faces of the "witnesses" (prophets and sibyls), except the one above which is frontal, emphasize the perspective developments and revolve and descend in a repeated rotary movement, attracted by the figurative and symbolic core. As in the marble tondos, where the smooth surfaces of the foregrounds flowed into the "unfinished" backgrounds, to emphasize depth and distance, the resonant pictorial texture of the main group crumbles in the progressive blurring, from St. John to the nudes. In fact, in the foreground group itself the painting is denser on Mary's knees than on the face and head of St. Joseph. A work "typical" of the inquiring mind and genius of Michelangelo, it shines out at the beginning of the 16th century as an element of attraction and crisis for many personalities, great and less great, and then becomes a model for late 16th- and 17th-century pictorial programs. This painting was executed for the marriage of Agnolo Doni and Maddalena Strozzi, which took place at the beginning of 1505. Some scholars, however, set its date ahead to 1506 or to 1508–10. The magnificent frame is by Domenico di Francesco del Tasso, and was probably designed by Michelangelo himself.

315

ANDREA DEL SARTO
Florence 1487 — Florence 1531
Madonna of the Harpies (1517)
Oil on panel;
8 ft 10¼ in × 5 ft 10 in (207 × 178 cm).
Inscribed in Latin on the pedestal is the
signature: AND. SAR. FLO. FAB. ("Andreas del
Sarto, Florentine, made it") and below: AD
SUMMU(M) REG(I)NS TRONU(M) DEFERTUR IN
ALTUM MDXVII ("To the Queen raised to the
highest throne." 1517). It was executed for the
nuns of San Francesco in Via de' Pentolini; in
1685 it was acquired by Ferdinando de' Medici
and placed in the Pitti Palace. In 1795 it was
moved to the Tribuna of the Uffizi. There are
many preparatory drawings in the Louvre and
the Uffizi.
The book the Madonna holds with her hand is a
symbol of wisdom, and the pedestal on which she
stands is decorated with sphinxes (not harpies, as
they are traditionally described) which are
mythological symbols of the widsom of Minerva.
The accompanying figures are St. Francis (the
Franciscan order first supported the dogma of
the Immaculate Conception) and St. John the
Evangelist, who was designated by the dying
Christ as the adopted son of Mary, and in whose
Gospel there is a reflection of the Neoplatonic
mystique. The inscription is the beginning of a
hymn celebrating Our Lady of the Assumption,
Queen of Heaven and *sedes sapientiae* — the seat
of wisdom.

ANDREA DEL SARTO. *Madonna of the Harpies.*

One of the most famous 16th-century Italian paintings, this work has long
been considered the prototype of Florentine "classicism." It skillfully com-
bines Leonardo's "nuances," Raphael's "proportion" and Michelangelo's
"monumentality." For this skilled balance, Andrea del Sarto merited
Vasari's description as the "faultless painter." There is no question that pro-
grammatically it is Andrea's most ambitious work, and its complexity in-
cludes its iconography. With Michelangelo's *Doni Tondo*, it is perhaps one
of the highest manifestations of a type intellectualized religious feeling of
Neo-Platonic derivation, characteristic of the Florentine cultural milieu
even after Savonarola's reforms. Indeed it was painted immediately after
an intense and dramatic experience of Michelangelo's work, and the painter
moreover utilizes proportions and rhythms inspired by Alberti. The space,
however, is monumentally vast, and the entire composition is based on an
unfaltering structure, in which the broadly shadowed, low-keyed colors give
resonance to the spaces. Del Sarto achieved one of the most heroic attempts
to redirect Florentine painting into the channel of its glorious 15th-century
heritage.

RAPHAEL
Urbino 1482 — Rome 1520
Portrait of Leo X with Two Cardinals
(1517–18)
Oil on panel; 60½ × 46¾ in (154 × 119 cm).
Since 1589 it has belonged ot the Uffizi, although
from 1799 to 1815 it was in Paris as part of the
Napoleon's loot.

RAPHAEL. *Portrait of Leo X with Two Cardinals.*

This portrait is perhaps the masterpiece of the artist's last years, and cer-
316 tainly the work of this period most completely executed by his own hand,

On pages 318–19:
TITIAN
Pieve di Cadore *c.* 1488–90 — Venice 1576
Venus and Cupid (after 1555?)
Canvas; 47 × 76¾ in (119 × 195 cm).
The painting came to the Uffizi in 1632 from the
estate of Antonio de' Medici, but there is no
mention in the documentary sources of the
person who commissioned it.

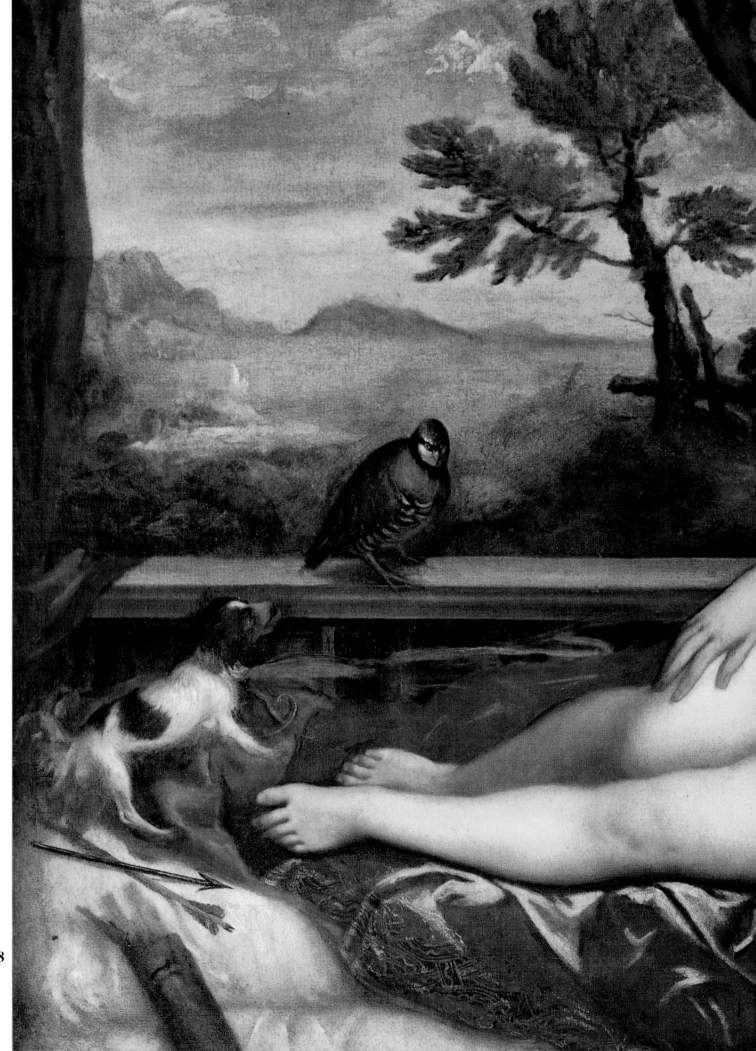

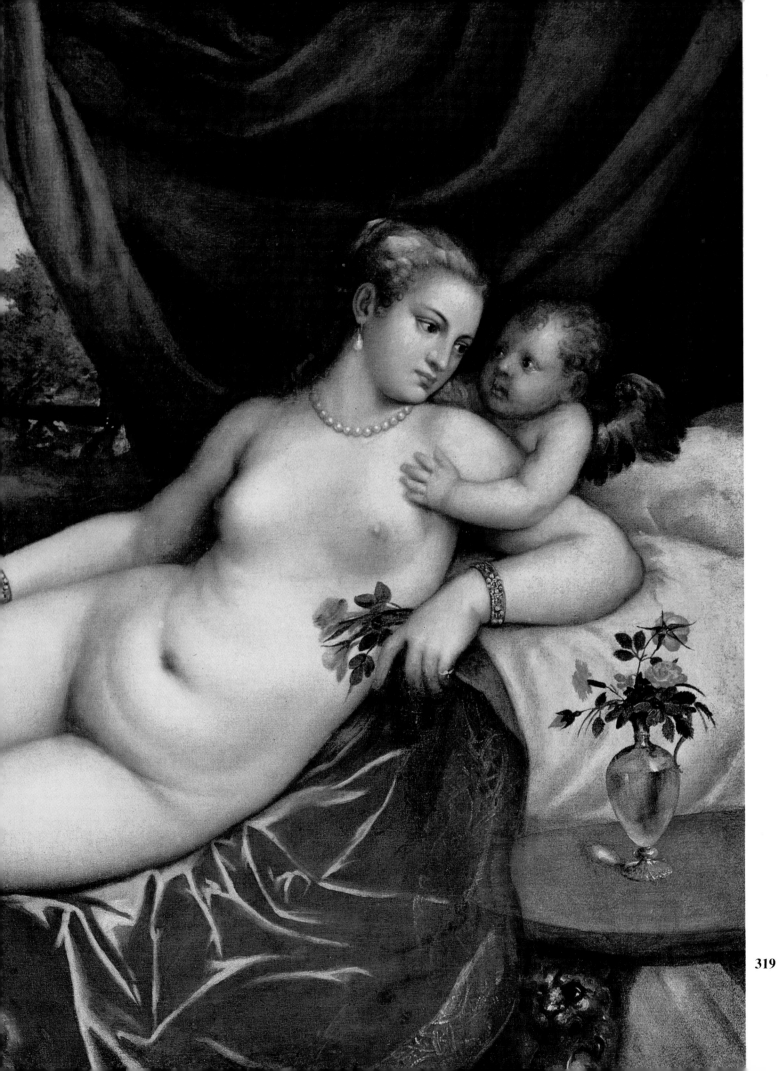

though the participation of Giulio Romano is documented. The "invention" is of the highest caliber. Note the structure of the central figure with its three-quarter turn in the armchair; the architectural plan of the two bodies at the side, like chapels built around a central apse; and the outpouring and the attraction of the red fullness of the table. The relationship of these elements, the abstraction of the calm surfaces, the intense expressions of the three men are the highlights of this painting. As if to accentuate further this golden ideal of space, the color extends without marked refractions, almost in a monochrome, and it takes an anonymous place around the "invention," as if to avoid altering its essential values.

TITIAN. *Venus and Cupid.* *pp. 318–19*

Titian painted three pictures in which this image of a nude Venus appears, not exactly reclining but lying on her side on a bed hung with velvet, and turning her head towards an appealing cupid. In the versions in the Prado and the Kaiser Friedrich Museum, Berlin, the composition is embellished with a third and very important figure, an organ player who turns to look at the group, suggesting a narrative plot and emphasizing the aesthetic and sensual tone. In this version, which Gronau, Berenson and Tietze consider to be entirely by the artist's own hand, there is a greater sense of serenity. The harmony of the beautiful woman remains intact, as she lies near a

AGNOLO BRONZINO
Florence 1503 — Florence 1572
Portrait of a Youth with a Lute (after 1532)
Oil on panel; 37 × 31 in (94 × 79 cm).
Provenance is uncertain and there are no documentary sources.

320

JACOPO TINTORETTO
Venice 1518 — Venice 1594
Portrait of Jacopo Sansovino (*c.* 1566)
Canvas; 27½ × 25½ in (70 × 65 cm).
Since Borghini mentions it as being in Florence
in 1584, the assumption is that it was sent there
in 1566, when Sansovino was named a member
of the Florentine Academy. Hadeln held that it
was a studio work; there are other versions of the
painting, which Tietze considered copies of this
one, agreeing with Berenson that this alone is by
the master's hand.

window opening on to a landscape seen as if through a heat haze. Pallucchini
(1952–53) accepts Berenson's suggestion that it was executed after 1555,
and explains some stiffness in the purple mantle and in the modeling as the
work of assistants.

AGNOLO BRONZINO. *Portrait of a Youth with a Lute.*
Despite the fact that there are no documents for the dating of this master-
piece, it is clear that the work belongs to Bronzino's early efforts in por-
traiture, along with the *Martelli Portrait*, the *Youth with a Book* and the
earlier Panciatichi portraits. Besides, Vasari himself recounts that on his
return from Pesaro (1523) Bronzino executed a series of portraits that were
"extremely natural and done with incredible diligence ..." Some scholars
have attempted to establish a parallel between the portraiture of Bronzino
and Parmigianino. Aside from certain cultural correspondences, the ac-
centuated revival of 15th-century models — in the manner of defining the
environment, in the relationship of line and color and in the tension
produced by the subtle glazing of the color surfaces — is more characteristic
of Bronzino's own contribution.

321

JACOPO TINTORETTO. *Portrait of Jacopo Sansovino.* *p. 321*

Jacopo Tintoretto's portraiture has not yet been systematically distinguished from that of his son, Domenico, and by some scholars these portraits are doubted when compared with the highest creations of imagination. In fact, it must be recognized that his feeling for humanity helped him mainly in sounding the depths of the faces of the old. It is enough to recall the *Jacopo Soranzo* in the Castello Sforzesco, Milan, or the *Alvise Cornaro* of the Pitti, and their dematerialized and visionary effect. The portrait of the 80-year-old Sansovino, however, is the image of an artist who is still fully active (he displays the implements of his profession) and whose shrewd glance seems to be fixing his friend, Tintoretto, as he is in the process of painting him. From the letter of Calmo, we know that there was a strong friendship and mutual respect between the two artists.

PAOLO VERONESE. *Annunciation.*

In the museum of Padua there is a precedent for this *Annunciation*, in a version showing a wide separation of the two figures of the angel and the Virgin. Since the 18th century, scholars have vacillated between ascribing

PAOLO VERONESE
Verona 1528 — Venice 1588
Annunciation
Canvas; 6 ft 4 in × 9 ft 6½ in (193 × 291 cm).
Originally in the Venetian collection of Paolo del Sera, it was taken to Florence and acquired in 1654 by Cardinal Leopoldo de' Medici, as a work of Veronese. Subsequently it was assigned to Zelotti, to the school of Veronese, to the studio of Zelotti, and finally restored to Veronese, an attribution followed by the majority of critics.

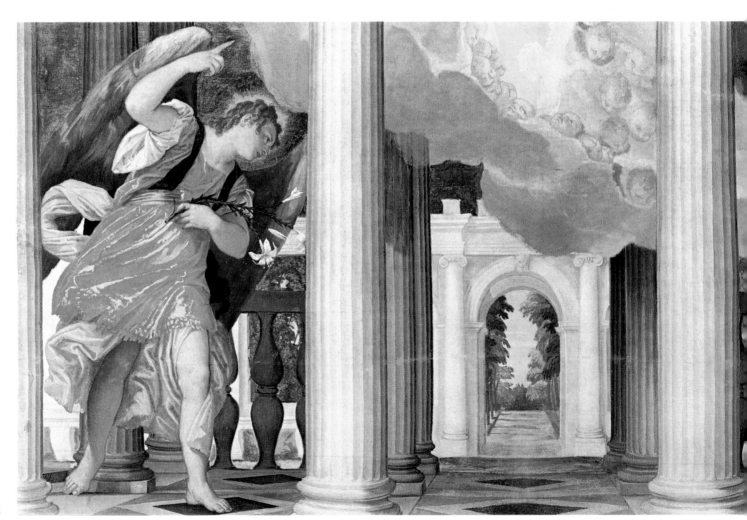

the authorship to Veronese or to Giuseppe Porta, called Salviati. This shows how readily the work may be seen in a Mannerist key, especially the angel, with his complicated and violent gesture.

If, as seems reasonable, the Paduan work was done in 1552, this reprise of the motive in the Uffizi canvas may be four or five years later, and is still reminiscent of the *Coronation of the Virgin* in the sacristy of San Barnaba (an association suggested by Pallucchini). The impression of greater distension is conveyed mainly by the structural composition, which is spread horizontally and marked by the caesuras created by the white columns and the doorway opening on a tree-lined avenue. It is a theme that Veronese will take up again in his *Annunciation* of the Accademia, Venice, a work of his late maturity. Here the rich, gay color is shot with nervous yellow highlights, as if reflected from the light that is bursting from the glory of the angels.

CARAVAGGIO. *Youthful Bacchus.*

Although its quality casts doubt on Bellori's assertion that it was the painter's first work, it is certain that with *Ailing Bacchus, Boy Bitten by a Lizard* and *Boy Peeling a Pear* (known through copies) this painting belongs to the earliest phase of Caravaggio's career.

Compared to the other canvases mentioned above, which are close to it in the relationship between figure and still-life, this *Bacchus* has a greater balance in the closed passages of color, solidly defined in tense, resonant fields, within strong linear demarcations. The classical pose and the subtle calculation of the composition go well beyond the equivocal "realism" that is too often attributed to Caravaggio. This cannot be reconciled with the portrayal of forms in the splendid still-life.

In this formal perfection, which is certainly unusual in a very young artist and partially justifies those scholars who prefer a later dating, the torpid expression of the face is barely accentuated by the tilt of the head (with a very slight relaxation of the features that may recall Michelangelo's youthful *Bacchus*). It is perhaps the only element providing an immediate emotional contact with the spectator.

GIAMBATTISTA TIEPOLO.

The Erection of the Statue of an Emperor. *p. 325*

The work has been known since the first decade of the 20th century, and Sack, who was the first to publish it, already mentions its bad state of preservation. Perhaps this is the reason for some hesitation, based on the deterioration of the paint, as to its authenticity. In conception, however, it is typical of Tiepolo. In the upper part, the Angel of Fame is a precursor of Truth in the Tiepolo ceiling in the museum of Vicenza, while the figures below are boldly foreshortened and arranged in stepped sequence. The proud soldiers are taken from the repertory already assembled in the Dolfin canvases, and in contrast is the appealing figure of light tonalities on the left.

CARAVAGGIO
Caravaggio 1573 — Porto Ercole 1610
Youthful Bacchus (*c*. 1589)
Oil on canvas; 36½ × 33½ in (93 × 85 cm).
Published by Marangoni, following a suggestion
by Longhi, in 1917 as a copy after Caravaggio,
and by the same scholar in 1922 as an original. It
was in the Uffizi reserves. Probably it is the
Bacchus that Bellori indicates as the first work by
the master.

GIAMBATTISTA TIEPOLO
Venice 1696 — Madrid 1770
The Erection of the Statue of an Emperor
(1734–35)
Canvas; 13 ft 9¼ in × 5 ft 9¼ in (420 × 176 cm).
The work came to the Uffizi in 1900 from the
Seminario Arcivescovile of Udine. From a
payment recorded there it can be dated between
1734 and 1735. Morassi (1962) ascribed it to
Menescardi. At the exhibition in Udine (1966)
Rizzi again proposed giving the authorship to
Tiepolo, but Morassi is still doubtful.

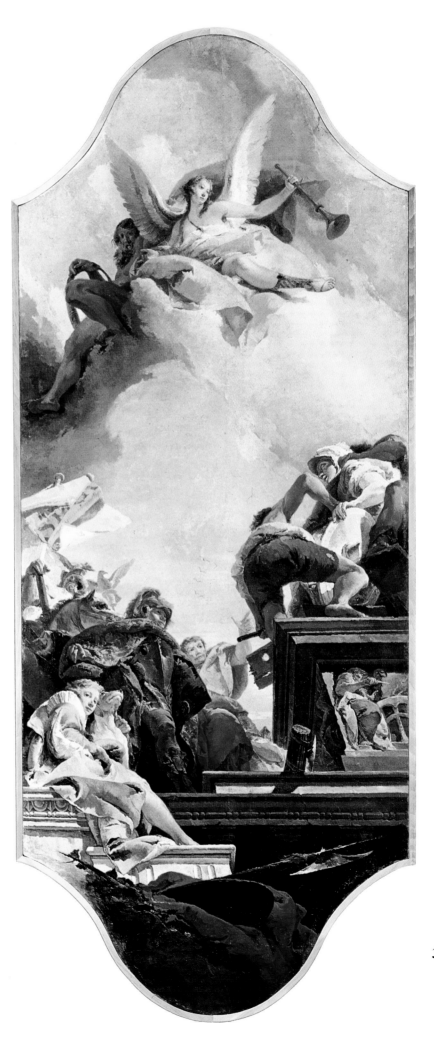

ALBRECHT DÜRER
Nuremberg 1471 — Nuremberg 1528
Adoration of the Magi
Oil on panel; 39½ × 45 in (100 × 114 cm).
Monogrammed and dated 1504. The wings are in
Frankfurt and Munich.

ROGIER VAN DER WEYDEN
Tournai *c.* 1398 — Brussels 1464
Entombment (1449)
Oil on panel; 43¼ × 37¾ in (110 × 96 cm).

ROGIER VAN DER WEYDEN. *Entombment.*

This is one of van der Weyden's masterpieces, and was executed during his brief stay in Italy in 1449. It is obvious that Rogier is not interested in narration. In fact, where Italian Renaissance painters like Raphael and Titian put the cortège transporting Christ into the scene or represent the moment when Jesus is lowered into the tomb, the Flemish painter avoids external drama and concentrates his attention on the nude and tortured body. Rogier's devotional intention is not to represent a given moment in the Passion, but to offer the lacerated image of Christ as an object of piety and adoration The figures are thin and wavering, almost lacking in weight. To a certain extent, the painter is returning to the stylizations of the Gothic tradition, which Jan van Eyck had surpassed in the name of a more human-

327

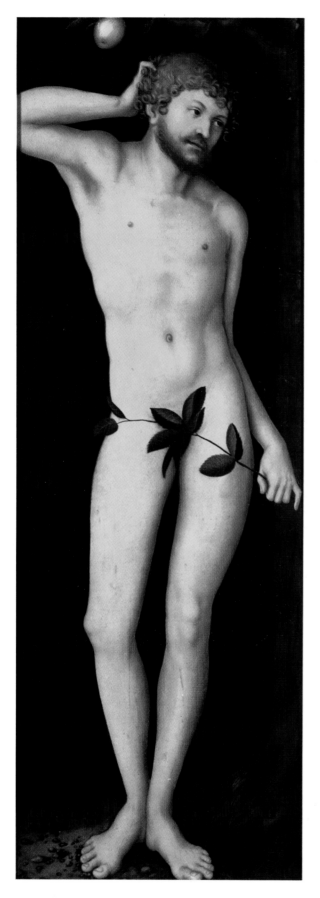

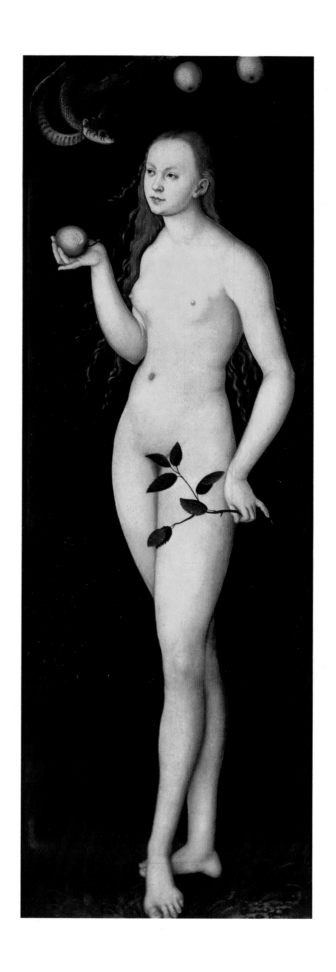

LUCAS CRANACH THE ELDER
Kronach *c.* 1472 — Weimar 1553
Adam and Eve
Oil on panel; 67¾ × 24¾ in (172 × 63 cm)
and 65¾ × 24 in (167 × 171 cm) respectively.
The *Adam* is monogrammed and dated 1528.

istic naturalism. In van der Weyden's panel, the importance given to the landscape may occasion surprise, as the painter, in contrast to van Eyck, often considered nature as a disturbing element, and in his great *Descent from the Cross* in the Prado he had set his figures against a gold ground. It is likely, however, that the inclusion of the broad landscape in the *Entombment* was specifically requested by the Italians who commissioned the work. Indeed, for the Italian admirers of the "new discipline from Flanders" an essential aspect of the Lowlands' pictorial miracle was the landscape passages evoking so subtly a sense of airy spaces. The symmetry and the Renaissance grandeur of van der Weyden's composition are probably the result of a study of Italian art. The problem of the influences experienced and exercised by the artist on the Italian peninsula has not yet been adequately investigated.

PETER PAUL RUBENS
Siegen 1577 — Antwerp 1640
Henry IV at the Battle of Ivry
Oil on canvas;
12 ft 5 in × 22 ft 8 in (379 × 692 cm).
Work in progress from 1628 to 1631, but
unfinished.

ALBRECHT DÜRER. *Adoration of the Magi.* *p. 327*
This famous painting fuses various aspects of Dürer's art. It shows his taste for chiseled images with continuously vibrant contours, as well as his thorough study of perspective. Again, there is his psychological unity and tension in narration and strong feeling for landscape, which is more compact

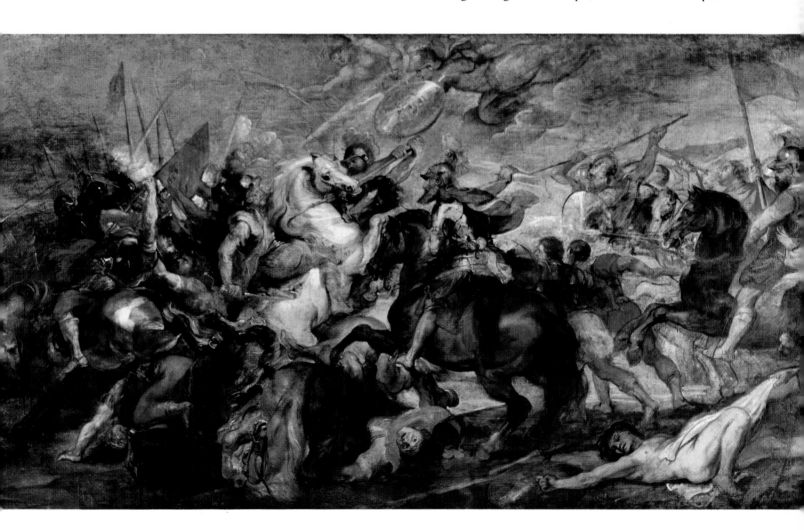

and organic than in the Flemish painters. The work also testifies to the tension, ever present in Dürer, between theory (which the artist termed *Kunst*) and manual ability (*Brauch*). The *Adoration of the Magi* is the central panel of the *Jabachsen Altarpiece*. Its two wings are in Frankfurt and Munich.

LUCAS CRANACH THE ELDER. *Adam and Eve.* *p. 328*
What a contrast there is between the severe, rational and Renaissance art of Dürer and the playful, decorative art of Cranach. Whereas Dürer is pre-

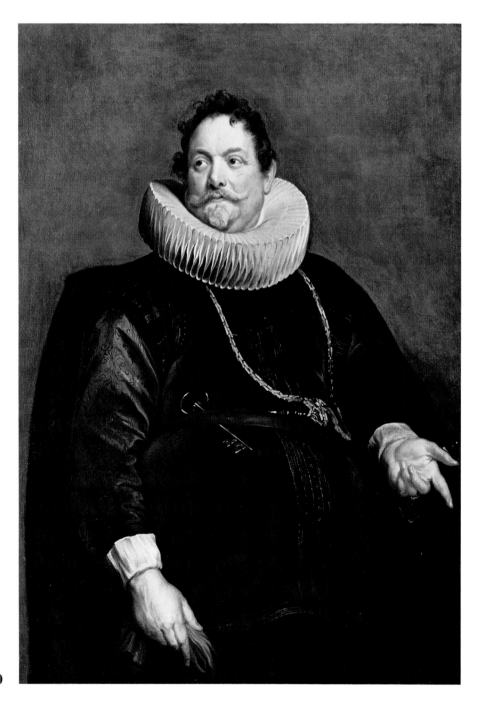

ANTHONY VAN DYCK
Antwerp 1599 — London 1641
Jan van Montfort
Oil on canvas; 48 × 35 in (122 × 89 cm).

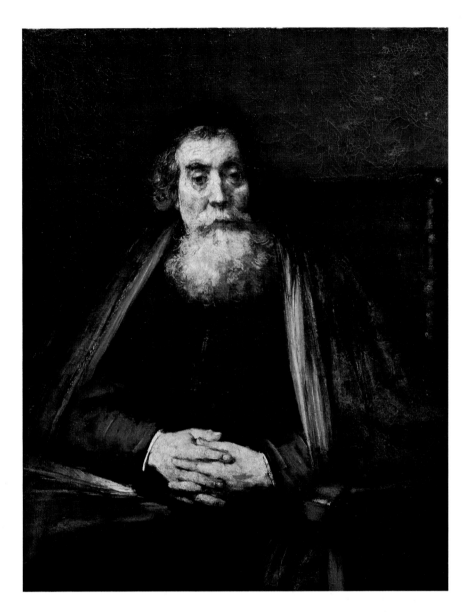

REMBRANDT VAN RIJN
Leyden 1606 — Amsterdam 1669
Portrait of an Old Man
Oil on canvas; 40¼ × 28¾ in (102 × 73 cm).
Signed; date illegible.
According to Zwarts (*Oud Holland*, 1926) it is
the Rabbi Haham Saul Levy Morteyra of the
Portuguese community in Amsterdam. It should
be dated perhaps around 1658.

occupied with the problem of the proportions of the human body (both in his paintings and his graphic work there is considerable evidence of these intensive studies), Cranach's nudes are free of any preconceptions or even observation of "anatomical correctness." Naturally it would be a waste of words to state that in art this is perfectly legitimate. Cranach's nudes (Eve, Venus, Diana, Judith, Lucrece) are slender, elongated, flexible, boneless and often affected in their poses. A cold, refined eroticism is exuded. Often the figures are set against dark grounds that throw the silhouettes into relief and highlight the flesh of the bodies. Cranach repeatedly painted the figures of Adam and Eve against a dark background. He also placed them in front of impressively painted, stylized foliage. Finally, he showed them in the Earthly Paradise, surrounded by animals. Cranach's art still presents problems concerning the definition of his style and the clarification of its relationship with Italian and Flemish art.

PETER PAUL RUBENS. *Henvry IV at the Battle of Ivry.* *p. 329*

In 1622 Marie de' Medici had commissioned Rubens to do two large series of pictures for the decoration of the Palais du Luxembourg, which had just been built. The first series of canvases — 22 in all — was completed by the painter in February, 1625 (it is now in the Louvre). Immediately afterwards, Rubens started to work on the second cycle, which was to represent episodes in the life of Henry IV, Marie de' Medici's husband, who had beden assassinated in 1610. The project was not completed, however, because of dissension between Marie de' Medici and her son, Louis XIII, and her subsequent departure for the Low Countries. As shown by the inventory of Rubens' possessions made after his death, the master had started on six of the very large canvases. Two of these have come down to us: the one reproduced here and a second, also in the Uffizi, representing the *Triumphal Entry of Henry IV into Paris after the Battle of Ivry*. Preparatory sketches for some of the compositions have also been preserved. The two gigantic canvases in the Uffizi are in an incomplete state, and it is this that makes them so interesting. In *Henry IV at the Battle of Ivry* the influence of the great Italian models (Leonardo's *Battle of Anghiari*, Giulio Romano), is clear, but the impetus with which the artist has attacked his theme is entirely new and Baroque.

ANTHONY VAN DYCK. *Jan Van Montfort.* *p. 330*

The restless and elegiac van Dyck distinguished himself primarily, as is well known, in the field of portraiture. In the early 17th century he gave ideal interpretation to a large part of the European aristocracy, conveying not only their exterior pomp but also the refinement of their style of living. In Rubens, it has been said, "the men are like lions and the women like domestic animals: strong, healthy and beautiful beings, but not human figures with a spiritual invididuality" (Friedländer). This observation could never be applied to van Dyck, who aims rather to spiritualize and exalt his clients. The present portrait "is certainly one of the most vigorous by van Dyck, in the sureness of the organization of the forms and the color, which make up the translation of the subject's arrogant air of self-confidence into pictorial terms" (Salvani).

REMBRANDT VAN RIJN. *Portrait of an Old Man.* *p. 331*

Rembrandt's art should be seen in the historical context of middle-class Amsterdam society, which was certainly the most advanced society in Europe at the time. Thanks to this privileged position, Rembrandt was able to free himself without external difficulty of the mythical superstructures which were so much a part of the work of that great man of the world, Rubens. Rembrandt's independent attitude grew in intensity in his later years, when the artist increasingly left behind conventions, employing thick impasto and a short-hand technique. The present portrait, probably of an Amsterdam rabbi, is dated about 1658.

VATICAN MUSEUMS

ROME

THE BUILDING

The history of the buildings that house the Vatican Museums, and include the decorated apartments and chapels, is extremely complicated, since there has been no period from the 15th century to our day when there has been no building activity going on. The vast ensemble came into being with the reconstruction of St. Peter's in the 15th century. Before this time the residential accommodations at the Vatican must have been insignificant, and until the Babylonian Captivity at Avignon the popes preferred the Lateran as the center of their activities.

The first reorganization of the Apostolic palaces and galleries was undertaken by Nicholas V, who added to what remained of the 13th-century buildings the part of the palace giving on the Cortile di San Damaso, and made a chapel (which he had Fra Angelico fresco) in a tower constructed at the time of Nicholas III. In this way a four-sided complex was formed, to which Sixtus IV added the Sistine Chapel, built in the next to the last decade of the 15th century by Giovannino de' Dolci and decorated by the best-known painters of the day.

Innocent VIII had the Palazzetto del Belvedere built on plans by Antonio del Pollaiolo. Here is the beginning of the impressive prospect later developed by Bramante during the pontificate of Julius II (1503–13) when he joined the Palazzetto to the main palaces by means of a long corridor in which the Museo Chiaramonti was subsequently arranged.

Meanwhile Alexander VI (1492–1503) had had his apartments decorated, and Julius II, with the refined taste of one of the greatest art patrons of the Renaissance, had his Stanze frescoed by Raphael. In the time of Julius II and Leo X, some of the most celebrated artists of the century worked in the Vatican palaces — Bramante, Raphael and Michelangelo. To the first two we owe the Logge and the Stanze, to the last the decoration of the Sistine Chapel ceiling and later the *Last Judgment* on the rear wall of the chapel; as well as the frescoes of the Pauline Chapel, ordered by Pope Paul III (1534–50).

Gregory XIII (1572–85) was responsible for many of the stucco and painted decorations of the palace dating from the second half of the 16th century, and above all the beautiful Gallery of the Maps (Galleria delle Carte Geografiche). His successor, Sixtus IV (1585–90), had the architect Domenico Fontana build the new premises for the Library. This required the construction of a wing cutting across the Cortile del Belvedere where there was a change in ground level, and thus created two smaller courtyards. To Fontana we also owe the part of the Apostolic Palace which we see from St. Peter's Square.

While the 17th century is to be remembered for progress on the building of St. Peter's, in the 18th century interest revived in the Vatican palaces, no longer considered as residences or places to receive people, but as proper museums. The complex of galleries built on to the Palazzetto, at the behest of Clement XIV and Pius VI, contains the sculpture museum that bears their names. The architects were Michele Simonetti and Giuseppe Camporesi, who produced a notable example of Neo-Classical style conforming to the best 18th-century museum standards. From 1817 to 1822 Rafaello Stern built the New Wing of the Museo Chiaramonti, which lay parallel to Fontana's Library and divided the Cortile del Belvedere into three parts. In the fourth decade of the 19th century the halls of the future Egyptian Museum were redecorated in a Neo-Egyptian style.

In the 20th century the problem of creating a single entrance providing access to all the museums and the decorated apartments, was resolved by the construction of the double spiral staircase leading to the Museo Pio-Clementino and the Egyptian Museum on one side, and to the Pinacoteca on the other. This arrangement was conceived at the time of the construction of the new Vatican Pinacoteca, which was inaugurated in 1932.

KEY

1	Atrio dei Quattro Cancelli	15	Sala delle Nozze Aldobrandine	29	Sala Sobieski
2	Scala Simonetti	16	Borgio Apartment	30	Galleria e Cappella di Pio V
3	Museo Pio-Clementino	17	Salette Borgia	31	Sala delle Dame
4	Scala del Bramante	18	Sistine Chapel	32	Galleria delle Carte Geografiche
5	Fontana della Galera	19	Galleria d'Arte Sacra Contemporanea	33	Galleria degli Arazzi
6	Museo Gregoriano Egizio	20	Sala Regia	34	Galleria dei Candelabri
7	Scala Chiaramonti	21	Scala Regia	35	Sala della Biga
8	Museo Chiaramonti	22	Sala Ducale	36	Museo Gregoriano Etrusco
9	Galleria Lapidaria	23	Raphael's Loggia	37	Salette degli Originali Greci
10	Braccio Nuovo (New Wing)	24	Chapel of Nicholas V	38	Scala dei Rilievi Assiri
11	Museo Profano	25	Sala dei Chiaroscuri		
12	Vatican Library	26	Raphael's Stanze		
13	Sistine Hall	27	Cappella di Urbano VIII		
14	Museo Sacro	28	Sala dell'Immacolata		

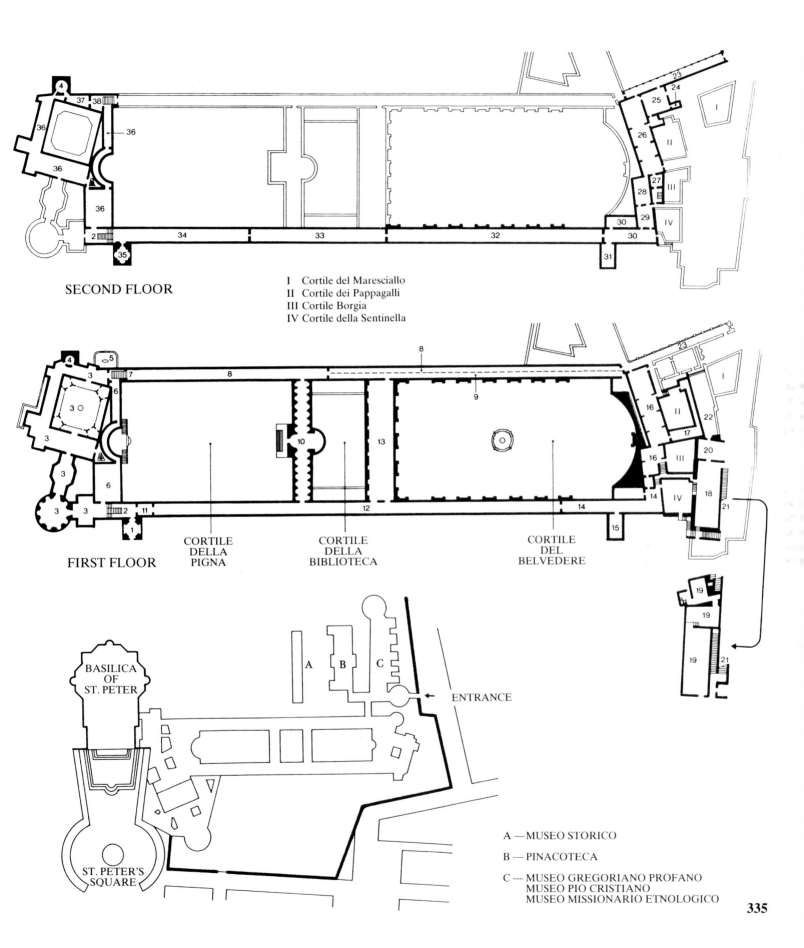

SECOND FLOOR

I Cortile del Maresciallo
II Cortile dei Pappagalli
III Cortile Borgia
IV Cortile della Sentinella

FIRST FLOOR

CORTILE
DELLA
PIGNA

CORTILE
DELLA
BIBLIOTECA

CORTILE
DEL
BELVEDERE

BASILICA
OF
ST. PETER

ST. PETER'S
SQUARE

ENTRANCE

A — MUSEO STORICO

B — PINACOTECA

C — MUSEO GREGORIANO PROFANO
MUSEO PIO CRISTIANO
MUSEO MISSIONARIO ETNOLOGICO

335

EXEKIAS.

Black-Figure Amphora with Achilles and Ajax Playing Dice.

Exekias, whose signature recurs 11 times on examples that are considered among the most beautiful products of Attic black-figure pottery, specifies in only two cases (the amphora considered here and the one in Berlin with *Heracles and the Nemean Lion*) that he was also responsible for the pictorial decoration. On the lip of this amphora may be read in fact: *Echsekias egrapsen kapoeseme* = "Exekias painted me and made me" — instead of the usual "Exekias made me," which qualified him as a potter and which is repeated on the shoulder of the vase above the back of Achilles.

In one of the two large metope compositions (which in fact constitute the pictorial decoration of the vase, otherwise covered almost entirely with black varnish) appear the figures of Achilles (to the left) and Ajax (to the right) intent on a game of dice or checkers. From the mouths of the two heroes emerge "balloons" with their respective statements: "four" (*tesara*) on Achilles' part; "three" (*tria*) on the part of Ajax. And here the "backwards" writing assures us that the word is really coming out of his mouth. It is thus likely that the game is a kind of *Morra*, or fingers' game (with or without dice) and it is not a foregone conclusion that Ajax is losing just because he states that he has a lower number.

On the other metope are seen Pollux (with the dog) and Castor with the horse Kylaros, fêted (it is not clear whether the scene is of a return or a farewell) by Leda and Tyndareos. All are identified by their respective names. Nor is there lacking (written backwards under the belly of the horse) the inscription praising the young boy, Onetoride, who is greeted in other vases by Exekias as well, with the title of *kalòs* (beautiful), customary in such inscriptions. The Vatican amphora is the best known work by the master, who represents the ultimate and most refined phase of Attic black-figure ware. The ornamental and miniaturistic calligraphy of a Klitias, the strict compositional wisdom of an "Amasis painter" here appear perfected, while the spirit of rising naturalism and the influence of contemporary sculpture confer a new heroic dignity and a monumentality on the human figures.

The years around 530 B.C. were crucial. Around that time the new red-figure technique was born (and adapted to fully pictorial effects, as the brush was more manageable than the burin) and the same period saw the appearance (as documents and the work of a Cimon of Cleonae attest) of the first attempts to represent oblique images in painting (foreshortenings by which shields and wheels were no longer drawn as round but as oval). These attempts were decidedly revolutionary vis-à-vis the black-figure tradition. On the other hand, the punctilious technique of incising was utilized for calligraphic involvements making a gratuitous arabesque (although the spirals on the thighs of the players are justified by the presumable presence of metal thigh-pieces), along with certain pictorial effects of light or texture (as in the luminous Tintoretto-like construction of Achilles' foot). Thus at this point the black-figure style still succeeded in reconciling the divergent decorative and illustrative aims by which it was imbued from the beginning — but only when it was sustained by a virtuoso of the burin like Exekias.

EXEKIAS
Black-Figure Amphora with Achilles and Ajax Playing Dice (c. 530 B.C.)
Terra cotta painted in the black-figure technique (the field left in the natural color of the clay). Details engraved with burin. Touched up with brown, white (these retouches have disappeared) and violet; height 24 in (61 cm).
Gregorian–Etruscan Museum.

336

APOLLONIUS OF ATHENS. *Male Torso ("Belvedere Torso").*
Of uncertain provenance (but certainly Roman), this sculpture was formerly in Palazzo Colonna from 1433, and in the Vatican from 1523–34 where it was very much admired by artists, particularly by Michelangelo. The torso was named the *Belvedere Torso* after its previous place in the Vatican collections. It is one of the few marbles to have escaped the dangerous and often fanciful "completions" by restorers who from the Renaissance on, falsified masterpieces found in fragmentary condition, until 19th-century historicism created greater respect for originals.

Nevertheless it cannot be excluded that a "modern" polishing has touched up the surfaces, which appear to be less worn than is generally the case in finds from excavations. The damage from this alteration of the surfaces, is largely compensated for by the recovery of the original conditions in terms of what Alberti would have called the "reception of the lights." In fact the *Seated Boxer* of the Museo delle Terme — which is signed by the same Apollonius, son of Nestor, of Athens, who carved his name on the rocky base of the Vatican torso — although undamaged, allows only an approximate appreciation of its original values. The thick accumulation of verdigris, opaque and relatively light, just where the forms recede into shadow, has in places inverted the chiaroscuro relationships, which fundamentally represent the only specific reality of a sculptural work. The *Belvedere Torso* thus *is* and does not *seem to be* a masterpiece, and Apollonius turns out to be a personality of outstanding stature, even if the *Boxer* seems to reduce him. It appears that Apollonius lived in the second half of the 1st century B.C., and it is understood that he "copied" preceding works, of the 3rd and 2nd century, in the tradition of Lysippus, assuming that a neo-Attic label, in the classicist sense, has been attached to the Augustan Age, and assuming that in general, so far as late Hellenism is concerned, sculpture turned to the conception of a single viewpoint. None of this has been proved, and it is possible that the *Belvedere Torso* represents a current that on its own went beyond the results of Middle Hellenistic sculpture, that is, it took complete possession of three dimensional space and has its hallmark in torsion and spiraling movement. In this sense the *Belvedere Torso* was indeed exemplary for Michelangelo, not only in torsion and *contrapposto* but also in the emphatic anatomy of the large and compact muscular masses, which are not inert but "in action." Both the back view (left) as the front view (right) find exact counterparts in Michelangelo, and this, strange to say, is better seen in the pictorial than the sculptural work: from the *Ignudi* of the Sistine Ceiling, to the St. Bartholomew of the *Last Judgment*. Seated on an animal skin, the *Belvedere Torso* has been taken for the fragment of a Heracles, a Polyphemus, Prometheus, Mars, Amicus, Silenus or a Philoctetes. It is not possible to visualize, without imagining them made up with Michelangelesque replacements (certainly irrelevant), how the missing portions must have appeared (it is obvious that the work of art, if truly such, is unpredictable); and, to console us, we have been told that it is beautiful because it is a fragment, and entire it would be ugly.

APOLLONIUS OF ATHENS
Male Torso ("Belvedere Torso")
1st century B.C.
Marble; height 62½ in (189 cm).
Pio-Clementino Museum.

APOLLONIUS OF ATHENS
Belvedere Torso
Front view.

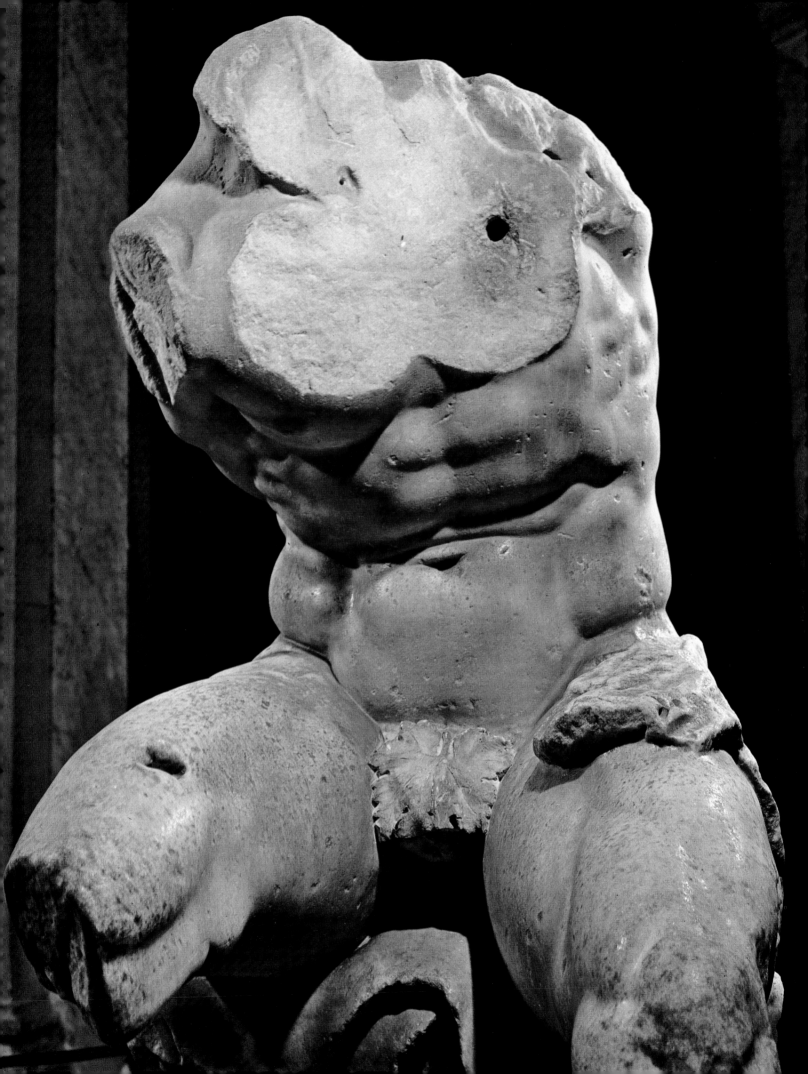

ROMAN COPY (AFTER GREEK ORIGINAL). *Daughter of Niobe.*
The dramatic theme of the slaughter of the children of Niobe was tackled very early in Greek art, both in painting and sculpture. A version with many figures (disposed — it seems — in the open, as in a landscape painting) was seen by Pliny in Rome by the Temple of Apollo Sosianus (constructed in 32 B.C.). There was some doubt then whether the author was Scopas or Praxiteles. From this it appears that Pliny's attribution was stylistic (evidently a practice to which the connoisseurs of the time were already dedicated), and it was obviously justified by the simultaneous presence of Scopatian and Praxitelean motives. And this would indicate a later, already substantially "Hellenistic" moment. The group must have been copied many times: an almost complete series of the figures now in the Uffizi, in Florence, was excavated in Rome at the end of the 16th century. *The Chiaramonti Daughter of Niobe* (so named because it was originally exhibited in the rooms arranged by Pius VII under the name of Museo Chiaramonti; since 1947 it is in the Belvedere) which was discovered at Tivoli also in the 16th century and transferred to the Vatican by Cardinal Ippolite d'Este (nephew of the protector of Ariosto of the same name), repeats one of the figures of the series in Florence, but reveals a better hand (or greater fidelity to the original) in the freer treatment of the heavy drapery that corresponds to the movement of the figure, and has been given a better rhythm and more coherent stylization. Schefold, on the basis of the Florentine example (in which the head has been preserved), believes he has identified the original (lost) head of *The Chiaramonti Daughter of Niobe* in a modern bronze cast in a private Swiss collection.

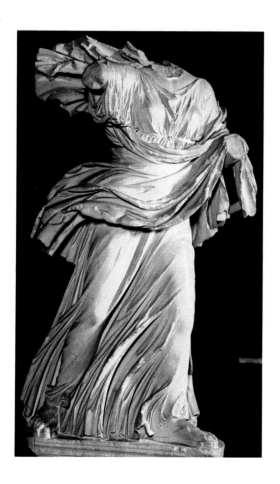

ROMAN COPY AFTER A GREEK OR HELLENISTIC ORIGINAL
The Chiaramonti Daughter of Niobe
1st–2nd century A.D.
(after original of 4th–3rd century B.C.)
Marble.
Chiaramonti Museum.

ROMAN COPY AFTER A BRONZE ORIGINAL BY THE BITHYNIAN ARTIST DOIDALSES
Bathing Venus
After a 3rd-century B.C. original
Marble; height 32¼ in (82 cm).
Pio-Clementino Museum.

ROMAN COPY AFTER DOIDALSES. *Bathing Venus.*
It is from a famous *Crouching Venus* by the Bithynian artist, Doidalses, who lived in the 3rd century B.C. (the lost original was in bronze and could be seen in Rome at the time of Pliny), that the numerous examples existing today are thought to be derived. These however differ too much from one another to offer certain evidence as to the exact appearance of the original.
From it however surely derives the knowledgeable spatial construction of this figure, winding upon itself in accordance with a complex "closed form" module. The classicistic type of the head would suggest on the other hand a variation on the part of the copyist, given that the less idealized and saucier head (less "Greek" and more "French") seen in some of the other copies corresponds better to the frankly amorous and provocative charms of the nude.

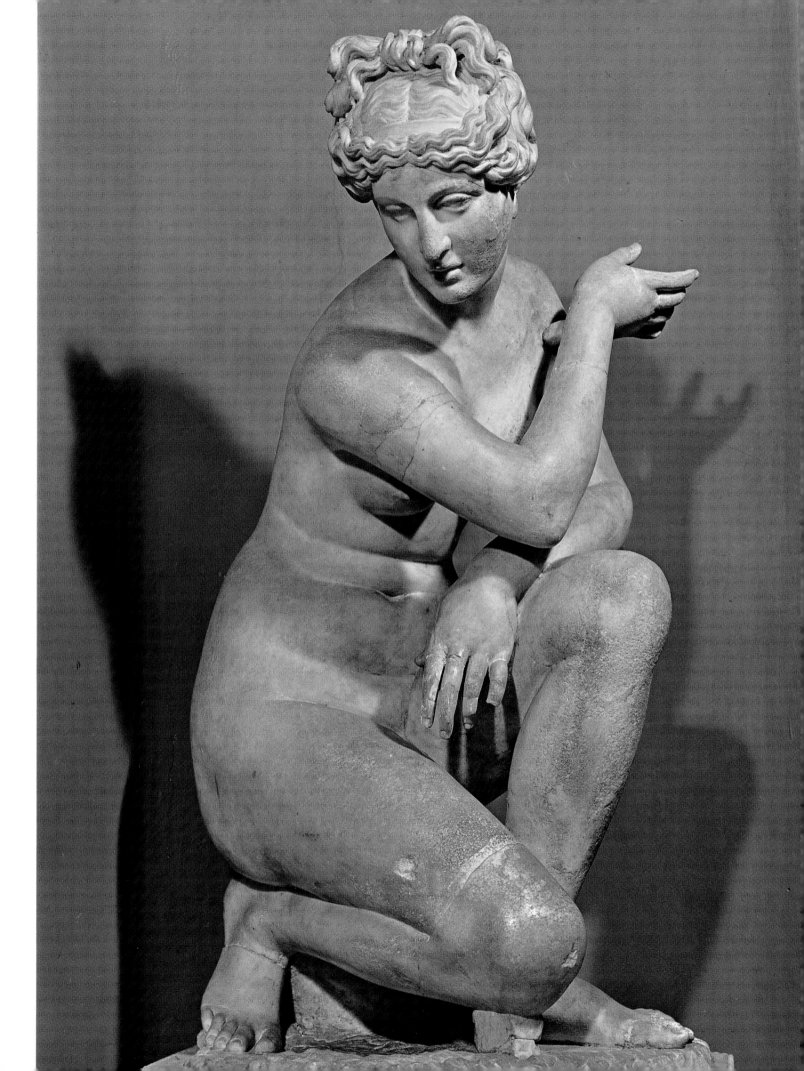

BACCIO PONTELLI (?)
Florence *c.* 1450 — Urbino *c.* 1494
Interior of the Sistine Chapel
In construction from 1472 to about 1480;
length 119 ft 9 in (36.5 m); width 43 ft (13.4 m);
height 68 ft (20.7 m).
Restoration work on the ceiling was begun in
1980 and is due to finish in 1988. The next fresco
to be restored will be *The Last Judgment* on the
far wall. Work is due to be completed in 1992.

INTERIOR OF THE SISTINE CHAPEL.

The architectural plan for the building, founded in the latter half of 1473, in an advanced stage of construction in 1477 and finished around 1480, is attributed by Vasari to Baccio Pontelli. Historical and stylistic considerations make this attribution probable if not certain.

The Renaissance had made "its entrance into Rome walking on Gothic crutches" (Bruhns), and while the Florentine burghers were erecting their extremely gentlemanly palaces, marked by sober decorum and clear measure, the houses of the great Roman families — a class of proud and turbulent aristocrats — in the 15th century were still being built with turrets and battlements, and closed off with high rough walls. The Sistine, too, was created not only as the "major chapel of the Sacred Palace" but also as a military redoubt of the Vatican city, which had been conceived from the time of Nicholas V as an armed citadel at the edge of the great, illustrious and untrustworthy metropolis of Rome.

The idea that Pope Sixtus IV proposed to his architect was to construct a building that on the exterior would appear as a bulwark and defence of the Church and of the supreme and absolute authority of the pontiff, and on the interior would express the conception of the firm and jealous guardianship of the purity of the Faith and the solemn manifestations of its principles. The architect was able to give concrete form to this thought by designing the exterior in the form of a high and sturdy bastion, and on the interior creating a hall notable for its simplicity and geometrical severity, and for the weighty and hermetic sealing of the space with a barrel vault carried on lunettes. In short, he defined a firmly limited interior which nevertheless gives the feeling of ample space. To "read" the interior space of the chapel correctly it is necessary to take into account both the real membering — the horizontal cornices, the upper order of pilasters, the balcony-style tribune, the marble screen — and the simulated, painted membering, such as the pilasters of the two lower orders and the niches of the popes in the upper order; for unquestionably the architecture of the chapel was conceived in conjunction with its pictorial decoration, for which the architect certainly provided the divisions and proportions. Thus the rectangular hall, divided in two by the screen and regularly measured off into rectangular fields by the painted and real pilasters, bears the impress of a quiet geometry that breathes a sense of isolation and detachment, of jealous closure and strict protection from the world. The effect naturally was more apparent when the ceiling bore only the starry-sky decoration painted by Piermatteo d'Amelia, before Michelangelo imposed on it his framework of illusionary architecture and his powerful and awesome figures. The majestic vault, originally conceived as an unbroken span for the immense, precious casket, nevertheless possessed in its brilliant connection between walls and cap-like vault an implicit dynamic content, on which without sapping it Michelangelo was able to graft the powerful tension of his framework. Even if the absolute purity of expressive creativity is lacking in the Sistine, one cannot deny the author the possession of the highest gifts as a learned practitioner of architecture, and the intelligence to have known how to translate into adequate expression the guiding idea of Pope Sixtus. This was the creation of a sacred place where intimacy of meditation would not exclude the formality necessary in the public manifestation of the sacred principles and authority of the head of the Church.

343

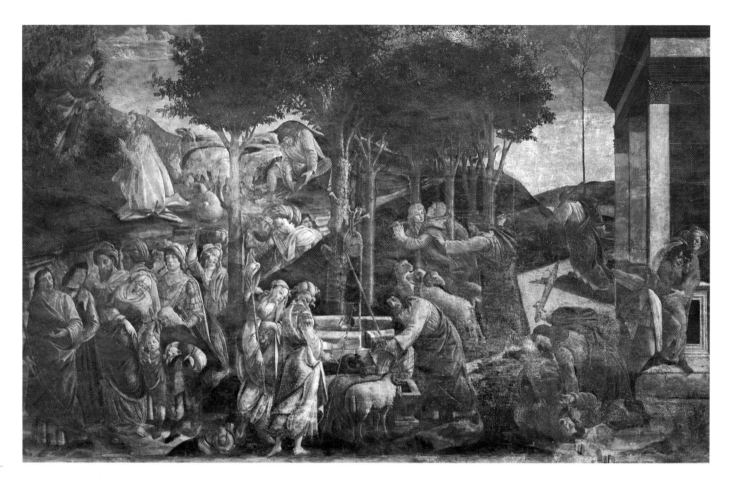

SANDRO BOTTICELLI. *The Trials of Moses.*

The trials are those that Moses, forced into exile in the land of Madian, underwent before being called by God to the work of redeeming his people. They are intended as parallels to the temptations of Christ, which are represented in the fresco opposite. On the right, Moses slays an Egyptian who had mistreated a Jew (being succored by a woman on the threshold of a porticoed house). Following this, in the background, is seen the flight of Moses. A little more to the left and towards the foreground, Moses confronts the shepherds who had driven away from the spring the flock belonging to the daughters of the priest, Jethro. Then, center foreground, he waters the flock in the presence of the two girls. On the left in the background, Moses removes his shoes and then kneels to hear the orders that Jehovah, who has appeared in a burning bush, will give him. In the foreground, Moses is on a journey with all of his family and his brother Aaron; perhaps the exodus from Egypt is represented. In this composition the painter manages to overcome brilliantly the difficulties offered by the complicated and dispersive theme, through his personal conception, already affirmed in the *Primavera,* by which the space is identified with the development of the action in time by means of the melodic course of the line. The unity of the composition is achieved by the insertion of the diagonal movement of the landscape into the angular and contrasted rhythm of the figures, whose tension is relaxed in the bucolic interlude of the meeting with the daughters of Jethro. It is the dominant episode, but not the absolute center of the composition, as it also is inserted into the linear development of the picture.

SANDRO BOTTICELLI
The Trials of Moses
1481–1482
Fresco; 11 ft 5 in × 18 ft 4 in (348 × 558 cm).

PIETRO PERUGINO. *Christ Giving the Keys to St. Peter.*
It was given to Perugino to paint, parallel to Botticelli's *Destruction of the Company of Korah, and of the Sons of Aaron*, the fresco ideologically most important in the entire cycle: the one containing the legitimation of the absolute power of the pope. It is a fact that in clarity of formal exposition and dignity of utterance, this compositon responds better than any other to the spirit that Pope Sixtus wanted to impress on his chapel, and on the paintings that adorned it. Viewing the entire composition, we observe the complete correspondence of the style — above all in the circulating vision of space, already verging on Raphael, and governed by a radiating system of perspective lines, converging on the temple — with the clarity and hierarchy of values controlling the illustrative conception. In the detail reproduced here, it is worth observing how the figures in the foreground, arranged on a sort of stage in front of the space defined by the perspective, are constructed and draped with Florentine solidity, and are animated by a breath of the vehemence of Melozzo. They live in the rarefied atmosphere created by the slow amplitude of the rhythm that links them all in turn, and by the intensely musical modulation of the volumes. With the intensity of the color and the terse luminous quality recalling Piero della Francesca, the composition seems to voice a slow, sweetly harmonious song, like a smooth and solemn sacred ceremony.

PIETRO PERUGINO
Christ Giving the Keys to St. Peter
1481–1482
Detail.
Fresco; 11 × 18 ft (335 × 550 cm).

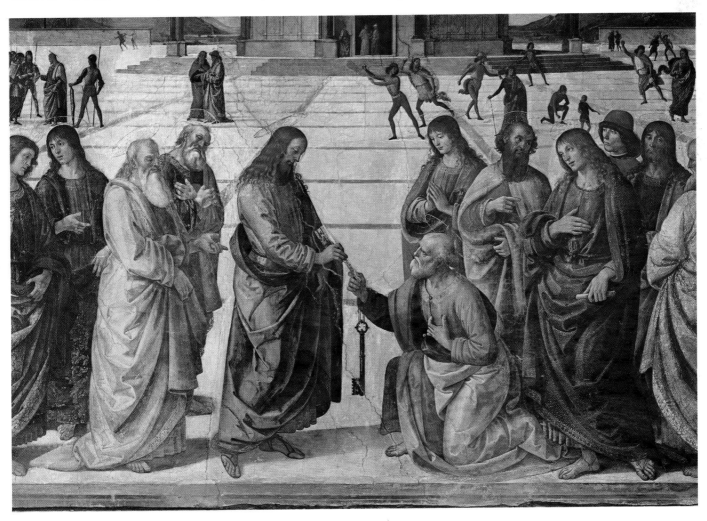

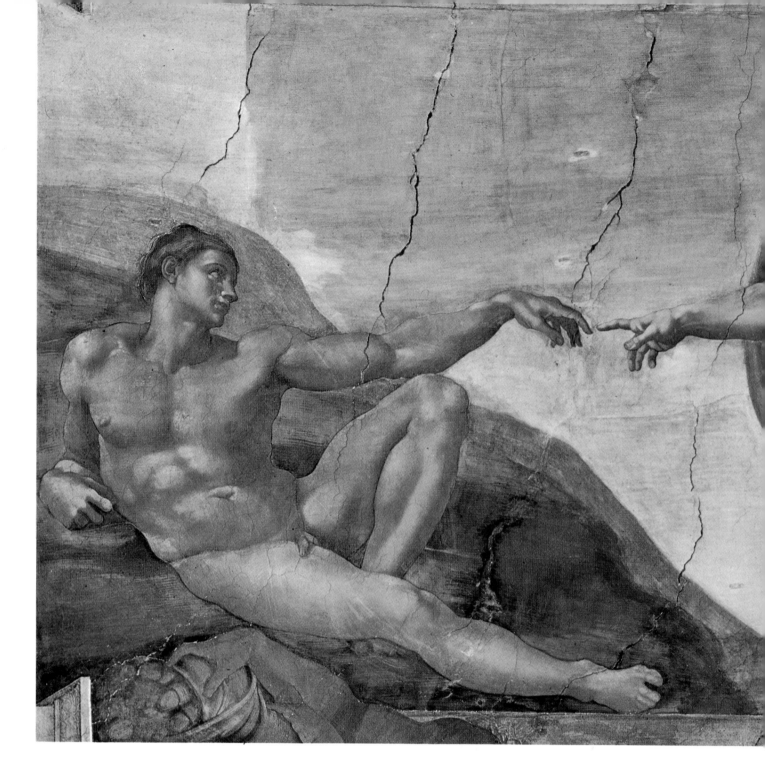

MICHELANGELO. *Creation of Adam.*

The value of this composition in its formal and expressive aspects will not be understood completely unless one bears in mind the radical iconographic revolution accomplished by Michelangelo. Before him the Creation had been conceived as the work of a Daedalus who shapes the first man out of the mud of the earth, or as that of a thaumaturge who infuses breath into an already formed Adam by the laying on of the hand. Only Michelangelo shows us the Creator as an original force of nature. The organization of the composition around the counterpart relationship between the bare earth on which Adam lies and the wind-swollen mantle of the Lord, thus acquires full significance. Like no other artist, Michelangelo has positively rendered

MICHELANGELO
Creation of Adam
Sixth of the biblical scenes (counting from the entrance).
Fresco. Probably executed in the final months of 1511.

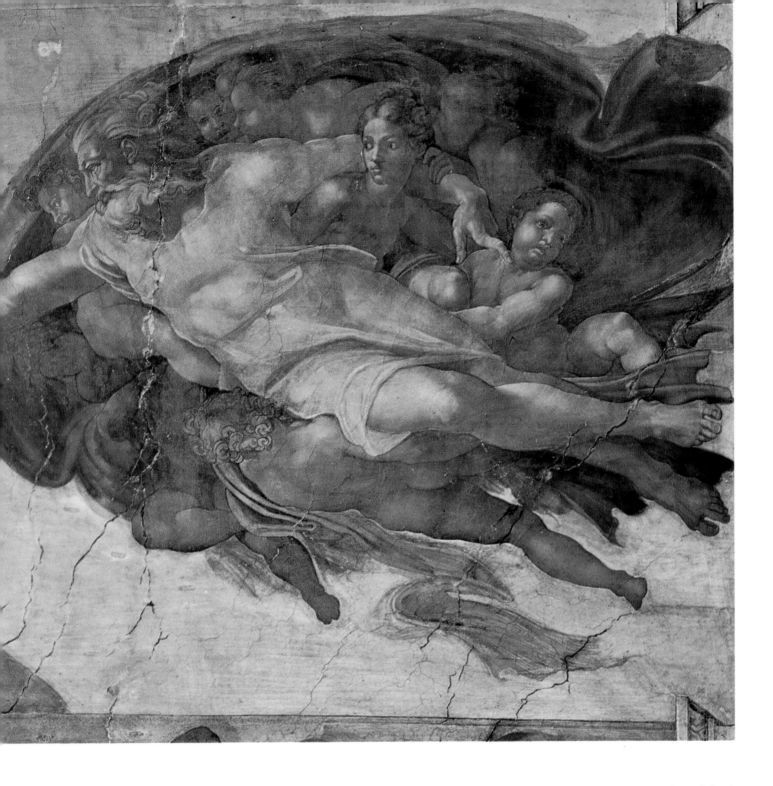

here the terrible solemnity of the barely created world and the idea of God as absolute vital energy. The pictorial conception is of such elemental simplicity, that the felicitous invention of the vital spark struck by the contact of the fingers assumes the highest prominence. In the dialectical contrast between the spherical structure of the mantle that shelters the restless band of angels, and the elongation of the line of His body, the image of the Lord acquires human size and at the same time conveys a sense of lightning flight. The figure of Adam, on the other hand, with the robust body in balanced pose, has superb beauty in which the harmony of the form coincides with the harmony of the rhythm of the limbs, sluggish and impatient at the same time.

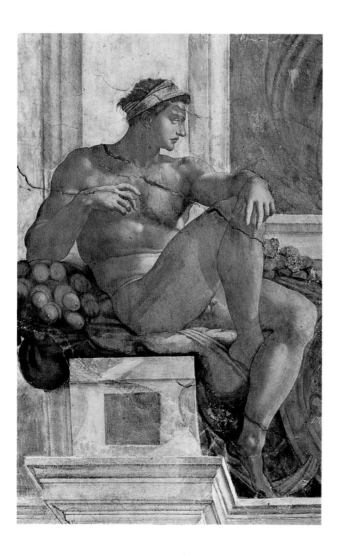

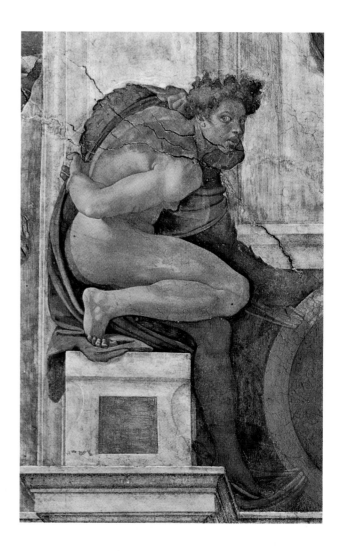

MICHELANGELO. *The Ignudi.*

It has been suggested that the large *Ignudi* which appear on the ceiling of the Sistine Chapel framing the smaller scenes, and supporting from above the bronze medallions bearing biblical scenes, are probably to be understood as angels who assume the classical forms of the Platonic Eros. They thus belong to those allusions to the humanity of the Gentiles, of which the Sibyls clearly are part, and accordingly to the Greco-Roman world that the artist wished to include, along with the men of the Bible, in the universal history of humanity before the Law, but already aspiring to Redemption. The *Ignudi* also count as expressive elements, echoing with their exalted animation the drama of the central scenes. The figure reproduced above left belongs to the group following the fresco of the *Separation of the Dry Land from the Waters*, which was the first in order of execution (chronologically last) of the scenes of the creation of the world. The *Ignudi* participate in the crescendo of animation that marks the scene, as the origin of the cosmos is gradually approached. Here, two of them — above right and opposite — gather their strength, the concentration expressed in their faces and body, while others let themselves go in free dramatic movements. Observe how in part the expressive force depends on the relationship between the intense expansion of the plastic mass and the firmness of the contours.

MICHELANGELO
Ignudi (Male Nudes)
Flanking the scene of the *Separation of the Dry Land from the Waters.*
Frescoes probably executed in 1512.

348

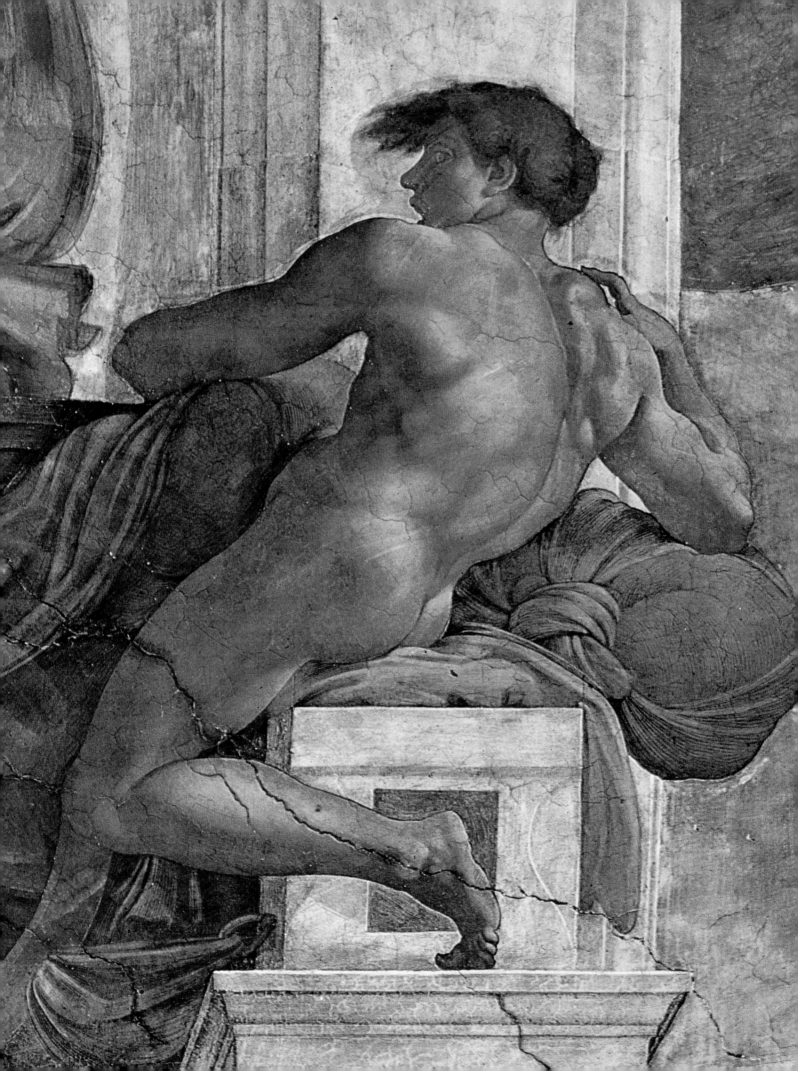

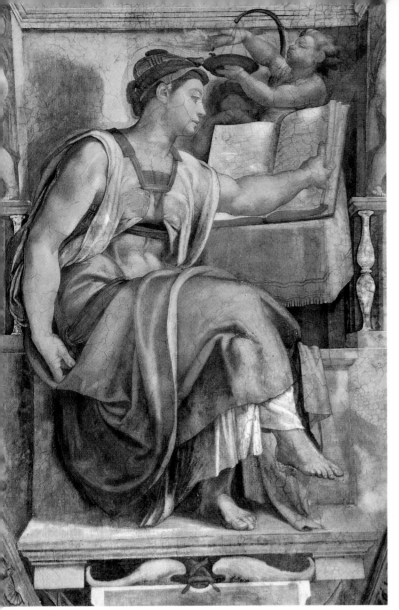
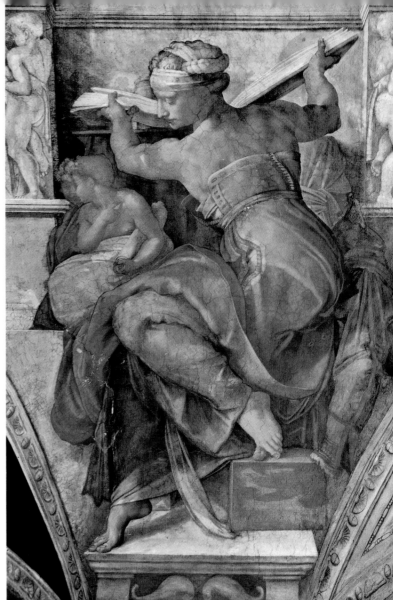

MICHELANGELO.

The Eritrean and Lybian Sibyls, the Prophets Jeremiah, Isaiah and Daniel.

On the ceiling of the Sistine Chapel the *Eritrean Sibyl* and *Isaiah* flank the *Sacrifice of Noah* (third scene from the entrance) and were executed probably in 1509. The *Jeremiah* and *Libyan Sibyl* flank the *Separation of the Light from the Darkness* (last from the entrance and were executed probably in 1512).

In characterizing the Prophets and the Sibyls, the artist does not appear to have referred specifically to any prophecies attributed to them, nor to the subjects of the neighboring scenes: he intended rather to portray given moments in the life of prophecy. Thus the *Eritrean Sibyl*, moved by an unexpected impulse, comes to life in the act of looking for the answer to a mystery in her book. A superb image, inspired by the central nude in Signorelli's *Last Day of Moses*, it acquires dynamic unity from the down-curving right arm, reminiscent of the arm of *David*. In *Isaiah* the theme is the very arousal of prophetic inspiration, and this is stated not only illustratively by the book being closed as the Prophet turns at the call of a voice or a vision, but also is expressed in the formal structure. The spherical space enfolding the figure, and isolating it from the terrestrial space of the throne, is identified

From left to right:
MICHELANGELO
The Eritrean and Libyan Sibyls
The Prophets Jeremiah and Isaiah
Frescoes.

350

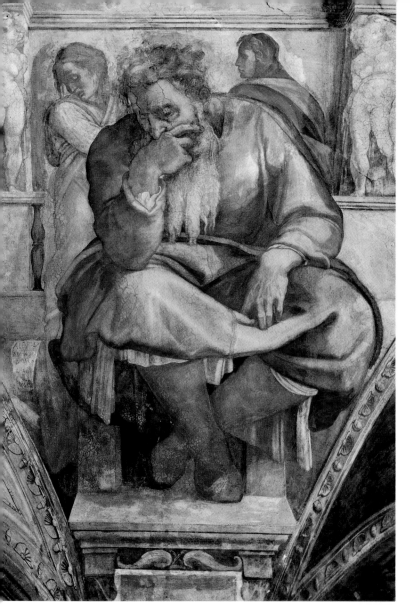

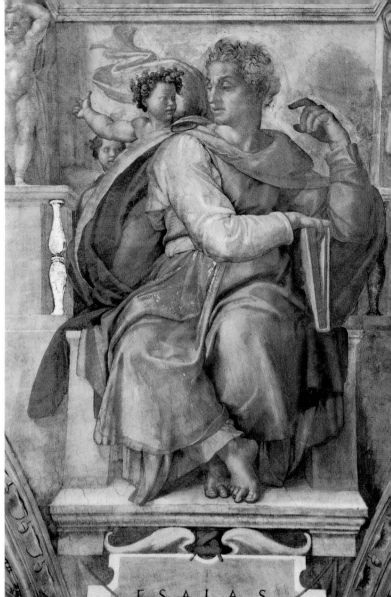

ESAIAS

with a continuous and intense rotating motion emphasized by a vast spread of pink, counterpointed by the green accent of the mantle that provides an effect of isolation. The Soothsayers discussed up to now belong to the first phase of the work. The transition from the first to the second phase is marked also in the Prophets and the Sibyls by an increase in size, power and profundity. An authentic prophetic furor is embodied in *Daniel* who pushes his legs out to the very edges of the throne, projects his torso forward and to the left, and has just removed his almost obsessed eyes from the enormous book that requires the added support of a putto-caryatid. The commanding figure of the *Libyan Sibyl* — which was studied, as a well-known drawing shows, from a nude model — is in the act of closing the book on the desk, and seems to be getting ready to descend from the throne and go into action. The elasticity of the contraposed movement is combined with a radiant sense of youthful, robust beauty, which is also conveyed by the luminous, predominantly warm hues of the robes, the vigorous turn of the bare shoulders and athletic arms. Contrasting with her, in type and in the moment of prophecy chosen, are the venerable old age and the closed construction of the *Jeremiah*, who is hunched over and absorbed in meditation. The blocked contraposition of the masses creates an exceptionally **351**

prominent plasticity, to which the lapidary intensity of the color and the restlessness of the two sad Virgins of Israel in the background contribute. Overhanging the altar wall is *Jonah*, symbol of the Resurrection, as he remained for three days in the belly of the whale, like Jesus in the tomb. But rather than Jonah's typological function, Michelangelo wants to stress his quarrel with the Lord, so as to repeat his constant thought that faith is a difficult and resistant conquest, as well as to conclude his series in a dramatically exalted atmosphere. An intense rotation, heightened by contrapuntal notes, unleashes here in a tempestuous finale the power accumulated in the entire sequence of the Soothsayers.

MICHELANGELO. *The Last Judgment.*

On the commission received in the autumn of 1533 from Clement VII and confirmed by his successor, Paul III, Michelangelo, after three years of meditation and preliminary drawings, carried out from 1536 to 1541 the fresco of the *Last Judgment* on the altar wall of the Sistine Chapel. The distance between the artist's two major works in painting would appear to be unbridgeable if measured form the portrayals of the Creation — mournfully dramatic but also animated by a joyous vitality — to the lowering and desperate atmosphere of the *Last Judgment*. If, however, one starts from the existential melancholy of the Generations of Israel, and follows in the *Slaves* and *Prisoners* for the tomb of Pope Julius and in the Medici tombs the gradual recovery of vital tension against a constant background of closed and mournful meditation, the *Last Judgment* will appear as the culminating manifestation in a long process of development in the spirit of Michelangelo. He had been sorely tried in those decades by misfortunes in Florence and in his family; and disheartened as to the validity of human endeavor, was ever more inclined to seek refuge in an unattainable mystic identification with God. Giving up any frame for the composition — by requiring an illusionary reading from the spectator, this would have led to the vision of a limited even though vast space — the painter floods the entire immense wall with an open and unlimited space, abolishing any measurable relationship with the figures and evoking the image of an abysmal void, in which swim, desperately alone in the midst of a crowd, the bodies of the risen, isolated within separate plastic organisms. The torrents and the whirling stream of the figures in the celestial court rushing towards Christ, the fall of the damned to the right and the ascent of the blessed to the left — all happens against the background of a limitless and perturbed space, evoked by the audacious and complex foreshortening of the figures. A truly cosmic force is unleashed by the measured and terrible gesture of the *Judge*, impressing upon the universe an irresistible rotatory movement which goes on not with the tranquil regularity of a phenomenon of gravity but with the uncontrolled fury of a universal catastrophe. This unleashing of forces acquires an overwhelming power by submitting to the control of art, in a compositional fabric that is very solid and worked on the principle of counterpoint. A dialectic between outbursts of unchecked movement and motives of stops and balances dominates the separate figures as well as the relationships between the parts of the composition. The elliptical motion of the *Saints* and

MICHELANGELO
The Last Judgment
1536–1541
Fresco; height 44 ft 11¼ in (13.7 m); width about 43 ft 4 in (13.2 m).
Restoration work on this colossal fresco will be completed in 1992.

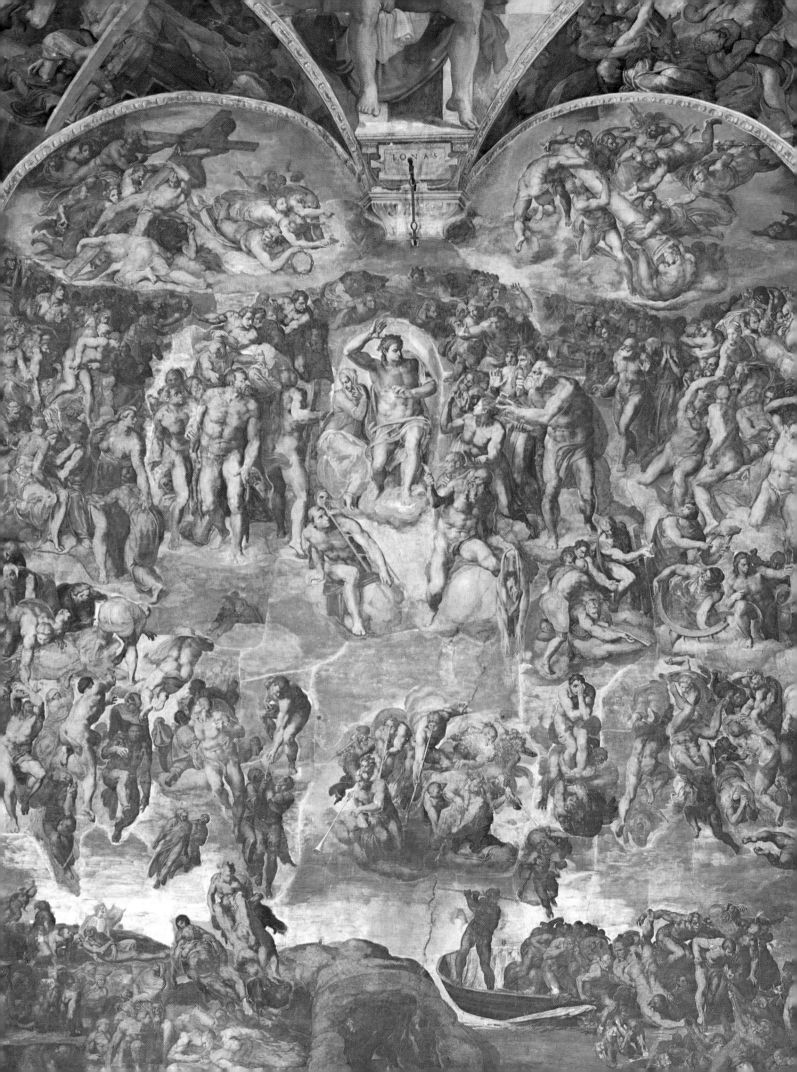

Patriarchs around the *Judge* is broadened in the external ellipse formed above by the most distant figures running up, and below by the righteous ascending, and the sinners falling. The hinge is the group of the *Trumpeting Angels* at the lower center, from which two descending obliques depart — marked by the lines of the trumpets — thus establishing the link between the lower level containing the *Resurrection of the Dead, Charon's Boat, Minos* and the *Mouths of Hell*. But groups of the risen on the left and the damned on the right provide transition to the vertical action of the righteous and the sinners in the zone above, creating an interlace and interaction of force and directions. The *Angels* in the lunettes are part of this, too, as the Cross and the column they are carrying offer two diagonal directions, which are immediatley interrupted by the vortex of figures below but echoed farther down by the two already cited obliques.

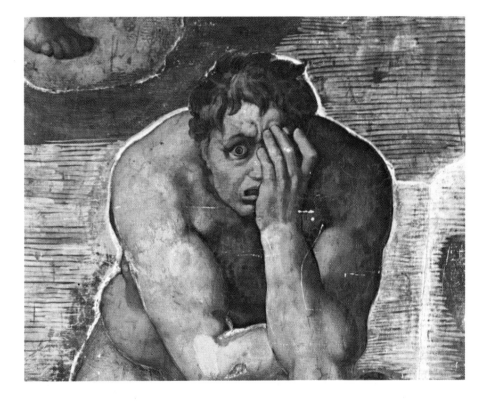

MICHELANGELO
The Last Judgment
Detail.

RAPHAEL. *Disputation of the Sacrament.*
Constructed by Nicholas I, the Stanze had already been partially decorated by Piero della Francesca, Andrea del Castagno and Benedetto Bonfigli, when Pope Julius II gave the order for the fresco decoration to be resumed — in 1508 — by a group of artists that had been recommended by Bramante. Among these were Perugino, Sodoma, Bramantino, Baldassare Peruzzi, Lorenzo Lotto, Giovanni Ruysch and Michele del Becca. The initiative was due to the fact that the new Pope, as Paolo Giovio reports: "... did not want to see at every moment ... the figure of his predecessor, Alexander, his enemy, and called him *marrano*, Jew and circumcised." He could not have been very satisfied with the first list, but accepted Bramante's new suggestion to call in Raphael, who had become the most prominent personality in Florentine painting.

354 The *Disputation of the Sacrament* (so called through a false 17th-century

interpretation of a passage in Vasari) was the first scene to be frescoed by the Urbino master. The scene is set out of doors, around an altar on which is a monstrance with the Host, which is the single perspective center of the entire complex and harmonious composition, from the geometric foreground of the steps to the landscape in the rear and the vault of heaven. Taking their points of departure from the Host, as if in intermittent waves, are the aureole of the Holy Ghost and the great nimbus of Christ in Glory, which seems to expand, by reflection, in the arched wall, a simulated architectural opening, an ideal arch of triumph. In plan, a formally geometric marble pavement, suggesting nostalgia for basilican space, is connected as by allegory with the images of buildings in construction scattered in the landscape, and the "architecture" of the figures in air. Seated on a balcony of zephyrs, as if portrayed in the shell of an imaginary apse, they are part of an

RAPHAEL
Urbino 1483 — Rome 1520
Disputation of the Sacrament
Stanza della Segnatura.
Detail.
Fresco in lunette; 25 ft 3¼ in (770 cm).

ensemble suspended from above, that in turn recalls a half-lowered theater curtain. In this painting there is evidently an echo of the great excitement over the new St. Peter's which was being built.

The manner and style in which the *Disputation* has been painted is still clearly of Florentine extraction, with reminiscences of Leonardo, Fra Bartolomeo, Andrea del Sarto and even more remote recollections going

355

back to the artist's studies with Perugino. However, the work has a monumentality that has not been seen before, the courtly spirit of a history painter, and above all a surprising novelty in imagery.

RAPHAEL. *The School of Athens.*

In the fresco of *The School of Athens* Raphael shows an ever-increasing interest in Michelangelo's style and methods, culminating in the homage of painting the master's portrait in the guise of Heraclitus, which he included in the fresco probably after seeing part of the Sistine ceiling in 1510. The figure does not appear in the preparatory cartoon now in the Pinacoteca Ambrosiana, Milan. Nor does the architecture of the background, whose entirely new character, that is its wholly un-Utopian aspect, give credence to the hypothesis that it is a view of St. Peter's following Bramante's project, as its resemblance to the section by Peruzzi in the Uffizi confirms. It cannot be excluded that the pope wished to see a view of the edifice as it would be on completion, but utilized here in the context of his political and cultural program, which is in fact the theme of this hall.

Apart from this, the independence of Raphael's style with respect to Michelangelo's was already pointed out by Vasari, when he stated that Raphael: "considered that painting does not consist merely in making nudes. Its field is broader and among perfect painters are those who can express, well and easily, all the inventions in a story and its many variations with good judgment. In the composition of the scenes one who knows how not to confuse with too much and also not to make them too poor with too little, may be called a valiant and judicious master ... He considered, too, how important ... it is to make portraits that appear to be alive. In truth, in him we have art, color and invention ... brought to that end and perfection for which one could scarcely have hoped, nor should anyone think ever to surpass him."

It is interesting at this point to observe how the philosophers and sages of antiquity, in the elect assembly, are represented by eminent contemporary personalities, according to a sort of Platonic reincarnation; and among them artists are portrayed (including the self-portrait of Raphael), to indicate the ideological nature of painting. The success of this work was enormous. As Vasari mentions, Julius II wanted "... to tear down all the scenes of the other masters, old and modern, so that Raphael alone would have the glory of all the labors that had gone into those works up until that time." And certainly what astonished the pontiff and the scholars of the court (among them Bembo, Bibbiena, Castiglione and Inghirami) could not have been only the excellence of the painting, but the discovery of new possibilities of life, the effective illustration of the ideal Hellenism which was sought after, but which no one as yet had succeeded in visualizing in so stimulating and disturbing a form. It is obvious that the pope's enjoyment of the work did not depend only on its expressive quality, but above all on the subject matter and the concepts which certainly no one else had achieved with such keen, full-bodied and convincing lyricism.

RAPHAEL
The School of Athens
Stanza della Segnatura.
Fresco in lunette; 25 ft 3¼ in at base.

RAPHAEL. *Parnassus.*

Parnassus is an archeological theme in literature, from Homer to Virgil, from Dante to Petrarch and the Petrarchists of the 16th century, yet Raphael had the ability to bring it up to date in the form of the humanistic "repose" especially dear to the authors of the dialogues on poetics as an ideal milieu. Mythological divinities, ancient seers and modern poets may thus find themselves all together, in good company. As in a dream, the figures in the party with their vital, almost magnetic presence, spangle the serene landscape. Opposite *Parnassus*, the *Theological Virtues* are painted above the window overlooking the Belvedere. Thus the decoration of the Stanza della Segnatura (so designated after the ecclesiastical tribunal of the same name, which according to tradition subsequently sat here, although the hall was originally intended for the pontifical library) followed a specific cultural program, in as much as it illustrated the supreme truths, *Revealed Truth* and *Natural Truth, Beauty* and *Justice,* to which corresponded on the ceiling the respective allegories of *Theology, Philosophy, Poetry* and *Justice,* as in a sort of *speculum doctrinale* — Mirror of Doctrine. As the major and minor representations are linked ideologically, so Raphael shows that he conceived them in a single formal plan, in as much as the lunette scenes are arranged around the real cubic space of the hall like satellite exedras in a centralized architectural system, which was one of the major subjects of inquiry among the architects of the period.

RAPHAEL
Parnassus
Stanza della Segnatura.
Fresco in lunette; 21 ft 12 in (7.70 m) at base.

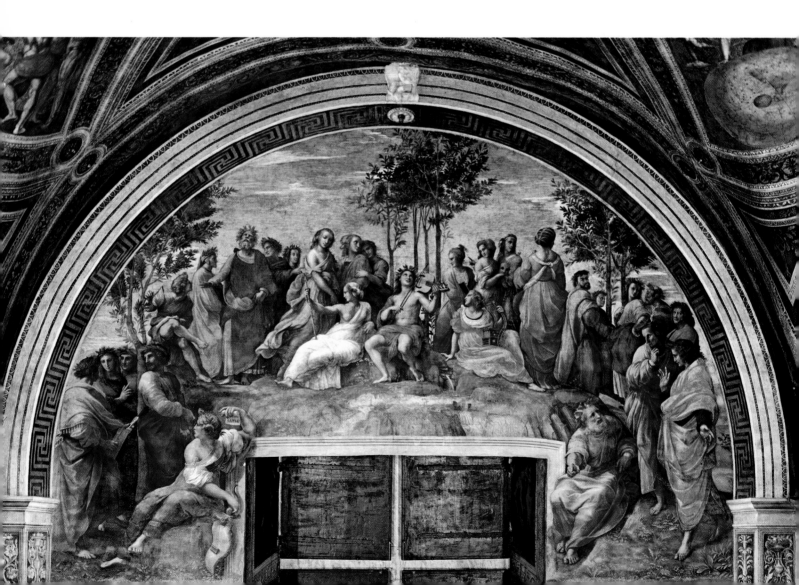

D·M·D·X·IIII

RAPHAEL
AND
GIULIO ROMANO
Rome 1492 — Mantua 1546
Expulsion of Heliodorus from the Temple
Stanza di Eliodoro.
Fresco in lunette; 24 ft 7 in (750 cm) at base.

RAPHAEL AND GIULIO ROMANO.

Expulsion of Heliodorus from the Temple.

The *Expulsion of Heliodorus from the Temple* gives the name of Heliodorus to this Stanza, painted between 1511 and 1514, in which are represented other closely related themes (*Miraculous Mass of Bolsena, Deliverance of St. Peter, Meeting of Attila and St. Leo*) that appear to have their connection in another aspect of the pope's program — this time political and religious — and allude in these early years of Reformation unrest to an intransigent attitude in defense of the Roman papacy.

The part most surely by the hand of Raphael seems to be the group on the left, which is connected with the adjoining *Miraculous Mass of Bolsena* by its brilliant color. Below it is written the date of 1514, year of the succession of the new pontiff, Leo X (following the death of Julius II in 1513), who had continued the work of decoration, but obviously not without having a say in its conception. In this painting he seems to be present at the biblical event as an outsider, a spectator; in reality the figure may be a later addition, as it masks part of the superb group behind, which was certainly conceived by Raphael but probably executed by others. Traces of alterations, indeed of a real reworking, are also found in the group on the right, behind the actual version which is attributed to Giulio Romano, and it does reflect his statuesque late Roman classicism (note the recollection of the *Laocoön* and of the Trajanic relief on the Arch of Constantine).

359

RAPHAEL AND GIULIO ROMANO. *Fire in the Borgo.*

It is the last work in the Vatican Stanze that has the savor of Raphael, and gives its name to the room; it was executed between 1514 and 1517. For this room, scenes showing popes of the name of Leo were planned, in honor of Leo X. The present episode refers to a miracle attributed to Leo IV, who by appearing and giving his benediction was said to have extinguished a dangerous fire that had broken out in the populous Borgo quarter. In the background the pope appears in the loggia of a Raphaelesque palace and beyond is discernible the façade of the Constantinian Basilica of St. Peter. The project seems unquestionably to be Raphael's and has a distinct stage-set and antiquarian flavor, probably relating to his renewed archeological interests and to the new Latinizing culture of Leo X. Thus the chronicle of

RAPHAEL AND GIULIO ROMANO
Fire in the Borgo
Stanza dell' Incendio Borgo.
Fresco in lunette; 21 ft 12 in (000) at base.

the miracle is identified with the myth of the burning of Troy, and on the left appears the celebrated Virgilian group of Aeneas, fleeing with his family. The execution of the foreground figures is attributed to Giulio Romano, the rest to Giulio Penni.

RAPHAEL. *Miraculous Mass of Bolsena.*

In the *Miraculous Mass of Bolsena*, one of the most sublime frescoes of the entire cycle, the neo-Venetian color experiments begun around 1511-12 and here related in particular to Titian and Lotto, come to maturity.

RAPHAEL
Miraculous Mass of Bolsena
Stanza di Eliodoro.
Detail of Chair Bearers.
Fresco.

360

Like the other scenes in the Stanza di Eliodoro, this one belongs to the series of miracles serving as apologia for orthodoxy, which was undergoing considerable shock. If the episodes of the *Expulsion of Heliodorus from the Temple* and the *Meeting of Attila and St. Leo* had a flavor of almost nationalistic defiance, in the sense of "out with the barbarians," the present scene was dedicated to the defense of the fundamental mystery of the Catholic Church: the Eucharist. It represents a miracle that took place in 1263, when a Bohemian priest, tormented by doubts on the truth of transubstantiation, while journeying from Prague to Rome celebrated mass at Bolsena. He then saw blood drip from the consecrated Host and bathe the corporal. The miracle also had important consequences for art: St. Thomas Aquinas composed two hymns (*Sing, my tongue the Savior's glory* and *Sion lift they voice and sing*) for the mass of the feast of Corpus Domini, instituted ad hoc by Urban IV in 1264; in its honor the Cathedral of Orvieto was built, its reliquary fashioned by Ugolino di Vieri, and the *Miraculous Mass of Bolsena* painted.

The composition, as in the case of the *Parnassus* and the *Deliverance of St. Peter*, was organically adapted to the limited space of the wall, which is cut by a window. The scene is thus disposed to include two approaches, at the sides, leading to the center of interest above — the altar with its background of a curving parapet. The details of the groups at the side are splendid: the one on the left for its quietly stirring animation; that on the right for the beauty of the portraits of the cardinals and the abstract, unmoved dignity of the chair bearers.

RAPHAEL
The Judgment of Solomon
Stanza della Segnatura.

Left:
RAPHAEL
The Fall
Detail.
Stanza della Segnatura.

Below:
RAPHAEL
Poetry
Ceiling fresco in Stanza della Segnatura.

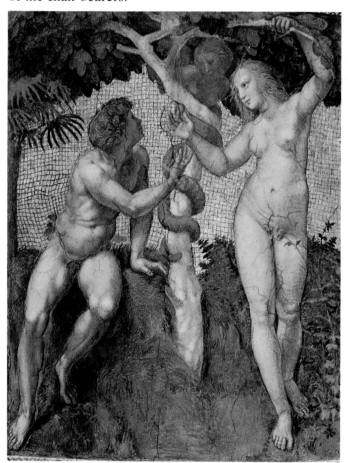

362

RAPHAEL. *The Fall* and *The Judgment of Solomon.* *pp. 362–63*
The two paintings on the ceiling of the Stanza della Segnatura alternate with two other emblematic episodes (*Astronomy, Apollo and Marsyas*) in the vault sections and with those bearing the tondi of *Philosophy, Theology,* etc., all part of the complicated doctrinal program of the decoration. The figures in these scenes are cut out against simulated gold mosaic backgrounds and are of a clearly didactic kind but not less beautiful for this. Indeed they played a highly important part as forerunners of numerous illustrated editions of the Bible.

RAPHAEL. *Poetry.* *pp. 362–63*
The allegory of *Poetry* is an inspired figure (the inscription reads: *numine afflatur* — Virgil, Aeneid, VI, 50 — following the conception of the Platonic Phedra) with burning eyes and wings to indicate flights of the imagination. The division of the vault, and its decoration with grotesques, had already been carried out, apparently by Bramantino — by Sodoma some believe — when Raphael began his work.

GIOTTO. *The Stefaneschi Polyptych.*

GIOTTO AND ASSISTANTS
Colle di Vespignano 1266 — Florence 1337
Detail of the *Stefaneschi Polyptych:*
Christ Enthroned with Angels and Cardinal Jacopo Stefaneschi (c. 1330–1335)
Panel; 7 ft 2 in × 8 ft (220 × 245 cm).
Great Altar of St. Peter's by Cardinal Stefaneschi, who paid 400 gold florins for it.

The monumental triptych that Cardinal Stefaneschi commissioned Giotto to paint in 1298 was intended for the spacious Constantinian Basilica of St. Peter. Painted on both sides, on one it shows *Christ Enthroned with Angels and Stefaneschi in Adoration* in the center and to the right and to the left, the *Martyrdoms of St. Peter and St. Paul;* on the other side, *St. Peter in Benediction with Angels, Saints and Donor* and to the right and to the left, *St. Andrew and St. John the Evangelist, St. James and St. Paul.* Numerous figures of saints, angels and prophets are included in the pilasters, medallions, pinnacles and predella. It is not surprising that Giotto, as the critics have ascertained, loaded at this moment of his maturity with commissions, entrusted the execution of the grandiose project to several of his most gifted students (Bernardo Daddi has been mentioned as one of them). He himself, however, determined and drew up the composition, and certainly followed the various phases of the execution. Giotto's most extensive firsthand participation is seen in the central panel of Christ, whose majestic pyramidal structure echoes the profile of the pinnacle. The dimensionality of the picture, already articulated by the outward-projecting arms and powerful knees of the central figure, is also achieved through the spacing of the minor figures; the foreshortening of the steps and of the carpet with its flattened squares; and above all by the sharp convergence of the sides of the throne, that are cut off at the top to suggest the separation between the plane closest to the spectator, which is that of the frame, and the more distant planes that progressively merge into undefined golden space.
In some of the lateral sections appear isolated instances of the students' specific inclinations: a contour emphasized more insistently at the curves and angles; the development of the color in a lighter value, with sharp clear accents and minute luminous flushes in the faces, whose dramatically fixed expression is thus emphasized. Nevertheless, the plan and structure are

Giotto's: in the *Martyrdom of St. Paul* (not illustrated here), one can see the affinity in structure between the two compact groups of figures connected at the center by the body of the saint lying prone, and the two heights behind them — sketched in broad planes — diverging upward from the saddle of the hill and prolonged by the cylindrical forms of the crumbling tower on the right, by the pious woman catching the saint's mantle on the left. Typical of the master is the choice of moment in illustrating the martyrdom of St. Paul. It is not the capture or the slaying, but the moment immediately afterward, when his head has already rolled on the ground, his disciples are bowed in silence and the soldiers are getting ready to go back, impassive like the cut-throat in the foreground shown in the act of sheathing his sword.

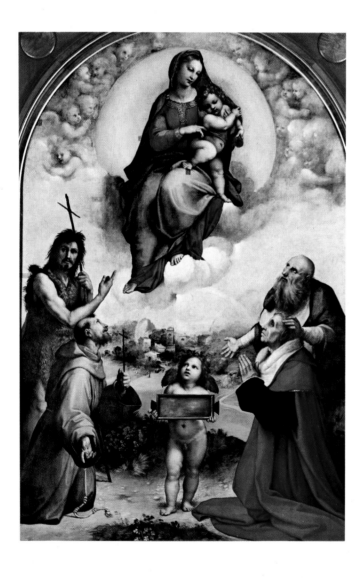

RAPHAEL
Madonna of Foligno (1511–1512)
Panel transferred to canvas;
10 ft 6 in × 6 ft 4 in (320 × 194 cm).
Commissioned by Sigismondo Conti for the church of S. Maria di Aracoeli, it was then donated to the Convent of S. Anna in Foligno in 1565, at the request of a granddaughter of Conti, the abbess of the convent. Confiscated by the French in 1797, it was restored to them and subsequently — in 1815 — returned to Italy.

RAPHAEL. *Madonna of Foligno.*
The panel was dedicated to the Virgin by the humanist Sigismondo Conti, secretary to Pope Julius II, as a mark of gratitude for the protection accorded to his house in Foligno, which had been struck by lightning but was undamaged. Conti is portrayed kneeling as he is presented by St. Jerome; to the left are St. Francis and St. John the Baptist; in the center

LEONARDO DA VINCI
Vinci 1452 — Amboise 1519
St. Jerome (c. 1482)
Panel; 40½ × 30 in (00 × 00 cm).
Provenance: collection of Cardinal Fesch, Napoleon's uncle.

Sigismondo's house, emerging from the mists and the greenish hills, is surmounted by the parabolic curve of the rainbow, and the orange globe of the thunderbolt is about to hit it. Above, in a nimbus surrounded by a host of blue cherubim, are the Madonna and the Child. The arched form of the panel and the corresponding curves of the golden nimbus, the rainbow and the grassy areas in the foreground show that the artist wished to enclose figures and environment in a compact organization, transferrring the crystalline constructions of the kind he studied in Piero della Francesca and Perugino to a monumental dimension. It is during these years, when the great enterprise of the Vatican Stanze (1510–11) was well advanced, that Raphael lived the most intense period of his brief, meteoric career. Brimming with Umbrian and Tuscan culture, he had moved to Rome, perhaps having sensed the symptoms of retrenchment and crisis in the Florentine world. In Rome he became aware of the different stylistic currents popularized by such artists as Sodoma, Bramantino, Sebastiano del Piombo, Lorenzo Lotto, Dosso and Battista Dossi. Decisive new impulses were given to the works of many of these painters by Raphael's solutions. He in turn was not indifferent to what he saw in their work, and in this painting the influence of the new Venetian color — of Bellini and Giorgione — is apparent. It is seen in the moist landscape, in the surfaces full of tonal passages which soften the supporting composition — surfaces that are more compact than ever and shining in warm browns of the flesh, in grays and silvery blues, in sumptuous reds.

LEONARDO. *St. Jerome.* *p. 367*

The panel, which was sawn in two at an unknown date, was put together by chance in the 19th century by Cardinal Fesch, who found the first half at a junkman's, where it was used as the lid of a box; and five years later the second, at a shoemaker's. The painting belongs to Leonardo's first Florentine period, and is contemporary with or a little later than the large *Adoration of the Magi* in the Uffizi. The figures of the saint about to beat his breast and of the lion curling his tail like a whip are diagonally placed in a rocky landscape. Without any form of introduction or accent to lead into the composition, the images almost spring up from the bleak earth and twist forward towards the light. The movement is intensified in the sorrowful head — the eye sockets, the black gash of the mouth — of the hollow-cheeked saint. The rejection of any traditional composition is reflected in the pictorial technique, for the monochrome impasto in the ocher tones does not fill the contours but is built up on an outline sketch, defining the spatial relationships by graduated passages from dark to light. Note how the lion measures the extent of the space in the foreground with the reserved curves of the tail and the hindquarters, and the density of the empty space embraced by the knee and bent arm of the saint. In the background, to the right, is the sketch of a cathedral; to the left, veiled blue-green transparencies evoke distant shores.

HISTORY OF THE MUSEUMS

CATALOGUE OF THE ARTISTS
AND THEIR MASTERPIECES

ALTE PINAKOTHEK
MUNICH

The Alte Pinakothek in Munich houses in its galleries one of the most significant and precious collections of art from the beginning of the 15th to the middle of the 19th century. Some parts of the collection have no equal anywhere in the world: the magnificent group of early German paintings, with works by Dürer, Altdorfer and Grünewaid, or the splendid, unbelievably rich Rubens collection. The paintings on display in the Alte Pinakothek (Old Picture Gallery) are the best works from the immensely rich heritage gathered together in the course of 300 years by the princes of the House of Wittelsbach, and which already numbered about 8,000 paintings at the time of the laying of the foundation stone of the Alte Pinakothek in 1826.

Duke Wilhelm IV of Bavaria (1493–1550) was the first of this succession of great patrons, while the first real collection to take shape was formed by Wilhelm's son, Albrecht V (1550–79), who was an ardent collector.

However, the most important figure to emerge was that of Maximilian I (1597–1651), the first Bavarian duke to become Elector. He was not only the most illustrious and powerful prince of his time, whose political activity spanned the whole of Europe, but he was also a man of infinite culture and an enthusiastic and scholarly collector. He introduced new criteria for collecting works of art, in which artistic considerations took precedence over mere interest in the subject depicted. With unyielding determination Maximilian began putting together the richest and most beautiful collection of the works of Albrecht Dürer. It was also during these years that the nucleus of the collection of works by Rubens was formed.

Another great patron-prince was Maximilian II Emanuel (1675–1726). He constructed the mighty *Galerieschloss* (Castle Gallery) in the castle at Schleissheim, where he amassed an enormous number of art treasures; the inventory, published in 1761, showed this rich and magnificent collection now to be one of the most important in Europe. In 1698 he made his most important acquisition when he bought from Gisbert van Ceulen, an art dealer in Antwerp, 101 paintings among which were 12 paintings by Rubens, including three portraits of Hélène Fourment, 13 van Dycks, 8 Brouwers, still-lifes by Snyder, paintings by Wouwermann, Fyt and Murillo. The Schleissheim inventory shows only a few, though by no means insignificant, Italian works: Titian's *Charles V Seated* and *Profane Love*, Paris Bordone's double portrait, and others. The collection of Dutch and Flemish painting was rich in both quantity and quality.

In the second half of the 18th century, with the death of Wilhelm Maximilian II (1777) the Bavarian line of Wittelsbach came to an end, and the Elector Karl Theodor took possession of Bavaria and the Palatinate lands. He brought with him to Munich all the works of the galleries of Düsseldorf and Mannheim, preponderantly from the Netherlands school (works by Rembrandt, Brouwer, Dou, Ter Borch and others); from the Flemish school (canvases by Rubens, van Dyck and a few paintings by Bruegel); from the Italian school (Carlo Dolci and the Neapolitans) and Spanish (Murillo).

When the Elector Karl Theodor died (1799), the line of Pfalz-Zweibrücken came to rule with Maximilian IV Joseph, who collected more than 1,000 paintings, mainly by Dutch and Flemish masters such as Ruisdael, Wouwermann, Metsys, and Teniers, but also many French, including important works by Claude Lorraine, Chardin, Boucher, Greuze, Poussin, Le Brun and many others. New contributions came with the secularization of church possessions in Bavaria and the Tyrol.

The most important of these were from the early German school but there were also some valuable canvases by Tintoretto, Tiepolo and Rubens. Other acquisitions came from the evacuations of the castles of Dachau, Neuberg and Haag between 1803 and 1804, and from the incorporation of the galleries of the free cities of Augsburg, Bamberg and Nuremberg, while others came from the margravate of Ansbach. In the same period (of the Napoleonic Wars) the French carried off to Paris 72 paintings of which only 42 were later recovered.

The last great collector was King Ludwig I (1825–48) who, while he was still Crown Prince, enriched the Gallery with works by Giotto, Fra Filippo Lippi and Filippino Lippi, Ghirlandaio and Perugino and, above all, Raphael's two masterpieces: *Madonna della Tenda* and *Madonna Tempi*.

In the second half of the 20th century the patronage of several German banks has made possible a series of important acquisitions which have helped to make up the shortages relating to the French and Italian schools of the 18th century. Among these are works by Guardi, Boucher, Fragonard, La Tour, Nattier and Pater.

THE BRITISH MUSEUM
LONDON

Among the great English national museums the British Museum is unique in that it is the only one to have been founded as both a library and a museum in the strict sense. It owes its character and its foundation to an extraordinary man, the ardent collector and scholar, Sir Hans Sloane (1660–1753), who, in the course of his life, succeeded in putting together an encyclopedic collection of works of art, antiquities and natural history objects. He expressed the wish that on his death, his entire collection should be offered to the Crown, in other words, to the Nation, for less than half of what it had cost him (£20,000; he had paid £50,000), so that it would be preserved "for the benefit and purpose of the betterment of the arts and sciences, and for mankind." Hans Sloane's bequest, marked the foundation of many of the Departments in the British Museum, which was instituted by an Act of Parliament in 1753.

Department of Ethnography. Sir Hans Sloane's collection included many pieces that he described as "artificial curiosities" and that today would be described as ethnographical specimens. In 1770 the Museum had already greatly benefited from the Pacific voyages of explorers like Captain James Cook (1728–79) with items from the South Sea islands, but it was only with Henry Christy (1810–65) that ethnography acquired a scientific basis. When he died Christy left his fortune and his great collections to four trustees among whom was Sir Wollaston Franks (1826–97), who transferred the collections to the British Museum together with the funds intended for future acquisitions.

Department of Egyptian Antiquities. The original nucleus came from Sir Hans Sloane's own collection composed mainly of statuettes of divinities. Only later, with the surrender of the French in Egypt in 1801, came the first acquisitions of large sculptures including the *Rosetta Stone*. At the start of the 19th century Henry Salt, Consul-General for Great Britain in Egypt, amassed a collection of monumental sculpture which was then acquired by the Museum. From that time on the British Museum has continued to acquire valuable pieces from private collections and archeological excavations. Today its collection of Egyptian art is second only to that in Cairo, and reflects all aspects of life in ancient Egypt.

Department of Western Asian Antiquities. Not until 1825 did some fragments of sculpture from the Persepolis, with a small group of objects collected by Claudius James Rich from around Babylon and Nineveh, reach London and the British Museum. The Museum also received finds from Nimrud, Nineveh and Assur from excavations carried out in 1845 by Austen Henry Layard and more than 20,000 tablets inscribed with cuneiform characters. The excavations of Sir Leonard Woolley and others at Ur and the surrounding area of Al-Ubaid, brought to light the rich culture of the Sumerians.

Department of Oriental Antiquities. Part of Sir Hans Sloane's collection was made up of some Arita pieces (Japanese ceramics) that he had acquired from the Swiss collector Engelbert Kaempfer. During his stay as a doctor on the island of Deshima (1690–92) Kaempfer had got together pieces of great value, books and prints, among them some significant examples of Chinese 17th century colored prints.

Department of Greek and Roman Antiquities. The origins of the Greek and Roman collections can be linked to the journeys made around the Mediterranean by rich collectors and cultured Englishmen in the 17th and 18th centuries. The most valuable acquisition of Greek sculpture came in 1816 with marble sculptures from the Parthenon and the Erechtheum of Athena. These collections are known as the "Elgin marbles" named after Thomas Bruce, 7th Earl of Elgin, who sold them to the British government.

Department of Prints and Drawings. This is one of the greatest European collections of prints and drawings in which all the schools of Europe are richly represented over a span of five centuries.

BRITISH LIBRARY

Department of Printed Books and Manuscripts. The British Library was founded in 1753 with the purpose of housing, together with other collections, the Cottonian Library, assembled by Sir Robert Cotton (1571–1631) comprising almost 950 volumes.

By the Act of Parliament that had instituted it, the British Library acquired, in addition, Sir Hans Sloane's collection of approximately 4,100 manuscripts and 40,000 printed books, a rich heritage that, for the most part, reflected his interest in medicine. The third great library to be acquired by Parliament in 1753 was the Harleian Collection of Manuscripts, founded by Robert Harley, 1st Earl of Oxford and his son Edward, 2nd Earl. It contained 7,600 manuscripts dealing mainly with the history of the Bible and the Christian Church, French and English history, classical Greek and Latin literature, but also important Turkish and Hebrew writings. Four years after its foundation in 1757, George II presented the library with the collection known as the Old Royal Library, made up of manuscripts and printed books collected by the kings and queens of England from Edward IV (1461–83) onward. George III inaugurated a new library which included a notable collection of books from Joseph Smith, British Consul in Venice. Later, George IV, in 1823, presented his father's library of 120,800 volumes. This example of royal benefactors of the 18th century was repeatedly imitated from then on by many private and enthusiastic collectors, with donations, legacies and funds for the enlargement of its collections.

THE NATIONAL GALLERY
LONDON

The National Gallery in London was founded in 1824, and is one of the most recent picture galleries in Europe. It differs from those of most European museums because, unlike these, its original nucleus was not a princely or royal collection taken over by the state. In fact, the National Gallery was created expressly as a museum for the public, and all its policies including that for acquisitions, have been developed accordingly.

In 1823 the question of a museum arose and Parliament voted £60,000 for the purchase, presentation and exhibition of the private collection of John Julius Angerstein, a rich London merchant, which comprised 38 works, including six paintings from the series, *Marriage à la Mode* by Hogarth, and five magnificent canvases by Claude Lorraine. In its early years the National Gallery was fortunate in receiving as gifts or bequests from important private collectors, some of the most beautiful works in its possession. In 1826 it acquired Sir George Beaumont's collection consisting of six canvases, including Rubens' famous *Château de Steen* and Canaletto's *The Stonemason's Yard*, and later, after Beaumont's death in 1828, a small beautiful Claude which the benefactor had been unable to bring himself to part with during his lifetime.

At this time in addition to the fruits of a shrewd purchasing policy, new acquisitions came from legacies and private collections. In 1831 the Rev. William Holwell Carr bequeathed to the Gallery his famous collection including *Woman Bathing in a Stream* by Rembrandt and, most noteworthy, Tintoretto's *St. George and the Dragon*, which to this day remains one of the most admirable paintings in the Gallery.

In 1837, Queen Victoria came to the throne, marking the start of the so-called Victorian Age, characterized by an ever increasing interest in the cultural life of the capital. The following period of intensive development was sustained by the regular rhythm of acquisitions, made with funds supplied by Parliament. At first the collection consisted mainly of works from various Continental schools of painting, as English artistic tastes always leant towards the Italian Renaissance and French masterpieces of the 17th century, from Poussin to Claude. However, towards the middle of the century the Gallery began to acquire English paintings and in 1874 Robert Vernon donated the first 157 English modern works. On the death of the English artist, Turner, in 1851 after complicated legal disputes resulting from his will, many of the artist's works – oil paintings and watercolors – entered the National Gallery. Today they are divided between The National Gallery, the Tate Gallery and the British Museum.

By the mid 19th century the National Gallery had become a major institution. In 1885 the administration was reorganized and a new statute provided, among other innovations, the nomination of the director of a new Board of Management. The first director was the painter and connoisseur Sir Charles Eastlake who bought brilliantly and purchased many paintings now widely recognized as artistic masterpieces and historically representative works.

In 1861 after the death of Albert, the Prince Consort, Queen Victoria gave the Gallery a group of works by German artists in her husband's memory, among which was Lochner's *St. Matthew, St. Catherine and St. John the Evangelist*. In the second half of the century the National Gallery acquired some of the most outstanding pieces of its collection. In particular, in 1871, it bought Sir Robert Peel's collection of valuable works by Dutch and Flemish masters. In 1876 it acquired 94 pictures from the Wynn Ellis collection, and in 1885 Raphael's *The Ansidei Madonna* and van Dyck's *Equestrian Portrait of Charles I*. In 1892 the Gallery purchased from the critic Thoré *Young Woman Standing at a Virginal*, by the artist Vermeer, the finest of all Dutch painters, and today one of the most prized: in 1895 it bought two Rembrandts from the collection of Lord Saumarez. In 1890 three paintings came from the Longford Castle: Holbein's *Jean de Dinteville and Georges de Selve, "The Ambassadors,"* Velázquez's *Portrait of Admiral Pulido Pareja* and Moroni's *A Nobleman*, acquisitions made possible by the generosity of private contributions (from Lord Rothschild, Lord Iveagh and Charles Cotes). In 1903 the National Art-Collections Fund was formed for the collection and acquisition of paintings, and from the beginning the foundation showed itself to be a strong and vital force. Indeed, the following year it acquired Titian's famous *Portrait of a Man* and, in 1909, was instrumental in keeping Holbein's *Christina of Denmark, Duchess of Milan* in England. Among the acquisitions around that time were a Frans Hals in 1908, a Masaccio in 1916 and Altdorfer's revolutionary *Landscape with a Footbridge*. Other paintings followed thanks to an act of Parliament on the basis of which works of art could be accepted by the State in lieu of inheritance tax. It was in this way that Rogier van der Weyden's very moving *Pietà* entered the National Gallery.

Among the most interesting acquisitions are Paolo Uccello's *St. George and the Dragon* and Leonardo's cartoon of *The Virgin and Child with St. Anne and St. John the Baptist*. In addition to the series of shrewdly successful purchases the Gallery has been enriched by remarkable donations. Among these was the bequest of George Salting in 1910, who left 192 pictures, and of Hugh Lane in 1915 who bequeathed his collection containing among other works, Renoir's *Les Parapluies* and two canvases by Manet and Degas. In 1924 Dr. Ludwig Mond left the Gallery his *Crucifixion* by Raphael (an early work) and a later work by Titian, a *Virgin and Child*.

However, it is especially the 19th and 20th century French schools that needed to be enriched. Canvases by Courbet, Monet and Renoir were added and the much acclaimed masterpiece by Cézanne, *Les Grandes Baigneuses*, imported from France in 1964.

HERMITAGE
LENINGRAD

The Hermitage State Museum is one of the greatest in the world. Today the Hermitage buildings spread along the banks of the Neva for almost a kilometer, incorporating almost 400 rooms, with about three million works of art from different civilizations, epochs, states and peoples. Its history began in the middle of the 18th century with Catherine II's purchase of several pictures by Flemish and Dutch painters from a Berlin merchant called Gotzowsky in payment of his debt to the Russian Treasury. These paintings, which were brought to Russia in 1764, were used to decorate several rooms in the newly built Imperial Winter Palace and are generally considered the first step towards the foundation of the museum. However, the collecting of European art had already started in Russia by the beginning of the 18th century, when on the order of Peter I a small collection was acquired, comprising Dutch paintings, including *David's Farewell to Jonathon* by Rembrandt, and a few classical antiquities, among which was the *Taurida Venus*.

During the second half of the 18th century the royal collections were added to extensively, greatly heightening the prestige of the palace and its owner. Catherine's propensity for collecting art spread to the Russian aristocracy, who also developed a taste for it. It was during this period that the most famous collections were formed. All of these collections became part of the Hermitage collection after the revolution.

Dimitry Golitsyn, the Russian ambassador to Paris and then the Hague, was especially active in adding to the royal holdings. In 1768 he purchased the collection of Count Carl Philippe Cobentzl, the then Austrian ambassador, which comprised 46 pictures, the most valuable being two works by Rubens, and also 4,000 drawings, which marked the beginning of the Hermitage's great graphics collection.

Four years later in 1772, the celebrated Crozat Collection was purchased in Paris. This consisted of almost 400 canvases, including Giorgione's *Judith*, Rubens' *Bacchus*, Raphael's *Madonna with Child and St. Joseph*, Titian's *Danaë*, several van Dyck portraits and seven Rembrandts. This collection also brought the first works of French artists to the Hermitage – Louis Le Nain, Poussin, Watteau and Chardin. The Hermitage's last 18th century purchase in Paris was in 1781, when it bought Count Baudouin's collection (119 canvases), which counted nine Rembrandts and six van Dyck portraits among its treasures.

During the 18th century besides Paris and The Hague, works were also arriving from other European capitals. In 1769 the heirs of Count Heinrich Brühl, a former minister under the Saxon King August III, sold his collection to the Russian count. This was an important addition to the palace holdings notably bringing with it Rembrandt's *Portrait of an Old Man in Red*, and *Portrait of a Scholar*, Watteau's *Embarrassing Proposal*, Rubens' *Perseus and Andromeda*, and *Landscape with a Rainbow*, Cranach's *Venus and Cupid*, and works by Tiepolo, Bellotto and Bruegel. The collection also contained numerous drawings. Ten years later, in 1779, the Hermitage acquired the Walpole Collection consisting of 198 canvases including works by 17th-century Italian, Flemish and Dutch masters, notably Rubens, van Dyck, Snyder, Rembrandt and other works by Rosa, Giordano, Poussin, Claude Lorraine and many other artists. No less important at this time are the acquisitions of several sculptures. In 1769 a consignment of classical antiquities arrived from the Russian ambassador in Rome, and a few years later in 1785 the Lyde-Brown Collection was acquired, parts of which were added to the section of classical antiquitites, and the rest formed the nucleus of the European sculpture collection. The outstanding work of this collection was Michelangelo's *Crouching Boy*.

At the beginning of the 19th century the Hermitage housed 3,996 works of art. There were three main acquisitions during the first half of the century. In 1814 the major portion of the Malmaison Palace collection of the Empress Josephine, first wife of Napoleon, was purchased consisting of 118 canvases of Dutch, Flemish and French schools. The collection also included a few works by Canova and by several contemporary French sculptors. In 1814 and 1815 the Hermitage purchased a valuable collection from the English banker Coesvelt in Amsterdam. The most valuable works in this collection were those by Spanish artists: Velázquez, Zurbarán, Pereda, Morales, Pantoja de la Cruz, all of which formed the cornerstone of the Spanish collection. The collection of the Spanish Minister, Manuel Godoy, was acquired in 1836, and this added several noteworthy Spanish canvases to the museum, by artists such as Ribera, Murillo, Ribalta and others. A very substantial addition to the Hermitage's treasures came in 1850 through the acquisition of the Barbarigo Palace collection in Venice. No less than six of the Hermitage's eight Titians came with this collection.

In the succeeding years, the Hermitage's collections continued to expand. Among several notable additions was the acquisition in 1866 from the Duke of Litta of Leonardo da Vinci's beautiful work known as the *Litta Madonna*, and in 1870 a work by the young Raphael was added, now known as the *Conestabile Madonna*. Apart from the many individual works acquired in the second half of the 19th century, was the important purchase in 1915 of the huge collection (700 works) of Dutch and Flemish paintings from the famous scholar and geographer P. P. Semyonov-Tein-Shansky. During this time the opportunity arose to add to the English portrait collection by acquiring works by Gainsborough, Romney, Lawrence, Raeburn and Hoppner from the Aleksei Khitrovo collection.

In the 20th century through the work of the State Commission for the Registration of Works of Art the Hermitage received collections from former imperial country palaces and from the private residences of aristocrats who had fled abroad. All this meant tremendous change within the Hermitage's collection of paintings, particularly to the sections on Italian and French art, which were considerably expanded.

The departments of European drawings and of applied and decorative art and sculpture expanded rapidly, thanks to generous additions from the Shtiglits Museum, the Academy of Arts and the Yusupov Collection. In addition the vast collections of some magnificent pieces of porcelain, furniture, silverware, textiles, rugs and lace from every civilization and country, make the Hermitage Museum the only one of its kind in the world.

LOUVRE
PARIS

The first nucleus of the collection at the Louvre can be traced back to Francis I (1515–47), who gathered together paintings, sculptures and other objects. On his return from military campaigns around Milan he chose Fontainebleau as his residence, and invited such masters as Leonardo, Rosso Fiorentino and Benvenuto Cellini to France. He added to his collected works by Titian, Fra' Bartolomeo, Raphael, Sebastiano del Piombo, and in the last year of his life he ordered the construction of the Louvre to begin on the right bank of the Seine on the site of a 13th-century fortress.

The royal collections did not grow much under the following kings, until 1610 when the young Louis XIII came to the throne. Louis XIII was not himself an enthusiastic collector, but he was fortunate in having as his minister Cardinal Richelieu, a true art lover who acquired many famous works by masters such as Leonardo, Veronese and Poussin. At this time the Queen Mother, Marie de Médicis also commissioned various works, including the well-known suite of canvases by Rubens, now on exhibition at the Louvre. When Louis XIV came to the throne in 1643 the whole collection amounted to only slightly over 200 paintings, but at his death 72 years later in 1715 over 2,000 paintings had been amassed; a tremendous growth which marks the most brilliant half-century of French collection. From the beginning of his long reign, the king and his minister, Cardinal Mazarin, planned a systematic development of the royal art treasures, and they were fortunate enough to be able to buy some very important private collections, including that of Charles I, king of England. When Charles's collection was dispersed, during Cromwell's revolution of 1649–50, a major part of it came into the hands of Mazarin and or Evrard Jabach, a German banker and a director of the East India Company. At Mazarin's death in 1661, Louis bought the best pieces; thus Raphael's *Portrait of Baldassare Castiglione* and Correggio's *Antiope* came to the Louvre. Louis XIV bought more than 5,000 drawings and 100 paintings from Jabach and in 1665 Mazarin's grandson sold him 13 paintings by Poussin. The same year Don Camillo Pamphili sent to Paris paintings by Albani, Annibale Carracci's *The Hunt* and *Fishing Party* and Caravaggio's *Fortune Teller*. Other gifts enriched his personal collection. From the Republic of Venice came the *Supper in the House of Simon* by Veronese, and from the collection of the landscape architect Lenôtre came works by Claude Lorraine, Albani and Poussin. Around the end of the century there was a renewed interest in Northern art. All the Holbeins in the Louvre today had already been bought as part of the Jabach collection, but now Louis XIV bought some famous works by Rubens.

In the 18th century, the Regent, Philippe, Duc d'Orleans, was like Louis XIV, a patron of the arts, but the collection set up was a private one, and it was dispersed at auction after the Revolution. During the reign of Louis XV (1715–74) and Louis XVI (1774–92) the huge paintings of the previous century were less popular. In this period the most important acquisition, in 1742, consisted of paintings from the collection of Amedeo di Savoia; these were for the most part 17th-century Italian paintings. At the same time it was felt by influential people that arrangements should be made in order to organize, house and take proper care of the now huge royal collection. In 1749 110 masterpieces from the collection were exhibited in the Luxembourg and so the first, though only temporary, public gallery in France came into being.

The Count of Angivillier was in a way the creator of the museum as we know it today. Under his guidance important progress was made in planning and building the "Grande Galerie" of the palace of the Louvre. The Count also began a policy of systematic buying, like that of Louis XIV, trying to collect from periods and schools which had hitherto been poorly represented.

It is clear that the Revolution of 1789, rather than destroying the projected museum, brought it into being. The Musée Central des Arts was established by decree on July 27, 1793 and less than a month later it was opened to the public in the Louvre's Grande Galerie. The creation took place at a time of confiscation of property from churches and from the homes of the aristocrats who fled the country. From private collections came Michelangelo's *Slave* and Mantegna's *Allegories*, while van Eyck's *Madonna and Chancellor Rolin* and Fra' Bartolomeo's *Marriage of St. Catherine* were taken from the church of Nôtre-Dame at Autun. The policy of confiscations assumed alarming proportions under Napoleon, who despoiled all the conquered lands of their masterpieces, especially Italy.

However, on Napoleon's defeat after the Congress of Vienna in 1815 more than 5,000 works of art were returned to their respective countries: nevertheless a hundred or so masterpieces, some of which have already been mentioned, remained in the Louvre and were never sent back to their country of origin.

In the 19th century, the Louvre rearranged its collections as well as engaging in the purchase of other works. The new emperor, Napoleon III, was ambitious in this direction, and added considerably to the Museum's holdings. In 1863 the whole Campana Collection was bought. It consisted of a variety of objects and of paintings by Tura, Crivelli, Signorelli (*The Annunciation*), and Paolo Uccello's *The Battle of San Romano*. Five years later, in 1868, La Caze left the Louvre 800 paintings, including, among others, works by Ribera, Rembrandt, Rubens, Hals and a group of French 18th-century canvases (Watteau, Fragonard, Chardin) which filled an important gap, since the museum had few works of this period.

From the second half of the 19th century until the present day the Louvre has continued to expand and develop and many important purchases have been made. In the same period the Museum has received some splendid gifts, among them *The Card Game* by Lucas van Leyden from the Lebaudy estate; the "Amis du Louvre" have given the Museum Vouet's *Allegory: Prudence Bringing Peace and Abundance*, as well as *Saint Sebastian* by Georges de la Tour and *Young Choirboy* by Claude Vignon. Baroness Gourgaud's gift includes the *Young Woman with Mandolin* by Delacroix, as well as various Impressionist and modern works. The Impressionist collections are now housed solely in the new Musée d'Orsay.

THE METROPOLITAN MUSEUM OF ART
NEW YORK

Greek and Roman Art. The classical collection was the first section of the Metropolitan Museum of Art to draw international attention in 1874 and 1876 when General Luigi Palma di Cesnola sold it 6,000 priceless objects that he had excavated on Cyprus. When, in 1903, Cesnola became the Museum's first director until his death in 1904, he used the new Rogers Fund to make three remarkable purchases: the first lot of ancient glass for what has now become the world's best collection; a hoard of Etruscan bronzes from near Spoleto, including a sculptured ceremonial chariot; and finally frescoes from near Naples, where the eruption of Vesuvius in A.D. 79 had preserved the only Roman painted room now outside Italy. The Museum began acquiring Greek sculptures in 1908 and over the years consistent purchasing has amassed a continuous series of pottery from Minoan times to the end of the Roman Empire.

Far Eastern Art. As long ago as 1879 some 1,300 Chinese porcelains were bought by subscription. A Han bronze was given in 1887 by the Chinese diplomat, Chang Yen Hoon, as the first of a splendid series that now covers the development from the early dynasties onward. In 1902 Heber R. Bishop bequeathed over 1,000 jades of all sorts. The ceramic collection covers the production of 4,000 years, thanks to the generosity of J. P. Morgan, Benjamin Altman in 1913, Samuel T. Peters in 1926, and John D. Rockefeller, Jr. in 1960. As a result of China permitting the export of works of art, the series of monumental Chinese sculptures became the most varied exhibition to be found in any single place. The purchase of the Bahr Collection brought many Chinese paintings, and other purchases have added the Sung painting of *The Tribute Horse* in 1941, and the Han handscroll *The Shimmering Light of the Night* in 1977 from the Dillon Fund. The valuable collection of Japanese screens includes works carried out by Korin and his school.

Islamic Art. The collection took shape in 1891 when Edward C. More bequeathed outstanding Persian and Hispano-Moresque pottery, Egyptian, Syrian and Mesopotamian metalwork and glass, including the largest series of enameled glass mosque lamps outside Cairo. These categories were subsequently greatly enriched by a series of donations which brought to the Metropolitan a large number of examples of Islamic miniature painting, carpets, carved and painted stucco wall decorations and pottery.

Ancient Near Eastern Art. This department was officially created in 1956, however, the collection of ancient objects, began long before that date. In 1932, John D. Rockefeller, Jr. gave the colossal guardian figures and the Assyrian reliefs from the Northwest Palace of Ashur-Nasirpal at Nimrud. The Department also received many fine exhibits from further excavations in which it took part, in Iraq at Nimrud and in the southern part of the country during the 1950s and 60s.

Egyptian Art. This department's great archeological collection comes principally from excavations dating back as far as 1907. In 1913 the Museum bought the mastaba tomb of Pernebi at Saqqara and installed it in the Museum at the entrance to the Department. Of particular interest are the extraordinary models of Egyptian life from about 2000 B.C., which were discovered in the tomb of Mekutra by Herbert Winlock during a series of excavations.

In 1915 Theodore M. Davis bequeathed 1,100 Egyptian objects found during his personal excavations in Egypt; and in 1926 Harkness gave the finest private collection of Egyptian small and precious objects, gathered by Lord Carnarvon. However, the most important exhibit is still the sandstone Temple of Dendur, a gift from the Egyptian people to the people of the United States.

Primitive Art. This Department was, in effect, founded on what was probably the greatest private collection of the 1940s and 50s: that of Nelson A. Rockefeller. Today the collection is housed in the new Wing, which was named in honor of his son, Michael C. Rockefeller.

European Paintings. A few months after the Museum was founded in 1870, it purchased 174 European paintings in Paris. In 1887 Catherine Lorillard Wolfe bequeathed 143 paintings and provided a fund out of which the Museum later bought Goya's *Bullfight*, Delacroix's *Abduction of Rebecca* and Daumier's *Don Quixote*. In 1889 Henry Gurdon Marquand gave 37 paintings that he had bought with extraordinary perspicacity especially for the Museum. These included Vermeer's *Woman with a Jug*, van Dyck's supremely elegant *Portrait of James Stuart*, three Hals portraits, and works by Petrus Christus, Ruysdael, and Gainsborough.

In 1907 a successful buying campaign was begun directed by Roger Fry and his assistant Bryson Burroughs. Between them, these two secured important works by Renoir, Veronese, Tintoretto, Rubens, Giotto, Botticelli and Carpaccio and in 1913 the Metropolitan became the first museum to purchase a Cezanne. The year 1913 also brought the bequest of Benjamin Altman with canvases by Botticelli, Titian, Vermeer, four works by Memling and two by Velàzquez. In 1929 the Havemeyer bequest brought in almost 2,000 works of art the most important of which were purchased on the advice of artist Mary Cassatt. These included paintings by Hugo van der Goes, Bronzino, El Greco, Goya, and an incomparable wealth of Impressionist works by Courbet, Degas, Manet, Renoir, Cezanne and Cassatt herself. During the 1930s, despite the depression, the Museum managed to secure Mantegna's *Adoration of the Shepherds*. Jules Bache's bequest of 63 paintings included works by Titian, Crivelli, Rembrandt, Velàzquez, Watteau, Fragonard and Goya. Samuel A. Lewisohn's bequest in 1951 brought Gauguin's *Ia Orana Maria*, Seurat's sketch for *La Grande Jatte*, and van Gogh's *Arlesienne*. The Museum of Modern Art, in return for a subsidy in 1943, gave the Metropolitan "classic" works of the 19th and 20th century, including two Cezannes, three Matisses and one Picasso, later to be joined by another, his *Portrait of Gertrude Stein*, which was left to the Metropolitan in the author's estate.

Subsequent acquisitions were no less important. In 1967 Adelaide Milton De Groot bequeathed her entire collection of paintings of the School of Paris, the most important of which is van Gogh's *Self-Portrait*. However, one of the most significant purchases of the last 30 years is the Robert Lehman collection, which represents almost all branches of European art from the 14th century onwards.

376

THE NATIONAL GALLERY
WASHINGTON

Unlike the world's other great museums the National Gallery of Art in Washington is entirely the product of private collecting, closely linked with the art market. Most European museums are the result of centuries of collecting by enlightened rulers and wealthy aristocrats, and the history of their collections is strictly bound up with that of the works of art themselves. The National Gallery of Art, however, came about in the quite different context of private collecting within the 20th century. The original nucleus of the Gallery arose, in fact, from the private collections of some of the greatest American art collectors of our time – Mellon, Widener, Kress. Despite the fact that the fundamental motive for forming such collections was the unashamed intention to make sound financial investments, all of these great collectors displayed a genuine love of art, and agreed that their works of art should be made available to the American public by the creation of a large museum, which would serve as an essential educational and cultural instrument. And so it was from this fortunate coincidence of public and private interests that the National Gallery of Art in Washington came into being.

The first great collector interested in the foundation of a new museum was Andrew Mellon, First Secretary of the Treasury (1921–31) and later Ambassador to Great Britain between 1932 and 1933. Of Irish origin, this great industrialist, financier and philanthropist from Pittsburgh in Pennsylvania, not only offered his private collection as a foundation, but he also donated the funds to build the museum. His one condition was that the American government should provide for the institution in the future. Work was begun in 1937 and the museum was inaugurated four years later in 1941.

An ardent collector from his youth, Andrew Mellon traveled extensively in Europe where he formed numerous business links and friendships with skilled art dealers and antiquarians among which were the Knoedlers, who made possible one of the most sensational scoops of the century: the acquisition, in 1930–31 of 21 masterpieces from the Hermitage Museum in Leningrad, which had already been sold to the millionaire Gulbenkian. Among these were outstanding works by Raphael, Botticelli, Veronese and van Eyck. The acquisitions continued in increasing numbers until the last years of his life, in the awareness that they were destined for the museum which sprang from his initiative. Among others, he acquired Masaccio's *Portrait of a Youth*, Gainsborough's *Landscape with Bridge* and, most importantly, Duccio's *Nativity* which is a panel from the famous *Maestà* painted from Siena Cathedral, and now broken up and dispersed in collections throughout the world. Nor did Mellon ignore American art, putting at the museum's disposal a wide selection of works obtained by the acquisitions of Thomas B. Clarke's entire collection, which comprised various portraits including that of *Mrs. Richard Yates* by Gilbert Stuart, one of the best American portraitists of the period.

While Mellon's collection is the result of the acquisitions and taste of a single individual, Widener's is the result of two generations of collecting, representing one of the most spectacular art collections that has ever been gathered together in America. As well as an excellent collection of paintings it also includes many valuable sculptures, tapestries, porcelain, jewelry and furniture. Widener's interest was mainly centered around the more classic works of European art: the Italian Renaissance, 17th-century Dutch and 18th-century English painting. There are many prestigious signatures from Mantegna to Bellini, Andrea del Castagno, Titian, El Greco, van Dyck, Rembrandt, Vermeer, Constable.

The third private collection to contribute to Washington's National Gallery of Art belonged to Samuel Kress, a self-made man, who owned a chain of large retail stores. When Mellon died Kress became the most important collector in the United States and, perhaps, in the world. His great passion was for Italian art, not only from the traditionally admired periods, but also from the 16th and 17th centuries. Although his policy of buying was based mainly on advice given to him by art experts, he realized the importance of widening his contacts with the wealthiest families in England, Italy and France, without neglecting the American collections, like those of Robert Lehman and Dan Fellows Platt. On his death the best of his collection came to the National Gallery of Art in Washington, which today exhibits over 300 works from the astounding collections put together by Kress in less than half a century. Among the artists represented are Duccio, Botticelli, Piero di Cosimo, Ercole de' Roberti, Giorgione, Titian, Lotto, Bosch, El Greco, Clouet, Poussin, Le Nain, Watteau and many others.

Besides the acquisition of these extraordinary collections the contribution made by other private donations was also of great importance. Of exceptional interest is Lessing J. Rosenwald's collection of 1943, which brought to the Gallery 1,000 high quality drawings and engravings including works by Dürer, Schongauer, Lucas van Leyden. The creation of the Impressionist and a Post-Impressionist section is owed, once again, to a businessman, Chester Dale, who bequeathed to the National Gallery a stupendous collection of French paintings from the 18th to the 20th century, as well as works by Tintoretto, Rubens, Zurbarán and the American school.

Horace Havemeyer donated Manet's *Gare St. Lazare*, an Impressionist masterpiece and still one of the most highly admired pictures in the Gallery. From the Garbasch family came more than 200 American primitives, and from the Freling-Huysen collection, some canvases by Goya.

PRADO
MADRID

The Prado Museum has the richest and most comprehensive collection of Spanish paintings in the world. Of some 30,000 paintings on display almost a third are from the Spanish school, and of these 100 are by Goya, about 50 by Velázquez, as many by Ribera, almost 40 by El Greco, and the same number by Zurburán and Murillo, to cite only a few of the most famous names. The quantity is astounding, but especially so is the consistently high quality of the works chosen by successive kings of Spain, and collected for their palaces and royal residences. The history of the Spanish collections is, indeed, linked to the personal taste of individual Spanish sovereigns and to the favorable economic and political situations of the country in the 16th century and during the first half of the 17th.

Towards the end of the 15th century in Spain the taste of the Court was still oriented towards the painting of the Low Countries. It was not until the reign of Charles V (1516–56) that Spanish culture began to develop on a broader European scale; thus the establishment of the existing patrimony is owed to him and his passion for Italian art, which provided the royal collection with some of the Prado's finest Titians.

Charles V's son, Philip II (1556–98) continued to commission works from Titian, together with paintings by Tintoretto, Veronese, El Greco, Patinir, Metsys, and Bosch from whom he acquired the famous *Garden of Delights*. The collection did not grow very much during the reign of Philip III (1598–1621), a period which was important chiefly for the presence in Spain of El Greco. Philip IV (1621–65), however brought a new breath of life with him. Not greatly endowed as a politician, he was undoubtedly the greatest collector Spain had ever known and had the good fortune to buy a great number of masterpieces from the rich collection of Charles I of England, when it was dispersed after Cromwell's civil war. Most importantly, Philip IV brought to his Court the greatest painter of the golden age of Spanish civilization, Velázquez, and it is thanks to this king that the great number of paintings by the hand of this artist are in the Prado today. They include *The Surrender of Breda, Las Meninas, The Fable of Arachne* and the series of court portraits. Twice the king sent Velázquez to Italy to purchase paintings for his collection, and these included Tintoretto's Old Testament scenes and Veronese's *Venus and Adonis*. Another great painter of the period to come to the court of Philip IV was Peter Paul Rubens from Belgium who was twice sent there on diplomatic missions. The Prado now houses many of his works. However, the reign of Philip IV saw the inexorable decline of Spain, economically as well as politically. This decline continued under the rule of Charles II (1665–1700) who was neither a great politician nor an enlightened patron of the arts. On his death in 1700 the royal collections numbered 5,539 paintings, a considerable heritage which, nevertheless, some years later in 1724, was seriously depleted after a fire at the Alcazar in Madrid, and suffered further losses during the wars of Succession and Independence.

Isabella Farnese, the wife of Philip V (1700–46), had her own collection, which included, among other works, several paintings by Murillo. Philip V was the grandson of Louis XIV of France and so the Spanish Court of this period was also receptive to French tastes, as is confirmed by paintings, Rigaud, van Loo, and Watteau. With the accession to the throne of Charles III (1759–88), fresh interest was awakened in contemporary painting and artists such as Corrado Giaquinto, Giambattista Tiepolo and Anton Raffael Mengs came to paint at his court in the new royal residence of Buen Retiro. At the same time works from the past began to be acquired and the royal collections received paintings by Domenichino, Agostino Carracci and Rembrandt. Charles IV (1788–1808) is remembered for the purchase of Raphael's *Portrait of a Cardinal* and, especially, for enriching the collection of Spanish works. The most significant cultural event of his reign was the appearance of Francisco Goya as "pintor da camera." He, like Velázquez over a century earlier, worked for the court, and the Prado has a splendid group of his paintings, drawings and cartoons for tapestries, unequaled anywhere in the world.

In 1819 Ferdinand VII (1808–33) opened the royal collections to the public thus establishing the Museo Reale (Royal Museum) in which he showed great interest, adding works by Spanish painters. Later, Isabella II (1833–68), further enriched the collection with acquisitions that included the celebrated *Hay Wain* by Bosch. In the same period paintings from royal palaces and various other residences were given to the museum. In the second half of the 19th century the museum's collection continued to expand with works of art chosen from among the thousands of pieces in the royal heritage. In 1872 the Museo Nacional de la Pintura (National Museum of Painting) became part of the Prado. It had been installed in the convent of the Trinitarians and included several works confiscated from various convents and religious orders that had been suppressed in 1836. Other pictures came from donations like that of Count Emil d'Erlanger in 1881, who had bought and restored Goya's own house. A few years later in 1894, Romantic and post-Romantic paintings from the bequest of Don Ramón de Eurazan added luster to the newly opened section devoted to modern painting. The bequest of the Duchess of Villahermosa dates from the following year. In 1915 Don Pablo Bosch left the museum a rich and valuable collection of paintings and medals. In 1941 the generosity of the collector, Don Francisco Cambo, filled a gap in the Prado's collections with works by Taddeo Gaddi, Giovanni del Ponte, and Botticelli. The museum's policy in recent years has been directed towards filling certain gaps in the existing collections in order to present a more complete survey of European painting.

UFFIZI
FLORENCE

The huge edifice that today houses the Uffizi Gallery was built by order of Cosimo I de' Medici in 1559. The architect was Giorgio Vasari. Work began the following year in 1560. Originally it was intended to be offices of the State Judiciary, and it is from this first use that the gallery took its present name. Later Cosimo had the idea of constructing a corridor to link the Palazzo Vecchio to the Pitti Palace, so work went on for far longer than expected and, in 1574, when both Cosimo and Vasari died, it was still unfinished. Alfonso Parigi and Bernardo Buontalenti were called in to continue the work and they remained faithful to the original design. The Gallery was completed in 1581 at the time of Francesco I, who had succeeded his father, Cosimo.

All the Medici grand dukes left their own personal imprint on the Gallery in the form of a work of art as a gift. Thus Cosimo II (1590–1621) donated Correggio's beautiful painting *Adoration of the Child*, which had been given to him by the Duke of Mantua. From the estate of Don Antonio de' Medici came the Mantegna's *Triptych*. When the sovereign family of the Rovere of Urbino died out in 1631, their art collections were inherited by the Grand Duchess Vittoria, last of the line and wife of Ferdinando II de' Medici. Among the most important works in this collection are Piero della Francesca's great *Diptych of the Duke of Urbino* in which Federico II da Montefeltro and his wife, Battista Sforza, are shown in profile; a group of works by Titian, including the *Venus of Urbino*, *Portrait of Eleonora Gonzaga* and a portrait of Francesco Maria della Rovere, almost certainly painted in Venice during the duke's exile after he had been driven from Urbino by Cesare Borgia.

Michelangelo's *Holy Family* was already hanging in the Tribuna by 1635: the famous *"Tondo Doni."* In 1639 an exchange was made with the Duke of Modena and the Gallery acquired Correggio's *Rest on the Flight into Egypt*. It is thanks to Cosimo III who succeeded Ferdinando II in 1670, that the Gallery obtained one of Rembrandt's greatest paintings, *Portrait of an Old Man*, and it was Cosimo who also donated Leonardo's *Adoration of the Magi* to the Uffizi. Meanwhile his son, Ferdinando, was stripping churches and convents of many works of art to enlarge his own private collection which, on his death in 1713, became part of the Gallery. Among all these paintings was *The Madonna of the Harpies* by Andrea del Sarto.

When, in 1737, with the death of Cosimo III's last male child, the Medici dynasty became extinct, its end was marked by an act of enlightened generosity. The sister of the last grand duke, Anna Maria Luisa, wife of the Elector Palatine, drew up an agreement with the new ruler, Francesco III of Lorraine, confirmed on her death in 1743, by her last will and testament. This bequeathed the whole of the Medici collection to the person of the prince "but on the express condition that it is as an ornament of the State, for the utility of the public and to attract the curiousity of foreigners, and that none of it shall be taken out of the Capital and the State of the Grand Duchy." Everything, then, remained the inalienable heritage of the city of Florence. This same Anna Maria Luisa had herself, enriched the Medici collection when on her return to her native country in 1717 after her husband's death, she brought with her many works of art and precious objects.

Under the House of Lorraine and especially with Pietro Leopoldo and Ferdinando, the organization of the Gallery underwent a revision in the spirit of the Enlightenment. From 1789 Luigi Lanzi introduced a new system of classification by "schools" which concentrated particularly on painting, and much of the other material in the Gallery was taken elsewhere. Along the corridors new rooms in a refined Neo-Classical style were opened, happily taking their place next to the 16th-century rooms and respecting the measured harmony of Vasari's designs.

Important additions were made at this time. In an exchange with Vienna's Imperial Museums Florence succeeded in acquiring Titian's *Flora*, Giovanni Bellini's *The Sacred Allegory* and Dürer's *Adoration of the Magi*. In 1791 Ferdinando of Lorraine acquired Rubens' great canvases, *Henry IV at the Battle of Ivry*, *Henry IV's Triumphal Entry into Paris after the Battle of Ivry*, together with, probably, the magnificent portrait of the artist's first wife, Isabelle Brandt. The paintings arrived by sea at Leghorn in 1798. During the reign of Napoleon many works were transferred to Paris including the famous marble sculpture called the *Medici Venus* which was later returned after Napoleon's defeat and, the Congress of Vienna in 1815, when France was forced to return purloined works of art.

At one time the Uffizi Gallery also housed all the archeological finds belonging to the Medici, from Etruscan masterpieces (urns and bronzes) to ancient Roman and Greek artefacts. Also Renaissance sculptures from the time of Donatello onward, which were executed for the Medici, were also once kept there. However, between the end of the 19th century and the beginning of the 20th century, most of these were taken to form the basic nucleus of the Archeological Museum and the Bargello Museum. In 1973 Vasari's Corridor to the Pitti Palace was opened to the public. In the following years other masterpieces found their way to the Uffizi: works by El Greco, Chagall, De Chirico, Marino Marini, have reaffirmed the vitality of one of the most advanced museums in the world.

VATICAN MUSEUMS
ROME

The ensemble of the Pontifical Monuments, Museums and Galleries is undoubtedly one of the most important in the world, because of the quality of the works and because the settings in which they are preserved and which are created for them are architectural works of equal historic and artistic importance.

The Vatican Museums had their origin in the private collections of Cardinal Giuliano della Rovere, which he brought to the Apostolic Palace and exhibited in the Belvedere Garden when he was elected Pope in 1503 and took the name of Julius II (1503–13). This typical humanistic open-air museum was then enriched by the munificence of Leo X (1513–21), Clement VII (1523–34) and Paul III (1534–50).

In the 18th century, Benedict XIV (1740–58) founded the Museo Sacro of the Vatican Library, to which his successor, Clement XIII (1758–69) later added the Museo Profano dedicated to the minor art of antiquity.

The ensemble of the Vatican Museums became truly magnificent with the creation of the Museo Pio-Clementino under Popes Clement XIV (1769–74) and Pius VI (1775–99), to house such famous works as the *Venus of Cnidus*, the *Sleeping Ariadne*, the *"Belvedere Torso,"* the *Laocoön*.

An important section was added to the museums by Gregory XVI (1831–46) with the Museo Gregoriano-Etrusco, which includes the stupendous amphora by Exekias, illustrating *Achilles and Ajax Playing Dice*.

The Pinacoteca, one of the most recent sections of the Vatican Museums, founded by Pius VI after the return from Paris, under the Treaty of Tolentino, of the works of art removed by the French, includes works by Giotto, Fra Angelico, Melozzo da Forli, Leonardo da Vinci and Caravaggio. The large hall is devoted entirely to works by Raphael.

The Sistine Chapel. This was built between 1475 and 1483 by Giovannino de' Dolci after the plan of Baccio Pontelli for Sixtus IV. The 12 frescoes, disposed in two cycles of six on the main walls, represent scenes from the *Life of Moses*, and scenes from the Life of Christ. The two series begin on the altar wall, but the first two frescoes – the *Finding of Moses* and the *Nativity*, both by Perugino – were destroyed in the 16th century to make room for Michelangelo's *Last Judgment*, which was executed under Paul III from 1531 to 1541.

The vault of the Sistine Chapel was painted by Michelangelo between 1508 and 1512, by order of Julius II. Michelangelo decided to connect his work with the compositions existing on the walls, by painting on the ceiling the Genesis of the world, from the beginning of the Creation to the Flood and the resumption of life on the earth devastated by the Flood, with the family of Noah.

The *Last Judgment*, on the altar wall, was executed under Paul III, from 1535 to 1541.

Raphael's Stanze. Towards the end of 1508 Julius II entrusted to Raphael, then 25 years old, the decoration of the Stanze, which had been built by Nicholas V in the 15th century and were intented by him to serve as the pontifical apartment. Various 15th-century painters (among them Piero della Francesca) had worked there, but their compositions were destroyed to make room for new frescoes, except for part of the ceiling decorations.

Stanza della Segnatura. This was originally planned as the private library of Pope Julius II and was the first room to be painted by Raphael who worked on it from 1508 to 1511. The frescoes here are the so-called *Disputation of the Sacrament*, the *School of Athens*, and *Parnassus*.

Stanza di Eliodoro. This was the private antechamber to the apartments and was painted by Raphael between 1512 and 1514. The name derives from the representation of an episode in the Old Testament, the *Expulsion of Heliodorus from the Temple of Jerusalem*. The scene alludes to the efforts of the pope to free the State of the Church from usurpers. Famous frescoes here are the *Miraculous Mass of Bolsena*, *The Deliverance of St. Peter* and *The Meeting of Attila and St. Leo*. This historical meeting between the king of the Huns and the pope took place near Mantua, but the artist, with poetic license, has set it before the gates of Rome.

Raphael's Logge make up the facade of the old Vatican Palace. Decoration was begun by Bramante for Julius II and completed by Raphael and his students (1514–18).

Chapel of Nicholas V. This is the private chapel of the popes, also well known as the Chapel of Fra Angelico, who from 1447 to 1450 covered the walls with admirable frescoes of scenes from the lives of the two saintly deacons, Stephen and Lawrence.

Pauline Chapel. Built by Antonio the Younger, under Paul III, it is decorated on the side walls with two frescoes painted by Michelangelo: *The Conversion of St. Paul* and the *Crucifixion of St. Peter*, the first of which was executed between 1542 and 1545, the second between 1545 and 1550.

CATALOG OF THE ARTISTS
AND THEIR MASTERPIECES

PRE-COLUMBIAN ART

ROMAN ART

ROMAN BYZANTINE ART

SELJUQ ART

SPANISH ART

SUMERIAN ART